THE
⚜ ART ⚜
MUSEUM

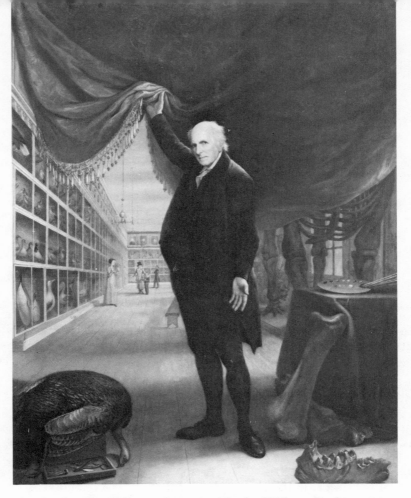

The Beckoning Gallery: the artist Charles Willson Peale portrays himself in his Philadelphia Museum, founded in 1785, a portent of museums to come.

Also by Karl E. Meyer

THE ART MUSEUM

POWER,
MONEY,
ETHICS

by KARL E. MEYER

A TWENTIETH CENTURY FUND REPORT

WILLIAM MORROW AND COMPANY, INC.

NEW YORK 1979

Grateful acknowledgment is made to the following for permission to reprint previously published material:

Jerome S. Rubin, "Art and Taxes." *Horizon*, Vol. 8, No. 1 (Winter 1966). Copyright © 1966 by American Heritage Publishing Co., Inc. Reprinted by permission of the publisher.

Geoffrey T. Hellman, *The Smithsonian: Octopus on the Mall*. Copyright © 1966, 1967 by Geoffrey T. Hellman. Reprinted by permission of J. B. Lippincott Company.

From *The Scene: Report on Post-Modern Art* by Calvin Tomkins. Copyright © 1971, 1976 by Calvin Tomkins. Originally appeared in *The New Yorker*. Reprinted by permission of The Viking Press, Inc.

H. L. Mencken, "The Sahara of the Bozart." Copyright © 1920 by Alfred A. Knopf, Inc., and renewed 1948 by H. L. Mencken. From *A Mencken Chrestomathy*. Copyright © 1949 by Alfred A. Knopf, Inc.

From *Art on the Edge* by Harold Rosenberg. Copyright © 1973, 1975 by Harold Rosenberg. Originally appeared in *The New Yorker*. Reprinted by permission of Macmillan Publishing Co., Inc.

Museum Ethics: A Report to the American Association of Museums by Its Committee on Ethics. Copyright © 1978 by the American Association of Museums. Reprinted by permission.

Thomas Hoving, *The Chase, The Capture: Collecting at the Metropolitan*. Copyright © 1975 by The Metropolitan Museum of Art. Reprinted by permission.

Michael J. Montias, "Are Museums Betraying the Public's Trust?" *Museum News*, Vol. 51, No. 9 (May 1973). Copyright © 1973 by the American Association of Museums. Reprinted by permission.

Duncan F. Cameron, "The Administrative Structure of the Museum and Their Management." Speech presented at UNESCO Symposium on Museums in the Contemporary World (November 24-28, 1969), Paris, France. Reprinted by permission of Mr. Cameron.

Library of Congress Cataloging in Publication Data

Meyer, Karl Ernest.
 The art museum.

 Bibliography: p.
 Includes index.
 1. Art museums—United States. I. Twentieth Century Fund. II. Title.
N510.M47 069'.9'7 78-11780
ISBN 0-688-03390-3

BOOK DESIGN CARL WEISS

Printed in the United States of America.

First Edition

1 2 3 4 5 6 7 8 9 10

FOREWORD

MORE THAN A DECADE AGO THE TWENTIETH CENTURY FUND UNDER-
took sponsorship of research by William J. Baumol and William G.
Bowen that resulted in the publication of a landmark study, *Perform-
ing Arts: The Economic Dilemma*. At the same time the Fund also
began to seek a study on the visual arts, specifically the art museum
in the United States. An analytical appraisal of these institutions,
dealing particularly with the public policy aspects of their expanding
activities, seemed necessary to round out the Fund's first work on the
performing arts and its subsequent studies of government subsidies to
the arts. The difficulty was in finding the right research director. After
several false starts, the staff invited a proposal from Karl Meyer. Al-
though not an arts scholar, Meyer had produced excellent work in
related fields. His interest in art museums and his willingness to in-
vestigate and analyze almost every aspect of their growth convinced
the Trustees to support his study.

The Fund's confidence in Meyer's skills as an investigative reporter
was not misplaced. An indefatigable researcher, he spent more than
three years exploring the subject and writing his report, more than
double the time originally allocated. Despite the respect for deadlines
instilled in him during his many years as a reporter, Meyer remained
at work long hours after the Fund's contemplated deadline had passed
and his appropriation was exhausted; the more he examined the com-

plex business of the contemporary art museum, the more he felt a need to look further. His book, although it may not be the definitive work on the subject, is a remarkably full and informative account of the critical issues confronting museums and the public.

Meyer's willingness to deal with troubling controversies—the role of trustees, the costs of operation, the rising price of acquisitions, and the significance of the institutional art market; the recent emphasis on blockbuster exhibitions rather than on permanent collections; the professionalism of staff and influence of politics—has resulted in an independent appraisal of the financial and ethical problems that all museums now face. Like the authors of all Fund-sponsored studies, Meyer has been free to state his own views. Other critics may reach different conclusions, but Meyer has, I think, identified almost every area of museum activity in which the public and public policymakers should be involved, and he provides recommendations for future policy.

Meyer's style has the virtue of being lively and entertaining, but his ability to write about museums and museum people in such a way that the book can be read purely for pleasure should not obscure his effort to deal with significant policy issues. We at the Fund believe that his report should stimulate debate within museums and among the broader public who have only recently become aware of their stake in what had long been regarded as a private cultural preserve.

—M. J. ROSSANT, Director
Twentieth Century Fund

ACKNOWLEDGMENTS

THE ART MUSEUM IS THE RESULT OF A THREE-YEAR VENTURE ENcompassing visits to fifty-three museums in twelve states and the District of Columbia. I interviewed, in addition to museum directors and trustees, curators and docents, collectors and critics, art historians and public officials, auctioneers and art dealers, foundation executives and working artists—in all, nearly 300 people.

Without the generous assistance of the Twentieth Century Fund and its director, M. J. Rossant, I could never have carried out the project. During the first year of research I was assisted by Anne Marie Cunningham, now an associate editor of *Natural History*, who conducted scores of interviews in five cities and unearthed invaluable information at archives and libraries across the country.

I am also enormously grateful to the Twentieth Century Fund staff. My thanks to John E. Booth, the Fund's associate director, who more than a decade ago urged that a study on museums be undertaken. In the early stages of the project Marc Plattner of the Fund's research staff made valuable suggestions; in the later stages Steven M. L. Aronson was of inestimable assistance in editing the manuscript. Mary Laing copy-edited a preliminary version of the book, and I am grateful as well for her suggestions. Randy Gilbert took time out from her duties at the Fund to gather the statistics on museum building programs that are reproduced in the appendix. And Wendy Mercer, the

comptroller, was uncommonly civilized in the handling of fiscal minutiae. M. J. Rossant, the Fund's director, commissioned no fewer than five outside readers to review the manuscript (to one of them—Angelica Rudenstein, a curator at the Guggenheim Museum— I am particularly indebted); he also took the time and trouble to alert me to every deficiency in successive drafts, and if I have not always concurred in his comments, I have certainly been prodded to rethink my views.

To Julie Houston of William Morrow, I owe the distinct pleasure that any author feels in the warm support of a publisher. Illustrations were expertly gathered by Laurie P. Winfrey.

In the course of this project, I have assembled an entire library of books, annual reports, official documents, exhibition catalogues, art magazines, and newspaper clippings. To assure that each source has been correctly cited, an experienced researcher, Schellie Hagan of *Audubon* magazine, sifted through this archive. Errors of fact and, of course, all judgments remain my responsibility alone, not that of the Twentieth Century Fund or the people who have assisted me.

I also wish to state that I was almost invariably received graciously by those I interviewed, even by men who are chary of journalists, such as Norton Simon, Armand Hammer, and Thomas Hoving (having arrived at judgments that I know each of them will dispute, I am the more mindful of the need to stress their willingness to be questioned). I was shown similar courtesy by the scores of people I interviewed at a half dozen professional conferences, of the American Association of Museums, the College Art Association, the American Council of the Arts, the Texas Association of Arts Councils, and the Western Association of Museums—or, acronymically speaking, AAM, CAA, ACA, TAAC, and WAM. In addition, thanks to the assent of the museum's president and director, I was able to attend an otherwise closed board meeting of the Museum of the City of New York; I also attended a board meeting of the Museum of New Mexico, in Santa Fe, one of the few such institutions that opens its board meetings to the public.

Finally, I record the support of my family and of Tina West, to whom this book is affectionately dedicated.

CONTENTS

FOREWORD by M. J. Rossant 5

ACKNOWLEDGMENTS 7

INTRODUCTION 11

CHAPTER I : THE AMERICAN HYBRID 17
 The Museum Idea 17
 From Dimes to Riches 22
 Art and Taxes 31
 "Populism" and "Elitism" 36
 Castling on the Mall 44

CHAPTER II : THE POLITICS OF PATRONAGE 58
 Rich Museum, Poor Museum 58
 The Funding Contraption 64
 Detroit Goes Dark 69
 The Cultural Bureaucracy 73
 The Medici Mentality 75
 Looking to Washington 86

CHAPTER III : NEW YORK, NEW YORK 91
 Hovingism 91
 The Capital of Art 98
 Three Directors 102
 Build Now, Argue Later 110
 The Annenberg Finale 119

CHAPTER IV : GALLERY WITHOUT WALLS 126
 Art and Mortar 126
 Monuments to What? 131
 Towering MOMA 134
 Wright's "Little Temple" 140
 Look on My Works! 144
 Architecture as Destiny 148
 Alternatives 159

CHAPTER V : "THE HARD COIN OF ART" *163*

 The Market Flypaper *163*

 From Academy to Auction *169*

 The Unique Commodity *176*

 Dealers or Collectors? *180*

 A Confusion of Values *185*

CHAPTER VI : THE SOVEREIGN COLLECTION *193*

 La Chasse *193*

 Chesterdale *199*

 An Art Olympics *201*

 "Everybody Does It" *208*

 Who Owns Museum Art? *211*

 Indian Giving *213*

 In Quest of a Code *216*

CHAPTER VII : MIDWAY TO PROFESSIONALISM *219*

 Gentlemen v. Players *219*

 Trusteeship *223*

 Museum Workers, Unite! *227*

 MOMA: Exit Hightower *231*

 Boston: Exit Rueppel *234*

 Brooklyn: Exit Cameron *236*

 Professionalizing the Board *238*

 Paying the President *240*

CHAPTER VIII : SUMMING UP: SIX PROBLEMS IN SEARCH OF A SOLOMON *243*

 Is a National Arts Policy Needed? *244*

 Art for Diplomacy's Sake *250*

 The Arts of Taxing *256*

 Projectitis *260*

 Searching for a Yardstick *262*

 Pyrotechnics or Lighthouse? *265*

APPENDICES *270*

NOTES *324*

BIBLIOGRAPHY *334*

INDEX *345*

INTRODUCTION

As THE SUBTITLE OF THIS BOOK IS MEANT TO EMPHASIZE, I HAVE not sought to write a history or aesthetic critique of the American art museum. I have deliberately confined myself to those features of the art museum that touch on public policy and have tried to avoid gratuitous forays into that treacherous, vendetta-ridden swamp in which scholars and critics exchange sniper shots about the true nature of art.

I have attempted to examine with a layman's eye an institution as fascinating as it has been inadequately explored. Wherever possible, I have illustrated general constructs with details chosen in the hope that they would breathe a measure of life into esoteric abstractions.

I am fully aware that many of the controversies I describe may be regarded from a different perspective by those directly involved. If my judgments have any merit, it is because they are those of an extraterritorial observer, unencumbered by occupational ties or delusions of infallibility. The researching and writing of this book have consumed the better part of three years. During this time, my own point of view changed many times, for I found the art museum to be like one of those ingenious Russian dolls that, when opened, contains a nest of ever smaller figurines—culminating in a thimble-sized damsel at the core.

William Hazlitt conveyed something of the art museum's seductive

elusiveness when he wrote, in 1823, of London's recently opened
Dulwich Gallery:

> A fine gallery of pictures is a sort of illustration of Berkeley's *Theory
> of Matter and Spirit*. It is like a palace of thought—another universe,
> built of air, of shadows, of colours. Everything seems "palpable to
> feeling as to sight." Substances turn to shadows by the painter's arch-
> chemic touch; shadows harden into substances. . . . The material is in
> some sense embodied in the immaterial, or, at least, we see all things
> in a sort of intellectual mirror. The world of art is an enchanting de-
> ception. We discover distance in a glazed surface; a province is con-
> tained in a foot of canvas; a thin evanescent tint gives the form and
> pressure of rocks and trees; an inert shape has life and motion in it.
> Time stands still, and the dead reappear, by means of this "so potent
> art!"[1]

In the pages that follow, my concern is mainly with the institu-
tional scaffolding—or secular apparatus—of Hazlitt's airy palace of
thought. In the United States perhaps more than in any other country,
the art museum has come to occupy a privileged promontory. All over
America, it has become a heraldic emblem of local pride, with
cities encouraging museums to compete among themselves for costly
acquisitions and spectacular loan shows, to be displayed in galleries
designed by the master architects of the age. As André Malraux
remarked a generation ago, the cathedrals of America are its art
museums.

But it is not architectural magnificence and the splendor of col-
lections alone that make the American art museum unique. Breaking
with European practice, major public galleries have zealously at-
tempted to educate a mass audience by means of splashy exhibitions,
special programs, and even unabashed hucksterism. Writing ad-
miringly of the multifarious range of gallery activities, Germain
Bazin, former chief curator of the Louvre, likened the American
museum to "a university for the general public—an institution of
learning and enrichment for all men." [2]

In recent years, response of the public has been unexpectedly ar-
dent. There are many explanations for the sharp increase in museum
attendance—among them greater leisure and educational opportuni-
ties for the middle class, extensive publicity for museum shows, an
epidemic of collecting, and, not least, simple curiosity about art. And
as the queue at the entrance has grown, so has the roll of those hoping
to influence and participate in museum decisions.

What goes on in the public art gallery has become a matter of great

interest to a cluster of constituents, some of them very recent converts to the cause of art: corporate underwriters, government patrons, diplomats, politicians, educators, community activists, auctioneers, private dealers, collectors, artists, and scholars. With considerable warrant, *The New York Times*'s chief art critic, Hilton Kramer, observed in 1974: "Almost unnoticed, and certainly without any single power contriving its fate, the museum has more and more become one of the crucial battlegrounds upon which the problems of democratic culture are being decided." [3]

In terms of public policy, the problem is to distinguish legitimate claims on the art museum from spurious and self-serving ones. This difficulty is compounded by the pace of museum expansion. Sometimes the concrete has already been poured before a community, or for that matter a museum board, realizes to what purpose. Since 1950 the United States has committed at least a half billion dollars to the construction of 10.2 million square feet at art museums and visual art centers, the equivalent in footage of 13.6 Louvres, or of a paved highway, six feet wide, from New York to California (see Appendix A).

This devotion to the visual arts is heartening. In 1876, having inspected the Philadelphia Centennial Exposition, William Dean Howells acidulously commented in *The Atlantic* that America spoke mainly in strong metals "and their infinite uses." The most popular attraction was Machinery Hall, dominated by the Corliss engine, with its fifty-six-ton flywheel. As Howells complained, the United States "talks too much in sewing machines." [4]

In bicentennial 1976, by contrast, the triumph of the art museum was blazoned in the very sky of Washington. To celebrate the opening of "The Eye of Jefferson," the National Gallery of Art presented a fireworks display faithfully re-creating a *feu d'artifice* that the author of the Declaration had once witnessed in France. (The rocketry was manufactured by the same Paris firm that had mounted similar displays in Jefferson's day, *avant le déluge*.) In paying homage to Jefferson, the National Gallery organized its most elaborate exhibition, boasting major loans from museums throughout Europe (the Uffizi sent the Medici Venus and the British Museum the Greek urn said to have inspired Keats's ode).

During 1976 bicentennial events took place in more than forty other Washington museums, only two of which (the original Smithsonian and the Corcoran Gallery of Art) had existed a century before. The Smithsonian Institution alone accounted for twenty-three bicen-

tennial exhibitions installed among nine museums (one of the exhibitions was a re-creation in miniature of the 1876 Philadelphia Exposition).

The importance of museums recently has been confirmed in other ways as well. Among the guests at the Jeffersonian fireworks were 1,500 or so delegates to the annual meeting of the American Association of Museums, which had just been convened at the Shoreham Hotel. Although during most of its sixty-year history the AAM had been only marginally involved with the federal government—as befits typically local institutions managed by private boards of trustees— the convention was addressed by leading members of Congress, the chairmen of the two national endowments, and a half dozen lesser functionaries on the subjects of tax laws, grant programs, the new Arts and Artifacts Indemnity Act, and the soon-to-be-approved Museum Services Act. Shortly before, the monthly AAM magazine, *Museum News*, featured an article headed "The Washington Connection."

For the most part, AAM conferees were favorably disposed to these federal programs. But a sobering warning was sounded by no less a figure than the secretary of the Smithsonian himself, the Honorable S. Dillon Ripley:

> As museums come closer to success in establishing a precedent for government funding for services and for services rendered, akin to massive support for colleges and schools, it would be wise to look ahead and consider that with federal funding come certain reciprocals: oversight, control, bureaucratic management, accountability, and increased administrative and overhead responsibilities. . . . I would urge one and all to recall that the education apparatus in this country now suffers to an extent from vast federal support. The prescription of policies stems from the spending power. Money begets power, but the ultimate power rests with the dispensers of money. Museums would do well to measure thus their independence against their eventual dependence on government funds.[5]

Ripley was not describing a mere specter; his own institution—the recipient of more than $100,000,000 in annual federal appropriations—was at that very moment contending with government auditors and the basilisk eye of Congress. Yet the Smithsonian, like many another museum, had brought its troubles on itself by initiating expansion programs a bit too indiscriminately and then enthusiastically overselling them. The institution's problems with Congress stemmed initially from serious misgivings on the part of key legislators about the terms the Smithsonian had accorded the uranium magnate Joseph

H. Hirshhorn in order to secure his much sought-after collection for a new Smithsonian museum bearing his name.

Indeed, the case of the Smithsonian and the Hirshhorn Museum illustrates a theme that will recur frequently in this study. It was public money that was used to build and maintain the Hirshhorn, but the dispensers of the money had neither the time nor the information to pass reasonable judgment on the merits of the project. More important, there is no defined tradition of cultural patronage in the United States to which both government and museum can look. The danger exists that an ad hoc decision can turn into a permanent taxpayer commitment of $2,000,000 a year in maintenance for a museum lacking an endowment from the donor.

In most American museums, policy is shaped by an essentially autonomous board of distinguished private citizens, including a few ex officio public members. Few museum trustees can claim professional expertise in the arts or sciences. Thus, if a director is eloquent in his endorsement of a project, the prospects are good that influential trustees will go along and the full board will approve.

Over the course of more than a century this system has worked surprisingly well, as attested to by the number and splendor of American art museums. What has thrown the museum world into disarray is a brute fiscal reality—rising deficits. Until recently museums have been able to keep their books in precarious balance by juggling municipal appropriations, endowment income, private contributions, and revenues generated by internal operations. But beginning in the 1960s, art museums, along with other cultural institutions, have had to cope with both steeply rising costs and declining private and municipal support. Bills have come due for expansion programs approved in the sanguine, growth-minded years. Hence, the introduction of admission charges; hence, the desperate appeals to state legislatures and Congress. Hence, also, this study.

The entire lay public—taxpaying citizens, elected officials, community leaders, and workaday journalists—has been impelled to consider the specialized claims of the art museum. Any number of difficult questions arise. How is the performance of an art museum to be judged? How can trustees be made more accountable? What exactly is behind the continuous hiring and firing of museum directors? Why, since so many grants are provided by corporations, state arts councils, and the national endowments, does the art museum still need money? What are the hazards for the art museum in becoming embroiled with

the art market? Is the deaccessioning of surplus art a breach of public trust? Are tax incentives for gifts to museums too generous? Does the sale of reproductions of works of art compromise the purpose of the art museum? And so forth.

It would be presumptuous for me to suggest that I can offer definitive answers to these questions, but I have made every effort to present information and to make my own judgments. I realize that I have inadequately explored some topics, museum education programs in particular. But no one book can do justice to a subject so wide and varied as the art museum. As I researched, excavated, compressed, interviewed, meditated, and summarized, I always tried to keep in mind that thimble-sized damsel at the core of the Russian doll—a magical emanation, beyond the power of dollars to measure, that can make time stand still.

—KARL E. MEYER
Weston, Connecticut

I

THE AMERICAN HYBRID

> We are a composite people. Our
> knowledge is eclectic. . . . We
> beg, borrow, adopt, and adapt.
>
> —JAMES JACKSON JARVES
> *The Art-Idea* (1864)

THE MUSEUM IDEA

JUST AS AMERICANS ARE A COMPOSITE PEOPLE, THE AMERICAN ART museum is a composite national institution. It is an amalgam of contraries, not unlike our system of cultural patronage. Its roots are at once republican and revolutionary, patrician and bourgeois; it is both public and private; it looks backward as well as forward. Professing a universal creed, it is also nationalist and even at times chauvinist. And no one is certain what its real mission is. The confusion extends to nomenclature.*

The word "museum" derives from the Greek *mouseion*, signifying a place or home of the Muses.[1] But none of the nine Muses was identified with the visual arts, and there were no museums, as we know them, in ancient Greece. The alternative term, "art gallery," is just as elusive. Of the ten meanings for "gallery" given by *Webster's Third*

* Notes are given following p. 323, with full citations in the bibliography. For reasons of clarity and concision, I have throughout adhered to traditional usage in pronouns.

International Dictionary, the first is "a covered space more or less open at the sides for walking," and the fourth is "an institution devoted to the collection and exhibition of works of art." "Museum" is now generally understood to mean "an institution devoted to the procurement, care, and display of objects of lasting interest or value" and as such may contain objects of aesthetic, historical, or scientific interest. "Gallery," on the other hand, has a narrower meaning; there are, for instance, no galleries of natural history.

Still, the Hellenic idea of a museum as a haven of all the arts persists in the United States. Most larger art museums sponsor programs of music, poetry, dance, film, drama, and history, and a number of them conduct courses of instruction in the plastic and visual arts. Few confine themselves to the passive exhibition of paintings and sculpture.

In its deepest sense, the art museum speaks in the language of Greek mythology. The nine Muses were, after all, the daughters of Mnemosyne, the goddess of memory, by Zeus, the god of power. Art museums can be seen as temples of remembered power: creative, dynastic, financial, political. They are to this extent a Western invention—one now universally imitated. Today the national museum is as much an emblem of sovereignty as a flag, passport, or parliament.

That it has become so is due in part to the first major social upheaval of the modern era, the French Revolution, and to the impact of the Louvre on foreign visitors. One such spellbound traveler was James Jackson Jarves, an American who would later settle in Florence and become a celebrated art collector. In 1864 he published *The Art-Idea*, a manifesto for his fellow citizens, in which he extolled the art museum as an instrument of education and moral nourishment and urged the founding of museums modeled on the Louvre.

> To stimulate the art-feeling, it is requisite that our public should have free access to museums, or galleries, in which shall be exhibited, in chronological series, specimens of the art of all nations and schools, including our own, arranged according to their motives and the special influences that attended their development. After this manner a mental and artistic history of the world may be spread out like a chart before the student, while the artist, with equal facility, can trace up to their origin the varied methods, styles, and excellences of each epoch.[2]

The result, he contended, would be a "perpetual feast," affording the most intense and refined enjoyment, mingling pleasure with Christian morality.

As Jarves expressed this hope, the United States was being rent by the Civil War. No museums of the kind he envisioned existed in the

New World. But by the time of his death, in 1888, he had witnessed the first fruits of his "art-idea": a half dozen new art museums, most of them open without an admission fee, each of them determined to rival the Louvre in the scope of its collection. What Jarves could hardly have anticipated was that the success of his lofty art-idea would be assured by none other than the new business moguls, who would find the art museum an attractive hobby and make it fashionable.

As a social mechanism, art has long been a meeting ground for the wellborn and the newly rich. In the eighteenth century, art auctions served a social as well as an economic function. Since they were frequently held *in situ* on the estates whose treasures were to be dispersed at public sale, the bidder could see for himself how the aristocracy lived as well as what objects it had collected. An obligatory feature of the stately residence, in England and on the Continent, was the picture gallery, with its ancestral portraits and objets d'art. Another common feature was the "cabinet of curiosities," crammed with natural and artistic marvels. The gallery and cabinet were themselves museums in embryo.

These collections were based, in turn, on royal models. Since the Renaissance the rulers of Europe had been sharpening their appetites on works of art, both classical and contemporary—with the result that art became a recognized form of plunder. The sacking of Rome in 1527 by the soon-to-be Hapsburg Emperor Charles V yielded treasures that would one day enrich the Austrian national museum. The Swedish national collection is swollen with the booty seized by Gustavus Adolphus and later by his daughter, Queen Christina, during the religious wars. The avaricious and discerning Jules Cardinal Mazarin took full advantage of French military victories to amass a magnificent collection; it was known through Europe, writes Francis Henry Taylor, that Mazarin could always be bribed with an art object, "provided the quality were good enough." [3]

The greatest artists of the era, Titian and Rubens among them, enjoyed a royal vogue as European courts vied with one another for the privilege of patronage. The competition for prize works was so keen that ambassadors sometimes doubled as purchasing agents or bidders at auction. Even kings and queens, whatever their feelings about the Puritan regicides, did not scruple to share in the spoils when Parliament put up for sale, between 1649 and 1653, the fabulous art collection of the beheaded Charles I.

It was from these princely collections that the earliest art museums evolved. By the eighteenth century they included the Louvre, the

Medici collections in Florence, the Vatican museums, and the Dresden museum. But public access was highly restricted. The British Museum, the first national institution of its kind, chartered in 1753 by Parliament and supported by public revenues, was open only to visitors who had made written application in advance and been approved—a practice that continued for nearly forty years.

That the right to see such collections belonged to all citizens was asserted for the first time on August 10, 1793, a year to the day after the overthrow of the French monarchy. The Louvre was proclaimed a *musée révolutionnaire*, open to everyone on three days of the ten-day week adopted by the Convention. As French armies swept over Europe, the seizure of art was seen as a form of moral reparations. When wagons full of art arrived from the Netherlands in 1794, the French officer presiding over the operation was moved to say, "Too long have these masterpieces been sullied by the gaze of serfs. . . . They rest today in the home of the arts and of genius, in the motherland of liberty and sacred equality, in the French Republic." [4]

Under Napoleon, these seizures became routine and systematic. One of his campaign aides, Baron Dominique-Vivant Denon, who had the title of Inspector General of the French Museums, was nicknamed *l'Emballeur* ("the packer"), having transplanted to France the best examples of the art of Egypt, Greece, Italy, the Low Countries, Spain, Germany, and Austria. Once in the Louvre, the works were for the first time displayed chronologically so that visitors could see the unfolding of successive civilizations, as in a visual encyclopedia.

From the outset, this new conception proved enthralling. Belgian-born physician Edward Meissner noted in his diary in 1819: "Anyone who lived in the metropolis of the world at that time had the exhilarating feeling of living in the midst of the art of all ages. . . . The French seem to have robbed not so much for themselves as for the convenience of the world at large." [5] Schiller, a partisan of the Revolution, extolled the Louvre in verse:

> What the art of Greece created,
> Let the Frank by dint of battle
> Carry to his vaunted Seine.
> Let him in superb museums
> Show the trophies of his valor
> To the marvelling citizen.

Writing in our own time, Germain Bazin, former chief curator of the Louvre, has made this case for Napoleon:

Perhaps some future age will find immoral that which we think entirely natural. Is not the power of money as much an instrument of domination as military strength? Which is more moral—to conquer works of art with dollars or by men fallen 'on the field of honor'? All depends on motives and circumstances. For a revolutionary France attacked by Europe and turned conqueror under the menace of invasion, the capture of works of art was the prerogative of the victor, a noble means of seeking indemnity for losses sustained in men and arms. . . .[6]

Whatever the morality involved, the very notion of a national gallery organized on art historical principles is a legacy of the French Revolution, as is the belief that all citizens should have access to such museums. At the Congress of Vienna the victorious allies insisted on the return of most of the uprooted art, and in time, the repatriated masterpieces formed the core of new public galleries in Amsterdam, Milan, Naples, Brussels, Madrid, Munich, and other cities. The English, too, were bestirred by the French example, establishing their National Gallery in 1832.[7]

Before the Revolution, the idea of a "cultural patrimony" did not exist; no one, with the notable exception of Byron, thought it odd, for instance, that the carvings of the Parthenon should be carted to England as diplomat's booty, without the Greeks' having any say in the matter. When Greece became independent in 1833, a fiercely nationalist open letter was sent to the British Parliament demanding the return of the "holy relics" to "newborn Hellas,"[8] and by 1866 ground had been broken for a Greek National Museum.

The link between bourgeois nationalism and art was forged in Paris. Notwithstanding its royalist roots, the art museum was given a republican patina by the French; in this guise it was a magnet for art-minded citizens of the young American Republic.

"Be it borne in mind," James Jackson Jarves wrote in *The Art-Idea*, "that the greatest museum of Europe was founded by republicans. It was not until the people had won political power that the rulers threw open to them the treasures which had hitherto been enjoyed in selfish privacy, or displayed only as reflections of aristocratic taste and magnificence. When absolutism began to give way to democratic ideas, one of the first results was the restoration to the people of their art of previous ages."[9]

To Americans like Jarves, it seemed wholly proper that government should support art museums, in the same way that it assisted schools, libraries, and parks, all of which belonged to the fabric of civic-minded popular rule. Although Jarves realized that art museums had a narrower appeal than public parks and were not so obviously utili-

tarian as public libraries, he was convinced that the display of great art not only could elevate the masses but also could have a practical benefit in terms of improved design in manufacture. He was, as well, quick to see that museums would stimulate tourism: "The city of America which first possesses a fine gallery of art will become the Florence of this continent in that respect, reaping a reward in reputation and money sufficient to convince the closest calculator of the dollar that no better investment could have been made."

In these arguments, Jarves reflected his own experience and the spirit of the age. Born in Boston in 1818, the second son of Deming Jarves, who made a fortune in the manufacture of Sandwich glass, he settled in Hawaii, where he became the editor of the first newspaper published in Honolulu and ultimately the historian of the islands. On a trip to Europe in 1851 to negotiate commercial treaties between the U.S. and the British and French, he visited the Louvre. From that moment on he dedicated his life to art.

Having moved to Florence, Jarves began collecting the works of then obscure Italian masters, such as Sassetta and Pollaiuolo. In all, he was to write a dozen books about Italy and art, encouraged by his friends John Ruskin and the Brownings. By 1860 he had returned to the United States in possession of the largest and most important collection of early Italian works in the New World. He attempted to sell his collection to public institutions in Boston and New York, but its quality was derided by critics ("pre-Giottoesque ligneous daubs," wrote one). Eventually, and with misgivings, Yale College accepted Jarves's pictures as collateral on a $20,000 loan. When he was unable to repay the sum, Yale put the collection up for public auction in 1871—and in the event submitted the winning bid of $22,000. Thanks to that purchase, the Yale University Art Gallery contains one of the most important collections of early Italian masters in the country.

It is no wonder, then, that Jarves's vision of the great art museum seemed quixotic in the 1860s. A child of the age of Emerson, he could not have foreseen that nationalism and materialism would bring his art-idea to spectacular fruition.

FROM DIMES TO RICHES

When Jarves published *The Art-Idea* in 1864, there were essentially two kinds of museum in the United States. One was the "dime" museum, an emporium of curiosities operated for profit and dedicated

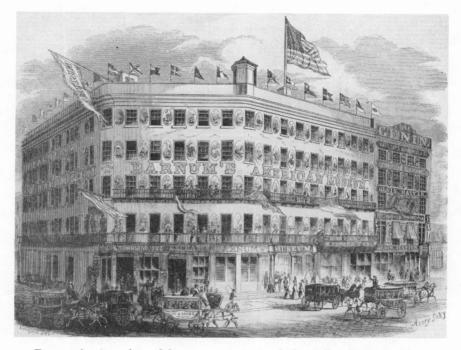

Barnum's American Museum, greatest of the "dime" museums, *c.* 1854

to entertainment. The other was the impecunious but high-minded public gallery, usually an appendage of an art academy, library, historical society, college, or private club. Both kinds of museum were to prepare the way for a sturdy American hybrid.

The most famous "dime" museum was operated in New York by Phineas T. Barnum, who in 1841 had purchased on credit the American Museum located on Broadway that John Scudder had founded in 1810. Under Barnum, it became a byword for showmanship and clever humbug. Its attractions included jugglers, fleas, living statuary, rope dancers, dioramas, a Fairy Grotto, a Storm at Sea, and entire tribes of American Indians. "It was my monomania to make the museum the town wonder and town talk," Barnum wrote in his memoirs. "I studied ways to arrest public attention; to startle, to make people talk and wonder; in short, to let the world know I had a Museum." [10]

Barnum proceeded to fill the museum with anything—living or dead—that would draw a crowd: the spurious Feejee Mermaid, bearded women, Siamese twins, and the twenty-five-inch-tall Charles S. Stratton, whom Barnum brilliantly renamed Tom Thumb. Early on, he set about trying to buy the famous relics of Europe for display in the American Museum; he came close to buying Madame

Tussaud's Waxworks and stirred a furor in England by encouraging the belief that he wished to buy the cottage at Stratford-on-Avon in which Shakespeare had been born.

There were similar "dime" museums in many American cities. Typical of them was the Western Museum in Cincinnati, which at one time employed a young woman by the name of Frances Trollope to help arrange such spectacles as the Invisible Girl, Hecate and the Three Weird Sisters, and a Magic Chamber of "SPECTRAL FIG-URES and curious animals." Drawing liberally on her museum experiences, Trollope went on to write the best-selling *Domestic Manners of the Americans* (1832), a chronicle of American crudity. Of the picture galleries then existing in New York, she wrote: "The Medici of the Republic must exert themselves a little more before these can become even respectable." [11]

Nevertheless, the "dime" museums served their unpretentious purpose, which was to provide a mass audience with diversion; and as a result, the American museum became associated in the public mind with showmanship and theatricality. The frenzied publicity generated by today's blockbuster show betrays a debt, if seldom acknowledged, to the equivocal genius of P. T. Barnum.

The early-day public galleries were in aim and spirit very different from the "dime" museums. Even before the American Revolution the educated classes, made up of professional men, well-to-do merchants, and landowners, had begun to establish public galleries. The first was organized in 1773 by the Library Society in Charles Town, South Carolina, its collection initially consisting of the area's natural curiosities. The Massachusetts Historical Society, which was to serve as a model for others, was founded in 1791 and soon encompassed a small public gallery as well as a library. And with the opening of the Trumbull Gallery at Yale in 1832, colleges also began forming collections of art for teaching purposes.

In Philadelphia an American counterpart to the Royal Academy, the Pennsylvania Academy of Fine Arts, opened in 1805, dedicated to the improvement of public taste and the training of artists; the first of its annual exhibitions was held six years later. In New York the American Academy of Fine Arts was launched in 1802, evolving in a generation into the National Academy of Design, which also continues to sponsor annual exhibitions.

Each of these institutions was the fruit of spontaneous citizen initiative. Nearly all of them were organized as nonprofit corporations and

placed under the control of private, self-perpetuating boards of trustees. A pattern of local initiative and private control was thus fixed and prevails to the present day. It is not the structure but the sponsorship of the art museum that has changed so conspicuously over the years.

In the early days of the art museum, trustees were members of the professional and landed classes, rather than, as in the museum world today, men of great wealth. In the case of the New-York Historical Society, established in 1804, of its twenty-nine founders, nine were clergymen, five lawyers, and four physicians. Old New York names predominated: Peter G. Stuyvesant, a great-great-grandson of the one-legged Dutch governor of New York, Rufus King, De Witt Clinton, Henry Brockholst Livingston, Anthony Bleecker. Among the society's early presidents were Gouverneur Morris, Albert Gallatin, and Hamilton Fish—men whose prominence was ancestral or political, not financial.

After the Civil War, grander museums were established, robustly nationalistic in outlook and reflecting the aggressive, restless temper of the new American elite.

The Metropolitan Musuem of Art in New York traces its origins to a Fourth of July party held at the fashionable Pré Catalan restaurant in the Bois de Boulogne in 1866. Between toasts, John Jay, a lawyer and the grandson of the first Chief Justice of the U.S. Supreme Court, declared to his fellow New Yorkers at the table that it was "time for the American people to lay the foundations of a National Institution and Gallery of Art." Three years later, after long deliberation, the Union League Club, of which Jay was president, decided to take upon itself the founding of a great museum in New York City. A Committee of Fifty, two-thirds of whom belonged to the Union League Club and four-fifths to the Century Association, was appointed to carry out this ambitious plan. The museum's clubbish origins were to leave an enduring imprint.

Founded in 1863, the Union League Club was not a purely social institution. Its name proclaimed its devotion to Unionism and thus to the new Republican party; in New York the club was clearly identified with the reform movement that challenged Tammany Hall. On another level, the club was the bastion of prosperous entrepreneurs; in their business no less than in their political dealings, Union Leaguers promoted transcontinental fusion through rails, cables, and ballots.

By contrast, the Century Association gave (and continues to give)

weight to intellectual and artistic distinction in its selection of members. Formed in 1847 as an outgrowth of the National Academy of Design, it was conceived of originally as an assemblage of artists. The differing traditions of the founding clubs were to coexist uneasily within the new museum.

The first Union League meeting (which established the Committee of Fifty) was presided over by William Cullen Bryant, poet, journalist, and liberal reformer. But the true architects of the Metropolitan were wealthy businessmen, mostly self-made. Among them were John Taylor Johnston, the museum's first president, and William T. Blodgett, a benefactor and founding trustee. Johnston had made his fortune in railroads, Blodgett in real estate, and each was an avid collector of art.

Of the founders of the Metropolitan, the most far-seeing was Joseph H. Choate, probably the greatest corporation lawyer of the era. So fluent was Choate as a defender of the postbellum plutocracy that in 1895 he had suceeded in persuading the U.S. Supreme Court that the income tax was unconstitutional and indeed a communistic measure—with the result that the federal government did not tax incomes until the ratification of the Sixteenth Amendment in 1913.

Choate drafted the charter of the Metropolitan Museum, which was approved by the New York State legislature in 1870. He contrived the most favorable possible terms for the museum, negotiating directly with William Marcy "Boss" Tweed, the Tammany ruler of New York, who at the time was eager to avoid unnecessary conflict with Union League reformers. Under the charter, the museum was to be built in Central Park at a cost of $500,000 in city funds; the city also was to provide all maintenance expenses. Yet the institution was to remain under private control, governed by a board of twenty-one private members, plus a group of ex officio trustees, including the mayor. In effect, the City of New York was being committed to support generously, if not munificently, a museum over which it would have no real power. (In 1870 Choate negotiated a similar arrangement for the American Museum of Natural History, of which he was also a trustee.)

There remained the interesting question of who actually would own the Metropolitan. Choate devised a compromise: The city would own the buildings, and the trustees would own its contents. But the meaning of the word "own" would become a problem, as we shall see.

Choate's uncommon skill at negotiation can be seen when the charter of the Metropolitan is compared to that of the Boston Museum

of Fine Arts, which was founded in the same year. The Boston institution also owes its existence to the initiative of a private club, in this case a private library, the Athenaeum, which for years had operated an art gallery. But the founders of the Boston Museum of Fine Arts, nearly all of them Brahmins, proudly declined seeking any city subsidy other than the use of city land for the site of the building. The entire cost of the building, $230,268, was raised by private subscription. The result of the museum's early reliance on private resources was to place it at permanent disadvantage in its continuing rivalry with the Metropolitan.

Joseph H. Choate was not only a gifted attorney but also one of the most acclaimed public orators and wits of his day. In his speech at the inauguration of the Metropolitan's new building in 1880, with an eye to the foibles of his clients, he made this plea:

> Think of it, ye millionaires of many markets—what glory may yet be yours if you only listen to our advice, to convert pork into porcelain, grain and produce into priceless pottery, the rude ores of commerce into sculptured marble, and railroad shares and mining stocks—things which perish without the using, and which in the next financial panic shall surely shrivel like parched scrolls—into the glorified canvas of the world's masters, that shall adorn these walls for centuries.[12]

Since often enough the new-rich found themselves burdened with the problem of how to spend their money, Choate's contention that art could yield dividends in pleasure, prestige, and public service fell on receptive ears. Among the converts, the most redoubtable was J. Pierpont Morgan.

Between the 1890s and 1913, the year of his death, Morgan spent about half his fortune on art, usually paying the highest prices, acquiring entire collections *en bloc*, and impelling a generation of dealers to tremble at the very mention of his name. In fewer than twenty-five years, Morgan assembled what was probably the world's greatest collection of art in private hands; following his death, its worth was appraised at $60,000,000, compared with $68,000,000 for the remainder of his estate. His taste in art, not to mention yachts, set the standard for magnificence in the age of moguls.

Morgan was elected to the Metropolitan board in 1888 and in 1904 succeeded to its presidency. According to Calvin Tomkins, the historian of the museum, Morgan took pains "to fill the vacancies on the board with millionaires of his own choosing—men like Henry Walters, Henry Clay Frick, John G. Johnson, George F. Baker, and Edward S. Harkness—and as a result the Metropolitan's board of

trustees was not only the most exclusive club in New York, but also, without a doubt, the richest." [13]

All over the country other museum boards tended to follow suit. Before the end of the century major galleries had been founded in Washington, Philadelphia, Chicago, Brooklyn, Detroit, St. Louis, Cincinnati, San Francisco, Pittsburgh, and elsewhere. In nearly every case they were governed by self-perpetuating private boards, and in time art museum trusteeship was synonymous with wealth.

The new mood was perceptively caught by Henry James, who, revisiting New York in 1907 after a long absence, was among the marveling visitors to the Metropolitan. "A palace of art, truly, that sits there on the edge of the Park," he wrote in *The American Scene*, predicting that "Acquisition—acquisition, if need be on the highest terms—may, during the years to come, bask here as in a climate it has never before enjoyed." For there was money in the air, "ever so much money. . . ." [14]

But if America had become a world museum power, it was not, surely, in the terms that James Jackson Jarves had envisioned. Again and again, Jarves had stressed the moral dimension of the fine arts, which he saw as confirming the superiority of democracy and Christianity. The connection of great art and great wealth had only dimly occurred to him, and certainly, his own experience of the world had not encouraged any such linkage. But there was no denying that art had become a talisman of wealth—thanks to impulses that were only partly rational and that remain partly inscrutable.

In *The Theory of the Leisure Class*, Thorstein Veblen argued that the chief incentive for amassing wealth was not simply the consumption of goods. "The motive that lies at the root of ownership is emulation," he wrote. "The possession of wealth confers honour; it is an invidious distinction." [15]

The prestige attached to specific possessions varies from age to age and from culture to culture. Among the American Indians of the Northwest, prestige derives from the ritual destruction of valuable possessions in a potlatch. In eighteenth-century England the construction of useless "follies" on country estates was a fashionable pastime. In our own culture, ownership of works of art confers a kind of automatic status.

No doubt the allure of art owes much to its association with magic and religion. The painters who adorned the Ice Age caves of France and Spain were in all probability shamans employing sympathetic

magic to assure fertility and an abundance of game. Even in the Bible, art and religion were entwined to the point where Jehovah saw fit to warn the Children of Israel to abjure the graven image.

But if the association of art with the supernatural is all but universal, the idea of a secular art market is a Western contribution, the seeds of which lie in classical Greece and imperial Rome. Hellenic potters were the first to sign their wares; sculptors, painters, and architects were known by name; and as early as the second century A.D. there existed the equivalent of a guidebook, compiled by Pausanias, commending to travelers the works of various artists. The Greeks, moreover, were conscious of the power of art as political propaganda. Pericles in his funeral oration in 431 B.C. justified the expenses incurred in the building of the Parthenon on the grounds that it "will make us the wonder of this and succeeding ages." [16]

Rome absorbed and enlarged upon the Greek tradition. In 189 B.C. a Roman general, Marcus Fulvius Nobilior, returned from the conquered Greek city of Ambracia with 785 bronze and 230 marble statues, which he proceeded to install in a new temple dedicated to the Muses. Future conquerors followed his example, and in the course of only a few centuries Rome evolved into an open-air museum of Mediterranean art.

The earliest international art market—complete with dealers, collectors, auctioneers, and forgers—was in fact a Roman innovation. Horace describes a rage for primitives in the Augustan era and gives an account of a collector who was so gullible that he paid 100,000 sesterces for a bronze worked up in the archaic manner. Clearly, works of art had already acquired honorific status as a commodity. Divorced from a specifically religious context, art was now also prized as a possession that had a monetary value, depending on its rarity and authenticity and, as always, on the opinion of the critics.

Continuity in history can be exaggerated, and historians differ on the degree to which the Renaissance was precipitated by the rediscovery of classical antiquity, as Burckhardt maintained a century ago. In the fine arts, nevertheless, the influence of classical models was everywhere to be seen. One of Michelangelo's earliest works was a sleeping Cupid, executed in marble in the classical style. When one of the artist's patrons saw the work, he advised Michelangelo to sell it in Rome as a genuine antique. It was promptly bought by a cardinal for 200 ducats, of which Michelangelo received only 30, a circumstance that roused the artist—who had been cheated in the process of cheating—to furious protest. The story, which comes

to us from Michelangelo's biographer Condivi, suggests that the art market and its equivocal morality were recognizably in operation in the sixteenth century.[17]

What Rome was to the ancient world, the United States is to ours —a comparative upstart with immense political and economic power, yet relying heavily on borrowed cultural traditions. The parallel is a familiar one and can be pushed to extreme, but it has a core of truth. With the help of Virgil, the Romans, embarrassed by their lack of a glorious past, invented one wherein the Caesars could claim a line of descent deriving from Troy and the Olympian gods. A similar obsession with continuity often afflicts Americans with more money than pedigree, and the art museum can be seen as an assertion of continuity, a means by which wealth is gilded with antiquity.

As James Jackson Jarves wrote, America

has no antecedent art: no abbeys in picturesque ruins; no stately cathedrals, the legacies of another faith and generation; no mediaeval architecture, rich in crimson and gold, eloquent with sculpture and color, and venerable with age; no aristocratic mansions, in which art enshrines itself in a selfish and unappreciating era, to come forth to the people in more auspicious times; no state collections to guide a growing taste; no caste of persons of whom fashion demands encouragement to art-growth; no ancestral homes, replete with a storied portraiture of the past; no legendary lore more dignified than forest or savage life; no history more poetical or fabulous than the deeds of men almost of our own generation, too like ourselves in virtues and vices to seem heroic, —men noble, good, and wise, but not yet arrived to be gods; and, the greatest loss of all, no lofty and sublime poetry.[18]

This catalogue of missing ingredients echoes the list compiled by Henry James in his biography of Nathaniel Hawthorne. Among the "items of high culture" nowhere to be found in the America of the 1830s, at least according to James, were:

No State, in the European sense of the word, and indeed barely a specific national name. No sovereign, no court, no personal loyalty, no aristocracy, no church, no clergy, no army, no diplomatic service, no country gentlemen, no palaces, no castles, nor manors, nor old country houses, nor parsonages, nor thatched cottages, nor ivied ruins; no cathedrals, nor abbeys, nor little Norman churches; no great universities nor public schools—no Oxford, nor Eton, nor Harrow; no literature, no novels, no museums, no pictures, no political society, no sporting class—no Epsom nor Ascot! [19]

Nations, like nature, abhor a vacuum. Within the context of American history, the art museum has helped fill the void.

James Jackson Jarves presaged that art collecting would become a national obsession when he wrote in *The Art-Idea* in 1864: "America has already advanced from indifference to fashion in matters of art. It has become the mode to have a taste. Private galleries in New York are becoming almost as common as private stables."

In the 1870s art collecting was already an avocation of the new millionaires. Banker James Stillman filled his Manhattan mansion with Titians and Rembrandts, and his neighbor, mining magnate William A. Clark, dined in full and luminous view of Gobelin and Beauvais tapestries. Vanderbilts, Fricks, and Gateses were accumulating rare jades, illuminated manuscripts, Greek vases, and Renaissance masterpieces. Rarely did the new moguls show any interest in the work of living artists. Nor were they very much concerned with music, literature, drama, or dance. The visual arts in every form were their preserve, and their tastes ran to the impeccably blue chip.

There was, of course, the obvious investment attraction—paintings, sculptures, and objets d'art were certain to appreciate in value; the best of the collected objects had come festooned with the crests of kings and princes.

But impulses other than cupidity and snobbery were at work. Americans live in a universe of copies and imitations, from fake architectural renderings of Gothic cathedrals to spurious French restaurants; we tend to dwell in a house of mirrors in which nothing is ever what it seems to be. A work of art, on the other hand, has uniqueness and authenticity. A verifiable Rembrandt makes a claim upon us that neither fashion nor the media can distort; unlike stocks and bonds, it has the appeal of something solid, like an anchor in a swamp.

By the turn of the century, for whatever reason, the accumulation of great works of art had become a form of conspicuous consumption inspiring emulation and conferring honor on the possessor. But collecting posed a problem. How could the collections be perpetuated in a manner that would satisfy both private need and public good? The art museum provided an answer, and the tax laws the incentives.

ART AND TAXES

Two fiscal measures have been indispensable to the rise of the art museum in the United States: the Payne-Aldrich Tariff of 1909, which added to the duty-free list the importation of original works of art more than twenty years old, and the charitable deduction provision in federal and state laws taxing income, estates, and gifts.

Without these legislative inducements, it is safe to say the museum explosion in this century could never have occurred.

The change in tariff rules was directly related to the tax problems of a single collector: J. Pierpont Morgan. In 1907, when Congress was debating new tariff laws, the most important voice in the deliberations was that of Senator Nelson Aldrich of Rhode Island, the chairman of the Monetary Commission charged with establishing new duties. The following year, in London, Aldrich and other commission members were invited to dine with Morgan. According to Aldrich's biographer:

> Mr. Morgan got them deeply interested in his famous collection of pictures. He told them he wanted to give it to the Metropolitan Museum. But under the tariff law as it then stood getting the pictures into the United States would cost a million and a half in the way of duties. The next year Mr. Aldrich put free art into the tariff bill of 1909. Eventually Mr. Morgan gave the pictures to the Museum.* [20]

In approving this exemption, Congress was clearly encouraging the importation of art. When several senators protested that the exemption would favor the rich collector, they were answered by Benjamin R. Tillman, a South Carolina Democrat and sometime populist, nicknamed Pitchfork Ben:

> I had the opportunity to visit the great art galleries of Florence, Paris, and London. . . . I saw enough to convince me that the American people can afford to encourage the importation of some of those masterpieces, something that we can get as a means of elevating the thought and inspiring the artistic genius of our people. . . . If you want to whack these multimillionaires, cut out some of the special privileges you are giving them elsewhere in the getting of money; but if they want to bring anything from abroad here which is worthwhile, let us let them do it. They will in time die out, and an art gallery will become, in all probability, the legatee of their collection. [21]

Four years later, in 1913, the tariff laws were further amended, and all original works of art, including those less than twenty years old, were put on the duty-free list—largely due to a campaign waged by John Quinn, a New York lawyer and collector of avant-garde art who that year had helped organize the famous Armory Show. Seizing upon what a burden the 15 percent customs duty levied on modern art had been to the sponsors of the show, Quinn bombarded members

* In fact, only part of the Morgan collection went to the Metropolitan; the bulk of it was put up to auction by his heirs.

of Congress with letters protesting a law that penalized living artists.

Also in 1913, the Sixteenth Amendment to the Constitution became law, permitting Congress to impose a federal income tax. In the beginning, rates were low; in 1913 a U.S. citizen with a taxable income of $1,000,000 was obliged to pay only $60,000 in federal taxes. By 1944 the same taxpayer faced a bill of almost $915,000. Estate and gift taxes also rose dramatically. The federal estate tax in 1916 had a maximum rate of 10 percent; by 1932 it had climbed to 45 percent; and today it ranges from a minimum of 3 percent to a maximum of 77 percent on estates of more than $10,000,000. When J. Pierpont Morgan died in 1913, his heirs paid no federal tax on his estate of $128,000,000; today the combined state and federal taxes on the Morgan estate would come to more than $100,000,000.

In 1924 a gift tax was adopted to prevent the rich from circumventing estate taxes by transferring property during their lifetimes to putative heirs. This federal levy was repealed in 1926, readopted in 1932, and is now fixed at approximately three-fourths the rate of federal estate taxes.

The impact of all the levies—income, estate, and gift taxes—has been to make the Internal Revenue Service a Maecenas of the art museum. Indeed, the National Gallery of Art in Washington came into being following a claim filed by the commissioner of the Internal Revenue Service against former Secretary of the Treasury Andrew W. Mellon for a deficiency in his federal income taxes of $1,319,080.90 for 1931, plus a 50 percent penalty for fraud. Mellon indignantly countered that he had in fact overpaid his taxes that year—by $139,045.17.

Mellon's case rested on his assertion that he had not claimed a charitable contribution for five paintings purchased from the Soviet Union (among them Raphael's *Alba Madonna* and Botticelli's *Adoration of the Magi*) for $3,247,695. His lawyers argued that Mellon had given these works to the newly established A. W. Mellon Educational and Charitable Trust with the intention of transferring them to a National Gallery of Art to be built solely at his expense. Mellon's defenders claimed that the litigation was politically motivated, a vindictive act on the part of the incoming Roosevelt administration. Yet it also was a fact that Mellon had been preternaturally secretive about his generous intentions and that the witnesses at a 1935 Board of Tax Appeals hearing who spoke in his defense were invariably interested parties—most notably the dealer Joseph Duveen, who, the

The Founder: Andrew W. Mellon, who declined to have his name placed on the National Gallery of Art

following year, in a single transaction, would sell Mellon forty-two works of art for $21,000.00.*

The Board of Tax Appeals, over the strenuous objections of federal prosecutors, ruled in Mellon's favor, and in 1936 President Roosevelt, professing complete surprise and delight at "your wonderful offer," accepted the gift of art and money on behalf of the nation. Mellon died the following year and did not live to witness the 1941 opening of the magnificent National Gallery, the site and design of which he himself had chosen.

At the core of Mellon's legal defense was the concept of the charitable deduction, rooted in Anglo-Saxon common law. Beginning with the Federal Revenue Act of 1917, Congress has allowed a deduction from taxable income of contributions to American organizations that are "operated exclusively for religious, charitable, scientific, literary, or educational purposes." A similar provision had already existed in federal estate tax laws and was subsequently adopted in the case of gift taxes.

* For differing views about this important controversy, see Behrman, *Duveen*, 263–70; Finley, *A Standard of Excellence*, 35–53; and Walker, *Self-Portrait with Donors*, 129–32. Finley was the National Gallery's first director, and Walker was his successor. See also Hersch, *The Mellon Family*, 316–58, for a detailed account.

The factors that combine to make the donation of works of art so attractive to donors have been succinctly analyzed by Jerome S. Rubin, a New York attorney, in an article in *Horizon*:

A gift of tangible property, such as a work of art, is deductible in the amount of the fair market value of the property at the time of the gift, irrespective of how much the donor may have paid for the property. Moreover, the donor is not taxed on any increase in value. The postwar bull market in the art world, itself feeding on the tax laws, has thus opened up extraordinary opportunities for the high-bracket taxpayer. A gift to a museum of a Degas drawing bought before World War II for $1,000 and worth $20,000 in 1963, would have netted the 80 percent taxpayer a deduction of $20,000, and therefore a tax saving of $16,000, whereas the sale of the same drawing to another collector at a price of $20,000 would have resulted in a capital gains tax of $4,750 and cash in hand of only $15,250. (These figures reflect federal taxes only; state income taxes would also have taken their toll, thus making the charitable gift still more attractive.)

Clearly, under these circumstances, it is more rewarding to give than to sell; in responding to his sense of altruism and high purpose, the astute collector has been able to benefit not only his soul but his bank account.[22]

All American art museums have benefited from this seductive arithmetic; for that matter, so have dealers and art speculators. Geraldine Keen, salesroom correspondent for *The Times* (London), maintained in 1971 that this tax concession "has resulted in untold treasures finding their way to America and has provided the underlying strength of the art market since the war." [23] Another British analyst, Gerald Reitlinger, put the matter more lightly: "It is the main source of the champagne and television-screen entertainment of the modern sale room." [24]

For the art museum, the efficacy of the system was demonstrated by the Tax Reform Act of 1969, which eliminated the right of an artist to claim a charitable deduction for the market value of any work given to a nonprofit institution. Under the new law, the artist could deduct only the literal cost of materials for a painting or sculpture. In the two-year period before the tax laws were changed, the Museum of Modern Art was given 321 works by ninety-seven artists, but in the three-year period after the reform, the museum was given only 28 works of art, most of them prints, by fifteen artists. The National Collection of Fine Arts in Washington claimed that the new law had cost it at least six major donations from artists, including a Thomas Hart Benton painting valued at $100,000.[25]

The 1969 law also eliminated the right of individuals to claim a

deduction for the market worth of papers contributed to libraries and historical archives. In the seven months following the change, no gifts of manuscripts whatsover were made to the Library of Congress, according to its general counsel, John J. Kominski.[26] Other public institutions have reported the same drastic diminution in the flow of contributions.

In the United States the art museum has been able to flourish partly because of incentives built into the Internal Revenue Code. There is thus a justifiably widespread general interest in museum performance. No other country provides a similar tax inducement to collection growth; without the silent, ungrudging, assent of all taxpayers, neither the art museum nor the art market could enjoy its exuberant expansion.

The extent to which taxpayers benefit from these art inducements raises far more complicated issues. Since the turn of the century, museum professionals themselves have been trying to define the nature of the art museum. The difficulty of arriving at a definition can be grasped in the starkly opposing views of two pioneering figures in museology, John Cotton Dana (1856–1929) and Paul J. Sachs (1878–1965).

"POPULISM" AND "ELITISM"

Dana is an undeservedly forgotten figure in American museum history. His death occasioned little comment. He was the quintessential museum populist, yet his name means nothing to the museum radicals who, without knowing it, repeat the arguments he had first made a half century earlier.

Like James Jackson Jarves, Dana was an offspring of the New England enlightenment. Born in Woodstock, Vermont, he attended Dartmouth College and then adventured in the Great West, becoming in 1889 the director of the public library in Denver, Colorado. He later described his general outlook:

> I am an agnostic religiously. I labored with the hosts of orthodoxy for some eight years, finally conquered, and in my present freedom can think without much bitterness of the religious atmosphere of New England in general and Dartmouth College in particular. . . .
>
> Since about 1887, I have gained a much clearer view of the great truths, and am pleased to announce myself an egoist, a pessimist and an anarchist. I am proud to state that during the revival of long range philanthropy I was able to found the Society of Friends of Human Freedom.

John Cotton Dana, the evangel of museum populism

I passed through a mild attack of socialism, and subscribe to the Henry George theory in a measure. I am a thorough-going free trader and an unterrified Jeffersonian Democrat.[27]

He followed these precepts in his capacity as chief librarian in Denver. He saw the library as "the most inviting, the most wholesome, the most elevating and the most popular place in the city for those who, without comfortable homes, wish to while away an hour or two. It should attract such visitors, and it should hold them. This applies especially to young people."[28]

His ideas may have been controversial, but he went on to be elected president of the American Library Association in 1895. "See that your library is interesting to the people of the community, the people who own it, the people who maintain it," he declared in his presidential address. "Deny your people nothing which the book-shop grants them. Make your library at least as attractive as the most attractive retail store in the community. Open your eyes to the cheapness of books at the present day, and to the unimportance, even to the small library, of the loss of an occasional volume."[29]

In time Dana became interested in art, especially in Japanese prints, a multiple art form of comparatively modest cost. In a show of Japanese prints he arranged in Springfield, Massachusetts, in 1898,

The Newark Museum, Dana's temple to the urban muse

he stressed "the simple way that the Japanese artists take to say a great deal." His concern with art intensified following his appointment, in 1902, as chief librarian in Newark, New Jersey. The city had no museum, and not long after his arrival he began mobilizing support for an institution that would differ in spirit from existing models. He said to a potential donor:

> My real purpose in writing you is to call your attention to the fact that New York has a huge building devoted to the promotion of art interests of all kinds. It is called the Metropolitan Museum of Art. This museum it is, with its vast plant, its huge endowment, and its liberal appropriations from the city, which should furnish rooms for the display of the American art of today of all kinds. . . . I look upon it as a piece of idle folly on the part of that institution that they decline not simply to buy, but, what is far more reprehensible, even to display the work of contemporary artists and artisans in any field.[30]

Dana was given his chance to create a new kind of museum when money was found to build a permanent home for the Newark Museum, which had been established in 1909. Drawing on his experiences as librarian and educator and on the traditions of Emerson and Thoreau, he broke courageously with orthodox doctrine. To begin with, he had the Newark Museum's new building built on a down-

town street, rather than on a splendid, isolated site; it was simple and utilitarian in design. For one of its early exhibits he arranged a display of New Jersey textiles, which cost less than $800 to install. He founded branch museums and launched an extensive school loan program. Under his leadership efforts were made to stimulate better design in such "humble" articles as pots, pans, and teacups. He saw to it that the museum program was integrated into the arts and science curricula of local elementary schools. In Dana's view, the museum should be an instrument of visual instruction, and its objectives should include: "Making the city known to itself, and especially to its young people; presenting one of the city's activities in an attractive, interesting and advertising manner to nonresidents; encouraging improvements in manufacturing methods; presenting a modern industry in a comprehensive and enlightening manner to pupils in the schools." [31]

As for costly acquisitions, Dana scornfully remarked, "these gain newspaper notice, attract an occasional student, and stimulate an occasional donor to add other like objects to them." [32]

In *A Plan for a New Museum* (1920), which Dana published at his own expense in his native Woodstock, he wrote:

> It is easy for a museum to get objects; it is hard for a museum to get brains. The objects are seen, talked about, wondered at and bring praise to those who give them and prestige to those who choose them for purchase. . . . But, objects do not make a "museum"; they merely form a "collection."
>
> What is true of museum objects,—rare, wonder-producing and pride-evoking objects,—is true also of museum buildings. It is easy to get them, much easier than to get museum brains. They are large, monumental, obtrusive, make impressive photographs, help to give cities plausible reasons for existence, furnish to donors a refined publicity for unselfish expenditures and endow laborious trustees with a sense of duty done and with the immortality of bronze tablets. But a building of the kind that is usually constructed to house a museum, is not in itself a museum; it is almost always a storehouse for "collections."
>
> Probably no more useless public institution, useless relatively to its cost, was ever devised than that popular ideal, the classical building of a museum of art, filled with rare and costly objects. And it adds to its inutility a certain power for harm. To its community it gives a specious promise of artistic regeneration, and it permits those who visit it to put on certain integuments of culture which, although they do not conceal aesthetic nakedness, inhibit the free exercise of both intellect and sensibility.[33]

All that was false, pretentious, and grandiloquent in art museums was abhorrent to Dana. Yet it does him no injustice to remark that

he raised questions so profound that his own answers could not help falling short of being satisfactory. And it is true that in seeking to make the art museum a part of the everyday life of the community, he failed to give proper weight to the notion that in the United States there might be a peculiar merit in an institution that deliberately set itself apart from the commercial values of "manufacture," to use one of his favored terms. He could have pressed the point that one of the objectives of an art museum ought to be to challenge, and confound, the pervasive utilitarianism of American life. (Had he lived into the age of commercial television, one can surmise that he might have been less sanguine about the merit of advertising.) Dana, in short, was more concerned with the utility of art than with its aesthetic significance.

Little more than a year after his death, in 1929, the Newark Museum mounted one of the first major shows of American folk art. The catalogue read in part: "In presenting this group of primitives the Newark Museum carries out an old plan of John Cotton Dana, who for many years had known and had been interested in this homespun type of American art." [34] The exhibition was arranged by Holger Cahill, who later moved on to the Museum of Modern Art, where in 1932 he organized "American Folk Art: The Art of the Common Man in America, 1750–1900." It was only apt that two years later Cahill was appointed director of the Federal Art Project, the most ambitious experiment in direct patronage of the living artist ever undertaken by the federal government.

If John Cotton Dana was the prototype of the museum populist, his polar opposite as museum elitist was Paul Joseph Sachs, the Harvard mentor of two generations of museum professionals. Sachs was as preoccupied with the scholarly role of the art museum as Dana had been with the popular. Sachs was partial to the discerning minority—collector, patron, and curator—whereas Dana was oriented to the mass audience. Today's art museum is caught in the attempt to reconcile the divergent and, at points, irreconcilable attitudes of these two men.

In 1864 Jarves in *The Art-Idea* spoke urgently of the need to establish courses of art history in American universities; at the time the museum profession simply did not exist. Sachs, more than anyone else, is responsible for its existence. From 1921 to 1948 he taught what was known as the museum course at Harvard; of the 388 students enrolled, at least 160 rose to responsible positions in leading

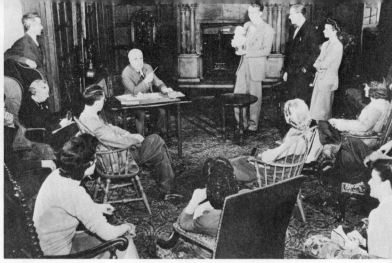

Paul J. Sachs, the shaper of Harvard's museum course, with his students

art museums. Among his students were future directors of the Metropolitan Museum of Art, the Museum of Modern Art, the National Gallery of Art, the Boston Museum of Fine Arts, and the Art Institute of Chicago. For more than a generation he was at the central academic switchboard of an emerging profession.

Sachs, like Dana, was a layman who only in mid-career became professionally concerned with art museums. After graduating from Harvard in 1900, he joined the family banking firm of Goldman, Sachs & Company, in New York. In 1915, at the age of thirty-seven, he accepted an invitation to become assistant director of the Fogg Museum at Harvard under Edward Forbes, a grandson of Emerson's. The idea of the museum course developed out of a conversation that Sachs happened to have with Henry Watson Kent, a curator at the Metropolitan Museum. The essential notion, as Sachs remarked, was:

> to implement my conviction that a museum worker must first and foremost be a broad, well-trained scholar, a linguist, and then in due course, a specialist, a scholar with wide bibliographical knowledge, a scholar with broad human sympathies including a belief in popular education, a curator and administrator taught to understand that in the twentieth century in America, a museum should be not only a treasure house but also an educational institution, and last, but no means least, that he should be a competent speaker and writer, as well as a man of the world with bowing acquaintance to other fields.[35]

Applicants to Sachs's course, having been carefully screened, met twice weekly, at the Fogg Museum and at his Cambridge home, Shady Hill. They were expected to take part in field trips and to meet dealers, collectors, curators, and other denizens of the art world,

to whom Sachs provided the passport of accessibility. His precepts made a profound impression on his students, one of whom was James J. Rorimer, the director of the Metropolitan Museum of Art from 1955 to 1966. Rorimer kept in his office a typed set of the notes he had taken while attending Sachs's course.

On March 7, 1927, Richard Offner, professor of fine arts at New York University, addressed the museum seminar:

> Hitherto many museums have ignored scholarship in ordering [donated] material. The original arrangement has been haphazard and has been allowed to become public. It then becomes merely a store-house. Objects in a museum should be illumined by scholastic ordering in their installation. They should be displayed in the light of modern scholarship. A museum should not be a public playground. It is primarily for scholars and when actuated by considerations of the public at large it soon loses its force.

Rorimer made the following notes of a class discussion on January 3, 1927:

> Requirements of museum director. Knowledge of two languages is practically essential—French and German. The Ph.D. is not as necessary in America as in Europe and not as necessary in the museum world as in the university world at present. Knowledge of dealers and collectors most necessary. No one should go into museum work without 3 or 6 months' volunteer work. The executive side can be learned purely by being in the museum, and the scholarly side in universities and schools.
>
> Women are employed in positions of importance with hesitancy, because they are apt to leave at any time. They are particularly adapted to carry work on in special fields: teaching children and lecturing— and they can do this with greater skill than men.[36]

These classroom notes were representative both of the teacher and of the era; in Sachs's view, scholarship and savoir faire were the cardinal virtues of the art museum professional. As he wrote to Bernard Berenson after meeting Kenneth Clark, then director of London's National Gallery, in Cambridge in 1936:

> May I say quite bluntly that I congratulate you on such a disciple and so devoted a friend. I have no hesitation in saying that he seems to me of all living museum directors by far the most competent and attractive. It's rare indeed to find the head of a great museum who in the best sense is a scholar and a gentleman, a collector and a connoisseur, and also a cultivated man of the world. I find so many who are merely administrators, or what in American slang is termed go-getters, or men who are uncouth or uncultivated or directors unable to select with conviction the best of a type. But it's rare indeed to find any man, and

particularly a young man, who has all the qualities that are most needed, and who in addition is blessed with an attractive, intelligent, and helpful wife. . . .[37]

In contrast with Dana, Sachs was an elitist, as the term is commonly (and loosely) employed today. In his deference to wealth and cultivation, he was an outright snob. Yet he had to have been much more than that, or he would not have made so great an impression on a generation of students, among them Alfred H. Barr, Jr., the almost obsessive aesthete who became (with some wire-pulling by Sachs) the first director of the Museum of Modern Art.

Sachs's fundamental loyalty was to the unique art object—the unique, the beautiful, and the spiritually nourishing object. It is not a mean devotion. The essential dilemma that the art museum poses in a democratic society is that the experience it offers does not readily translate into political vernacular. A high body count at the turnstile says little about the quality of perception that a visitor may bring to museum treasures.

The problem, which existed when the portals of the Louvre were flung open in 1793, has been compounded by the revolution in the visual arts, also incubated in Paris, that gave birth to the avant-garde. While John Cotton Dana was a schoolboy, the Impressionists were defying the academic tradition in *Salons des Refusés*, the first of which was organized in 1863. As the decades passed, the accepted styles of art—realistic, didactic, and instantly comprehensible—gave way to a new mode that was nonfigurative, antididactic, and—to many viewers—inaccessible. At the same time fields of art hitherto unknown to the Western eye—Oriental, African, Oceanic, and pre-Columbian—began working their influence on the European and American imagination.

An ordered hierarchy was supplanted by confusion. The visual horizon had widened; the realist image that had long dominated the art world had been distorted and even obliterated. Who was there now to say what constituted art? Critics and connoisseurs disagreed among themselves, yet the art museum, by virtue of its official status, was expected to be the arbiter. A new and unforeseen burden was thus imposed on the museum, which at the same time had become enmeshed in a soaring commercial market.

Art museums all over the world are having to cope with similar conundrums. In the United States the very structure of the institution —half private, half public—has contributed to the muddle. To justify public support for new buildings and programs, American art mu-

seums invariably invoke the arguments of a John Cotton Dana, emphasizing utilitarian benefits, such as education. To mobilize support from the private sector, they stress connoisseurship and collection building—the interests of a far narrower constituency.

Art museums have sought to be all things to all benefactors. With rising operating costs, the pressure for public funding has greatly intensified. Inescapably and increasingly legislators have found themselves having to deal with the claims of specialized institutions and to serve as arbiters in cultural patronage—tasks for which the American experience provides only the skimpiest guide. The resulting frustration is pointedly illustrated in the case of the Smithsonian Institution.

CASTLING ON THE MALL

The Smithsonian, "the Castle on the Mall," had its origins in the whim of an eccentric Englishman, James Smithson, and became a reality largely through the vision of John Quincy Adams. For most of its history its primary concern has been with the natural sciences, but within the past generation it also has become an international force in both the fine arts and the humanities. Essentially autonomous despite heavy dependence on federal appropriations, it has grown into the largest museum and research complex in the world.

The prestige of the Smithsonian is so immense that a magazine founded in 1970 bearing its name had reached a circulation of 1,500,000 by 1977. According to the publication's general manager, Joseph Bonsignore, gross revenues of *Smithsonian* in 1974 were around $2,500,000, an astonishing figure for a museum publication. He added, "It is impossible to measure the influence of the Smithsonian's name and identity. It was our greatest asset." [38]

In prestige, the Smithsonian ranks with the Louvre and the British Museum, but in the breadth of its concerns, it has no peer. A major center of research in the sciences and humanities, it also is the administrative umbrella for the National Zoological Park as well as for fourteen museums attracting some 20,000,000 visitors a year. (Included in its budget, although operationally independent, is the National Gallery of Art.)

Geographically and intellectually, its reach is extensive. There are Smithsonian outposts in New York; Cambridge; Boston; Detroit; San Francisco; Annapolis; Fort Pierce, Florida; Front Royal, Virginia; Mount Hopkins, Arizona; Silver Hill, Maryland; and the Canal Zone.

S. Dillon Ripley, reshaper of the Mall

It manages a conference center on the Belmont Estate in Easton, Maryland, and owns a onetime Coast Guard cutter, the *RV Johnson*, which it uses for marine research. Among its major bureaus are the Center for the Study of Man, the Archives of American Art, the Radiation Biology Laboratory, the Smithsonian Astrophysical Observatory, the Chesapeake Bay Center for Environmental Studies, the Smithsonian Tropical Research Institute, and the Woodrow Wilson International Center for Scholars. For good measure, it also is nominal landlord of the John F. Kennedy Center for the Performing Arts.

Its most spectacular spurt of growth has occurred since 1964, the year that S. Dillon Ripley, a noted ornithologist, took over as secretary, as the institution's chief executive officer is called. In little more than a decade he has become the preeminent museum expansionist in the country, his only rival being Thomas P. F. Hoving of the Metropolitan. Ripley personifies the Brobdingnagian tradition in museology, with its triumphs and its lapses.

Under Ripley, the Smithsonian has launched six new national museums, of which five are devoted to the visual arts—the Hirshhorn Museum, the National Portrait Gallery, the National Collection of Fine Arts, the Renwick Gallery, and the Cooper-Hewitt Museum of Decorative Arts and Design. Since 1966 the institution also has had the responsibility of administering the National Museum Act, with an annual budget of approximately $1,000,000 for programs intended to improve museum professional standards.

By tradition, Smithsonian secretaries have always been scientists. Ripley is the first secretary to manifest an intense concern with the

fine arts and the humanities. Thanks to the liberal powers granted the secretary and to the institution's peculiar status within the federal establishment, Ripley has been able to reorient the Smithsonian to spacious new goals.

The institution is not a federal bureau, but rather an independent entity inside the federal government. Under the Organic Act of 1846, it is managed by a fourteen-member board of regents, whose ex officio members include the Chief Justice of the United States, and the Vice President of the United States. Three members each are designated by the Senate and the House of Representatives, and six citizen-members are nominated by the regents.

In short, the Smithsonian stands in roughly the same relation to the federal government as the typical large art museum does to municipal government. Public representation on its board is numerically greater (eight out of fourteen members), but in all other respects the institution is a national version of the big local museum. It has enjoyed operational independence from the beginning. As Chief Justice William Howard Taft said at a 1927 Smithsonian conference, "I must make clear, gentlemen, that the Smithsonian Institution is not, and has never been considered a government bureau. It is a private institution under the guardianship of the government." [39]

Its operational autonomy is symbolized, and enhanced, by the fact that it has a private endowment with a 1976 market value of $44,705,000. Indeed, it was the original endowment that led to the creation of the institution, almost against the wishes of Congress.

In 1838 eleven boxes packed with gold bullion arrived in New York from London for deposit in the United States Mint in Philadelphia. Appraised at $508,318.46, a fortune at the time, the gold was the bequest of James Smithson, an illegitimate son of the duke of Northumberland. Smithson, who had never even been to the New World, had died in Genoa in 1829, leaving his estate to a nephew; almost as an afterthought, his will added that in the event his heir died without issue, the money should be used to found in Washington "under the name of the Smithsonian Institution, an Establishment for the increase and diffusion of knowledge among men." Six years later his nephew did die, childless, and the windfall legacy passed to the U.S. government.

To consider the surprise bequest, the House of Representatives appointed a select committee, under the chairmanship of Congressman John Quincy Adams, which in due course reported:

Of all the foundations of establishments for pious or charitable uses, which ever signalized the spirit of the age, or the comprehensive beneficence of the founder, none can be named more deserving of the approbation of mankind than this. . . . To furnish the means of acquiring knowledge is, therefore, the greatest benefit that can be conferred upon mankind. It prolongs life itself, and enlarges the sphere of existence.[40]

Nonetheless, there was spirited resistance in Congress to the acceptance of manna from England. That the integrity of the bequest was honored and the Organic Act of 1846 adopted was largely due to the nagging persistence of John Quincy Adams. At his urging, the United States agreed to carry out its trust responsibilities by creating a board of regents representing the three branches of government and distinguished citizens at large. The reason for this arrangement was clearly set forth in the House debates that preceded passage of the Organic Act:

Very considerable latitude of control, as to the means to be used, is given the board of managers, and the ends to be aimed at are described in comprehensive terms. But the most ample guarantee for the wise and faithful use of this discretionary power is obtained in the fact, that the board will consist of the Vice-President of the United States, the Chief Justice of the Supreme Court, three Senators, three members of the House, and six others to be chosen by joint resolution of the two Houses, who are required to submit to Congress annual reports of the operations, expenditures, and condition of the institution.[41]

By the same token, however, the very eminence of the board freed the institution from harassing scrutiny, and the very broadness of its charter gave it the sanction to venture far afield in diffusing knowledge among men. Only one thing was specified in the Organic Act —that the Smithsonian should maintain a national museum. All other details were left to the board and to the secretary.

The founding secretary was a Princeton physicist of exceptional ability, Joseph Henry. During his tenure a museum was begun in the original Smithsonian building in 1850, and the right of the institution to conduct its own affairs, without political meddling, was vigorously sustained. A National Museum was authorized in 1879; it was augmented, under Henry's successors, by other facilities: the National Zoological Park (1890), the Astrophysical Observatory (1890), the Museum of Natural History (1906), the Freer Gallery of Art (1921), the National Gallery of Art (which became a nominal Smithsonian dependency in 1937), the National Museum of History and Technology in 1964, the National Portrait Gallery in 1968, the

National Collection of Fine Arts in 1968, the Hirshhorn Museum and Sculpture Garden in 1974, the National Air and Space Museum in 1976, and finally, in New York, the Cooper-Hewitt Museum in 1976.

Appropriations reflected the expansion. When Ripley assumed office in 1964, federal appropriations to the Smithsonian were $17,-000,000; a decade later, $71,000,000; in fiscal 1976, $136,000,000. (The fiscal year 1975–76, it should be noted, included a three-month transition quarter owing to a change in the budget year.) Aside from its federal appropriations in fiscal 1976, the Smithsonian generated $16,900,000 from private sources, including endowment income, and received $15,500,000 in research grants and contracts—giving it a total budget of $153,587,000.

This expansion was in good part attributable to Ripley's extraordinary resourcefulness. Operating under a diffuse mandate and enjoying relative autonomy, the Smithsonian could justify almost any enterprise related to knowledge. It was only after expansion had occurred that there were any serious debates in Congress about the institution's budget, thanks in large measure to a long-standing tradition of appointing senior members of the House Appropriations Committee to the Smithsonian board of regents. In effect, the board was both the initiator and the judge of a budget request. Moreover, the other eminent regents—the Chief Justice, the Vice President, and ranking members of the Senate—had only limited time to spend on Smithsonian affairs, though their august presences tended to shield the institution from criticism.

Belatedly, the Congress discovered the results of its own permissiveness—that federal taxpayers were permanently committed to the support of projects perhaps too discreetly launched by the Castle on the Mall, among them the Hirshhorn Museum and the Cooper-Hewitt. The question of whether or not Congress had been forewarned was a valid one.

The origins of the Joseph H. Hirshhorn Museum and Sculpture Garden were recalled by Ripley in a memorandum he provided to the late *New Yorker* writer Geoffrey T. Hellman for a series on the institution. It said, in part:

> During the autumn of 1963, I was able to read over a good deal of the history and legislation of the Smithsonian. I was particularly struck by the Act of May 17, 1938 . . . in which, in connection with the receiving for the Nation by the Smithsonian Institution of the Mellon Collection, Congress provided that a site for a museum for contemporary

art should be assigned by the President to the Smithsonian Institution on the Mall. . . .

The concept was clearly stated that this museum of contemporary art would be a foil to the new National Gallery of Art which was envisioned as being a museum of stated masterpieces. . . . In 1946, a contest for a dramatic modern building for this purpose was won by Eero Saarinen. . . . Apparently this building was too startling for the Washington of the postwar years, and it was quietly shelved. . . . I had often thought about the years in the mid-1930s when my mother had been on the first women's committee of the Museum of Modern Art in New York City. Those were the formative years for contemporary art in the United States. . . . It appeared to me that there were two things to be done. The first was to stimulate the National Collection of Fine Arts in every way, to remove its light from under a bushel. . . . In the meantime, I strove to find a private collector who had been purchasing works of contemporary art all these years on his own. The only way to make up for lost time and acquire an important collection of contemporary art for Washington would be to take a "giant step" by finding someone who had already gone ahead and done it.[42]

A year later Ripley learned of the existence of the Hirshhorn collection. He wrote a letter at once to the uranium magnate inviting him to discuss turning the works over to an appropriate national museum. At the time Hirshhorn also was being courted by Governor Nelson Rockefeller, the Tate Gallery in London, a leading Canadian museum, and the city of Jerusalem.

Ripley visited Hirshhorn at his Round Hill Road estate in Greenwich, Connecticut, in 1965. He saw to it that shortly thereafter the Hirshhorns were guests of honor at a White House lunch. Over tournedos béarnaise and a good domestic red wine, both President and Mrs. Johnson expressed great interest in the project. Mrs. Johnson underscored her interest by a visit a short while later to Greenwich for a firsthand look at the Hirshhorn treasures, and the President, at Ripley's instigation, wrote the Hirshhorns a warm note.

An agreement was reached in due course: The federal government was to pay the expenses of building a museum on the Mall bearing Hirshhorn's name; the design of the museum was to be subject to Hirshhorn's approval, with title to the art passing to the government only upon completion of the project; a ten-member governing board was to be established, half of whose members would be nominated by Hirshhorn, who also would nominate the director; and Hirshhorn would not be required to supply an endowment to help meet future operating expenses. Finally, if the building was not completed in five years, the agreement would become void.

Joseph H. Hirshhorn, the art-loving uranium magnate

These terms aroused considerable disquiet in the museum world, in good part because they were likely to encourage other donors to demand equally one-sided arrangements. In 1966 Sherman Lee, the director of the Cleveland Museum of Art, wrote to Mrs. Johnson:

> Mr. Hirshhorn's offer may well be prompted by the most magnanimous of intentions but its acceptance ill accords with current standards of wisdom and professional knowledge in the arts. It is a mistake to accept a collection of contemporary art formed by one man and to use a large sum of public money to house and administer such a collection. If at least ten million dollars is available for a building to bear, not the nation's name, but that of the donor, sufficient funds ought to be available to set about the formation of a truly catholic and articulated national collection housed in a building bearing the collective name of all the people. Such a collection is already begun in the National Collection of Fine Arts, now bypassed by this proposed action.[43]

When the terms became known, a bitter press controversy ensued. Columnist Jack Anderson reported that Hirshhorn had been in legal trouble years earlier over alleged currency smuggling and stock manipulation. Anderson derided the design proposed for the museum —a circular structure on stilts—and charged that the sculpture garden would form a sunken gash scarring the Mall.

To this point there had been no real hearings on the merits of the Hirshhorn, and appropriations for it had been whisked through Congress on the heels of urgent White House endorsements. Not until July 1970 did a congressional committee seriously examine the project, in the course of its first oversight inquiry into the Smithsonian in more than a century. Some fifty witnesses testified before the House Subcommittee on Libraries and Memorials, whose chairman, Frank

Thompson, Jr., a New Jersey Democrat, was not so much hostile to the Hirshhorn as dubious about it.

It proved difficult for the committee to obtain information about the future operating costs of the museum. At one point Abram Lerner, the Hirshhorn director, and Charles Blitzer, the Smithsonian's assistant secretary of history and art, were asked by Congressman John Brademas what the cost would be for operating the museum over a ten-year period.

Lerner. I can't give you an exact figure of what the costs will be in the next ten years.

Brademas. A ballpark figure?

Lerner. It has been estimated by us that it will be somewhere in the vicinity of $1,000,000 a year for the maintenance of the museum. That is, for the operation of the museum.

Brademas. The operating costs will be $1,000,000 a year and this is, of course, after the construction of the museum?

Lerner. Yes.

Brademas. You are suggesting that with $1,000,000 a year you would be able to maintain the facilities themselves and, in addition, support the kind of activities that you have been here projecting for the future?

Lerner. The $1,000,000 applies only to the maintenance of the professional activities of the museum, to the actual operation of the museum, not to the physical maintenance of the museum.

Brademas. I am not being combative, I just want to understand what we are talking about here. You are telling the subcommittee that once the museum has been constructed, approximately $1,000,000 a year would meet the costs of the actual physical maintenance of the plant and equipment?

Lerner. No, sir, only of the activities of the museum itself.

Brademas. I am just a simple country boy from Indiana. All I want to know is how much money we are talking about that this committee will have some responsibility for overseeing, in terms of the cost of maintaining and operating the physical facilities and the cost of the professional and other staff.

Lerner. Sir, I refer only to the professional and administrative costs.

Blitzer. May I just say a word? Our normal budgeting separates the budget of a particular museum which goes for what Mr. Lerner has been talking about, the professional expenses, the professional staff, the operation as a museum, separates that from amounts that are budgeted for our buildings management department, for the actual physical maintenance and guarding of the building. Our estimate, this is a ballpark figure, is that perhaps under each of these headings in a period of ten years the annual expenses would be about $1,000,000 each annually.

Brademas. So, to maintain the facilities and to provide the spectrum of services and activities of which Mr. Lerner has been speaking

would cost approximately $2,000,000 annually. Is that what you are telling us?

Blitzer. Yes.[44]

This was the first time the public was clearly informed of the scope of the permanent commitment made to operate the museum, which had already been approved for construction.

For his part, Ripley was now eager to play down his personal role in initiating the Hirshhorn Museum. He told the subcommittee:

> In effect, the collection was accepted for the United States by the President of the United States. We have been informed that the President does not accept collections for the United States without a suitable inquiry. We were also informed that at the time an inquiry was made as to the character and so on of the donor. This is not therefore a germane subject for the Smithsonian Institution, who then are [sic], as it were, handed the collection, the gift, by the President of the United States.[45]

There is no reasonable way of reconciling Ripley's 1970 account with the memorandum he had supplied a few years before to *The New Yorker*. He was asking Congress to believe that the Smithsonian had been "handed" the collection, once it had become a focus for contention and President Johnson was no longer in office. The impression that Ripley was making—of someone also skilled at pious dissimulation—was to bring the Smithsonian into serious conflict with Congress.

The collision was anticipated in an exchange between Frank Thompson and Assistant Secretary Blitzer at the 1970 hearings. Blitzer conceded that "if this whole matter of the Hirshhorn gift had been considered at the appropriate time by this committee, I think we all would find ourselves in a much less awkward situation," to which the chairman replied, "I understand that. I don't consider that the subcommittee is in a particularly awkward situation. . . . We are simply trying to gather together information. I think that these hearings have been altogether very constructive. The Congress has neglected this whole matter for too long. The responsibility for us not knowing more than we do lies partly in ourselves and in our predecessors." [46]

The Hirshhorn opened in 1974 and from the beginning was a great popular success. Despite critical doubts about the quality of the collection, visitors packed the museum's circular galleries. It attracted more than 3,000,000 visitors in its first two years, a record for any museum of contemporary art. As important as the curiosity that pre-

vailed about the building itself and the controversial collection was its strategic location across from three other vast museums on the Mall. With the 1976 opening alongside it of the National Air and Space Museum, which averaged 1,000,000 visits every twenty-four days, the Hirshhorn benefited even more in attendance.

Yet for all his successes, Ripley found that he was now the object of almost continuous critical scrutiny. In 1970 the Government Accounting Office (GAO) launched a series of investigations into the financial practices of the Smithsonian. The most searching of the inquiries was initiated in June 1976 at the request of Senator Robert C. Byrd, chairman, and Senator Ted Stevens, ranking minority member, of the Subcommittee on the Department of Interior and Related Agencies.

Comptroller General Elmer B. Staats reported to the senators in 1976 that in the opinion of GAO investigators, the Smithsonian was eluding statutory requirements in its distribution of federal funds to the private, nonprofit corporations that it operated. The institution retorted that the redistribution of funds was a vital element of administrative flexibility but conceded that it had failed to inform Congress of how it planned to use private funds.

One of the GAO's examples of a new undertaking relying in the beginning on private funds was the Cooper-Hewitt Museum in New York City. The museum's collection, comprising several hundred thousand objects relating to historical and contemporary design—textiles, wallpaper, furniture, ceramics, drawings, and so forth—was housed from 1897 to 1963 in Cooper Union, a professional school that charged no tuition. When lack of space and funds impelled the trustees of Cooper Union to discontinue the museum (originally established by founder Peter Cooper's three granddaughters), the American Association of Museums formed a committee to explore ways of preserving the museum intact in New York.

Initially approached in September 1964, the Smithsonian pledged its help only in the event that no organization in New York could be found to operate the museum. Four months later, in the absence of a savior, the Smithsonian's board of regents agreed to absorb Cooper Union's collection. A contract was approved in 1967, and the institution assumed the burden of funding and operating yet another museum. The GAO notes:

> Before the Smithsonian Institution signed the agreement to acquire the Museum in October 1967 it had not notified the appropriate congressional committees of its intentions to acquire the Museum. Signing

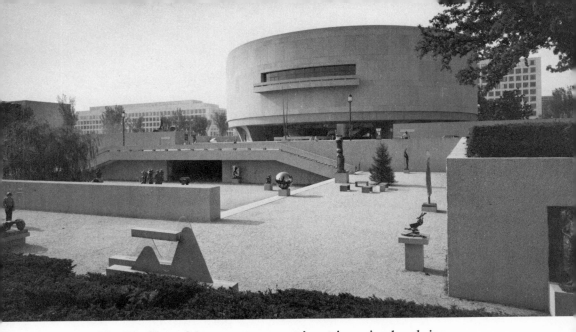

The Hirshhorn Museum, a magnate's art in a circular shrine

of the agreement was not a sudden or unplanned action. It was preceded by over two years of negotiations. Furthermore, the Smithsonian did not notify the Congress even after the signing until an inquiry was made by a member of Congress.[47]

(The Smithsonian countered by saying that articles about the proposed museum had appeared as early as 1965 in *The New York Times* and that the agreement had been approved by its board of regents, six of whose members were also members of Congress.)

In 1972 the Carnegie Corporation gave the Smithsonian the Andrew Carnegie mansion, which ocupies the entire block of Fifth Avenue from Ninetieth to Ninety-first streets. The structure was remodeled at a cost of $2,500,000 in private and $159,000 in federal funds. Renamed the Cooper-Hewitt Museum of Decorative Arts and Design, Smithsonian Institution, the new museum opened in October 1976. Simultaneously, a new line item appeared in the federal budget for fiscal year 1977: operating expenses of $367,000 for the new museum (an additional $248,000 was allocated to the Cooper-Hewitt from other Smithsonian departments). It should be noted in fairness that the Cooper-Hewitt receives the bulk of its support from private sources, and that its exhibitions have been well attended, and well received (unlike other Smithsonian museums, it charges an admission fee of $1).

As the GAO report makes clear, the Smithsonian, by tapping endowment income and other private sources, can launch ventures on

its own without notifying Congress, which in the long run is called on to bear the operating expenses. The Smithsonian offered this official reply:

> Chapter 4 of the Report briefly describes four centers of Smithsonian activity: Cooper-Hewitt Museum, Chesapeake Bay Center for Environmental Studies, National Zoological Park's Conservation and Research Center, and the Smithsonian Tropical Research Institute. While these have been administered by the Smithsonian for periods ranging from three years in the case of the Conservation and Research Center to over thirty years in the case of the Tropical Research Institute and thus should not be categorized as newly established, the Institution completely respects the Congressional need to be promptly informed of Smithsonian plans that might involve substantial new Federal expenditures, and will provide comprehensive and timely information to the appropriate Congressional committees.[48]

In what was an augury of a fast-changing climate, the Smithsonian regents in 1976 reluctantly concluded that the institution could not afford to operate Hillwood, the Washington estate bequeathed to it by cereal heiress Marjorie Merriweather Post, and Hillwood was returned to the Post Foundation later that year. At the same time Ripley deferred consideration of a proposal that the Smithsonian take over the operations of the financially troubled Museum of African Art, a small private institution located near the Capitol.

But congressional criticism did not abate. A new inquiry into Smithsonian management was ordered in May 1977 by Democratic Congressman Sidney R. Yates of Illinois, chairman of the Interior Subcommittee of the House Appropriations Committee. Yates had resigned the previous year from the institution's board, in part because he was troubled by what he felt to be his dual loyalties as regent and as legislator. After a nine-month investigation, in which fourteen years of board minutes and documents were carefully reviewed, the subcommittee staff concluded that under Ripley the institution was circumventing civil service regulations, inadmissibly juggling private and public funds, and initiating new projects without prior approval of the board of regents.

For example, the report asserted, museum souvenir shops and such publications as *Smithsonian* had been made to seem more profitable than they actually were by being given space rent-free. Revenues from these operations were then used on a discretionary basis to switch employees from the federal to the private payroll. (About 75 percent of the institution's 4,600 employees are on the federal payroll, 20 percent are paid from private funds, and 5 percent from grants and

contracts.) Funding practices for the mixed work force were found to "defy logical explanations."

Yet the investigation did not bring to light "any current, significant misuses of federal funds or property for personal benefit." Considering the explosive growth of the Smithsonian under Ripley, the remarkable fact about the successive inquiries has been their low yield of muck. There have been no charges of dishonesty or impropriety. The chief count against Ripley has been institutional aggrandizement, for which Congress must share in the blame.

Much of the criticism no doubt stems from general irritation with Ripley's manner, which is patrician and can be disdainful. He is a tall man with the aloofness of a nabob, as befits someone who, on his mother's side, is descended from a Scottish family long prominent in British India. His tone can be dismissive. He was unembarrassed when the Washington *Post* took him to task for reviewing a book written by his son-in-law, also an ornithologist. "Well, I read it," he countered, "and I thought it was a good book. Actually I was astonished. One is not normally overwhelmed by whoever marries one's daughter." [49]

He has been frequently criticized for spending too much time in Litchfield, Connecticut, a picturesque eighteenth-century town where he has a residence, bird preserve, and office. Yet despite his frequent migrations to his country seat—which consumed 255 days between June 1975 and September 1976—as both administrator and scholar he manages to produce an impressive amount of work. He is an ornithologist of standing, trained at Yale (where he served as director of the famed Peabody Museum), Columbia, and Harvard. Ripley's publications range from such studies as *The Search for the Spiny Babbler* and *The Trail of the Money Bird* to a ten-volume handbook on the birds of India and Pakistan, which he is completing in collaboration with Dr. Salim Ali.

An air of superiority and a record of success are sure to inspire criticism, not all of it warranted. By any reasonable measure, the Smithsonian's eighth secretary ranks as one of its best. Ripley has brought life and animation to the Mall, once a zone of dispiriting emptiness. Thanks to him, through new museums and such spectacular galas as the Smithsonian's Festival of American Folklore, crowds have been drawn to a national common extending from the Capitol to the White House.

What may seem to be voracity to one observer will strike another as uncommon enterprise. In 1969 the institution acquired control of

the Archives of American Art, begun in Michigan and comprising more than 5,000,000 items covering two centuries of American history. Within a few years the Smithsonian had opened five regional centers—in Washington, D.C., New York, Boston, Detroit, and San Francisco—making available originals or microfilm copies of manuscripts, photographs, sketchbooks, letters, catalogues, interviews, and financial records of galleries and arts organizations. It is impossible to place a dollar valuation on the return realized from so precious a scholarly resource.

The real problem posed by Ripley's tenure is not that he has achieved outstanding results as well as perpetrated occasional outstanding blunders, but that in a democratic society it is often difficult for the layman, or the average legislator for that matter, to distinguish between the two. The Smithsonian's expansion is but a federal instance of a common community problem. In many cities, art museums derive their support from both public and private funds, as does the Smithsonian itself; these museums are likewise managed by distinguished boards and guided by expansion-minded directors. New buildings and new programs proliferate, and ultimately the public is asked to pick up the bill, either directly or indirectly.

When growth must be justified, the first resort is invariably to attendance figures. Ripley echoes John Cotton Dana in insisting (in *The Sacred Grove,* a collection of his essays on museums) that an overcrowded museum is a healthy museum. The Smithsonian's primary purpose, he argues, is popular education; in Ripley's view, if the wonders of a fantastic collection like that of the Metropolitan cannot somehow be brought to the humblest among us, "then the purposes of the organizing committee of the Metropolitan Museum in 1870 have not been served." [50]

It can be doubted that Ripley would apply so simple a standard to a natural history museum's concern with ornithology. Museums of every kind serve both a popular and a specialized audience, and weighing the rival claims of each would tax the wisdom of Solomon, not to speak of that of legislators, trustees, curators, and directors, as will be seen in the pages that follow.

In another sense, the Smithsonian's experience is pertinent. The backlash of suspicion and criticism stirred up by Ripley has its source in the justifiable belief that the Smithsonian has asked Congress to sign a check for programs contrived in the Castle on the Mall without adequate consultation or forewarning. This, too, is a motif that will recur.

❧ II ❧

THE POLITICS OF PATRONAGE

No good deed goes unpunished.

—ANDREW W. MELLON, founder
National Gallery of Art

RICH MUSEUM, POOR MUSEUM

THE AMERICAN MUSEUM IS "FAT, THIN, LARGE, SMALL, GOOD, BAD, young, old, has many heads, eats money, is fuzzy, gives itself with joyous abandon, and is loved by absolutely everyone." An anonymous director volunteered this splendid summary to the compilers of *Museums USA*, a 1974 survey by the National Endowment for the Arts that sought, with a measure of success, to classify and to analyze a disordered miscellany.[1] The initial discovery, sure to chasten any would-be generalizer, is that the American museum universe is more like the Milky Way than the solar system.

Museums in the United States are not the planned creations of a national government, nor are they rooted in the rich and ancient sediment of a royal past. They have evolved at the local level, mostly under private auspices, although often with considerable government help and the stimulus of tax incentives. But this in itself suggests that museums are well regarded by Americans—a fact borne out by healthy attendance figures, opinion polls, and the response of elective officials to the museums' appeals for help. Significantly, although

museums are at times the focus of bitter contention, criticism has been directed at their performance as distinct from their existence. Everybody, or nearly everybody, approves of the establishment of museums; that is why there are so many of them.

According to *Museums USA,* there were at least 1,821 solidly organized museums in this country in 1971–72, of which 340 were art museums, 683 history museums, 284 science museums, 186 art/history museums, and 328 a combination of some or all of the above. The great majority of these institutions were small or modest in size, with only 52 art museums, 56 science museums, and 17 history museums reporting annual budgets of $500,000 or more.

Unsurprisingly, art museums were shown to be the wealthiest of American collecting institutions, their endowment balances totaling $484,000,000, compared with $130,000,000 for science museums and $102,000,000 for history museums. Art museum income in 1971–72 was $158,000,000, outpacing science museums ($153,000,-000) and history museums ($69,000,000). There is no reason to suppose that this financial ranking has changed since *Museums USA* was compiled. If anything, the supremacy of art museums has been confirmed—not least of all by J. Paul Getty's recent $700 million-dollar bequest to the J. Paul Getty Museum in Malibu, California.

It is something of a paradox, then, that the anguished cries of financial distress issue for the most part from art museums—and from the largest among them at that. Two great American art museums have been averaging seven-figure annual deficits: the Art Institute of Chicago and the Museum of Modern Art, both of which have had to dip into endowment capital. In city after city, leading art museums have been forced to close some of their galleries for lack of sufficient security personnel, to curtail services, and to tighten admission schedules. Mandatory or "suggested" entry fees have been imposed at museums that once proudly disdained the ticket kiosk. Some or all of these signs of trouble can be seen in Detroit and Hartford, Boston and Brooklyn, Philadelphia and Chicago, San Francisco and Washington, D.C.

Testifying in early 1978 before the House Subcommittee on Select Education, E. Laurence Chalmers, Jr., the salaried president of the Art Institute of Chicago, stated that between 1971–72 and 1976–77 the combined deficits of nine leading art museums had swollen from $402,000 to $2,229,000. And Chalmers was understating the financial problem since his list of museums included the well-heeled Houston Museum of Fine Arts, the relatively small Rhode Island

School of Design, and the Chicago Historical Society, a middle-sized institution that, strictly speaking, is not an art museum. (Others were the Boston Museum of Fine Arts, the Baltimore Museum of Art, the City Art Museum of St. Louis, the Museum of Modern Art, and the Art Institute of Chicago—in the latter two cases, the deficit for 1977–78 was optimistically projected at a third below the million-dollar level of preceding years.)

Unable to meet operating costs, two middle-sized public art galleries, the New York Cultural Center and the Pasadena Museum of Modern Art, closed down. (The Pasadena Museum was resurrected as the Norton Simon Museum of Art at Pasadena.)

From the look of things, the American art museum's pleading poverty has an absurdity about it that might have appealed to a Daumier. There is no institution more redolent of establishment wealth and power. Cynosure of the collector-magnate, its walls adorned with the names of prestigious benefactors, the large art museum is normally in a palatial building designed to impress on all visitors that the riches of this world shall endure.

To add to the sense of general implausibility, many of the institutions pleading for emergency financial assistance periodically announce million-dollar (or more) acquisitions, costly building plans, and blockbuster shows involving large outlays of cash. A taxpayer may reasonably question how such institutions can justify their Macedonian cries for help.

The short explanation is that the operating expenses of the art museum have been rising in recent years at about double the rate of its income and that the money available for acquisitions, buildings, and exhibitions can seldom be diverted to meet maintenance expenses. The experience of the Art Institute of Chicago is typical of many of the larger museums; according to its president, operating costs have averaged a 10 percent annual increase during the past five years, while income increments have averaged only 5 percent. For its operating budget, the institute is primarily dependent on appropriations from the City of Chicago, which has had other financial distractions.

In this respect, to be sure, the museum is not unlike other hard-pressed arts institutions; however, its payroll is larger, and while symphonies and operas may concentrate their programs in a season, the art museum operates on a year-round basis. Also, unlike a theater, the museum's physical plant is expensive to maintain—the collection must be guarded and maintained even when the building is dark.

Within the special context of the museum economy, the public art

gallery is the most vulnerable to fluctuations in private support—that is, in contributions from individuals and foundations; 32 percent of the income for art museums came from private support in 1971–72, according to *Museums USA,* as compared with 14 percent for history museums and 18 percent for science museums. The generosity of private donors depends to a great extent on the vicissitudes of the stock market. It goes without saying that when the value of shares rises, foundations have more to spend and that individual donors are more likely to write out checks since gifts will not diminish net worth.

By the same token, when stock market prices fall, so does the value of shares in the museum's portfolio, with the result that in a period of inflation, wage increases, and spiraling energy costs, the museum's ability to tap capital gains is considerably lessened. This attrition in private resources has been matched by the financial distress of the art museum's primary public patron: city hall. *Museums USA* reported that in 1971–72, 13 percent of total art museum income derived from city and county governments, as compared with 2 percent from state governments and 6 percent from federal sources. City governments beset with inflation and declining tax bases, have either frozen or reduced their annual maintenance allocations to art museums.

For many public galleries, the squeeze is as untimely as it is cruel; at the moment least propitious for these institutions, the bills are coming due for costly expansion programs undertaken in the exuberant 1960s and early 1970s. As a result, art museum boards, although ideologically they tend for the most part to be hostile to big government, have become supplicants for state and federal aid. In the process, they have encountered the anomalies of what is probably the most complicated system of cultural patronage ever devised—the labyrinth of state arts councils and national endowments.

Since these agencies were modeled on private philanthropy and designed to limit direct subsidy of operating costs, art museum trustees have found themselves in the almost schizophrenic position of trying to reform a system that their own doctrines have helped shape. Swallowing hard and trying to ignore the proliferating ironies, museum trustees pressed for direct federal assistance. Their efforts were rewarded with the establishment, in 1977, of the Institute of Museum Services, appropriately contained within the Department of Health, Education, and Welfare. With the creation of the institute, the federal government was subsidizing for the first time at least part of basic museum operating costs.

A new chapter in American museum history has clearly begun, but the problem of fixing national standards for museum operations remains to be resolved.*

We must go beyond *Museums USA* in order to define the basic terminology of the museum universe. There are no official lists of museums, no easy definitions of public galleries. The closest thing to a Domesday Book is *The Official Museum Directory*, published annually by the American Association of Museums. However, it lists not only museums but also zoological and botanical gardens, natural wonders, landmark houses, one-room galleries in libraries, and minuscule historical societies displaying cases of arrowheads and stuffed birds. The 1975 edition carries entries for 5,225 institutions of every conceivable kind.

In 1972 the National Endowment for the Arts commissioned the National Research Center of the Arts, Inc., an affiliate of Louis Harris & Associates, Inc., to prepare a more precise analysis. The Harris researchers decided that for an institution to qualify as a bona fide museum it must meet the following requirements: keep its facilities open to the public on a regularly scheduled basis at least three months a year, have a budget of at least $1,000 a month, own part of its collection, employ at least one full-time professional, and be recognized as a tax-exempt nonprofit institution.

Of the 1,821 museums that met these standards, 728 were selected for detailed examination, including all 164 museums with an annual operating budget exceeding $500,000 and half of the 223 museums with annual budgets ranging from $100,000 to $499,999. Using the results of this study, *Museums USA* was able to make statistically defensible projections of museum operations, governance, finances, and so forth.

Museums USA did not attempt to go beyond general categories in defining the subspecies of each broad type. In the author's judgment, among art museums, there are the following distinctive, if sometimes overlapping, variants:

* The foregoing was written before the voters of California enacted "Proposition 13," mandating a drastic reduction in local property taxes and thereby causing a budget-cutting frenzy by municipal and county governments. Museums in Los Angeles and San Francisco were threatened with cuts of up to 90 percent in government operating assistance. As of August, 1978, it appeared that the cuts might not be quite so drastic but few doubted that major museums would receive reduced levels of aid. To the extent that Proposition 13 sets a national pattern, the vulnerability of art museums to fiscal disaster is plainly all the greater.

Encyclopedic. These are the institutions of world standing that aspire to represent in depth most major fields of art. A perfunctory list of such museums would include galleries in New York, Washington, D.C., Boston, Philadelphia, Chicago, Cleveland, Detroit, Brooklyn, and Los Angeles.

General. There are at least thirty general museums with substantial collections covering many centuries of art, and a number of them have outstanding specialized departments. Leading general museums include those in St. Louis, Kansas City, Toledo, Denver, Fort Worth, Houston, Dallas, Cincinnati, Milwaukee, Minneapolis, Des Moines, Hartford, Worcester, Providence, Newark, New Orleans, Atlanta, Birmingham, Raleigh, Miami, San Diego, San Francisco, Seattle, Portland, Pittsburgh, Wilmington, Honolulu, Baltimore, Richmond, Santa Barbara, Buffalo, Utica, and elsewhere.

Donor Memorial. Up to 100 American art museums can be characterized as consisting chiefly of individual or family collections, some large, some small, and many eccentric. Outstanding examples include the Frick Collection in New York, the Gardner Museum in Boston, the Phillips Collection in Washington, D.C., and the J. Paul Getty Museum in Malibu, California.

University Collection. Of 100 or so college and university museums, at least a score is of national and even world importance, including galleries at Harvard, Yale, Princeton, Smith, Oberlin, Stanford, Pennsylvania, Berkeley, Chapel Hill, Chicago, Madison, Albuquerque, Houston, Dallas, and elsewhere.

Specialized Gallery. From 100 to 150 museums specialize in collections of contemporary, regional, folk, or ethnographic art. Examples range from the Museum of Modern Art and the Jewish Museum in New York to the Textile Museum and the Museum of African Art in Washington, D.C.

Portmanteau Museum. A large number of historical museums and a lesser number of natural history and ethnographic museums contain important collections of objects of aesthetic interest—what might be called a portmanteau collection. Neither the New-York Historical Society nor the Museum of the American Indian, both in New York City, is, technically speaking, an art museum, but the former's display of nineteenth-century American art and the latter's of aboriginal artifacts constitute primary resources for art historians.

Institutes of Contemporary Art (ICAs). These galleries are unique in that they have no permanent collections but, rather, serve as showcases for temporary exhibitions, usually of avant-garde art. Well-

established ICAs can be found in Boston, Chicago, Fort Worth, Houston, Los Angeles, Cincinnati, and Philadelphia.

The overlap between the different kinds of museums is necessarily considerable, and distinctions tend to be arbitrary. Museum professionals would differ among themselves on such questions as which museums qualify for encyclopedic standing and whether or not the ICAs are museums in the commonly accepted sense. Moreover, some institutions that are popularly regarded as museums, such as the Barnes Collection in Merion, Pennsylvania, do not think of themselves as such (it took a court ruling that the Barnes Collection was an art gallery, not a private educational institution, to force it to admit the general public at fixed times each week).

But problems of nomenclature aside, most art museums, of whatever description, have become enmeshed in the perplexities of the American arts economy.

THE FUNDING CONTRAPTION

The American arts economy can be likened to a Rube Goldberg contraption in which a cat, lured by a mouse, jumps on a seesaw that tosses a fish into the beak of a stork. The stork thereby gets fed, but the method leaves something to be desired.

No other country has anything like our system of cultural patronage, which indiscriminately mingles private and public monies, direct and indirect subsidies, and funding by agencies at every level of government. The system is a fair reflection of the American wariness of—and inexperience with—official arts patronage.

A major defect of the system is that the amount of public aid to arts organizations cannot be measured with any degree of accuracy. Most European countries have ministries of culture, and assistance to the arts is a discrete and visible expenditure in the national budget. The figures apportioned on a per capita basis make the United States appear laggard and philistine. According to *International Investor,* in 1971 West Germany spent $2.42 per capita on the arts, Sweden and Austria $2.00 each, Israel $1.34, Great Britain $1.23, and the United States $0.15.

But the European and American figures are not really comparable since they do not reflect the considerable indirect aid given to all American arts organizations through the charitable deduction provision in the tax laws (to cite only a single form of indirect aid). According to the Commission on Private Philanthropy and Public

Needs, individual Americans contributed as much as $26 billion in 1973 to organizations qualifying for a charitable deduction. In the case of the art museum, the benefit includes not only gifts of money but also gifts of art, which are appraised at current market values for tax purposes.

J. Michael Montias, a Yale University economist who is also an art collector, estimates that in most cases the real cost to donors does not exceed 30 to 40 percent of the appraised value of their gifts. He goes on to comment in a *Museum News* article:

> This of course implies that the taxpayers of the United States contribute an average $600 to $700 for every $1,000 worth of bequests. A donation, in sum, is a joint contribution by a private owner and the public, with the peculiar feature that only one of the parties to the transaction—the owner, who usually has the smaller stake—has a say in setting the conditions under which the work will be transferred to a public institution.[2]

There are no reliable figures on the value of works of art contributed each year to museums. But one can get some sense of the scale of the giving when one considers the flow of gifts to the Metropolitan Museum of Art between 1965 and 1975. During that period, according to former director Thomas Hoving, the museum added 15,000 works of art to its collection, of which 85 percent were gifts or bequests. Since the donations included the Lehman collection and the Nelson Rockefeller collection of primitive art, each important enough to occupy an entire wing, the figure of $100 million does not seem excessive as the total worth of gifts and bequests made to the Metropolitan during this decade.

In short, if the taxpayer share of donations such as these were added into the calculation, one might arrive at a different assessment of per capita support for the arts in the United States.

For all its imperfections, the American system of cultural patronage is based on a logic grounded in the national experience. A program of patronage on the European model would hardly be feasible in a nation of continental scale divided into fifty states, each with a legislature and two U.S. senators. To imagine that a cultural bureaucracy in Washington could allocate funds without making continuing concessions to powerful local and sectional interests requires a willing suspension of belief. Even in Europe, the disproportion of arts funding in such major centers as Paris and London is a constant source of complaint.

Moreover, the European ministry of culture is in an ancient tradi-

tion of royal patronage and is treated with a measure of deference by elected parliaments. There are no such traditional restraints operating on members of Congress, and our one great experiment in direct federal patronage—the WPA arts projects—perished amid attacks of sustained virulence by the House Committee on Un-American Activities chaired by Congressman Martin Dies of Texas.

As part of the New Deal emergency program, the Roosevelt administration, beginning in 1934, organized four arts projects within the Works Progress Administration. Vigorously administered and uncommonly productive, the WPA arts projects led to the formation of 122 orchestras, 158 theatrical companies, 66 community arts centers, and a host of special programs for jobless creators from one end of America to the other. The WPA's enduring achievements include the establishment of an Index of American Design and an Index of American Composers and the preparation of a series of first-rate guidebooks for all states and territories and for many cities. WPA artists, including Jackson Pollock, Willem de Kooning, Louise Nevelson, Mark Rothko, David Smith, and Arshile Gorky, none of them earning more than $100 a month, produced a prodigious amount of work, not all of it mediocre: 2,566 murals, 17,744 sculptures, and 108,099 paintings. The total cost of the ten-year experiment is impossible to determine because the WPA lumped its $6 billion allocations together, but it can be estimated that the Federal Art Project spent perhaps $78,800,000 and the Federal Writers' Project spent perhaps $27,000,000.

What might have been the beginning of a continuing program of federal patronage ended on a note of spiteful political harassment by congressmen obsessed with the Red Menace. The exemplary state guides were found to be infested with left-wing bias; one midwestern congressman took violent objection to a reference, in a 1937 guide to Washington, D.C., that a step-grandson of George Washington had bequeathed a tract of land to his "colored daughter"—a reference that the Federal Writers' Project was able to document. Attacks of this unreasonable kind on all WPA arts projects became so vehement and incessant that with the advent of World War II President Roosevelt allowed the four programs to wind down and silently to perish.

For a generation thereafter President Roosevelt's successors were chary of proposing any measures calling for federal aid to the arts. When, as part of his Great Society program, President Lyndon B. Johnson in 1965 finally revived the concept of federal patronage, a very different instrument was proposed: two national endowments

that would operate under separate twenty-six-member councils appointed by the President. With the WPA experience in mind, the Johnson White House sought to insulate the endowments from direct political pressure by putting program direction under autonomous councils whose members, by virtue of their prestige and specialized knowledge, would guarantee the integrity of the system.

The legislation was drafted in its final form by Livingston Biddle, Jr., an aide to Senator Claiborne Pell of Rhode Island. It was Biddle's uncle George, an artist, who in 1933 had written to Franklin Roosevelt to call attention to the magnificent work of the Mexican muralists employed by their government in the 1920s, and at the same time he urged the new President to put American artists on the public payroll; this letter was the genesis of the WPA arts projects. (Forty-five years later Livingston Biddle, Jr., would become the third chairman of the National Endowment for the Arts.)

But the structural separation of the endowments from elected officials was not the only feature of the new federal program that derived from past American experience. A primary influence in determining the shape and policies of the two endowments was the tradition of private philanthropy in the United States.

The roots of the philanthropic tradition lie deep in the Protestant ethic. Calvin admonished in his *Institutes:* "No member [of the Christian body] holds his gifts to himself, or for his private uses, but shares them among his fellow members, nor does he derive benefit save from those things which proceed from the common profit of the body as a whole." [3]

This Calvinist dictum was given novel and concrete expression by the Scottish-born industrialist Andrew Carnegie, who, although not conventionally religious, was steeped in the Protestant ethic. In 1889 Carnegie published his pervasively influential essay "Wealth," in which he maintained that the rich were duty-bound to help the poor through what he called scientific philanthropy and thereby benefit the community "far better than it could or would have done for itself." [4]

A conscientious benefactor's obligation, Carnegie went on, was "to assist, but rarely or never to do it all. . . . It were better for mankind that the millions of the rich were thrown into the sea than so spent as to encourage the slothful, the drunken, the unworthy." [5] To these ends, philanthropy should be administered by experts and should be used to stimulate others to give. Following his own precepts, Carnegie spent the bulk of his fortune—some $230,000,000—on an imagina-

tive range of ventures, including the World Court at The Hague and the seeding of more than 3,000 public libraries.

It so happens that Carnegie won as a convert the one American best equipped to carry his gospel forward: John D. Rockefeller, Sr. "I would that more men of wealth were doing as you are doing, with your money, but be assured your example will bear fruit," the founder of Standard Oil prophetically wrote to Carnegie.[6] By 1910 the elder Rockefeller had given away $134,000,000, and his son and grandchildren have so enthusiastically carried on the tradition that the total philanthropic contribution made by the family is estimated at $2 billion. Despite the magnitude of these benefactions, the truth is that if this money had not been given away, most of it would have been taxed away. In 1974 the net worth of eighty-four Rockefellers was estimated at $1.3 billion, suggesting that practicing Carnegie's "gospel of wealth" does not require taking a Franciscan vow of poverty.

Carnegie could not have foreseen the peculiar eloquence that the Sixteenth Amendment to the Constitution would impart to his plea. Following the adoption of the amendment in 1913, Congress was finally able to enact a constitutional income tax, but in doing so, as we have seen, special deductions were allowed for charitable contributions. On this rock the cathedral of American philanthropy has risen.

Initially, private foundations concentrated their efforts on education, health programs, and scientific research. Philanthropy did not become a major factor in the American arts economy until the 1950s, when the Ford Foundation decided to channel major grants to cultural endeavors.

More important, and to a degree not commonly appreciated, the private foundation became the model for state patronage agencies. In 1960 Governor Nelson A. Rockefeller of New York felt that the time had come to mount a fresh attack on the economic problems of the arts; after extensive consultation, he concluded that the most effective instrument would be a State Council on the Arts, structured like a foundation with an autonomous board. When the Albany legislature approved his plan, the first state council was born—a tangible precedent for the two federal endowments six years later. Since that time, in good part as a result of the stimulus of federal money, arts councils have been formed in every American state and territory.

But the problem with all such patronage agencies is that in the Carnegie tradition, their grants are supposed to be "imaginative." Keeping the boilers going at arts institutions is certainly vital, but in

no sense does it qualify as creative, innovative, or even very visible grant making, resulting in the kind of dilemma that took acute form in the City of Detroit.

DETROIT GOES DARK

The fifth largest art museum in the United States, the Detroit Institute of Arts, boasts an encyclopedic collection containing everything from Cycladic sculptures and Impressionist masterpieces to Diego Rivera murals and a group of African art, of moderate quality, given by former Michigan Governor G. Mennen Williams. The museum is on Woodward Avenue, a busy thoroughfare, and the facade of its 1922 building is so stained by fumes that the patina—misleadingly—suggests a certain venerability. Two enormous modern wings were added during the 1960s, quadrupling the institute's exhibition area, which now covers 10 acres, or 500,000 square feet.

In 1975, for lack of city funds, the Detroit Institute was forced to close down for nearly a month, and when it reopened, only 25 percent of its gallery space was initially accessible. This was the first time that any encyclopedic gallery in the United States had had to take so drastic an economy measure.

The Detroit Institute was founded in 1885 and has been municipally owned and supported since 1919; in fact, it describes itself as the country's largest municipally owned museum, and it has thus been particularly vulnerable to the malaise of the great American cities—lack of municipal money. A private Founders Society and a city-appointed Arts Commission jointly manage the museum; the society, consisting of more than 12,000 members, raises money for acquisitions, special events, and school programs, while the City of Detroit has been paying basic operating costs (in 1974–75, about half the institute's budget of $5,000,000 was met by city hall).

As automobile sales fell sharply off in the mid-1970s and Detroit had suddenly to cope with a jobless rate of twice the national average, the city regretfully announced in 1975 that allocations to the institute would be cut by about 25 percent, from $2,242,039 to $1,602,336. This meant that six vacant staff positions would also remain unfilled.

The institute laid off fifty-eight city employees, most of them guards, and on June 16, 1975, it was forced to close its doors. Three weeks later it reopened on a reduced schedule. At the time it was attracting record attendance: In 1974–75, there were 874,474 visits, as compared with an average annual attendance of 722,311 for the

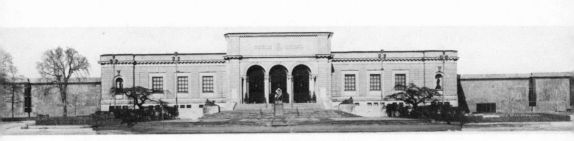

The Detroit Institute of Arts, a darkened giant

decade of the 1960s. What was felt to be an esoteric show, "French Painting 1774–1830: The Age of Revolution," which the institute had organized in partnership with the Louvre and the Metropolitan Museum, proved a popular success, attracting 162,000 visitors, a total exceeded only by a Rembrandt exhibition five years before.

The institute's deficit of $786,000 was not astronomic by museum standards; the problem was less its size than its nature. No museum expense is less popular than maintenance costs. Although the Founders Society had contributed $2,617,430 to the institute in 1974–75, most of this money was earmarked for the more glamorous purpose of acquisitions and special programs. Thus, in 1974, the institute was able to raise $1,100,000 to buy Caravaggio's *Conversion of the Magdalene,* and in 1976 it was able to pay a record $275,000 for an African sculpture, the Grand Kongo fetish. As the museum bulletin reported, during 1974–76, the institute added to its collection 559 pieces with a total value of $2,086,224.

The institute also found it easier to raise money for construction than for maintenance costs. A thirty-eight-gallery south wing was completed in 1966 at a cost of $3,785,000, of which $1,800,000 was met by a federal grant under the Public Works Acceleration Program for the renewal of depressed areas; the balance was privately underwritten, the largest gift, $1,000,000, being donated by Mrs. Edsel Ford. In 1971 a north wing of about the same size was opened, and all the money for it came from federal and city matching contributions.

The strain of adding these new wings was readily visible in the institute's budget—in 1966–67 the museum's operating funds were just over $3,000,000; in 1974–75 they were $5,996,219, of which $2,242,039 came from the City of Detroit, $1,533,000 from the

Founders Society's operating budget, $1,084,430 from the Society for acquisitions, $476,000 from federal works (CETA) programs, $415,000 for theater arts, $147,880 from the Michigan Council for the Arts, and $98,000 from miscellaneous grants.

The museum's financial position was therefore precarious for fiscal 1976–77 when the City of Detroit not only drastically reduced its contribution but also shaved $344,031 from the money allocated it by the Comprehensive Education and Training Act (CETA), an emergency manpower program enacted by Congress in 1973 that gave city governments a discretionary voice in spending approximately $1 billion a year.

Examining its balance sheets and taking prudent account of its comparatively small endowment of $10,000,000, the institute decided to appeal directly to the state government for relief. Governor William Milliken, a liberal Republican, was sympathetic and endorsed an urgent request for an immediate $500,000 as a direct state grant to the institute. The museum on its part mobilized a campaign that stressed the services the institution was rendering the entire state: Two of its exhibitions had toured twenty-two Michigan cities, ten of which were in the remote Upper Peninsula, and as surveys showed, seven out of ten museum visitors came from outside Detroit.

Frederick J. Cummings, the museum's soft-spoken and highly personable director, touched every possible chord in his appeal:

> This pantheon of 101 galleries—some $120,000,000 of building and art—displays a treasure which is world renowned. Its vast collection of art inspires us at the same time it educates us to the creative wonders of 50 centuries of civilization. Along with energetic Michigan people, with the natural Michigan beauties and a boundless Michigan future, the museum earns, we feel, its claim as one of Michigan's finest resources.[7]

Newspaper editorials echoed these arguments. Cummings, along with influential members of the Founders Society, became a familiar figure in the lobbies of Lansing. Still, some legislators wondered why state taxpayers should be asked to pick up the museum's bills.

"For most people, art is a hobby," said one of the dissenters, Richard Young, a Democratic state assemblyman from Dearborn Heights. "Nobody pays my way to see the Tigers. . . . We can close art institutions one day a week and it won't kill them." [8] Ignoring such protests, the legislature not only increased the emergency grant to $680,000 but also deleted a rider that would have required the museum to impose a mandatory $1 admission fee in place of the $1 voluntary contribution it was asking.

The outcome, as pleasing as it was to the institute, aroused only moderate enthusiasm at the Michigan Council for the Arts, which, like all such state agencies, questions the wisdom of direct legislative funding of arts organizations. In the words of Ray Scott, the council's executive director: "The line item is anathema." A line item is an automatic appropriation, usually based on a fixed formula and therefore requiring no deliberation by an arts council. If all arts programs were funded in such a way, there would be no reason for the existence of the Michigan Council, whose appropriations had soared from $484,000 in 1973–74 to $2,330,600 two years later.

For the institute, however, the line item has the obvious appeal of being a predictable allocation. When Governor Milliken in 1976 called for an additional $3,500,000 legislative grant to the museum to compensate for further reductions in city support, Walter R. Boris, chairman of the Michigan Council for the Arts, anxiously wrote to Director Cummings to ask what role he envisioned for the council in the future. Deftly and circumspectly, Cummings responded in a letter dated September 7, 1976:

> Answering your request directly to indicate our advice on what possible posture might be assumed in this matter by the Michigan Council for the Arts, I am only able to say, as head of a department of the City of Detroit, that The Detroit Institute of Arts fervently hopes for a stabilization of its finances, that we are profoundly grateful to the State for its recognition of our reduced municipal support, and that we wish to continue as a cultural institution serving all the people of the state. . . . I cannot forecast what directions [future] discussions will take, i.e. grants and transfers or return to direct support from the Michigan Council for the Arts through a line item as in 1975–1976. I do feel, whatever is worked out, that funding would be administratively more efficient and significantly less expensive if the designee were the Founders Society Detroit Institute of Arts, but this is not absolutely critical since the City wishes to sustain our activities in the public good.[9]

In his plea for predictability and administrative simplicity, Cummings spoke for many of his fellow museum directors, who are having to cope with essentially the same dilemmas.

Meanwhile, in its quest for more federal help the institute encountered many of the problems it was already experiencing with the state. The National Endowment for the Arts (NEA), although it does have an extensive museum program, has for years been wary of concentrating large sums on a single city, and has had a fixed policy against underwriting operating expenses. But the distress of the major arts organizations in Detroit was so extreme that in 1975

Nancy Hanks, chairman of the National Endowment for the Arts, made a special visit to the city. A politician par excellence, Nancy Hanks had surely noted that the new President of the United States hailed from Michigan and that his First Lady was known to be interested in the arts.

After her visit, endowment policies to the contrary, Miss Hanks announced that $250,000 would be made available to Detroit arts organizations on the condition that they raise $750,000 from other sources. In other words, she was saying that Detroit could qualify for a "challenge" grant—the kind of grant that often forces arts organizations to engage in interminable and sometimes tasteless fund-raising campaigns.

A director of development, Boris G. Sellers, had been hired by the Detroit Institute. He in turn had persuaded a local development firm, the Taubman Company, to contribute $45,000 to the museum and to sponsor fund-raising benefits at new shopping centers in suburban Dearborn and Sterling Heights. The museum invited couples to make $20 tax-deductible contributions to the museum for the privilege of attending a fete billed as "You . . . the Night and the Music." As a Founders Society appeal put it:

> Let us join together at the year's first great benefit entertainment—the *splashy, dressy* preview opening night at one or both of Detroit's newest, most wonderful places! Michigan has never seen anything like them. I can safely predict that they will become tourist attractions you'll want to show off. Our benefit evening includes music, dancing, ice-skating, band concerts, cash bars, people-movers, and an extravagant highlight—*a musical style show* by leading American designers. . . . Join up with your fun-minded friends and let your tax-exempt night keep the museum bright and beautiful! [10]

The benefit yielded $70,000 for the Detroit Institute, and eventually, through other such fund-raising events, the museum was able to raise its share of the endowment challenge grant. Small wonder, in light of this ordeal, that museums have decided to leapfrog the patronage bureaucracy and to stake a claim for direct federal help in meeting their rising operation expenses. In doing so, they have stimulated an overdue debate about our cumbersome system of cultural patronage.

THE CULTURAL BUREAUCRACY

Through an accident of unplanned parenthood, the United States has given birth to what can be described as a cultural bureaucracy, reaching from the community level to Washington, D.C. Entire cadres

of officials are employed to administer arts budgets (and to justify their own paychecks). There are worse things a government can do than support arts organizations. But most of what is published about the cultural bureaucracy tends to be excessively self-congratulatory. In what follows, I have deliberately striven for a cautionary note.

The organizational switchboard of the cultural bureaucracy is the American Council of the Arts (ACA), formerly known as the Associated Councils of the Arts, operating out of New York, which has evolved into a political lobby, if more high-minded than many others. The ACA took form in 1954, when Helen Thompson, executive secretary of the Symphony Orchestra League, invited representatives of community arts agencies to a meeting coinciding with the league's annual conference. For the period immediately after its founding, ACA was little more than a letterhead, with an annual budget averaging approximately $1,000. All that changed, however, when it received a grant from the Rockefeller Foundation and came under the tutelage of Nancy Hanks, then an officer of the Rockefeller Brothers Fund and project coordinator of the path-breaking report *The Performing Arts: Problems and Prospects.* Miss Hanks was elected ACA president in 1967, and it was from this post that she was recruited by President Nixon to be the second chairman of the National Endowment for the Arts.

There are more than 600 community arts agencies in the country, of which no fewer than 85 percent have been organized since 1960, according to the 1974 directory *A Guide to Community Arts Agencies.* Most of these agencies are the beneficiaries of some form of government aid, and their sponsorship is both public and private (some are affiliated with local chambers of commerce). All told, as of 1972–73, their gross budgets amounted to $24,341,938—data based on responses from 327 agencies.

At the next level are the state arts councils, the first of them founded in New York, with an initial budget in 1960 of $765,895. By 1975–76 the New York State Council on the Arts had a budget of $34,100,000 and had become the major source of funding in the state arts economy. In the same fiscal year, total state legislative appropriations to all arts councils amounted to $62,312,531.

On the federal level, the growth of the cultural bureaucracy is as imposing as it has gone unremarked. A 1975 ACA publication, *Cultural Directory,* itemizes no fewer than 250 federal or quasi-federal programs of assistance to the arts, varying from an Air Force program of commissioning paintings for its Arts Collection to the General

Services Administration (GSA) program of spending a fixed proportion of construction costs of new buildings on works of art (by 1975–76 the GSA was spending some $2,000,000 for works of art embellishing twenty buildings).

The keystone of the federal program is the two national endowments, whose initial appropriations of $5,000,000 together in 1966 have jumped thirty-fold to more than $180,000,000 (including special programs) by 1978–79—all of which has occurred with the endorsement of four successive presidents of the United States.

By 1978 there were at least 800 executive-level officials concerned with cultural patronage in the United States, many of whom employed a retinue of deputies, associate directors, assistant directors, program associates, administrative assistants, public information officers, fiscal management directors, and so forth. It seems reasonable to suppose that in 1977–78 approximately $400,000,000 in public monies was available in the aggregate for cultural patronage.*

What was conspicuously lacking was not so much money as policy. It could not be said with any certainty just how much money was being spent, at all levels of government, on the arts, much less how wisely it was being spent. In 1978 no member of Congress could even hazard a figure on the total federal allocation—extending from CETA programs to the Smithsonian Institution—for cultural patronage (leaving aside altogether the question of indirect assistance through tax laws). It was all too clear that a program of public assistance to the arts, prodigious in its amplitude, existed in a vacuum and that government, abhorring a vacuum, had filled it with a bureaucracy.

THE MEDICI MENTALITY

A particular difficulty with all forms of patronage, private or governmental, is that the patron, understandably wishing to be more than a passive conduit of money, seeks to share in the creative process. W. McNeil Lowry, former vice-president of the Ford Foundation, remarked in a speech in 1962: "We are catalysts rather than re-

* The estimate of the number of officials and the size of public expenditures is the author's and is based on an analysis of local, state, and federal data. The economist Dick Netzer, in his Twentieth Century Fund study, *The Subsidized Muse* (1978), calculates that in calendar 1975 total public support of the arts reached an estimated $282 million; his criterion is conservative since he includes in that figure only the identifiable arts activities of the National Endowment for Humanities and other agencies. My own inclination is to use the broader criterion of cultural patronage and therefore add in the entire NEH budget. But as Netzer rightly observes, all such data is hard to come by and must involve arbitrary judgments.

formers, participants rather than backers, communicants rather than critics. . . . Our investments in the arts are not so much subsidies as they are levers." [11]

"Fueling the Arts, or, Exxon as a Medici" was the headline of a January 25, 1976, article in the "Arts and Leisure" section of the Sunday *New York Times* by *New Yorker* staff writer John Brooks, who reported that during his conversations with three Exxon executives the name Medici cropped up: ". . . and no wonder: spending part of one's time giving away large sums of other people's money for worthy purposes—instead of trying to *make* money full time, as all of them used to—isn't bad fun." [12]

From the vantage of supplicant arts organizations, however, the limitation of the Medici mentality is that there is pressure to fashion a proposal that will beguile the patron. The psychic needs of the patron can thus become as important as the intrinsic requirements of the institution he represents. The funding tail wags the all-too-amenable dog, with the result, for example, that television programs on public broadcasting can be as much determined by the taste of an oil company patron as by the wishes of the programmers.

Lowry, who, during his years at the Ford Foundation, probably gave away as much money to the arts as any person in American history ($306,000,000 between 1957 and 1973), has described the role of government in the arts as "paying the heating bills." However reasonable this may seem in the abstract, it overlooks a political reality—that a new public agency, struggling to build political support, would be naturally inclined to spread its funds among many applicants and to give preference to those proposals that might yield a dividend in visibility.

Much to the point are the recollections of John Hightower, the first director of the New York State Council on the Arts. "We had $50,000 for a planning study, plus a $450,000 appropriation in the first year," he recalled in an interview. "We started with the supposition that we'd be out of business in the next year, in 1962. Therefore, we prepared a carefully designed strategy. We didn't want anyone to develop a financial dependency on the arts council, so direct operating expense funding was clearly excluded. If we were going to reach to the rest of the state—beyond New York City—we had no alternative except project funding. I wanted to develop a statewide constituency for the arts through the institutions we served. And we did." [13]

In the years that followed, the New York State Council grew steadily, but as the bias for project grants intensified, so did criticism of the council's approach. Major arts groups, starved for money, complained that they had to come up with "sexy" projects in order to secure council funding. The conflict reached crisis proportions in 1975, when a newly elected Democratic governor, Hugh Carey, appointed Joan Kaplan Davidson council chairman. During her sixteen-month tenure Mrs. Davidson was in day-to-day charge of an agency with an annual budget of approximately $34,000,000 and a staff of eighty.

In her disinterested zeal Mrs. Davidson was typical of many Americans who have assumed leadership of new arts agencies. Although not professionally trained in the arts, she had a winning enthusiasm for everything creative and was equally at home in the studio and the salon (her mother, Alice Kaplan, is an amateur painter and a past president of the American Federation of the Arts; her father, J. M. Kaplan, is a founder of the Welch's Grape Juice Company). She had run unsuccessfully as a Democratic candidate for the State Senate on Manhattan's Upper East Side but was better known for her role in guiding the J. M. Kaplan Fund, a foundation established by her father, which reported assets of $16,300,000 in 1975.

One of the best-publicized Kaplan Fund efforts involved Westbeth, a working and living facility for artists located in what had been a Bell Telephone laboratory in Greenwich Village. When the company decided to sell the thirteen-story structure, it was proposed that it be turned into studio quarters for artists, musicians, actors, and writers. Seed-money grants of $750,000 each were bestowed by the Kaplan Fund and the National Council of the Arts, and the Federal Housing Authority was persuaded to commit $11,000,000 to convert the laboratories into 383 loft types of studios.

Within two years after Mayor John V. Lindsay broke ground for Westbeth in 1968, the first tenants moved in. Each was chosen by a careful screening process. But creators are notoriously difficult as tenants: Some claimed poverty and refused to pay rent; others, in direct violation of their leases, sublet their studios; and still others moved out, leaving their mates, often nonartists and therefore not acceptable tenants, in possession. "Parnassus on the Hudson," as Westbeth was grandly called, became an economic debacle. The majority of tenants appealed to the Kaplan Fund for further help and were rejected. In the words of one Westbeth artist, Lucia Salemme,

Joan Kaplan Davidson,
a patron on the hustings

"After the building was open, Mrs. Davidson lost interest. We found ourselves on our own." [14]

Joan Davidson cannot be faulted for her goodwill. Westbeth was indeed a worthy and attractive project, but its history underlines the limits of the seed-money approach to philanthropy that Mrs. Davidson brought with her to her arts council post. One of her projects was to teach schoolchildren italic handwriting because, she told a *Village Voice* reporter, "It happens to be a fetish of mine. What I want to be when I grow up is a printer. Most of the kids in the state will never get to a play or a symphony. Maybe learning to write beautifully will be the most important art experience they ever get." [15]

The new chairman was an enthusiast for experimental funding, but leading arts organizations wanted solid, reliable funding. A few years earlier major New York City museums had pressed in vain for a line-item appropriation in the budget of the State Department of Education. In 1973 the state legislature, responding to the appeals of institutions large and small, came up with an arbitrary compromise. Half the funds allocated to the arts council would thereafter have to be spent on "primary organization," and at least 75 cents per capita would have to be spent on each resident of each New York county.

The council was given the task of selecting the "primary organizations," and in 1972 it presented an initial list of 72. Under Mrs. Davidson, the list grew to 115, with primary status being awarded to the Alliance for Latin Arts, the Afro-American Cultural Center, and the Millennium Film Workshop, among others. Complicating matters still further, the Albany legislators in 1975 inserted two line items in the council budget, awarding $625,000 for a Bicentennial Barge that was to float up the Hudson and $500,000 for the Earl W. Brydges Artpark, in Lewiston, the pet project of a powerful Republican politician—thus subtracting $1,125,000 from the $34,100,000 voted to the arts council.

The council was then faced with the difficult problem of dividing the remaining money in ways that would fulfill per capita requirements and at the same time satisfy "primary" art groups. With her limited political and administrative experience, the new chairman, for all her intelligence, was beyond her depth, and a storm broke around her when the council chopped $1,600,000 from the $8,000,-000 allocated to the visual arts division. This reduction meant a loss of basic support money for twenty-nine museums throughout the state, the biggest losers being the biggest museums. (The Metropolitan Museum, for example, which had received $1,200,000 the year before, was cut back to $670,000.)

Speaking in behalf of the short-changed museums was Joseph V. Noble, director of the Museum of the City of New York and president of the American Association of Museums. "The amount of grant money given by the council has been pretty much on a whim basis in the past," he asserted. "If you came up with a very sexy program, you might get a larger grant than if you just wanted to be able to keep your front-door open. We need a more rational approach to grant making, because it seems to us irrational that an institution has no idea of what it's going to get from one year to the next. If we can't get a rational approach, I guess we'll go to the state legislature." [16]

Museum directors and trustees banded together to mount a counterattack in the press, in Albany, and on the twenty appointees of the State Council on the Arts, one of whom was Thomas Hoving, director of the Metropolitan Museum. Mrs. Davidson was taken completely aback by the vehemence of the campaign. As she told visitors, the 1974 allocation to museums had represented a substantial increase over the previous year's figure, and there were more applicants than ever before for council grants, and after all, it was the state legislature, not the council, that had reduced the size of the allocation.

But museums believed that the 1974 allocation should be the rough minimum. How, they asked, was rational budget planning possible if council allocations were going to jump erratically up and down? To the surprise of very few in the art world, the state council backed down in December 1975 and approved additional grants of $960,000 to twelve cultural institutions, including six New York City museums.

Mrs. Davidson was unable to dissipate the air of confusion surrounding her first months in office; she was at a further disadvantage in having no personal ties to Governor Carey. There also were administrative muddles; by the end of fiscal year 1976, the council had

paid out only 69 percent of its grant money, as compared with more than 75 percent the previous year. The italic writing, so to speak, was on the wall. In August 1976, with crude brusqueness, Governor Carey forced Mrs. Davidson to resign and replaced her with Kitty Carlisle Hart, the widow of playwright Moss Hart and a well-known actress who had been serving on the council board for five years.

If Mrs. Davidson was the well-meaning but clumsy amateur performer on the high wire, Nancy Hanks, former chairman of the National Endowment for the Arts, was a professional aerialist. No one in arts patronage has dispensed more grants, given more speeches, chaired more conferences, and disarmed more politicians than Miss Hanks. Through her personal influence, what can be called the Rockefeller approach to cultural funding has become national policy.

The essence of this approach was summed up by John D. Rockefeller, Sr.: "Don't coddle, stimulate!" The purpose of philanthropy is to initiate projects rather than to sustain them, and three generations of Rockefellers have taken this precept to heart, to the unprecedented benefit of museums all over the world. John D. Rockefeller, Jr., was not only the patron of Colonial Williamsburg, but also the excavator of the Agora in Athens, the restorer of the Palace of Versailles, and the founder of the Cloisters in New York and of the Rockefeller Museum in Jerusalem. His wife, Abby Aldrich Rockefeller, the youngest daughter of Senator Nelson W. Aldrich of Rhode Island, was one of the founders of the Museum of Modern Art—beginning an almost dynastic association between that institution and her family. John D. Rockefeller III contributed generously to the Museum of Modern Art, Asia House, the Japan Society, the Whitney Museum of American Art, and the De Young Museum in San Francisco, which is to be the beneficiary of the important collection of American art he had assembled with the help of his enterprising wife, Blanchette, who happens to be the current president of the Museum of Modern Art.

Of the brothers, Nelson A. Rockefeller has been the vigorous *primus inter pares*, using his own money to found a Museum of Primitive Art (later given to the Metropolitan Museum) and New York State funds to build the costly Albany Mall, one component of which is a museum, and the Roy R. Neuberger Museum of the State University of New York at Purchase. Designed by Philip Johnson and John Burgee, the Neuberger Museum looked more substantial in sketches than it does built. Although it is located in a verdant stretch

of Westchester County, the museum has the hermetic air of a fallout shelter; its first director, Englishman Bryan Robertson, has said, "I couldn't take more than forty minutes in that museum. After a while, I had to go outside for a smoke. I would get up in the morning depressed at the thought of going to work, I would play the car radio to cheer up. The place is death to the spirit, reminiscent of Kafka's *Penal Colony*." [17]

Nelson Rockefeller cannot be blamed for the design failings of the museum, only for the fact that the public would have to pay for them. It was all very well for Rockefeller to assert spaciously, in reference to the Albany Mall, that "mean structures build small vision"; after all, he was not the one who would be permanently saddled with the maintenance costs of a misfired enterprise. There is a clear distinction to be made between delights of conception and the responsibilities of parenthood.

This is not to obscure the fact that the Rockefellers, more than any other American family, have prodded, usefully aggravated, and creatively energized at least three generations of their countrymen. In this respect, certainly, Nancy Hanks fits into the family tradition.

Hanks's association with the Rockefellers began in the mid-1950s, when she was named an assistant in the White House to Nelson Rockefeller, who was then special counsel to President Eisenhower. When Rockefeller resigned to run for the gubernatorial nomination in New York in 1958, Hanks was appointed to the staff of the Rockefeller Brothers Fund, where she worked with, among others, Henry Kissinger in preparing the series of studies *Prospect for America*. In 1965 she was appointed the project coordinator of a report on the problems of the performing arts, and soon thereafter she was elected president of the Associated Councils of the Arts.

Meanwhile, New York attorney Leonard Garment, a liberal Republican who was close to Nelson Rockefeller, had been appointed White House counsel by President-elect Richard M. Nixon. All White House staff members had been invited to submit memoranda on policy innovations. Garment, by sheer chance, had just read a *New Republic* article, "The Arts Go Begging," by journalist Michael Straight. "Support for the arts is a smaller item in our (national) budget than economic aid to Costa Rica," Straight had written with his accustomed vigor, "smaller than one minor grant made by the National Science Foundation to the Polytechnic Institute of Brooklyn." [18]

Garment was impressed enough to seek out Straight. They both

A pride of patrons. The late John D. III, Laurance, Nelson, and David Rockefeller seated with their sister, the late Abby Rockefeller Mauzé

felt that the national endowments that Johnson had established in 1965 had failed to realize their promise (their combined appropriation was at the time $5,000,000). By coincidence, this view also had been stated in a White House memorandum submitted by Nancy Hanks which was directed to Garment's attention at the same time. Weaving Straight and Hanks's ideas together, Garment fashioned a staff paper for the President advocating a substantial increase in the arts appropriation.

"I said this would be a quintessentially presidential thing to do," Garment recalled in an interview with the author. "The endowments existed, but they needed to be given life. I also made the point that Nixon's support would come as a real surprise. . . . That appealed to him. He asked what we should do. If he was really serious, I replied, he should double the budget of the endowments." [19]

Nixon concurred in Garment's recommendations and enlisted his help in finding a new NEA chairman. "One day it just came to me," Garment said. "Just like the Gershwin song—'Nancy, How About You?'—I thought Mike Straight would make a good deputy to Nancy, and he was appointed first." (Straight's designation had its ironies, since as an eastern insider—he was the grandson of the industrialist William C. Whitney and the son of Willard and Dorothy Whitney Straight, an owner of the *New Republic* and a supporter of Henry Wallace in 1948—he personified the liberal establishment that Nixon had devoted his political career to opposing.) Thus it was that Hanks and Straight became the tandem Nixon team at the National Endowment for the Arts, the bellwether of federal patronage.

Once in command, Nancy Hanks quickly reversed the policy of her predecessor, theatrical producer Roger L. Stevens, who had earmarked the largest share of NEA grants for well-established arts institutions. Under Hanks, grant money was widely diffused—to the point where she soon found herself spending a great deal of her time

Nancy Hanks,
the aerialist of patronage,
while chairman of the
National Endowment for the Arts

WIDE WORLD PHOTOS

reminding congressmen, whose offices she took care to visit periodically, about the NEA's benefactions in their states or districts.

Nancy Hanks, wherever possible, gave priority to innovative and preferably very visible projects, such as the Artrain. Launched in 1969 by the Michigan Council for the Arts, Artrain consisted of several refurbished Pullman cars hitched together, at a cost of $850,-000, to form a mobile art gallery. Over a period of five years it toured fifteen states, from the Rockies to the Deep South, and nearly everywhere it went there was media coverage, including an admiring national report on the CBS Evening News by correspondent Charles Kuralt. Still, as Nancy Hanks would probably be the first to concede, Artrain was more a gimmick than a significant aesthetic program. (For want of funds, Artrain ceased its rounds in 1975 and is now berthed in Detroit.)

On the important question of allocating federal funds for maintenance expenses, Hanks was firm—such grants were unnecessary and undesirable. In a 1973 article in *Museum News*, the journal of the American Association of Museums, she wrote:

> Given the Endowment's current level of funding, I believe that the policy of program/project support, rather than operating cost support, is appropriate at the present time. Unquestionably, this is a matter that needs constant evaluation and in-depth study. . . . Further, many local, county, and state governments believe it to be their responsibility to provide general maintenance monies for museums. Approximately 37.1 percent of operating expenditures of history museums is covered from these sources; 28.9 percent of science museums; and 16.5 percent of the expenditures of art museums. I think it would be a mistake for the Federal government to take any action that would in any way have the effect of decreasing or discouraging maintenance funding from local and state sources—both government and private.[20]

Seen from the vantage of the hard-pressed museum, however, such a statement could appear disingenuous and self-serving. Local governments were becoming increasingly less promising as sources for maintenance money, and in the opinion of many museum boards, a federal program was a necessity.

Miss Hanks, furthermore, minimized the difficulties that arts institutions faced in obtaining private funding for maintenance expenditures. Although there has been a substantial increase in corporate and foundation assistance to museums, very little of this money has been available for maintenance. With a few notable exceptions, private patrons have preferred to concentrate their benefactions on special projects.

According to *Museums USA*, about a fifth of all museum revenues of $22,600,000 in 1971–72 derived from foundation grants. There is a greater dependence on private philanthropy among performing arts groups. In a study of the finances of the performing arts undertaken by the Ford Foundation, it was found that in 1970–71 philanthropy accounted for 25 percent of the unearned income of opera companies, 85 percent in modern dance organizations, 42 percent in ballet, and 41 percent in nonprofit theaters. The study concluded: "The dollar amount of the increase in national foundation grants was greater than that of any of government grantmaking agencies." [21]

For the most part, however, foundation money does not consist of unrestricted gifts. William J. Baumol and William G. Bowen wrote in *The Performing Arts: The Economic Dilemma*, their 1966 study sponsored by the Twentieth Century Fund: "A special problem colors much of foundation giving to the arts. This arises out of the basic principle to which many foundations are committed—an emphasis on 'seed money,' on providing funds that will nurture an innovative activity through the period of its infancy, after which it can be left to fend for itself." [22]

It was partly to compensate for this bias that the Ford Foundation in 1973, on the urgent recommendation of W. McNeil Lowry, authorized maintenance grants totaling $85,000,000 to major symphony orchestras, on the condition that each recipient match the Ford gift. (At the time Lowry had seriously weighed the rival claim of the art museums, but decided that museums were in a stronger financial position than symphony orchestras and had more direct access to private wealth—a decision that museum trustees have never forgiven him for.) The same limitations apply to corporate underwriting. Since

corporate patronage is more often than not a high-minded form of public relations, donor corporations are eager that their gifts pay a yield in visibility. Usually, corporate patronage of museums consists of grants so that major loan shows can travel to a number of cities.

So ubiquitous is this patronage that in 1974 art critic Harold Rosenberg marveled in *The New Yorker*: "This season not a single museum was able to mount a major exhibition without contributions from the National Endowment for the Arts and a sponsoring business corporation—plus, in many cases, a grant from a state arts council."

Figures on the scale of corporate patronage have been prepared by the Business Committee for the Arts (BCA), a New York-based organization set up in 1967 at the urging of David Rockefeller. The BCA and its president, Goldwin A. McLellan, a former corporate personnel officer, have tried to keep track of all the proliferating programs of corporate support for the arts. McLellan calculates that total corporate patronage has grown from $22,000,000 in 1965 to about $150,000,000 in 1975—an increase of 600 percent. BCA surveys indicate that corporate gifts to museums amounted to $19,000,000 in 1970 and $26,000,000 in 1973, although it is impossible to arrive at exact figures because a number of corporate grants turn up in annual reports as donations by individual company executives.

Public relations motives notwithstanding, business support of the arts has made possible innumerable exhibitions and special programs. However, corporate funding has seldom been available for unglamorous maintenance expenses; only in rare instances do businesses make unrestricted gifts on a continuing basis to arts organizations, as has been the policy, for example, of the U.S. Steel Foundation. For the past decade, this foundation has made modest annual contributions to fifty or so arts organizations, including ten museums. It is agreeable to call attention to an approach that allows grant recipients to spend the money as they see fit.

The dilemmas of patronage are hardly new and were indeed anticipated in a famous commentary on Andrew Carnegie by Finley Peter Dunne, creator of Mr. Dooley, a turn-of-the-century sage who held forth in a Chicago saloon. In 1906, directing his attention to the dedication of a new "Carnaygie libry," Mr. Dooley said to the ever-attentive bartender Mr. Hennessy:

> He's havin' gr-reat sport with it. I read his speech th' other day, whan he laid th' corner-stone iv th' libry at Pianola, Iowa. . . . "Ladies

an' gintlemen," says he. "Modesty compels me to say nawthin' on this occasion, but I am not to be bulldozed. I can't tell ye how much pleasure I take in dishtributin' monymints to th' humble name around. . . . All I ask iv a city in rayturn f'r a fifty-thousan'-dollar libry is that it shall raise wan million dollars to maintain th' buildin' and keep me name shiny. . . . What ivry community needs is taxes and lithrachoor. I give them both. Three cheers for a libry an' a bonded debt! . . . I stake ye to this libry, which ye will have as soon ye raise the money to keep it goin'." [23]

In an oft-quoted put-down of the occasional pomposity of the great benefactor, Dunne has Hennessy ask Dooley what Carnegie means when he says he puts his whole soul into his philanthropy. "He means," replies Dooley, "that he's ginrous. Ivry time he gives a libry he gives himself away in a speech."

Pace Dooley, the debate goes on, and so do the dilemmas arising from our peculiar system of cultural patronage. As much through accident as design, it transpired that American museums have initiated a national dialogue on the system's inadequacies.

LOOKING TO WASHINGTON

Great decisions on issues of less than universal concern very often arise from providential circumstance. If, for example, two influential members of Congress had happened to be devotees of grand opera, we might today have an Institute of Musical Services in the federal bureaucracy to provide maintenance funding for stricken opera companies. In any event, the interests of grand opera did not find congressional evangels as powerful as Claiborne Pell and John Brademas, who are enthusiasts of museums. Largely because of their dedication, an Institute of Museum Services became a reality in 1977.

The patrician Pell, born in 1918 to an old New York family and an alumnus of St. George's School and of Princeton, was elected Democratic senator from Rhode Island in 1960. By virtue of his chairmanship of the Senate Subcommittee on Education, Arts and Humanities, he has been integrally involved in all legislation dealing with the arts. Livingston Biddle, while serving on Pell's staff, was responsible for the final wording of the legislation creating the two federal endowments—indeed, it was Biddle who conjured up the neutral term "endowment" as an alternative to the word "foundation." Through the years Pell has come to look upon the endowments with the watchful but loving eye of a parent, and this special relationship was tangibly confirmed with the appointment in 1977 of his former

Friends on the Hill: Congressman John Brademas and Senator
Claiborne Pell (right), champions of the museum

aide, Biddle, as the third chairman of the National Endowment for
the Arts.

Brademas, born in 1927 in Mishawaka, Indiana, of Greek de-
scent, a scholarship student at Harvard (on whose board of over-
seers he was later to serve) and a Rhodes Scholar at Oxford, has
represented South Bend as a Democratic congressman since 1959.
Once designated as the "brightest" member of Congress by *New
Times* magazine, Brademas has made education, libraries, and muse-
ums a special area of concern. At the same time he has moved up
the leadership ladder in the House of Representatives and was elected
Democratic whip in 1977. Working closely with Pell, Brademas suc-
cessfully fought for the creation of a new federal entity—the Institute
of Museum Services.

The idea of a museum institute was first proposed by Brademas in
a speech to the 1969 annual meeting of the American Association of
Museums. Citing the financial distress of leading museums, he called
for a new approach, involving direct federal assistance for operating
costs. Both Pell and Brademas were deeply troubled by what they
perceived as doctrinal resistance on the part of the two endowments
to providing maintenance support.

At a joint Senate-House hearing on endowment appropriations
in 1975, Brademas pressed Nancy Hanks on the question of whether
there were legislative obstacles to assisting arts institutions to pay their
light bills. Under interrogation, Miss Hanks conceded that the NEA's
preference for project assistance stemmed from guidelines approved
by its governing council, not from legislation. She acknowledged that
the laws gave the NEA greater flexibility, prompting Brademas to
remark:

It seems to me that that is an important point. . . . For example, in the field of museums, I saw in the paper this morning that Mayor Beame has had to impose a very substantial cutback in funds on cultural institutions in New York City, including museums. . . . I would therefore suggest, Miss Hanks, that it would be very useful if your council would address itself to this whole basic policy question.[24]

In order to mobilize support for his proposal for a Museum Services Institute, Brademas conducted hearings in a dozen museums around the country. He told visitors that he was troubled to find some museum witnesses afraid to speak their minds because of possible reprisals when their institutions filed grant applications with the national endowments; following subcommittee hearings in Dallas, several witnesses informed Brademas that they had been advised by Arts Endowment officials not to endorse a Museum Services Act.

But NEA disapproval did not intimidate other museum spokesmen, an eminent instance being C. Douglas Dillon, president of the Metropolitan Museum, former board chairman of the Rockefeller Foundation, ambassador to France under President Eisenhower, and secretary of the treasury under President Kennedy. At a 1975 hearing conducted in the American Museum of Natural History in New York, Dillon forthrightly stated the case for aggrieved museums:

> Federal funds have not hitherto been available to museums for operating support. While my understanding is that the national endowments could make such grants if they so desired, they have not done so to date. This contrasts sharply with the situation in Canada and most European countries where the central governments provide all or a major part of the needed operating support. . . .
>
> I am not suggesting a major change in the financing of museums— only that federal funds be made available to cover some ten percent of operating costs, with private sources and local and state governments carrying the other ninety percent of the burden.
>
> The question now arises: why a new institute? Why not simply appropriate more funds to the National endowments? It is clear that the endowments could find good uses for more funds, but the record indicates that simply providing more funds would not do the job. Unfortunately, there seems to be an overpowering temptation among those responsible for making grants in support of the arts to spread their largess as widely as possible. Encouraging the birth of new programs and new projects is apparently much more attractive to grant makers than providing basic operating support to existing institutions. . . .
>
> I have come to this conclusion reluctantly, because I would much prefer not to create new mechanisms or establish new bureaucracies, no matter how small. But my experience to date, both as a former foundation chairman and most recently with the New York State

Council on the Arts, has led me inexorably to this conclusion. There-
fore I wholeheartedly support the Museum Services Act with the one
proviso that I have no preference as to the location of the new institute
in the federal hierarchy.[25]

An opposing view was ardently expressed to the author by John
Hightower in 1975. Describing the Pell-Brademas proposal as "ter-
rible," Hightower pleaded, "The only way the arts can make a case
for themselves is collectively, not with the performing arts set against
museums. Next year, the symphony orchestras will be lining up at
Brademas's door. . . . He should take a stronger position and not
sell out to the most glamorous bidder."

But given the fact that two leading members of Congress, both of
them strategically placed on important committees, had an abiding
interest in museums, it would be asking a good deal of human nature
for museum trustees not to rejoice in their good fortune. Since legis-
lators tend to defer to one another on specialized proposals bearing
the names of influential sponsors, it was clearly only a matter of time
before the Museum Services Act was passed into law. Indeed, in
October 1976 President Ford signed the bill establishing the In-
stitute of Museum Services.

The question of where to locate the new institute was a topic of
considerable earnest deliberation. Senator Pell favored placing the
institute alongside the two national endowments as an equal partner
in an arts structure independent of other federal departments;
Brademas, however, had doubts whether science and natural history
museums would be given equal consideration in an institute coupled
with the Arts and Humanities Endowments, and successfully urged
that the institute become a new agency within the Department of
Health, Education, and Welfare. As he saw it, the main justification
for treating museums as a special case was that unlike other arts
organizations, they had a manifest educational purpose.

From a political point of view, the stress on the educational role
of museums had obvious appeal. The conviction that the federal gov-
ernment had a duty to encourage education was widely and deeply
held, and on it the new institute could rest unimpeachably. Experience
instructed that once the institute was founded, its growth would be
swift. The initial funding in 1977–78 was $4,011,000, well below
the $15,000,000 that had been authorized for it, but with administra-
tion support, the institute was voted $7,700,000 for 1978–79. In
light of the expansion of the two endowments from similarly modest
beginnings, it would not be astonishing if the Institute of Museum

Services reached the $50,000,000 funding level within a few years.

The expectation of growth was implicit in a vital bureaucratic mandate specifying that the institute director be an Executive Level V, meaning someone holding the same rank as the chairmen of the two endowments. In 1977 the Carter White House approved a suggestion by Brademas and appointed as director forty-four-year-old Lee Kimche, who had served for five years as assistant director for special projects at the American Association of Museums and who since 1974 had been executive director of the Association of Science-Technology Centers in Washington, D.C.

Following the pattern of the two endowments and of the National Science Foundation, a fifteen-member National Museum Services Board, headed by Senator Pell's good friend George C. Seybolt, former president of the Boston Museum of Fine Arts, was appointed by the President to set institute policies. Board members include Mrs. Joan Mondale, wife of the Vice President, C. Douglas Dillon, and, ex officio, the chairmen of the two endowments, the commissioner of the Office of Education, the director of the National Science Foundation, and the secretary of the Smithsonian Institution.

The first task that befell the new institute was deciding how to spend its limited funds. After intense deliberation, the institute's board and director prepared guidelines requiring that at least 75 percent of the grants be allocated expressly for general operating support of museums; the remaining money was earmarked for special programs, including conservation, staff development, and technical assistance.

For the purposes of the institute, a "museum" is defined as "a public or private nonprofit agency which is organized on a permanent basis for essentially educational or aesthetic purposes, and which, using a professional staff, owns or uses tangible objects, whether animate or inanimate; cares for these objects; and exhibits them to the public on a regular basis." But after spirited discussion, the board decided not to require that benefiting institutions be professionally accredited or publish independently audited budgets since smaller institutions would be put at a disadvantage by such conditions.

These definitions constitute a pioneering attempt to define a national policy for assisting museums. If there is a solid case to be made for limited federal support of basic museum operating expenses, any such program also implies a public right to insist on improved standards. A new era has begun for American museums—a fact now visible in the laws of the land.

III

NEW YORK, NEW YORK

The commonest mistake of Europeans who talk about America is to assume that the political vices of New York are found everywhere. The next most common mistake is to suppose they are found nowhere else.

—JAMES BRYCE, *The American Commonwealth*

HOVINGISM

IT IS NO SMALL DISTINCTION THAT THE TWO AMERICANS WHO HAVE earned world renown through their association with museums are P. T. Barnum and Thomas P. F. Hoving. Working in the museum profession is a difficult way to become a household name. In most large cities, for every 100 people who can identify the conductor of the local symphony, there are probably only 1 or 2 who can come up with the name of the leading local museum director. Even in New York, where the museum world has long been the object of the public's rapt attention, the average citizen is not likely to be able to name any director in the history of the Metropolitan. Aside from Thomas Pearsall Field Hoving, that is.

That Hoving escaped the traditional anonymity of a genteel calling

is not his only achievement. Like Barnum, and for some of the same reasons, he is associated in the public mind with a distinctive approach to museum operations—with priorities given to splashy shows, head-line-catching acquisitions, and continuous capital expansion. He is further celebrated for his appetite for controversy and his seignorial attitude to local government. Indeed, the term "Hovingism" can be given to an identifiable set of policies, some of which are directly traceable to the urban political strategy of another larger-than-life New Yorker, Robert Moses.

Hoving's reputation is unlike Barnum's in one conspicuous respect. The proprietor of the American Museum on Broadway, the impresario who brought Jenny Lind to the United States, was affectionately esteemed for his showmanship. With Hoving, on the other hand, there is an aroma of sulfur. Admiration for his considerable virtues is splotched by acrimony and clouded with a suspicion of bad faith. When in July 1977 Hoving left the Metropolitan after a decade as director, he went unmourned.

As we have seen, S. Dillon Ripley, secretary of the Smithsonian Institution and Hoving's only rival as a museum expansionist, has been severely criticized. Yet no one has written a novel about the Smithsonian, in which Ripley appears, in the flimsiest of disguises, as a rapacious, crafty, and cynical empire builder, as Hoving does in Barbara Goldsmith's *roman à clef The Straw Man*. There is as well *New York Times* reporter John Hess's *The Grand Acquisitors*, in which Hoving is characterized as a compulsive liar and likened to a Watergate cover-up artist.

Yet for all the venom Hoving's style invited, his accomplishments are impressive. Over the decades the museum had repeatedly an-nounced expansion plans, but each time its proposals had sunk in the quicksands of city government. Under Hoving, the Metropolitan was able to secure approval for a prodigious master plan involving five new wings and the expansion of the museum's gallery space by a full third. Moreover, by staging an unceasing charivari of special events, by 1972 it had become New York's premier tourist attraction and could claim substantially increased revenues from its operations, through admission and membership fees and sales in ever-expanding museum shops. Hoving brought treasures of incontestable quality to the Metropolitan—paintings such as *Juan de Pareja*, antiquities such as the Euphronios krater, and entire troves of art such as the Lehman collection—and crowds packed the galleries to see them.

Why, then, were so many so ungrateful to him? The question was

addressed in 1975 in *Newsweek* by one of Hoving's public relations aides, Richard Dougherty:

> Find a civic-minded headline in a New York newspaper and I'll show you Spiro Agnew as a rewrite man. At the Metropolitan Museum of Art, where I work, a new wing that houses the famed Robert Lehman Collection has opened. Any other city would be overwhelmed to have this new museum within a museum. The media in any other city would be singing the praises of the Metropolitan's trustees for having so splendidly enriched the cultural life of the community. Not so in New York journalism where nitpicking is perhaps the finest of arts.[1]

In fact, before Hoving, the Metropolitan basked in an indulgent press and was seldom the target of nattering nabobs of negativism. Under Hoving, the museum began actively to court media attention, sometimes verging on hyperbole. When it paid a record $1,000,000 for the Euphronios vase in 1972, Hoving asserted in an article in *The New York Times Magazine* that art history would now have to be entirely rewritten. In an institution whose *raison d'être* is a finely calibrated discrimination, a note of hysterical oversell came to prevail. If the press became leery of the Metropolitan's own assessment of its achievements, the museum could be held partly to blame.

There were as well more fundamental questions about Hoving's *modus operandi*. As director he did not trouble to conceal his contempt for such lofty notions as participatory democracy, and he systematically scorned pleas for debate, delay, and deliberation. In both his sense of mission and his tactics, he was very much like his avowed political mentor, Robert Moses.

For more than four decades, without ever holding elective office, Robert Moses ruled in New York like a potentate. He spent an estimated $27 billion on public works: highways, bridges, parks, tunnels, beaches, playgrounds, dams, public buildings, and public housing. He was in large part responsible for the construction of Lincoln Center, the United Nations, Co-op City, and the Coliseum. His most impregnable power base was the Triborough Bridge and Tunnel Authority, where he reigned as chief executive from 1933 to 1968. He had helped draft the legislation that created the authority and that at the same time ensured its existence in perpetuity by empowering it to issue new bonds. The never-ending stream of bridge and tunnel tolls gave Moses control over a bond-issuing agency with exiguous accountability; during his tenure the authority, although a public agency, was as autonomous as the privately governed Metropolitan Museum.

Moses despised small gestures and the small vision that bred them

("If your head is wax, don't walk in the sun," was one of his favorite adages). A man with a passion for the grandiose, he was also fascinated by museums. As New York City commissioner of parks from 1934 to 1960 he was "landlord" of a dozen city-assisted museums and zoos, on all of whose boards he served as an ex officio trustee. It was he who cleared the way for construction of The Cloisters, the Metropolitan's medieval outpost in Fort Tryon Park, but when it pleased him to do so, he also could foil the best-laid museum plans (partly because he disliked its design, he blocked a proposal to locate Frank Lloyd Wright's monumental Guggenheim Museum in Central Park).

His own long and rich experience in serving on museum boards persuaded him that they were antediluvian. He wrote in a 1941 memorandum to Mayor Fiorello La Guardia: "The board of a museum is not a House of Lords nor yet an exclusive social club. The present incumbents must let down the bars gradually. There must be less emphasis on wealth, old family, and big game hunting, and more on representing great masses of people potentially interested in the museums and their works." [2]

He later enlarged on the theme in *The New York Times*:

> Let me begin with our wealthiest and most powerful institution. The Metropolitan Museum of Art is still a club—exclusive, dignified, public-spirited, traditional, not fully aware of the significance of modern trends, relatively unimpressed by public opinion, removed from local pride and pressure. . . . This club does not have a single woman trustee, and when I called attention to this gap, I was politely informed that it could not elect one until it could elect two, because one would be lonesome, and it was also hinted that the jolly, informal stag atmosphere would never be the same, etc. [3]

On the Metropolitan board, Moses declined to play the passive role of the usual ex officio trustee; he demanded, and was given, a seat on the all-important executive committee. He knew from the inside that since all the board normally does is ratify decisions made in committee, public representation—if it were to be more than nominal—had to extend to the executive committee. It was by virtue of his strategic seat on this committee that Moses, almost single-handedly, was able to check the Metropolitan's expansion plans in the 1940s, which he objected to because they would have encroached on his turf, the sacrosanct Central Park.

Moses questioned as well the propriety of the museum's seeking to meet its capital expenses through city funds. In all, he had no intention of deferring to the museum board. He remarked years later, "The

arrogance and conceit of those people were phenomenal. They really felt they were the lords of creation, and that nobody had the right even to question what they did." [4]

Clearly, if the Metropolitan were to proceed with its long-postponed program of expansion, it would need as its chief someone as stubborn, political, and self-assured as Robert Moses himself. In 1966, the museum found its man in an admiring disciple of Moses's—Thomas Hoving, who was at the time serving in Moses's old job as commissioner of parks.

If Moses is a corsair, Hoving is, as columnist Murray Kempton once described him, a condottiere. Intense, lean, restless, and grimly humorless on any matter touching upon his prerogatives, Hoving looks and acts like a character in the memoirs of Cellini. Yet he has succeeded to a remarkable degree in combining an apparent commitment to art with a ruthlessness not traditionally associated with the museum world.

Combativeness seems to have been bred into him. His father, Walter Hoving, a Swedish immigrant, has been the chairman of Bonwit Teller and is now the very feisty chairman of Tiffany's. By common account, Thomas Hoving has had to struggle for the approval of a father coolly unimpressed by anything his son has ever done. A good, if pugnacious, student, Hoving was expelled from Phillips Exeter for striking a teacher and entered the Princeton Class of 1953 by way of Hotchkiss School. After graduating from college *summa cum laude*, he served in the Marines for three years and then returned to Princeton to study art history. His specialty was medieval art; his dissertation topic, a study of Carolingian ivories.

At a symposium on art history held in 1959 at the Frick Collection in New York, Hoving, with his jaunty self-confidence, made a favorable impression on James J. Rorimer, director of the Metropolitan. Not long afterward Rorimer recruited him as an assistant curator, and in time Hoving became his protégé, succeeding to Rorimer's former position as chief curator of The Cloisters. It was there that he first made a name for himself by persuading a doubting acquisitions committee to pay a reported $600,000 for a medieval ivory he was convinced was the Bury St. Edmunds Cross. The purchase was page-one news, and although scholars have questioned its attribution, it advanced the career of the young curator.

Hoving's political apprenticeship began in 1965, when his friend John V. Lindsay, the Liberal Republican congressman from Manhattan's "Silk-Stocking" district, against all odds won the race for

mayor. Hoving had prepared a campaign paper for Lindsay advocating a populist approach to park policy, and the mayor-elect invited him to oversee the program as commissioner of parks. The results were inspiriting; perhaps more than any other official, Hoving epitomized the breezy freshness of the early Lindsay years. He closed Central Park on weekends to automobiles and opened it to cyclists. He staged "happenings" that delighted the media and filled the park with exuberant crowds. And in the process he acquired invaluable experience in detecting the vital ganglia in the city politic.

Hoving had been serving as parks commissioner barely a year when Rorimer died at the age of sixty of a heart attack. At thirty-six, Hoving was considered too young for the august directorship, but he did have the inside advantage of being an ex officio member of the Metropolitan board. The trustees were eager not to lose any time in carrying out the expansion plan, and presently Hoving, with his unique blend of museum and political expertise, emerged as the leading candidate for executing the grand design. In December 1966 Arthur A. Houghton, Jr., museum president, announced that Hoving had been appointed the Metropolitan's seventh director.

His successor as parks commissioner was August Heckscher, director of the Twentieth Century Fund and adviser on the arts in the Kennedy administration. Heckscher well remembers the startling advice he received from Hoving: "Never forget that as parks commissioner you have a weapon possessed by very few people—something which Bobby Kennedy doesn't have, which Cardinal Spellman doesn't have— you have *eight hundred trucks!*" [5] Hoving later told journalist Barbara Goldsmith, who would make out of him the flamboyant Urban Museum of Art director Bartholomew Hayes in her scathing novel, that a public official's most powerful weapon is the *fait accompli* ("You can't sit in front of a bulldozer for very long. I mean, that's kind of silly").[6]

Robert Moses, recalling in 1970 Metropolitan directors he had known, said of Hoving:

> He learned all about parks in one year, which is quite a feat. He is strong for charisma. In any event, he has élan, taste, boldness, all directed to turning his museum from a highly respectable tomb into a live center and nationwide stimulant of broad culture. He is at the same time as intolerant, as contemptuous of previous city administrations, and as convinced of higher, if not divine, inspiration as most of the recent reformers. The Metropolitan under his dynamic direction is becoming one of the performing arts, and in most circles, including

some critical of the theatrical means he employs, his adventures are greeted with interest and usually with enthusiasm.[7]

Acknowledging Moses as "my teacher in all these things," Hoving told the author in 1975, "I see him very often, and I talked to him at great length before I took this job. Yes, there are definite parallels between us. But it is a mistake to compare what I've done with his accomplishments. Moses has made fundamental, massive, ameliorative changes—and no one will remember, or care, after five years what a museum director has done." [8]

Perhaps not surprisingly, Hoving and Moses admire the same characters in history. Asked which historical figure he identifies with most closely, Hoving named Baron Georges-Eugène Haussmann, Napoleon III's prefect of the Seine who, as the shaper of the *grands boulevards* and axial avenues, the Bois de Boulogne, the Luxembourg Palace gardens, and the site for the Opéra, transformed Paris. It is clear from the following descriptions that Moses has given of the baron that he, too, identifies with him to some extent:

> Baron Haussmann has been described as a "talker, an ogre for work despotic, insolvent, full of initiative and daring, and caring not a straw for legality." Everything about him was on a grand scale, both good qualities and faults. His dictatorial talents enabled him to accomplish a vast amount of work in an incredibly short time, but they also made him many enemies, for he was in the habit of riding rough-shod over all opposition.[9]

Lewis Mumford, writing in *The City in History*, characterizes the baron somewhat differently—as an archetypal planner, a regimenter of human functions and urban space, a man who really knew what was in the public interest, even though the common citizen might not concur in his concept or even understand it. Blessed with superior insight, the baron did not tolerate debate; in pressing forward in his grandiose schemes, he exemplified the precept of Benjamin Jowett to the ambitious young: "Never apologize, never explain."

But Haussmann was fortunate in having as his patron an authoritarian emperor. In a democratic society, anyone who aspires to emulate a Haussmann must contend with the frustrating machinery of elective officialdom. The rise of Robert Moses, and his reign as public works suzerain for more than four decades, cannot be explained without taking account of his ability to ally himself with such potent constituents as contractors, labor unions, insurance underwriters, planning officials, and automobile manufacturers. By the same token

Hoving's emergence—and his ability, like Moses, to ignore outcries of protest—spring from the museum's tacit alliance with a vibrant new constituency: the producers, sellers, and consumers of art. By the 1970s New York City had become a global force in making reputations, and prices, in the visual arts.

THE CAPITAL OF ART

A century ago New York was a city of infant museums, provincial ateliers, struggling art dealers, and unadventurous collectors. Today it is the "world" capital of art. Four museums of international renown —the Metropolitan, the Modern, the Whitney, and the Guggenheim— provide showcases for the newest kinds of art. An entire school of contemporary art takes its name from the city, and the masters of this school are as much imitated as were those of the School of Paris by American painters before World War II. But the word "capital" is appropriate in the other sense also: More money is spent on art in New York than in any other city except London—and London's period of primacy may be ending.

New York's importance as an art center was foreshadowed as far back as 1846, when Michael Knoedler, newly arrived from Paris, became one of the first European art dealers to establish a New York branch. At the turn of the century all major international dealers were represented in the city: Duveen, Wildenstein, Durand-Ruel, Colnaghi, Seligman. "As the first decade of the century drew to a close, Americans had become, as a group, the most important of my father's clients," writes Germain Seligman of his father, Jacques, the founder of the family firm.[10]

The more recent growth of art galleries has been astonishing. In 1927, when the New York Telephone Company published its first classified directory, the list of all art galleries in the city amounted to only 9½ inches. By 1955 the list took up 78½ inches, and by 1975 there were some 700 entries, taking up 134½ inches. By the late 1960s, according to John Russell Taylor and Brian Brooke's *The Art Dealers*, there were about 400 private galleries in New York, compared to 300 in Paris and 150 in London. How many of these are "serious" galleries is difficult to say since antique and curio shops figure in the listings. An enterprising Princeton undergraduate, Steven W. Naifeh, using listings in art journals to determine the number of "serious" dealers, arrived at a tentative figure of 73 in 1945, 97 in 1950, 123 in 1955, 154 in 1960, 246 in 1965, and 287 in 1970.

After 1970, Naifeh discovered, there was a burst of expansion as entire streets in the downtown SoHo district blossomed with new galleries.

The total private sales of art in New York can only be estimated. In 1976 the Committee of Galleries and Dealers in Support of New York City, tallying the responses of fifty-nine galleries to a confidential questionnaire, came up with a projected total of $300,000,000 in annual sales. (But since neither the committee nor the galleries had any incentive to understate sales, the figure must be used with caution.)

Auctions, on the other hand, are public events, so that the rise of New York as a major salesroom to the world can be fully documented. In 1964 Parke-Bernet, the leading auction gallery in New York, was taken over by Sotheby's of London. At the time, Parke-Bernet trailed Sotheby's and Christie's in net sales, but once under an aggressive British management, it began a steady climb, overtaking the London galleries for the first time in 1975–76, with total sales of $70,000,000 as compared to the previous season's $51,000,000. (Sotheby's three galleries in London accounted in 1975–76 for $65,-300,000, and Christie's for $66,200,000.)

The next year Parke-Bernet was back in third place, with total sales of $72,100,000, compared with $98,900,000 for Sotheby's London galleries and $82,400,000 for Christie's. And yet, at an art market conference in 1977, Peter Wilson, chairman of Sotheby Parke Bernet, predicted that "New York, if it hasn't already, will become the center for the traffic in fine art." The same year Christie's opened two galleries in Manhattan.

No less striking than the growth of New York as a speculative center for art purchases has been its emergence as a center for the avant-garde. The reputations—and the biggest sales—in contemporary art were made there during the 1970s.

Before World War I the market interest in contemporay art was all but nonexistent in New York. Among those who tried to awaken the curiosity of collectors in the avant-garde was pioneer photographer Alfred Stieglitz, who in 1908 opened the Photo-Secession Gallery at 291 Fifth Avenue. The response was negligible, and in 1911 the comparative handful of nonacademic American artists banded together to found the Association of American Painters and Sculptors.

Almost at once the new association voted to organize the International Exhibition of Modern Art, better known as the Armory Show, in order to call attention to unorthodox schools of art. In 1912 paint-

The Metropolitan Duumvirate: Director Thomas Hoving and President C. Douglas Dillon, divulging the museum's purchase of *Juan de Pareja*, still the most costly painting sold at public auction (knocked down for $5,554,000 at Christie's in London, in November, 1970)

ers Arthur B. Davies and Walt Kuhn toured Europe to gather the best examples of the most radical modernist works. They examined with mounting excitement the then little-known paintings of Van Gogh, Cézanne, Picasso, Gauguin, Matisse, Léger, Kandinsky, Braque, Rouault, Munch, Dufy, and Derain. In France they met Marcel Duchamp and obtained for the Armory Show its most notorious canvas, his *Nude Descending a Staircase*. By the end of their hegira Davies and Kuhn had assembled the first large assortment of works by the masters of European modernism to be shown in America.

In February 1913, when the show opened in the armory of the 69th Regiment of the New York National Guard, rented for $5,000 a month, there were some 1,300 paintings and sculptures on display. A full third of the art was European; its very novelty provoked controversy and even outrage—resulting, of course, in high attendance. The financial returns were modest: Duchamp's *Nude* was sold for a mere $324, Picasso oils for between $486 and $1,350, a Braque for $202.50. The highest price—$6,700—was paid by the Metropolitan for a Cézanne, the first bought by an American museum.

The Armory Show has been accurately described by Lloyd Goodrich, former director of the Whitney Museum of American Art, as the "opening gun in the long, bitter struggle for modern art in this

country." [11] As it happens, the Whitney, more than any other American museum, illustrates the apotheosis of modernism and its subsequent acceptance by society.

The Whitney Museum grew out of the informal exhibitions that Gertrude Vanderbilt Whitney sponsored in her Greenwich Village studio, starting in 1907. A sculptor as well as a patron of the arts, Mrs. Whitney gradually enlarged the display area to the point where she could hold annual shows. What was a Studio Club in her own home evolved into a museum in 1930, located on West Eighth Street in Greenwich Village and staffed initially by artists. After Mrs. Whitney's death in 1942, the trustees voted to move the museum to a building adjoining the Museum of Modern Art on West Fifty-third Street. But even the new space proved inadequate for the fast-growing collection, and in 1970 the Whitney moved again, this time to an imposing fortresslike structure that museum president David M. Solinger had boldly commissioned from Marcel Breuer and Hamilton Smith, in the heart of the Upper East Side gallery district on Madison Avenue. Bohemia had moved uptown—in more ways than one.

The assimilation of the avant-garde by a consumer economy found its most fitting ceremonial confirmation in the *vernissage* of "New York Painting and Sculpture: 1940 to 1970," marking the centennial of the Metropolitan Museum of Art on October 18, 1969. If the Armory Show had been organized by a comparative handful of artists who saw themselves as outsiders, "New York Painting and Sculpture" was by contrast organized by one curator, an enthusiastic and accomplished "insider" at the most distinguished American art museum. The curator was Henry Geldzahler, chairman of the Metropolitan's department of twentieth-century art and, since 1978, New York City commissioner of cultural affairs; so distinctive was his mark that in short order the exhibition became known as "Henry's show" (for this reason, it was belittled by critics who disagreed with his highly personal choices).

Whatever the aesthetic disputes over "Henry's show," its impact was palpable. Something of the mood of the occasion, a convergence of once-alien worlds, was caught by Calvin Tomkins in a *New Yorker* profile of Geldzahler:

> The stately, black-tie world of the Metropolitan trustees found itself mingling with tribal swingers dressed as American Indians, frontiersmen, Cossacks, Restoration rakes, gypsies, houris, and creatures of purest fantasy. The see-through blouse achieved its apotheosis that

night, and spectators lined up three-deep to observe the action on the dance floor—there was a rock band in one gallery and a dance orchestra in another, to say nothing of six strategically placed bars. Works of sculpture acquired festoons of empty plastic glasses, the reek of marijuana hung heavy in the air, and at one point late in the evening, while the rock group blasted away in a room full of Frank Stella's paintings and David Smith's sculptures, a tall woman and a lame sculptor wrestled for fifteen minutes on the parquet floor, untroubled by guards, spectators, or a century of Metropolitan decorum. Exhilaration was everywhere, compounded of pride, chauvinism, and sheer visual delight. The New York School had wrested the mantle of artistic supremacy from Paris (as one was forever being reminded).[12]

But there was an underside to the occasion. If New York was the new global atelier, it was also bound to attract speculators in art. Unlike at the Armory Show, there were no bargains available at "New York Painting and Sculpture." The very fact that Geldzahler had chosen an object for display doubtless added greatly to its value. For example, one of the sculptures in the show was *Becca* by David Smith, who had died in 1965; it had previously been offered for sale at $100,000, according to Clement Greenberg, executor of the Smith estate, but within a few years after the Metropolitan opening, it was appraised at $250,000—which is what the Metropolitan itself paid for it in an elaborate exchange with Marlborough Galleries involving six deaccessioned works from the museum's collection.

The relationship between market prices and museum display is a topic of considerable debate. Certainly no one can say that Geldzahler alone was responsible for *Becca*'s jump in value. But it was clear that the innocent era of the Armory Show, when masterpieces could be obtained for a few hundred dollars each, had vanished and that the cosier world of Mrs. Vanderbilt's salon had been supplanted by a glittering scene mingling consumerism, creativity, and media chic. Against this background, the dynamism of the Metropolitan under Hoving can be better understood.

THREE DIRECTORS

At its upper reaches the museum profession is a dangerous calling. The post of director has ceased to be a sinecure; the turnover is brisk, and "resignations" are usually of a nonvoluntary nature. The pressures are so intense that insomnia, alcoholism, nervous breakdowns, and even premature death must be counted among the professional haz-

ards. These strains arise in part from the irreconcilable demands placed upon the director, who is expected to be high-minded, political-minded, and market-minded—all at the same time. He is supposed to "educate" a large public without in any way sacrificing scholarly standards and to cater to the interests of the average taxpayer, the art market, and the wealthy donor.

"If the term 'museum' strikes terror to the heart of the average layman," Francis Henry Taylor, the Metropolitan's fifth director, sardonically observed in his monograph *Babel's Tower*, "it is as nothing compared with the sense of panic which its sound produces in the poor innocents who spend their lives rationalizing its very existence.

> Going back into the far reaches of time, the word *museum* has succeeded in meaning nothing vital to anyone in particular, yet at the same time it has strangely meant all things to all men. Through a metamorphosis lasting many centuries, it has emerged from the simple designation of a temple of the Muses to be the encompassing catch-basin for all those disparate elements of hereditary culture that are not yet woven into the general fabric of education in modern society. And since education has been defined as "the art of casting artificial pearls before real swine," it is only natural that museum workers have concerned themselves with the elaborate furnishing of the trough at the expense of the digestive capacity of the feeders.[13]

Taylor ran the Metropolitan from 1940 until 1954 when, baffled and disheartened, he resigned to take up his earlier post as director of the small Worcester (Massachusetts) Art Museum. Three years later, at the age of fifty-four, he died unexpectedly after a minor operation. His successor at the Metropolitan was James J. Rorimer, a man as reticent as Taylor was effervescent, who served until 1966, when he died in his sleep at the age of sixty. Thomas Hoving's reign lasted a decade, until 1977, when he resigned during a furor brought on by his own policies.

Each of these three directors attempted a different resolution of essentially the same problems; insofar as policy goes, they can be seen as personifying the protean nature of the museum.

In 1940, when Francis Henry Taylor took charge, the Metropolitan was somnolent; even its trustees—an all-male board of aging magnates, holding, among them, 120 corporate directorships—felt the need for fresh air. The outgoing director, Herbert E. Winlock, was an Egyptologist, and an arid, tomblike calm pervaded the mostly untrodden galleries.

Taylor, born in Philadelphia and privately educated in Europe, was in his thirties at the time of his appointment to the Metropolitan.

Francis Henry Taylor,
Metropolitan director
from 1940 to 1954,
reformer and educator

During his nine years at Worcester he captured national attention with his experimental shows, one of which had featured industrial machinery and another of which, "Ways of Seeing," had been installed by the famed Broadway stage designer Lee Simonson. At Worcester, Taylor began a program of regional art education, in collaboration with New England secondary schools, and pupil visits multiplied tenfold. Taylor was a true museum reformer, scorning the "Babylonian pleasures of aestheticism," which he felt too many museums were unduly stressing.

Of all the museum directors Robert Moses knew, Taylor was the most impressive—"a companionable man of deep learning and remarkable wit who did not suffer fools gladly and who resented stupid, pompous, and condescending patrons. His waspish asides, *bon mots*, and piquant personalizations traveled widely on the wings of gossip and finally reached highly placed and influential victims who could not forget and forgive." [14]

At the beginning of his tenure as Metropolitan director, Taylor coauthored *The Museum as a Social Instrument*, which dealt arrestingly with a range of museum problems. Taylor saw the essential purpose of the Metropolitan as educational, and he was frankly indifferent to collection growth. In this, he was very like John Cotton Dana, of whom he wrote: "He loved people, wanted to help them, and was willing to sacrifice the overhallowed prestige of scholarship and to

slow down the rate of growth of museum collections if that would benefit the public as a whole. He was an American rather than a pseudo-European." [15]

In the same study, Taylor realistically discussed the problems involved in measuring museum performance:

> Until recently the one criterion of their usefulness to which museums have always returned has been the number of people who were clocked in the doors. The reverence which attendance statistics have received and the manner in which they have been tossed glibly around as evidence of the glorious ways in which the museum has opened its arms to one and all is exceedingly misleading. Actually such statistics answer one very minor question and that one only. All they do is tell the number of bodies which have passed through a turnstile or flitted across the vision of a guard with a gadget in the palm of his hand. As to the really vital questions of "Who is he?" "Where is he from?" "Why did he come?" "Has he been here before?", and, most important of all, "What did he get out of his visit?", they offer no answer.[16]

At the Metropolitan, Taylor established a junior museum, launched educational programs, and put an end to the seventy-year policy of charging for admission two days a week. Under his leadership, and despite the fact that his taste did not run to nonobjective works, the Metropolitan for the first time paid attention to contemporary art. During World War II, when much of the museum collection was stored in a mansion called Whitemarsh Hall outside Philadelphia as an air-raid precaution, he filled the galleries with unconventional art, including cartoons and advertisements. Once the war was over, he organized trailblazing international loan shows from museums in France, Germany, England, and Austria. By 1950, in part as a result of these shows, annual museum attendance had passed the 2,000,000 mark. Taylor also oversaw the complete renovation of the major galleries, at a cost of $9,600,000, and the opening of a new restaurant, complete with pool and fountains.

However, as far as acquisitions were concerned, Taylor was a languid competitor, caring little for sensational prizes. In 1947, overcoming the misgivings of the boards of trustees of three museums, he negotiated what came to be known as the Three Museums Agreement, a bold attempt to subordinate intermuseum competition, wherein the Metropolitan, the Museum of Modern Art, and the Whitney Museum of American Art were each assigned a primary collecting field, with the provision for an exchange of art among them. But owing largely to trustee competitiveness, the agreement proved unworkable.

Despite his successes at the Metropolitan, Taylor was fundamen-

tally dissatisfied. Not long before his resignation, he remarked to a colleague, "Dammit, we've got them into the museum, but what do they look at? One thing after another—if they come to a firehose, they look at that too." [17]

Taylor's successor, James J. Rorimer, had spent his entire professional life at the Metropolitan. Trained at Harvard under Paul J. Sachs, he had come to the attention of the museum world in 1933 as the Metropolitan curator who had persuaded John D. Rockefeller, Jr., to underwrite the construction of The Cloisters. As its first director he wrote The Cloisters collection guide that has sold more than 100,000 copies since it was first published in 1938—making it the best-selling of all the museum's many publications.

Expressing the consensus, Robert Moses described Rorimer as a "quiet, dignified, highly respected director." [18] Unlike Taylor, Rorimer was a tireless acquisitor, fascinated by the art market. In 1961 he persuaded the museum trustees to authorize the winning bid of $2,-300,000 for Rembrandt's *Aristotle Contemplating the Bust of Homer*, at that time the highest price ever paid for a work of art offered at auction.

When the Rembrandt was put on exhibition, the popular response was overwhelming; Metropolitan attendance that year was 1,000,000 higher than it had been the year before, with most of the increase coming during the two months that *Aristotle* was on view. This experience was to have a profound influence on Metropolitan acquisition policy since it confirmed the attendance and publicity potential of a sensational new acquisition. Not only did such purchases yield a benefit in the press and at the turnstile, but they encouraged the notion that great art possessed the peculiar eloquence of a seven-figure price tag, a point the humblest museum visitor could grasp.

The lesson was not lost on Rorimer's protégé and successor, Thomas Pearsall Field Hoving. In a world very different from what it had been in Taylor's heyday in the 1940s, Hoving sought to supply a new resolution of museum dilemmas, blending the traditions of Taylor and Rorimer.

Hoving's influence on exhibition policy was immediately apparent. Stuart Silver, chief designer and director of installations, who had been with the Metropolitan since 1962, recalled that "under Rorimer, the exhibition schedule was nothing compared to what it has been since 1968. The tempo was easygoing, and this job was really a sinecure. With Hoving, we had an explosion. He insisted on scheduling

James J. Rorimer, Metropolitan director from 1954 to 1966, scholar and steward

© KARSH, OTTAWA

"In the Presence of Kings" within ten weeks. That set the tone: a frantic pace, short lead-time, rather extensive outlays." [19] By 1972 Silver's department was handling sixty exhibitions a year, three times the annual total during the Rorimer era. "In the Presence of Kings" was a foretaste of other Hoving shows: It displayed works associated with royalty, drawn from the museum's collection, and mounted with spotlights, graphics, and a startling juxtaposition of objects.

At the same time, in his public utterances, Hoving was at pains to underline the museum's affinity with the radicalism of the times. He liked to quote Francis Henry Taylor's definition of the museum as a "midwife of democracy," and in an interview with Grace Glueck of *The New York Times* cultural staff, he sounded all the fashionable notes: "The social order is in flux, and we must be relevant to it. The question is not *whether*, but exactly *how* we're going to get into the swim. The alternative is the possibility of being pushed in." [20]

Four months after he assumed command, Hoving held a press conference in Harlem to announce plans for a show celebrating Harlem's contribution to the life of the city. "At no time in the country's history," he said, with an earnestness suitable to the occasion, "has there been a more urgent need for a creative confrontation between the black and white communities. . . . It's one thing to drop renewal into Harlem, but let's not renew the heart out of Harlem before we look at what is there." [21] As he later disclosed, the idea had come to him during a discussion with Allon Schoener, former assistant director

of the Jewish Museum and later visual arts director at the New York State Council on the Arts. Hoving was so enthusiastic about the show that he stressed it in his first interview with the Metropolitan board when it was deliberating on Rorimer's successor.

In 1966, Schoener had mounted a very popular show on the Lower East Side ghetto at the Jewish Museum, and it was his—and Hoving's—intention that the Harlem exhibition should enjoy the same kind of success. Different problems were raised, however, by "Harlem on My Mind"; for one thing, the curator of the show was a defensive white liberal, and for another, there was no success story to be celebrated here. Then there was the embarrassing fact that the Metropolitan had never before shown any serious interest in American blacks; there were no blacks on the board, no black departmental heads. The museum's motives were no doubt lofty, but an air of paternalistic condescension was evident nonetheless.

In the event, "Harlem on My Mind" was to be remembered for the ineptness of its catalogue, which aroused the very acrimony the show was meant to inter. Edited by Schoener, the 256-page catalogue opened with a piece by Hoving recalling his Park Avenue childhood and lamenting that he had had little genuine contact with the blacks of Harlem:

> Any suggestion that we meet as equals and just talk just couldn't come up. To me *Harlem on My Mind* is a discussion. It is a confrontation. It is education. It is a dialogue. And today we better have these things. Today there is a growing gap between people, and particularly between black people and white people. There is little communication. *Harlem on My Mind* will change that.[22]

Unfortunately, in the haste to push the catalogue through the presses, Hoving completely missed the incendiary implications of its four-page introduction, written by a sixteen-year-old Harlem schoolgirl, Candice Van Ellison. Schoener had thought it appropriate that the catalogue feature an essay written as an assignment in a Harlem schoolroom. The essay, as finally published, included this passage: "One other important fact worth noting [about relations between Jews and blacks] is that, psychologically, blacks may find that anti-Jewish sentiments place them, for once, within a majority. Thus, our contempt for the Jew makes us feel more completely American in sharing a national prejudice." [23] This was a paraphrase of a passage in *Beyond the Melting Pot* by Daniel P. Moynihan and Nathan Glazer. In her original essay, Miss Van Ellison had quoted directly, but at Schoener's suggestion, she had eliminated the quota-

tion marks and had put the thought in her own words.

The catalogue appeared at a time when relations between Jews and blacks were worsening in the wake of a months-long teachers' strike. Faced with a storm of protest, the Metropolitan at first apologized for the catalogue and later withdrew it. By this time the museum was encircled by pickets, black and white, and there were calls for Hoving's immediate resignation.

Doubts also were voiced about the propriety of mounting the Harlem show in an art museum since its content was sociological and its mixed-media presentation (film strips, tape recordings, and wall-sized documentary photographs) essentially theatrical. Hoving defended the show as a wholly legitimate art museum function ("I'd do it again today," he remarked in 1976), but significantly, there were no similar exhibitions during the rest of his tenure.

Hoving's radical phase was short-lived. One of his first major appointments had been that of Harry Parker III as director of a greatly expanded educational program reaching out to the culturally deprived. But when Parker subsequently resigned to become director of the Dallas Museum of Fine Arts, his post at the Metropolitan was quietly abolished. The entire education program was then put in the charge of Philippe de Montebello, who in 1973 became vice-director for curatorial and educational affairs and who was in 1978 to be named Hoving's successor. De Montebello described the museum's educational policy in the 1975 annual report:

> In practical terms, the ongoing relationship between educators and curators is closest perhaps in the area of exhibitions, where the "educational" components of exhibitions are being devised by the educators in close cooperation with the curators. These interpretative elements are now fully integrated into the exhibition. The goal, of course, is to aid the viewer to place the work of art in its broadest context at the same time he is looking at it from a purely aesthetic point of view.[24]

In other words, the museum fulfills its educational mission by seeing to it that its special exhibitions are well attended, an objective that was crucial to other museum interests.

By getting more and more people to visit the Metropolitan, Hoving was also able to improve the museum's economic position. In 1965–66 two sources of revenue accounted for the major portion of museum income: Interest and dividends earned on endowment contributed $4,101,000, or 67 percent, and the city contributed $1,528,000, or 25 percent. The Metropolitan was then essentially a self-contained operation, without charging admission.

By contrast, in 1975–76, $16,334,000, or 59 percent of total revenues, was realized from museum operations: admissions charges, membership dues, shop sales, royalties and fees, restaurant and parking charges. Only $2,678,000, or 10 percent, was contributed by the city, and only $5,725,000, or 20.6 percent, came from endowment income.

These figures were cited in a letter to *The New York Times* in August 1977 from Roland L. Redmond, an emeritus trustee who from 1947 to 1964 had served as the Metropolitan's president. In Redmond's view, the museum had become hostage to its commercial enterprises, especially to its shop sales, and was in danger of becoming a merchandising operation, whose executive officer was going to have to be more of a store manager than an art historian.

Replying for the Metropolitan was Richard Dougherty, vice-director for public affairs, who asked, "Would Mr. Redmond have preferred a course that would have brought increased dependence on endowment income in a declining stock market, or on the city in its current financial plight, or would he perhaps have wished us to cut public hours at the museum to one or two days a week?" [25]

The exchange touches the very heart of a policy in which financial considerations can become paramount. The dilemma posed by the Metropolitan is that its performance is measured not just by box-office returns and by the prosperity of its commercial operations. It is a repository of values as well as of objects, and there is a point at which the museum, like any other nonprofit institution, will decisively compromise its character by succumbing to the siren appeal of commercialism. Without question, hard-pressed public libraries could improve their financial position by charging admission and rental fees for books, but such a policy is nearly unthinkable.

Dougherty's argument implies that the only alternative to the Metropolitan's current policies would be drastically to reduce museum services. The more complicated truth is that the Metropolitan during Hoving's reign deliberately initiated some very costly ventures —new buildings, exhibition programs, and acquisitions—that have forced it to search far, wide, and desperately for new sources of revenue.

BUILD NOW, ARGUE LATER

On the anniversary of its centennial in 1970, the Metropolitan announced its long-delayed expansion plan. Controversial and highly ambitious, involving five new wings, major alterations in existing

buildings, and the addition of 325,000 square feet of space, the plans would cost around $75,000,000 by the time they were fully executed. The City of New York was being asked to contribute $5,000,000 in capital expenses and to increase its annual maintenance costs by $860,000. The Metropolitan for its part stated that the master plan was final and inviolable and that no additional funding would ever be asked of the city.

The initial public reaction was favorable, if mixed, but there were questions that remained to be answered: Should the City of New York commit so much money to a single institution in a single borough? Had the possibilities of decentralizing museum operations been adequately considered? Would the new plans encroach on Central Park? Which city agency should be given the right of final review?

Hoving's strategy for obtaining approval of the plan was to avoid a general review by any city agency with the power to veto it. In fact, the master plan had not even been debated in its entirety by the museum board of trustees; it had been presented piecemeal, with a slide-show demonstration of each of its elements by architects Kevin Roche and John Dinkeloo.

The following were the major additions envisioned, not including parking facilities, renovations, and other capital expenditures:

1. The Lehman Pavilion, a 25,000-square-foot glass-roofed pyramid, was to be built on the western side of the museum. Funds for construction, estimated at $8,100,000, were to be raised privately (the actual cost was $7,300,000); annual maintenance funds were to be supplied by the Lehman Foundation, donors of the collection. (The pavilion opened in 1975.)

2. The Dendur or Sackler wing, an 80,000-square-foot glass-fronted enclosure for an Egyptian temple of the Ptolemaic period that had been presented to the United States by Egypt in gratitude for a $16,000,000 contribution, in blocked counterpart funds, to the UNESCO Nubian rescue campaign. Of the $9,000,000 the wing would cost, $1,400,000 was to be paid by the City of New York. Annual maintenance would be approximately $70,000.

3. The Michael C. Rockefeller wing, a 90,000-square-foot structure in the museum's southwest corner, would house 7,500 ethnographic works donated by Nelson A. Rockefeller. The estimated $11,700,000 cost of the wing would be met privately. Annual maintenance, to be met by the City of New York, would come to approximately $240,000. (The high maintenance cost was due to the large number of galleries requiring guards.)

The Megamuseum. A model of the original Metropolitan Museum expansion plan, as unveiled in 1970.

4. The American Bicentennial wing, a four-story, 130,000-square-foot glass-roofed structure, would be built on the south end of the building. Twenty-five period rooms were proposed, one of them to house the whole interior of a Frank Lloyd Wright prairie house. The cost of construction was estimated at $12,000,000, with an additional $3,000,000 for the installation of period rooms. The City of New York was to contribute $3,000,000 at the outset and meet annual maintenance expenses of approximately $250,000.

5. The 100,000-square-foot Western European Arts wing was to adjoin the Rockefeller wing. Its total cost was projected at $15,000,-000, with the annual maintenance, to be paid by the city, estimated at $300,000. (The project was later deferred until money could be found.)

Priority in construction was given to the Lehman Pavilion, which, from the taxpayer vantage, was the best bargain, since both its construction and its maintenance were to be privately underwritten. Within the museum world, serious misgivings arose regarding the terms the museum had agreed to: It had promised to house the Lehman collection in a separate wing bearing the donor's name and to display it in an environment resembling the old Lehman town house at 7 West Fifty-fourth Street. Over the years the Metropolitan's board had evolved a policy of rejecting such binding donor requests, and it was justifiably feared that in acceding to the Lehman terms, the museum would encourage other wealthy collectors to be as demand-

ing. Hoving rejoined that the quality of the collection justified any concessions the museum had had to make.

The Lehman Pavilion became the focus for the only major legal challenge of the Metropolitan master plan. In January 1971 the Municipal Art Society of New York sought to enjoin construction on the grounds that there had been no public review by the city's Board of Estimate. Along with other park and preservationist groups, the society was concerned with the steady shrinkage of grass in Central Park; from 1900 to 1966 the space devoted to walks and roads had increased from 39 to 101 acres, while open meadow space had shrunk from 55 to 16 acres.

The Municipal Art Society's case was undercut when the Parks Department endorsed the Metropolitan's plan. At one point the department's attorney, John J. Loflin, was asked by the presiding magistrate, Saul S. Streit, "Why do you want to bypass the Board of Estimate?" Loflin replied, "You will open up all this dissent in what I believe would be a harmful political atmosphere, where the donor's wishes might very well become frustrated." [26] The lawyer then produced a letter to Mayor Lindsay from C. Douglas Dillon, informing him that the Metropolitan was giving the Lehman Pavilion to the City of New York as a gift (under a 1963 charter revision, any gifts accepted by the city were exempted from scrutiny of the Board of Estimate).

Loflin remarked, "Whether that was a good idea or a bad idea is really not for us. But it was done; it was knowingly done . . . and under those circumstances, the mayor has acquired the power, including, among other things, the power to accept gifts that formally resided in the Board of Estimate." [27] For its part, the museum knew exactly what it was doing: Exercising its influence with the mayor, it had forced the city to waive the right of a Board of Estimate review.

The judge's ruling, upheld on appeal, served to spare the Lehman Pavilion from critical examination by a city board with plenary authority, on which all the borough presidents—with access to engineering expertise—were represented. The Metropolitan had the full support of the Parks Department, thanks partly to Hoving's friendship with August Heckscher, his successor as commissioner of parks. But Heckscher, despite his sympathy for the Metropolitan's master plan, felt that it required the approval of his own Parks, Recreation, and Cultural Affairs Administration. He was piqued to hear the museum argue that even the Parks Department had no review powers in that the Lehman Pavilion was to be built with private funds on lands

deeded to the museum in 1878 by the city. The museum's case was argued by Herbert Brownell, one of Mayor Lindsay's earliest political mentors and former United States attorney general, and was upheld in an informal ruling by the city's corporation counsel.

At this point Heckscher insisted on a full-scale hearing of the entire master plan. He wrote to Mayor Lindsay: "Tom Hoving has rather grudgingly acceded to this position. This means that the whole plan will be made public and subject to discussion. I am convinced that the museum . . . will be able to make a clear case for a program which will greatly increase its value and will involve building mostly over existing parking spaces." [28]

A hearing was held in the auditorium of the American Museum of Natural History. As expected, parks and conservation organizations raised objections to the master plan; also as expected, a procession of leading architects endorsed the plan, and a slide presentation was then quickly made by Kevin Roche. Minutes before the meeting ended, Hoving announced that he had just received a communication from the trustees of the Lehman Foundation threatening that "unless we build the Lehman Wing as planned they will offer the collection to a museum in another city." [29] When Lehman trustees were subsequently questioned by reporters, they said that they could not recall issuing such an ultimatum.

In the end the master plan was approved by the City of New York less through deliberation and debate than through default. A privately controlled institution had committed a financially hard-pressed city to support in perpetuity a plan that would make the Metropolitan as large as the Louvre. Heckscher had made his approval conditional on the museum's being more responsive to all the boroughs of New York. Thus five seats on the Metropolitan board were assigned to ensure borough-wide representation. Arnold P. Johnson, a Harlem civic leader, became the first black trustee; other appointments included Muriel Rosoff Silberstein, a Staten Island educator; Henry Saltzman, former president of the Pratt Institute in Brooklyn; Sol Shaviro, a founder of the Bronx Museum of Arts; and Judge Frank D. O'Connor of Queens. But this democratic leavening did not extend initially to appointing borough members to either the executive or the finance committee, where museum policy is fundamentally shaped (with the exception of Arnold Johnson, who was later named to the executive committee, and Sol Shaviro, who was assigned to the finance committee).

In the debates over the master plan, as in so much that happened

during the Hoving era, questions of means and ends became inextricably entwined. The physical growth of the museum may well have been desirable, but the administration's spend-now, debate-later approach was controversial.

So, too, was the Metropolitan's dazzling succession of blockbuster shows.

The Metropolitan became in effect a foreign office of the arts. Building on the tradition begun by Francis Henry Taylor, Hoving negotiated major loan shows with France, Russia, Italy, Mexico, Ireland, Japan, Israel, Egypt, Spain, Australia, Bulgaria, East Germany, and other countries. (Communist China would also have been on the list, except that the National Gallery of Art, one of whose ex officio trustees was Secretary of State Henry Kissinger, obtained exhibition rights for the Chinese archaeological show, which Hoving had been the first to propose.)

Under Hoving, the treasures of world art flowed to the Metropolitan: frescoes, tapestries, Scythian gold, Olmec heads, illuminated manuscripts, Russian folk costumes, prizes from the Prado, and masterpieces from Dresden. Many of these shows went on national tour.

But the ends were marred by what curators felt were often slapdash means. A common complaint was that Hoving, in his zeal to arrange exchanges and loans, was needlessly compromising scholarly standards. Internal dissent finally became public in 1975, when the late Anthony M. Clark resigned as chairman of the department of European paintings. Both Clark and his vice-chairman, John Walsh, having opposed the shipment to the Soviet Union of highly vulnerable wood-panel paintings, were relieved to read in *The New York Times* the following statement by Hoving about his negotiations with Soviet officials: "For that matter, they wanted some of our early Renaissance wood-panel paintings, which we couldn't send because they're too fragile." [30] Later the two curators learned to their astonishment that five panel paintings were at that very moment en route to Russia. This, they felt, constituted a breach of faith. Hoving maintained to the author that it had never been a question of all or no wood panels, "merely a question of which panels could be safely sent—besides, they're now back, and there was not one tiny problem." [31]

A similar dispute arose over another loan show, sponsored jointly in this country by the Metropolitan and the Detroit Institute of Arts, "French Painting 1774–1830: The Age of Revolution," which had been organized by the Louvre. One of the scholars who had helped

in its preparation was art historian Robert Rosenblum of New York University. At the last moment, arguing that financial considerations made the step he was taking paramount, Hoving reduced the number of works in the Louvre show from 206 to 150 and thereby saved the museum $150,000. Rosenblum retorted, "The reasons are nominally financial, but in fact, I suspect that the Metropolitan, as usual, is afraid that the exhibition will be too adventurous in terms of fresh scholarship and unfamiliar pictures to provide the predictable box-office response of an Impressionist anthology." [32] This view was echoed by the Detroit cosponsors of the show and also by Clark and Walsh, who resigned from the Metropolitan within a few weeks of each other.

In an unusual gesture for the museum world, Clark took his case to *The New York Times*, wherein he accused the Metropolitan of having allowed its relation to art to become "incidental, wrong, and even risky." [33] In his letter of resignation, a copy of which he gave to the author a few months before his death, Clark complained:

> I see constantly that the works of art of the permanent collection—your [Hoving's] primary duty and basic responsibility—are in neglect or at risk. Might not your frantic loans and exhibitions, the constant overreacting and overactivity of your regime, its hucksterism and poor reputation, explain this jeopardy? The "deaccessioning" program and the scrappily-organized construction campaign are typical programs of yours: they could have been handled with honesty and simplicity, with professional grace and skill, but weren't.[34]

Clark's misgivings were shared, if not so vehemently expressed, by many of his former colleagues at the Metropolitan. The department of European paintings had been a source of continuing trouble for Hoving, partly because it was involved in so many major loan shows. Other departments, such as Islamic art, were relatively tranquil. A new permanent gallery of Islamic art, installed by Richard Ettinghausen, the department's consultative chairman, who liked and respected Hoving, proved to be both a popular and a critical success—in fact, one of the triumphs of the Hoving era.

The blockbuster shows were a vital integument of Hovingism. Not only did they attract hordes of paying visitors, but they also were easy to have underwritten by corporations, foundations, or arts councils. The museum's 1975 annual report listed the following as patrons of special exhibitions:

"Romantic and Glamorous Hollywood Design—SCM Corporation;

"The Impressionist Epoch"—National Endowment for the Humanities, New York State Council on the Arts;

"Momoyama: Japanese Art in the Age of Grandeur"—Japan Air Lines, the J.D.R. 3rd Fund, Inc., National Endowment for the Humanities, Coca-Cola Company, U.S.A.;

"Paintings by Francis Bacon"—the Treadwell Corporation;

"The Passover Story"—Israel Discount Bank Ltd., N.Y., OSG Bulk Ships, Inc.;

"From the Lands of the Scythians"—National Endowment for the Humanities, Mr. and Mrs. Charles B. Wrightsman, Mrs. Helen W. Buckner;

"French Painting 1774–1830: The Age of Revolution"—N.Y. State Council on the Arts.

Such shows were, in short, substantially self-supporting. Like other Metropolitan ventures, they served to generate revenue from visitors. Francis Henry Taylor had abolished admission charges at the museum, and this policy continued until 1971, when visitors were asked to contribute something (initially, $1 was suggested, but the sum was raised to $1.75 in 1975 and still later to $2). As the museum's dependence on visitor revenue increased, so did the need for headline-catching attractions, such as spectacular acquisitions.

In both talent and temperament, Hoving was a collection builder. "I began as a collector," he has said, "and my instincts are still there. When I see something I want, I do everything I can to get it. I've bought $300,000,000 worth of stuff since I've been here, and I've never made a mistake. What other museum, what other city in the world, has gotten these things?" [35]

Hoving's motivating impulse was to upgrade the collection—to winnow out inferior works and use the revenues from sales to acquire masterpieces. The list of masterpieces he succeeded in acquiring is imposing: Velazquez's *Juan de Pareja* for $5,544,000, still the highest price ever paid for any work sold at public auction; Monet's *Terrasse at Sainte Adresse* for $1,411,200, the highest price paid for an Impressionist painting; the Euphronios kalyx krater for $1,000,000, the highest price ever paid for Greek painted ware; and the entire Packard collection of 412 Japanese works for $5,100,000.

Each purchase became front-page news and resulted in ever-higher attendance figures. But each contributed also to the general financial burden on the museum—a burden which the Metropolitan was able to relieve only by selling items from its permanent collection or by borrowing heavily against purchase endowments. To finance the acquisition of the Greek krater, for instance, the museum sold a collec-

tion of more than 6,000 ancient coins, which had been on extended loan at the American Numismatic Society, for $2,120,000 at a Zurich auction. This dispersal of a public collection was the target of bitter criticism by scholars. But far more impassioned was the controversy engendered by the sale and exchange of works from the museum's Adelaide Milton De Groot bequest, chiefly in order to recoup monies spent on the Velazquez.

A nonagenarian who died in 1967, Miss De Groot had stipulated in her will that the Metropolitan donate to other museums any works in her bequest that it did not wish to keep. But the terms of her will were not binding, and there followed a wholesale dispersal of her bequest, in which works by Rousseau, Bonnard, Modigliani, Beckmann, Léger, Dufy, Degas, Picasso, Renoir, Toulouse-Lautrec, Redon, and Gris were offered for sale or exchange. At no point did the Metropolitan volunteer any information about the "deaccessioning."

When the first reports of the sales reached the public—in the form of a sulfurous article by John Canaday, then chief art critic of *The New York Times*—Hoving denounced them as "99 per cent inaccurate." But little by little, it was revealed that the Metropolitan had indeed sold a number of treasures (from 1971 to 1973 alone, it sold or exchanged $4,500,000 worth of art); since all these works had been donated for public purposes, the public, in theory, was entitled to know about the transactions.

It was further reported that in the sale of Rousseau's *Tropics*, the Metropolitan board had broken with museum practice by overruling the objections of the departmental curator, Everett Fahy. The museum's position looked even worse when it was discovered that Marlborough Galleries, which had paid the museum $1,450,000 for both *Tropics* and Van Gogh's *Olive Pickers*, subsequently sold the Rousseau alone for $2,000,000 to a Japanese collector.

As a result of these news stories, the attorney general of New York State ordered an official inquiry to determine whether the museum had deliberately ignored donor wishes. Under pressure to make a full public accounting of past sales, the Metropolitan for the first time disclosed its transactions and agreed reluctantly to establish new procedures for deaccessioning. Satisfied, the attorney general absolved the museum of intent to violate the law. Hoving thus survived a scandal that would surely have toppled any other museum director; that he was able to do so was in good part attributable to his skill in managing the board and in retaining the support of its president, C. Douglas Dillon.

THE ANNENBERG FINALE

Throughout the Hoving decade at the Metropolitan, the most persistent criticisms were directed at the way the museum appeared to be engineering consent. Reasonable people could argue about the desirability of so many blockbuster shows or about the nature of the capital expansion program. What turned people into impassioned adversaries of the museum's policies was their belief that not only the City of New York but even the Metropolitan's board of trustees were being presented with a series of *faits accomplis* with a minimal opportunity for informed discussion. It was this concern that lay at the heart of the climactic controversy of the Hoving era, the dispute over the proposed Walter H. Annenberg Visual Arts Communications Center.

In an era of disclosure and "sunshine" laws, the Metropolitan board has been able to preserve an almost preternatural degree of secrecy. Neither its meetings nor its minutes are open to public scrutiny, despite the museum's heavy dependence on public money. Despite a token leavening of ex officio public representation—the mayor, comptroller, president of the City Council, commissioner of parks and commissioner of cultural affairs—the museum is effectively managed by thirty-five private trustees, and by a minority of them at that.

Only once in memory, in the case of the Annenberg Center, has an internal argument become a matter of detailed public knowledge, and this was as a result of the disclosure to the press of board documents bearing on matters of broad public concern. This breach of tradition was so contrary to museum custom that in 1978 the board issued a handbook for new members codifying the behavior expected of trustees. Titled *Information for Trustees*, the fifty-page booklet includes this pointed admonition:

> In the course of his or her duties, a Trustee may come into possession of information of which the Museum may be unaware and which may materially affect some aspect of the Museum's operations and activities. As a fiduciary, it behooves each Trustee to carefully evaluate such information and bring it to the attention of the Board or the appropriate officer at the proper time. Trustees should be careful, however, not to misuse confidential Museum information obtained in their official capacity and should refrain from dissemination of such information if such disclosure is not in the best interest of the Museum. Constructive criticism, made through the proper channels, is always welcome.[36]

Elsewhere, the handbook proffers this carefully phrased advice:

> As a general rule, when the Museum or its actions become the subject of public questioning in the press, individual Trustees may wish

to handle press queries by referring reporters to the Vice President for Public Affairs. This is deemed appropriate since individual Trustees cannot be expected to be aware of all developments in an institution as large and complex as the Museum.

It may be conjectured that the Annenberg controversy would have taken a far different form if these prescriptions had been literally heeded. That members of the board felt strongly enough to brave disapproval from their fellows was a clear indication of the seriousness of the issues raised by the Annenberg proposal.

Perhaps even more than trustees at other large museums, trustees at the Metropolitan have been carefully chosen for their ability to serve, and accommodate to, the interests of the museum. By tradition, board members have tended to be persons of wealth and lineage, most of them from the same social milieu. (The composition of museum boards is discussed in detail in Chapter VII.) During the Hoving era the Metropolitan board was invariably content to defer to the judgment of Douglas Dillon, who in 1970 succeeded Arthur A. Houghton, Jr., the chairman of Corning Glass, as president.

To his position as Metropolitan chief, Dillon was able to bring his skills as an investment banker (Blyth Eastman Dillon); as a major appointee in the Eisenhower and Kennedy administrations (ambassador to France and secretary of the treasury); as a collector of Impressionist art; and as a widely respected power in the worlds of philanthropy, society, and high officialdom. His manner, in contrast with Hoving's, is emollient. As museum president he took care to be briefed almost daily in his office at the Metropolitan or in his corporate suite in the nearby General Motors building on Fifth Avenue (the museum is the dominant landmark visible from his windows overlooking Central Park).

Without Dillon's steadfast support, Hoving would have had a precarious grip on the directorship. Time and again the president came to the aid of his besieged director and adroitly quelled criticism both from within and from without. It was a measure of the board's confidence in its president that the museum bylaws were rewritten to give Dillon and key committees greater authority. As of 1971, for example, it was no longer necessary for the executive committee to assemble in order to vote; the president was authorized to poll its members by telephone, thereby speeding decisions. Under Dillon, the bimonthly board meetings moved with clockwork precision to ratify decisions of key committees.

In 1974 the board elected to membership the prominent publisher

Walter H. Annenberg, who had just completed an eight-year term as United States ambassador to the Court of St. James's. As president of Triangle Publications, Inc., a media empire encompassing *TV Guide*, *Daily Racing Form*, and *Seventeen*, Annenberg had a net worth estimated at well over $200,000,000. He is an art collector, who, with his wife, Leonore (a niece of the Hollywood mogul Harry Cohn and a former wife of distiller Lewis S. Rosenstiel), has gathered Impressionist works of sufficient quality to warrant an exhibition at London's Tate Gallery. During his years as publisher of the *Philadelphia Inquirer* (which he sold in 1969 to Knight Newspapers) Annenberg campaigned, among other things, for the opening of the legendary Barnes Collection to the public. A conservative Republican, he was a Nixon supporter to the bitter end, and shortly after Nixon's resignation the Annenbergs invited the Nixons to "Sunnylands," their Palm Springs desert estate.

A generous philanthropist, Annenberg is also the founder of the Annenberg School of Communications, operated under a joint trusteeship at the University of Pennsylvania and the University of Southern California.

Within a year of his election to the Metropolitan board, Annenberg was sought out by Hoving as potential donor of a new museum orientation center to be designed by the celebrated Charles Eames. Annenberg was shown a film presentation and was favorably disposed, but he countered with a far more ambitious notion—the creation of an entire communications center at the Metropolitan, which could be yet another unit in his School of Communications. Here the new technology of television could be used to exploit the resources of the Metropolitan and to disseminate to a huge audience the message of great art. Annenberg had in mind such programs as Kenneth Clark's *Civilisation*, which he had greatly admired.

Hoving wrote to Annenberg on March 16, 1976:

> The vision that you expressed to me about the visual arts communication center would be a capstone [of the museum's education program] and would truly carry the Museum not only into the Twentieth Century but beyond as well. I find the prospect exceedingly invigorating. But one must approach the project with prudence and with an attitude that I can only describe as one that is lean, mean, practical and realistic from the planning stage to the possible execution of the plans. Economy of means is the password. Less is more. Common sense is the bottom line.[37]

From Hoving's vantage, the proposed center seemed to be a solu-

tion to a number of problems, his own included. The Metropolitan had been unable to raise the money required for the proposed Western European Arts wing; with location of the center there, construction plans could be modified to incorporate gallery space as well. Hoving, who had no written contract at the time, was nearing the end of his first decade as director, and Dillon was already telling visitors in 1976 that Hoving would be moving on in a year or so. Annenberg wanted Hoving to assume the position of founding director of the new center, which could mean a further decade's employment in a post of considerable influence. Hoving wrote to Dillon, on October 20, 1976:

> The Fine Arts Center will be a financially independent, semi-autonomous entity housed in an appropriate portion of the proposed new South-West Wing [as the Western European Arts wing was now being called] of the Metropolitan, utilizing all the most contemporary technetronic mechanisms to produce—over an initial ten-year period, renewable upon mutual accord—a distinguished series of educational materials for all levels of interest ranging from the general public through graduate students in the fine arts.[38]

In sonorous language, Hoving outlined the revenue-producing potential of television sales and spin-offs of books and art reproductions, all of which he felt would be within the chartered purpose of the museum (the letter is excerpted in Appendix C).

Meanwhile, the Metropolitan board as a whole was receiving only hints of what was afoot. Board members leaving for their summer holidays did receive minutes of an executive committee meeting on June 22, 1976, in which the Annenberg project was briefly described, along with a matter-of-fact resolution authorizing the museum to accept $160,000 from an Annenberg foundation for preliminary architectural designs and technical studies (with the proviso that in the event the board did not approve the project, the Annenberg foundation would be reimbursed by the museum).

The Annenberg proposal was not on the agenda at the regular bimonthly meeting of trustees in September; not until the following session, on November 6, was it formally presented to the full board—and by this time $160,000 had been committed to architectural designs, and other negotiations were well advanced. At this meeting a packet of documents was distributed to each trustee, and there was a slide presentation narrated by Hoving, who was at his most fluent. Yet, although the trustees were impressed, customary unanimity gave way to dissent. Peter H. B. Frelinghuysen, a trustee

since 1968 and a Republican congressman from New Jersey, both spoke and voted against the proposal. More extraordinary still, a city representative courted disapproval by venturing to ask a question.

The questioner was Charlotte Devree, who was sitting in for City Council President Paul O'Dwyer, an ex officio trustee. Most public trustees are too busy to attend Metropolitan board meetings and invariably send aides to take notes. Known in board parlance as city representatives, these aides are invariably mute during meetings. But Mrs. Devree had a background in the arts; she had once worked at the Metropolitan as a press aide under Francis Henry Taylor and she was the widow of Howard Devree, John Canaday's predecessor as chief art critic of *The New York Times*. Through the intercession of a friend, O'Dwyer had met Mrs. Devree and had asked her to serve as his representative on the board; though he had not known her well before, the City Council president was impressed with her credentials and agreed to the idea.

Mrs. Devree is mild-mannered, conscientious, and devoted to the Metropolitan. Over a period of three years she had remained silent at board meetings. This time, though she was dazzled by Hoving's presentation, she was troubled by a fiscal point: would the new center, she wanted to know, pay rent to the city since it would occupy space in a city-owned building? She recalls the glaring faces of both Dillon and Hoving who informed her that the center would be as rent-free as the birds and trees in Central Park.

After the meeting, Mrs. Devree studied the documents, and became increasingly concerned with the implications of the center, which was to operate under its own board (half the members to be chosen by the museum, the other half by Annenberg interests) and which could all too easily become a state-within-a-state. Her apprehensions were shared by Roland L. Redmond, an emeritus trustee and past president (1947–64) of the museum. A Wall Street lawyer who commutes from his home in Tivoli, New York, Redmond, with his formal courtliness, is a survivor of the world preserved in the novels of Edith Wharton. He had for years been a tireless, if always discreet, critic of museum policies under Hoving, which he compared unfavorably to those under Taylor and Rorimer.

Redmond prepared what was in effect an extended brief, amassing all possible arguments against the Annenberg center and, by extension, the Hoving-era policies. He feared the commercialization of the museum and questioned whether television was a fit tool for art education: "Whether we like it or not, television has certain limitations. . . .

A picture, no matter how accurate it may be, is only one aspect of a work of art. Any change in the angle from which an object is viewed or in its lighting, will affect the impression which it makes on a beholder." [39] (The Redmond letter, dated February 3, 1977, is also excerpted in Appendix C.)

Chance then entered in. The writer Barbara Goldsmith had just been asked to contribute an article on art to *New York*, which had been taken over only shortly before by Rupert Murdoch, the Australian media magnate. She proposed writing about the Annenberg center and got in touch with Charlotte Devree. After agonized consideration of all the issues involved, Mrs. Devree decided to provide Goldsmith with key board documents and the Redmond letter. Only later, and fearfully, did Mrs. Devree explain to Paul O'Dwyer what she had done, and why. The City Council president, who shared her concerns about the center, approved her decision.

The article, titled "The Annenberg Affair: Mystery at the Met," appeared in the March 7, 1977, issue of *New York* and carried this quotation from O'Dwyer: "The museum's furtive use of city land totally violates the land-use regulations in the new city charter. It offends the new sunshine laws and the old conflict-of-interest concepts. I intend to pursue this matter." [40]

Goldsmith's report, buttressed with quotations and statistics from private documents, provoked a furor and led to two official inquiries. The New York State Attorney General's Office, concerned about the conflict-of-interest implications in Hoving's negotiations with Annenberg, sent an assistant attorney general to the Metropolitan for the relevant files. At the same time members of the City Council and Manhattan Borough President Percy Sutton questioned whether the new center—by modifying the museum's "inviolable" expansion proposals—ran afoul of subsequent land-use ordinances. Within a week of the article's appearance, Sutton ordered a public hearing before the Manhattan Borough Board.

The hearing, on March 14, proved to be an emotional occasion, in which opponents and partisans of the museum were crowded into a small hospital auditorium and in which angry exchanges proved to be the rule. All the public grievances against the museum, consequential or petty, real or imagined, were given vent; and indeed, the fact that an art museum could stir up such passion was the most telling measure of the dangerous gap that had widened between the Metropolitan and the citizens it was supposed to serve. In essence, museum spokesmen asked for a vote of confidence on an admittedly complex

proposal that would have involved the Metropolitan's sharing management power with a school of communications founded by a strong-willed, thin-skinned centimillionaire.

Proof of Annenberg's low tolerance for criticism became dramatically apparent at the hearing. In his defense of the projected center, Hoving spoke derisively of those who would reject a gift of as much as $40,000,000 because of nit-picking over terms. As a closing flourish, Hoving read from an open letter to the people of New York City that Annenberg was publishing in the following day's *New York Times*. In the absence of "overwhelming approval" for the new wing, Annenberg declared, "I will drop the project in relation to the Metropolitan Museum of Art but shall certainly continue it at some other institution." [41]

This time the donor threat was not a bluff; twenty-four hours after the letter was published, Annenberg withdrew his offer, and with that decision the Hoving era was effectively over. Personal considerations may have affected Annenberg; he and his family were deeply affronted by a Pete Hamill column in the New York *Daily News* that dwelled on the gangland links of his father, who in 1939 had been indicted by a federal grand jury on charges of evading $3,258,809 in income taxes. (Walter Annenberg, then thirty-one, was also indicted, but all charges against him were subsequently dropped; his father was given a three-year prison sentence, despite pleas of ill health, and died in 1942, a month after his release on parole.) The prospect of further hostile comment about a past the family wishes to live down may well have been a decisive element in Annenberg's abrupt withdrawal of his offer.

There was no question of who the biggest loser was. The plans for the center involved an extension of Thomas Hoving's tenure at the Metropolitan. As of the time of his resignation, in July 1977, the director was out of office, and so he has remained.

If there was a lesson in the Annenberg affair, it was surely that the museum, though privately governed, is in truth a public institution whose purposes and plans are imperiled when it appears to forfeit public trust. But in the immediate aftermath of the Annenberg controversy it cannot be said that the Metropolitan board took this lesson to heart. In what can only be interpreted as a reprisal against O'Dwyer and Redmond, as of September 1977, city representatives and emeritus trustees were barred from attending executive sessions of the board's bimonthly meeting.

⚛ IV ⚛

GALLERY WITHOUT WALLS

For which of you, intending to build
a tower, sitteth not down first, and
counteth the cost, whether he have
sufficient to finish it?

—Luke 14:28

ART AND MORTAR

OUR BUILDINGS ARE A FORM OF SOCIAL AUTOBIOGRAPHY; IT IS
through bricks and mortar that we keep the most visible record of
our aspirations. Both the style and the sheer number of American
art museums bear witness to changing national values. The public
gallery in its initial form a century ago was invariably a pastiche
of a European original, conveying the aura of instant venerability.
But with the dedication of the arrestingly unconventional Museum of
Modern Art building in 1939, the United States ceased looking to
Europe and the past for inspiration. In fact, nowadays, new museums
abroad are more often than not pastiches of American originals.

Considering the scale of construction and the boldness of design
in most American art museums, it is surprising that so little has been
written about them. No book has been published on museum archi-

tecture, and articles of any substance on the subject could be listed on a page. Nor is there anywhere a list of new public galleries and visual arts centers, how much they cost, who designed them, how big they are, and when they were completed. In order to establish these primary facts, a questionnaire was sent to more than 150 institutions; the response reveals that since 1950 approximately $561,700,000 has been invested in art museums and art centers with an aggregate size of 10.2 million square feet—or the equivalent of 13.6 Louvres. (The list appears as Appendix A.)

In order to appreciate the magnitude of this national commitment to the visual arts, a historical comparison is pertinent. Laurence Vail Coleman, in his pioneering three-volume study *The Museum in America* (1939), calculated that the total expenditures involved in all science, history, and art museums as of 1938 was $18,000,000. With due allowance for both dollar depreciation and increase in construction costs, it can be asserted that since 1950 the United States has allocated more money for buildings for the visual arts than in the preceding 150 years and that in doing so, it has probably outspent the rest of the world combined. Given the persistent foreign stereotype of the United States as a society devoted to crass business values, this is an improbable phenomenon—especially since it is businessmen who have predominated on art museum boards.

Early in the century discerning European visitors were struck by the same paradox. Among them was the French art dealer René Gimpel, who, on an extended tour of the United States in 1923, was everywhere surprised and impressed by the Augustan splendor of the many new art museums. He was particularly struck by the Toledo Museum of Art, which had been munificently endowed by the glass manufacturer Edward Drummond Libbey. Gimpel was a brother-in-law of the legendary Joseph Duveen, but he was as wary of superlatives as Duveen was addicted to them; nevertheless, he wrote glowingly in his diary of the dedication to art of Mr. and Mrs. George Stevens, the director and assistant director of the Toledo gallery: "Mr. and Mrs. Stevens, who are only moderately well off, are devoting their lives to the museum. He gave up a fine situation for this post, which has obliged them to live, if not drably, at least quite unpretentiously. This devotion to the cause of art is found throughout the United States, and gives an idea of the fervor that convulsed the Middle Ages, when its churches were erected."[1]

Thirty-two years later, another French visitor to America, André Malraux, was asked if he agreed with Rebecca West that America's

cathedrals were her railway stations. "No," he responded, "her cathedrals are her museums." [2]

But the achievement is not only quantitative; beginning with the Museum of Modern Art (MOMA), the first art gallery of world importance to be designed in a wholly contemporary style, American museums have immeasurably encouraged the acceptance of architecture relying on new technology and exploiting the potential of new materials. To an extent seldom appreciated, the urban landscape has been influenced by the art museum. Office and apartment buildings, private houses, hotels, airline terminals, and shopping centers have been executed in the modern vernacular—partly, to be sure, for economic as well as aesthetic reasons since it was widely, if often mistakenly, believed that designs utilizing new materials involved smaller outlays.

An equally important factor in assuring the modernist truimph, for which the Museum of Modern Art also was in large part responsible, was the glamour attaching to architects of international renown. Architecture, more than most professions, is fused with the cult of personality. A famous name on a preliminary sketch encourages both financial support and media interest. A provincial city anxious to attract tourists will not go wrong by commissioning a leading architect to design an art museum.

Nearly every internationally known architect has at least one museum design in his portfolio. Museums and visual art centers in the United States carry the signatures of Frank Lloyd Wright, Le Corbusier, Walter Gropius, Ludwig Miës van der Rohe, Marcel Breuer, Eero Saarinen, Louis Kahn, Edward Durell Stone, I. M. Pei, Edward Larrabee Barnes, Kenzo Tange, Gordon Bunshaft, Kevin Roche, John Dinkeloo, and Philip Johnson.

Of this stellar assemblage, Johnson has been the most prolific; his commissions have included new wings for the Museum of Modern Art and Asia House in New York City; the Munson-Williams-Proctor Institute in Utica, New York; the Neuberger Museum in Purchase, New York; the Sheldon Memorial Art Gallery in Lincoln, Nebraska; the Amon Carter Museum of Western Art in Fort Worth, Texas; the Art Museum of South Texas in Corpus Christi; the University of St. Thomas Art Gallery in Houston, Texas; the Muhlenberg Center for the Arts in Allentown, Pennsylvania; and the Dumbarton Oaks Pre-Columbian wing in Washington, D.C.

Johnson's predominance as an art museum architect has been fairly won. In 1932 the Museum of Modern Art, then only three years old,

Philip Johnson, oracle of the International style and laureate of museum architects

founded a department of architecture, the first of its kind, and named as curators Philip Johnson and Henry-Russell Hitchcock, both of whom had studied, along with Alfred H. Barr, Jr., MOMA's first director, under Paul J. Sachs at Harvard.

As their inaugural effort in 1932, Johnson and Hitchcock mounted "The International Style," a show from which an entire school of contemporary design was to take its name. For the first time, the work of such innovators as Wright, Le Corbusier, and the Bauhaus architects was brought together synoptically in a single exhibition. Edward Durell Stone likened the impact of "The International Style" on architecture to that of the famous Armory Show on modern painting: "I know of no single event which so profoundly influenced the architecture of the twentieth century." [3]

From missionary Johnson evolved to practitioner and, in 1940, returned to Harvard's school of architecture—though nearly a generation removed from his fellow students—to earn his degree. Following his graduation in 1943, he served as a U.S. Army private, resuming his museum career at war's end. For a period he was both a MOMA curator and a practicing architect, but Frank Lloyd Wright's reproach, which he took to heart—that he was "carrying water on both shoulders"—impelled him to resign his museum post in 1954.

Three years later he was elected to the MOMA board of trustees and was soon given the commission of overseeing the museum's first major effort at expansion.

It can be clearly seen that to an unusual degree the cause of modern architecture in the United States has been associated with one man and with one museum. Certainly no one has done more than Philip Johnson to foster the idea that the art museum should express in a contemporary idiom the essential values of a community. "Once you could tell a lot about a community by its church," he has remarked. "It was the place the city took pride in. Now it is the cultural center, the museum as monument." [4] To Johnson, as to Malraux, the art museum was the equivalent of the cathedral in the Middle Ages, the palace in the eighteenth century, and the Eiffel Tower in the nineteenth.

Not in the United States alone, but in a dozen great cities of the world as well—a roll including Tokyo and Canberra, Jerusalem and West Berlin, Mexico City and Rio de Janeiro—the apotheosis of the museum was tangibly confirmed. New art museums costing millions of dollars each have gone up in an architectural mode inspired by the American example. Nowhere was imitation more flattering than in Paris, erstwhile capital of the visual arts. In opening the Centre Beaubourg in 1977, a museum complex costing an estimated $125,000,000, the French had clearly drawn on American experience both in using the museum as a showpiece for the boldest architectural style and in making the center a cultural agora.

In less than a quarter century the United States has revolutionized the accepted notion of what an art museum should look like: The old central bank gloom has yielded to an atmosphere in which new materials achieve dramatic effects almost as beguiling to the visitor as the objects on display. The victory of modernism was symbolically confirmed in 1975, when the Museum of Modern Art organized a major exhibition affectionately memorializing the once-dominant but now-defunct Ecole des Beaux-Arts style.

Still, there is a boomerang in every victory. Soon questions were being asked about the art museum in its striking contemporary guise: Had the building become an end in itself? Was the collection being overwhelmed by its setting? Were museum trustees being sufficiently prudent in calculating the costs of attention-catching new facilities? Was the public being adequately informed of the financial risks attendant upon growth? And what, finally, were the alternatives to soaring new structures, with their soaring maintenance expenses?

MONUMENTS TO WHAT?

The great architectural statement does not always lend itself to the purposes of the museum. Caverns of sculptured space can dwarf both object and visitor. A case in point is Miës van der Rohe's Brown Pavilion at the Houston Museum of Fine Arts, a curving arcade eighty-eight feet long and twenty-two feet high. "Apart from the Houston Astrodome," wrote Robert Hughes, art critic of *Time* magazine, when the pavilion opened in 1972, "one could barely imagine a less sympathetic space for showing art." [5]

Joshua Taylor, director of the National Collection of Fine Arts, has reflectively defined the problem in a paper prepared for a museum conference:

> Although the postwar architect has been freed from the necessity of historical reference, he may be bound by equally restraining notions. For example, space seen as a dynamic structure, a concept dear to schools of architecture in the 1950s, is not always a useful principle in museum design where, except in a sculpture gallery, the works on the walls, not the space flowing past, should be the source of the artistic experience. There can be a contest for expression between the artists of the works and the architect. Another problem with the museum as an architectural monument has been the unresponsiveness of the space, physically or aesthetically, to temporary exhibitions not in sympathy with the building's imposing character. It is conceivable that a conscientious museum director might feel compelled to select exhibitions on the basis of what will look good in his galleries.[6]

Indeed, the living artist may find himself pitted against the architecture of the museum in which his works are exhibited. Sometimes large canvases will be requested, as in the recent experience of Hib Sabin, a San Antonio artist who normally produces small surrealist paintings. The director of the Museum of Contemporary Art in Houston gently suggested that Sabin attempt "bigger statements," explaining that the gallery—designed by Gunnar Birkerts and resembling a peaked aircraft hangar—was not a sympathetic setting for works of modest size. In such extreme cases, the very shape of the museum helps determine what it will exhibit and collect.

There also are ideological and psychological overtones to debates about museum design. Some of them were sounded by the late Walter Gropius, the founder of the Bauhaus and longtime dean of the school of architecture at Harvard, in "Designing Museum Buildings," a 1946

speech to a regional museum conference in New England:

> The Caesars, playing God, intending to subjugate their subjects by fear, expressed their power by megalomaniac axes of superhuman scale. Hitler and Mussolini both received in rooms of colossal size, seated at the opposite end of the entrance so that the approaching visitor was made to feel uneasy and humble. In our democratic civilization where the emphasis is on the freedom of the individual the architect must not indulge in dictatorial superscale. . . .
>
> The essence of all these observations leads me to demand that man should be large in proportion to the architectural spaces. Thus, his biological qualities should determine the scale of the component parts of a museum, not the whims or fantasies of an ever-so-generous Maecenas and his all-too-obedient architect. . . . The building should be a means to an end, not an end in itself; then its scale will be human.[7]

Gropius, the most self-effacing of great modern architects, characteristically called his own Cambridge workshop The Architects Collaborative, or TAC. His collectivist, mildly socialist approach to architecture was a far cry from the romantic egoism of Frank Lloyd Wright and Le Corbusier, two of the great innovators in museum design.

Born Charles-Edouard Jeanneret in Switzerland in 1887, Le Corbusier changed his name in his adopted city, Paris, in 1923, partly to give a distinctive aura to his architectural persona. Steeped in the revolutionary ideals of Rousseau and in the philosophy ot Nietzsche, he believed that great art was of necessity arrogant and that it was incumbent on the artist to impose his superior conceptions of the universe on others. Le Corbusier's manner suited his outlook. He himself said, "One has to be conceited, sanctimonious, sure of oneself, swaggering, and never doubting—or at least not let it show. One has to be a show salesman. *Merde, alors!*" [8]

In 1922 he exhibited the first version of what he called *La Ville Radieuse,* a planned community for 3,000,000 with residential and commercial sections in zones divided by a gridwork of parks and highways. In the opinion of the influential urbanologist Jane Jacobs:

> His city was like a wonderful mechanical toy. . . . It was so orderly, so visible, so easy to understand. It said everything in a flash, like a good advertisement. This vision and its bold symbolism have been all but irresistible to planners, housers, designers, and developers, lenders and mayors too. . . . No matter how vulgarized or clumsy the design, how dreary and useless the open space, how dull the close-up view, an imitation of Le Corbusier shouts: "Look what I made!" Like a visible ego, it tells of someone's achievement.[9]

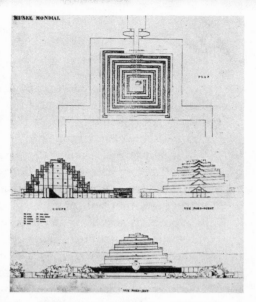

The acorn of modernism. Le Corbusier's sketch (*c.* 1927) for a world museum at Geneva, the first such design in a bold contemporary idiom.

EDITIONS DR. H. GIRSBERGER, ZURICH

When Le Corbusier turned his genius to the matter of museum design, he demonstrated the same prophetic brilliance in a proposal no less irresistibly bold. In 1927 the League of Nations conducted an international competition for the design of a new headquarters complex in Geneva. Le Corbusier's entry, which the judges endorsed and then subsequently disqualified on a petty technicality, included as an element what he called a World Museum: a hollowed pyramid with winding ramps, which would feature exhibits portraying the triumph of Mind over Matter, Justice over Evil, and Equality and Fraternity over Despotism. (Francis Henry Taylor later described the concept as "one in which the script might be the work of Victor Hugo executed by Cecil B. De Mille." [10])

Like his never-to-be-built *La Ville Radieuse*, Le Corbusier's rejected museum design was to have important reverberations in world architecture. Frank Lloyd Wright, very like Le Corbusier in temperament, used a similar concept in the Guggenheim Museum, also a hollowed structure with curling ramps. (The difference was that the Guggenheim got built—perhaps because it was commissioned not by an international organization but rather by an American mining magnate, Solomon R. Guggenheim, who was as much taken by Wright's mesmeric self-assurance as by the proposed museum design.)

One can plausibly speak of a psychic liaison between the great

entrepreneur and the great architect; each is the very incarnation of willfulness. It was not by accident that Ayn Rand, the prophet of egoistic materialism, modeled the hero of her best-selling novel *The Fountainhead* on Frank Lloyd Wright. The titan of finance tends to see himself as a misunderstood builder, the unsung architect of a new and better social order. But what may be the fantasy of the corporate overlord is the chosen mission of the master architect—to create structures that will endure for centuries.

This hypothesis serves in any case to explain the seeming paradox of avant-garde architecture's being championed by the conventional businessmen who monopolize art museum boards. In their professional life, magnate-trustees are hedged in by bookkeepers, regulatory boards, stockholders, trade unions, and a querulous press. *Pro bono publico,* they serve on the boards of art museums, hospitals, cultural centers, universities, foundations, and other nonprofit institutions, but in this capacity they also enjoy a sense of release from the frustrations that limit their freedom of private action.

When building plans germinate at an art museum, the renowned architect, with a reputation anointed by the media, can be counted on to present an exciting, if financially adventurous, scheme. Next, sketches are submitted, models executed, and slide shows organized. In his person, the architect is a throwback to the heroic era of individualism: strong-willed, idiosyncratic, visionary. What he is presenting to the board is not simply a design but also a heraldic symbol of power: civic, ancestral, financial, and aesthetic. The bolder the proposed design, the more likely it is that the board will approve it, as the experience of scores of communities attests.

The benefits are generally apparent—an explosion of museum buildings, most with vast expanses of glass and concrete, many with prows and towers reaching to the sky, and only a few that are truly mediocre as architectural statement. Whether these structures fulfill the purposes of an art museum is another question, and whether trustees have been candid and prudent in their expansion projects is still another. A number of these critical questions are thrown into relief by the projected transformation of the Museum of Modern Art.

TOWERING MOMA

Everything that Walter Gropius believed should characterize contemporary museum design—humane scale, elegance of line,

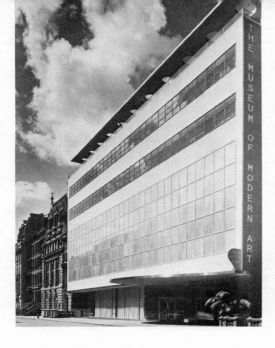

Miracle on West
Fifty-third Street, the
Museum of Modern Art
in its 1939 guise,
now only a memory

Spartan functionalism—combined to characterize the original Museum of Modern Art building on West Fifty-third Street in Manhattan. Familiarity has dulled the sense of excitement that the building aroused when it opened in 1939. Marking a radical break with all previous museum design, the structure was not grandly located in a park or plaza but rather was squeezed between buildings in a modestly scaled side street in Midtown. In place of a lavish foyer, there was a matter-of-fact reception area; in place of a monumental staircase, elevators; in place of wedding-cake ornamentation, plain steel and glass. Its galleries were flexible, intimately proportioned, and arranged so that no one display area was more important than any other.

Alfred H. Barr, Jr., the museum's founding director, had originally sought to employ an architect of international reputation. Frank Lloyd Wright and Le Corbusier were unacceptable on grounds of temperament—meaning that both of them had quarreled with the museum's architectural department—and none of the great Bauhaus masters was available. The commission went jointly to an orthodox architect, Philip L. Goodwin, who happened also to be a MOMA trustee, and to a young architect by the name of Edward Durell Stone, who, as an assistant in the design of Rockefeller Center, had impressed another MOMA trustee, Nelson A. Rockefeller. Together, Goodwin and Stone managed to produce a masterful homage to the Bauhaus—but in a distinctively fresh idiom.

Stone had been born in Arkansas, attended Harvard and the Mas-

sachusetts Institute of Technology, and traveled widely in Europe, where he first became fascinated by the new architecture. On his return to the United States in 1933, he designed a house in Mount Kisco, New York, that he claimed was the first in the International style on the eastern seaboard and soon afterward was hired to work on Rockefeller Center.

The MOMA building, in its low-scale simplicity, was typical of Stone's early work, but he later became celebrated for a monumentalism to be seen at its most Babylonian in the John F. Kennedy Center for the Performing Arts in Washington, D.C. Frank Lloyd Wright, although he derided the original MOMA building as an example of the "flat-chested" International style, admired Stone's later work. (Stone died in 1978 at the age of seventy-six.)

Following the grand opening of the MOMA building, annual attendance rose to 585,000 from 125,000 the year before, when the museum was still in temporary quarters in the concourse of the old Time-Life building in Rockefeller Center. Russell Lynes, in *Good Old Modern,* his history of the museum, writes: "What had been a missionary church in a Philistine jungle with a small band of passionately devoted young proselytizers dedicated to making converts began to look curiously like, and take on the airs and graces of, a cathedral of the new culture." [11]

This change in the museum's aspirations was accompanied by a change in directors. Alfred H. Barr, Jr., the austerely dedicated son of a Presbyterian minister, was dismissed in 1943, although he continued to serve as director of collections until 1967. His successor was René d'Harnoncourt, a descendant of a noble Austrian family whose forebears filled pages of the *Almanach de Gotha* and who had been working as an adviser on primitive art to Nelson Rockefeller. A gentle giant of a man, gifted and full of charm, D'Harnoncourt was an effective fund raiser. During his tenure, Philip Johnson designed and executed an east wing, a garden wing, and a new lobby, increasing gallery space by a third, and the museum also acquired an adjoining building, formerly occupied by the Whitney, which Johnson converted into a north wing, adding 38,153 square feet, to be used chiefly for administrative purposes.

As the museum grew, so did its operating budget: from $3,334,123 in 1964–65 to $7,194,100 five years later. Its 1964 deficit of $53,000 also rose during the same period—to $1,200,000. ("Why is it that when we double the size of the museum, we triple our expenses?" lamented William S. Paley,[12] then MOMA president.) In becoming

a cathedral, the Museum of Modern Art also had become a chronic insolvent. The museum's financial problems were particularly acute since unlike the Metropolitan and other New York museums, MOMA received no annual city appropriation for maintenance. Then, as now, the museum had to depend on revenues generated by admissions, membership fees, shop sales, endowment income, and private contributions, plus a modicum of assistance for special exhibitions from public, private, and corporate benefactors.

Investment decisions by the board's finance committee have not been brilliant. The market value of MOMA's portfolio fell from $24,230,000 in 1969 to $21,000,000 in 1972 to $16,100,000 in 1975. The decline was due in part to the museum's spending from capital in order to meet its annual deficit, in part to a faltering stock market, and in part to a growing reluctance of patrons to contribute as generously as they had in the past.

In 1976 the MOMA board of trustees found itself faced with a hard and disagreeable decision: The museum could either reduce staff and cut back services and thereby live within its income or else embark on a new and hazardous building program involving the sale of its air rights to a commercial developer. To adopt the first course of action would have meant breaking faith with the spirit of the museum; the board therefore decided to gamble on the second.

The proposal for a new tower, then conceived of as an office building, went as far back as 1968, but the idea had been shelved when the rental market for office space collapsed. A decade later the proposal resurfaced in the form of a luxury condominium tower, which would benefit from tax exemptions and, in theory, produce revenues sufficient to meet the projected annual museum deficit.

Advocates of the scheme included Blanchette Ferry Hooker Rockefeller (Mrs. John D. Rockefeller III), the museum president; David Rockefeller, a key trustee; Nelson A. Rockefeller, an honorary trustee and former president; the Arlen Realty Company, an aggressively competitive development firm that numbered among its projects the Olympic Tower (built in partnership with the late Aristotle Onassis), which provided the model for the MOMA plan; Richard Weinstein, former Mayor Lindsay's director of the Office of Lower Manhattan Planning and Development and a development consultant to the Rockefeller Brothers Fund; Donald Elliott, Lindsay's chairman of the City Planning Commission and now a partner in Lindsay's law firm, Webster & Sheffield; John Zuccotti, Elliott's

successor as chairman of the City Planning Commission and former Mayor Beame's first deputy mayor; and Jaquelin Robertson, a member of Lindsay's City Planning Commission and now chairman of Llewelyn-Davies Associates.

This team, armed with a feasibility study prepared by Weinstein, devised a plan whereby the museum would sell its air rights to a developer and place its profits in a tax-free trust managed by a Trust for Cultural Resources to be appointed by the mayor. The trust would then authorize the developer to spend $23,000,000 for an apartment tower and through the sale of bonds would raise an additional $20,000,000–$22,000,000 for gallery space that would double MOMA's exhibition area. Annual real estate taxes, estimated at approximately $350,000, that would normally go to the city would now go to the museum. Initially, the hope was that by 1981 the museum, with its expanded facilities, would have increased its attendance by 33 percent, its income from merchandising by 75 percent, its restaurant income by 213 percent—and, at the same time, would have held the increase in operating costs to 6 percent. The result of all this would be to bring the museum's projected annual budget of $8,003,300 into balance. (Subsequently these projections were more realistically revised.)

Special state legislation was required to authorize creation of the Trust for Cultural Resources. There was unexpected resistance in Albany, and on June 28, 1976, the State Assembly voted down the required legislation by a 72 to 53 margin. In what could incontestably be interpreted as a demonstration of the power of the MOMA consortium, the legislature, on the final day of its session, reversed itself and passed the bill, the only stipulation being approval by the New York City Board of Estimate. According to one account, Nelson Rockefeller had gotten in touch with every member of the legislature, and his efforts were reinforced by urgent appeals from Mayor Beame, former Mayor Lindsay, and William S. Paley, board chairman of both CBS and MOMA. In short order, the city Board of Estimate approved the plan.

The commission of designing the tower and the expanded museum was awarded to Cesar Pelli, the Argentine-born dean of the Yale University School of Architecture, whose best-known work was the Pacific Design Center in West Hollywood, a massive building sheathed in blue glass. Pelli's first sketch for the MOMA tower was nothing if not bold: a fifty-story building rising 596 feet, in which

the museum's street-level facade was transformed, eliminating the Goodwin-Stone original. (Later, responding to protests from architects, he altered the plan to preserve something of the original facade.)

Reaction from the critics was at best mixed. Ada Louise Huxtable, chief architectural critic of *The New York Times* and a member of its editorial board, wrote in the Sunday "Arts and Leisure" section:

> The tower is bad news, urbanistically, even though it is for a good cause. And there is no denying the fact, even with all kinds of diagrams and measurements, that the famous museum garden is being encroached upon—primarily for a restaurant to cover its upper level—a feature with income possibilities. And it is also clear that the design of the new building, which involves the restyled, incorporated facade of the original building, smudges to the point of obliteration the already compromised 1939 Museum of Modern Art by Philip Goodwin and Edward Durell Stone—one of the city's major architectural landmarks. To justify this kind of destruction, survival has got to be the name of the game.[13]

Yet the justification for survival rested in the main on a perilous series of assumptions and on optimistic projections of future revenues and operating costs. Moreover, major legal hurdles remained to be overcome: a lawsuit brought by the Dorset Hotel, claiming infringement of its air rights; a conflict with the neighboring Museum of Contemporary Crafts, whose building was to be absorbed by MOMA, and the question of how the IRS would look on deductions claimed by purchasers of the condominiums. Though the museum was able to resolve some of these problems, it still remained a hostage to a volatile real estate market, and as of summer 1978, a final decision to go ahead with Arlen had not been made.*

It did not instill confidence that the chief authors of the plan were key figures in state and city administrations whose talents had brought New York City to the brink of default.

That the museum knew full well that the entire project was fodder for hostile criticism was reflected in its reluctance to divulge relevant information. Disclosure, when it was made, was made grudgingly, and in a manner reminiscent of the Hoving era at the Metropolitan. Under statute, the meetings of the Trust for Cultural Resources are required to be open, but notices were not sent to the usual list of arts

* That summer, the MOMA plan received a further blow when a New York appellate court ruled that key elements in the museum's plan were unconstitutional, upholding the contentions of lawyers for the Dorset Hotel. By that time, MOMA had already spent around $3,000,000 on work connected with the project and had raised money and pledges totaling $20.2 million. A further problem was that Arlen, the prospective developer, was suffering heavy losses, and the museum was casting about for other partners.

reporters but, according to Lee Rosenbaum, editor of *Art Letter,* were addressed to news desks at major New York newspapers and broadcast stations—without any indication that the meetings involved the controversial MOMA project.

In the most thorough article published to date on the MOMA tower, in *Art in America,* Rosenbaum maintains that the plan is so complex, so fraught with imponderables, that even its staunchest defenders cannot fully get hold of it. Richard Weinstein's feasibility study has never been made public (Rosenbaum was refused access to it), so the basic commercial arithmetic has to be taken on faith. Yet how can it be taken on faith when all the advice given the museum comes from those who have a substantial interest in the execution of the scheme? The preliminary planning costs, which by 1977 had risen to $504,827, included fees of $54,740 for Richard S. Weinstein Associates; $143,000 for Donald Elliott's law firm, Webster & Sheffield ("Attorneys' fees are high," Elliott explained when questioned by Rosenbaum); and $250,505 for Pelli's architectural firm, Gruen Associates.

The MOMA plan is a veritable conflict-of-interest nightmare. For example, William Paley, the museum's chairman, happens also to be board chairman of the company (CBS) that own the parking lot that has been suggested to the Museum of Contemporary Crafts as a new site. (Acknowledging the conflict, Paley said that he turned the matter over to CBS lawyers, with instructions that he be kept out of it.) Richard Weinstein is now himself the executive director of the Trust for Cultural Resources, and Donald Elliott is its counsel.

Why then did the Museum of Modern Art elect to embark on such a course? A simple fact may explain a good deal. Whenever MOMA appeals for financial contributions for bricks-and-mortar, it encounters a far more positive response than when it seeks endowment funds—so positive a response that it calls its current drive for a larger endowment a building campaign. There is a glamour that inheres in architecture that can never be matched by the claims of ever-rising operating costs. Somewhere at the heart of this circumstance is Frank Lloyd Wright with his awesome genius.

WRIGHT'S "LITTLE TEMPLE"

The master builder from Wisconsin, in an uncharacteristically modest moment, called the Guggenheim Museum "a little temple in a park." A temple it is, but it is not so little. Few structures in the

history of architecture have done more to foster the notion that the building enclosing works of art should be as distinctive and original as anything on its walls.

In the hollowed shell of the Guggenheim, with its winding ramps and sense of overwhelming space, Wright demonstrated the dramatic potential of reinforced concrete, but in doing so, he advanced the cause of all contemporary architects, many of whom he belittled and despised. There are other ironies: Wright, to whom both nonobjective art and the City of New York were anathema, created a museum that from its opening in 1959 has been both an avant-garde shrine and a Manhattan landmark.

From the beginning, the Guggenheim was controversial. Lewis Mumford, otherwise a champion of Wright, wrote in *The New Yorker*: "Short of insisting that no pictures at all be shown, Wright could not have gone much further to create a structure sublime in its own right but ridiculous as a museum of art." [14] In *The New York Times,* John Canaday described the museum as a battlefield between architecture and painting, in which both were badly maimed.[15] Thomas B. Hess wrote in *Art News* that the Guggenheim reminded him of the sets in Alexander Korda's film *The Shape of Things to Come*: "You look for the greased wrestler banging a gong, and for Raymond Massey in his test-tube high hat." [16]

Leading architects rallied to Wright's defense. Philip Johnson called the Guggenheim "Mr. Wright's greatest building, New York's greatest building," and grandly pronounced the interior "one of the greatest rooms created in the twentieth century." [17] Edward Durell Stone reproached Wright's critics: "Why can't people relax and enjoy a fantastic structure instead of continually carping and criticizing?" [18]

Whatever its defects as a functioning museum, the Guggenheim, by boldly asserting the primacy of the building, has served, in effect, as a Magna Carta for the gifted architect. Its impact was strengthened by the fact that its opening happened to coincide with the 1960s building boom in cultural facilities of every kind.

When Wright was commissioned in 1943 to design the museum, he was seventy-four years old. He had never had a major commission in either New York City or Washington, D.C., and was regarded by the architectural establishment as a harebrained eccentric. Originally the museum was to be located in Central Park, but Robert Moses, then parks commissioner, disliked the design and vetoed the plan. Once a new site on upper Fifth Avenue was agreed upon,

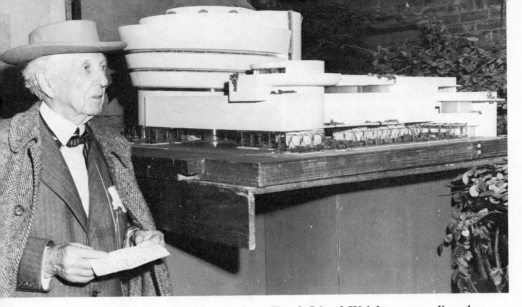

The Master and his creation: Frank Lloyd Wright expounding the merits of his once unconventional Guggenheim Museum

there were squabbles between Wright and petty city officials determined at any cost to enforce the building code requirements. The predictable result of all this was that the architect became increasingly resistant to any suggestion of compromise.

Wright had a congenial patron in Solomon R. Guggenheim, one of seven brothers who had amassed a great fortune in copper mining and himself a passionate collector of contemporary art. In the 1930s with the advice of Baroness Hilla Rebay von Ehrenweisen, his friend and museum director, Guggenheim turned a Manhattan town house into a shrine for his art. With the passing years, he became more and more preoccupied with the problem of providing a permanent home for his collection. Having given the commission to Wright— thanks in large part to the influence of the baroness—he wrote to him in 1946: "I have been trying to visualize how our paintings are going to look in the new museum—being installed right in the walls and without frames. . . . Will you please be good enough to let me know about this at your earliest convenience?" [19]

Wright, being Wright, ignored such queries. When, upon Solomon R. Guggenheim's death in 1949, his nephew Harry succeeded him as museum president, Wright claimed that all questions about the display of art had already been settled between him and the founder. Harry Guggenheim countered: "I find that there is not one shred of evidence to support your reiterated appeal to the memory of, to paraphrase you, that good man our benefactor who must not be

betrayed. On the contrary, let me refresh *your* memory of the fear that was always with him about his architect's method of presenting his cherished paintings." [20]

Deeply involved in this debate was James Johnson Sweeney, who had succeeded the baroness as Guggenheim director in 1952. Sweeney, who had made his reputation as MOMA curator of paintings and who was conversant with the avant-garde in all its multifarious forms, visual and literary, was legitimately worried about how the Guggenheim collection would look mounted on the buff-colored walls that Wright had ordered. Sweeney insisted on white ("Sweeney white— the color of death!" Wright exclaimed) and won, but in winning, he made an implacable foe of Wright, who had the advantage of dealing directly with Sweeney's employers, the trustees.

Less than a year after the grand opening Sweeney was forced to resign following a dispute with the board on how best to exploit the public's interest in the new museum. He was the first museum director to be felled by an unconventional building—and by no means the last.

In the Guggenheim's inaugural year there were 1,000,000 visitors, each of whom—museum members aside—paid a fifty-cent admission charge. But as other museums would also find, architectural novelty is a melting asset, and in the years ahead attendance sank as dramatically as it had once risen. In 1974 the Guggenheim's attendance was 353,969.

In less than a decade, as revenue from admissions declined, operating costs began to soar. Since the Wright building was not energy-efficient, it became increasingly costly to heat and to air-condition its 1,265,000 cubic feet. By 1974 admission income of $257,512 roughly equaled basic maintenance costs, and the annual deficit was $287,669. Like MOMA, the Guggenheim receives no annual stipend from the City of New York and is dependent on endowment income, grants, private contributions, and revenues from admissions and membership. Its annual budget ($2,200,000 in 1974–75) is approximately a quarter of MOMA's, but the museum is in pretty much the same financial plight: in order to meet its operating deficits, it has had to deplete its endowment, the book value of which was $12,-500,000 in 1975.

It is generally acknowledged that Sweeney's successor, the urbane Czech-born and Harvard-trained Thomas M. Messer, has made the most of a difficult building and has been a major force behind the

Guggenheim's series of distinguished exhibitions. But critical notices, however favorable, will not assure the museum's solvency.

Meanwhile, art museums of the grandiosity of the Guggenheim have been built across the country in cities large and small; some of them have the self-indulgence of the original without the genius, and most of them are breeders of fiscal problems that posterity will be called upon to solve.

LOOK ON MY WORKS!

A familiar motif can be discerned in the rise of community art museums in the United States. First, an association is formed by civic-minded amateurs, and an improvised gallery is established. As collections begin to grow, the original gallery is seen to be inadequate. A building campaign is launched, and a nationally known architect is sought for the commission. He submits a sketch for a building that is as costly as it is exciting; in some cases, he can be prevailed on to scale down his original proposal; in others, a local architect, of lesser reputation, is invited to submit a sketch for a less grand design.

One day the museum building opens, and there is a flurry of national publicity, followed by a succession of expensively mounted and critically acclaimed shows. In the first year attendance is high, and all concerned congratulate themselves on having put their city on the art world map. But as the novelty of the enterprise diminishes, so do attendance figures. At the same time operating costs begin inexorably to rise. The deficit mounts; programs and staff are reduced, and as a consequence, attendance declines still further. All too soon the community has a deteriorating monument on its hands.

To be sure, the scenario is nowhere quite so pat, yet in broad terms, it applies to cities as diverse as Raleigh, North Carolina, and Pasadena, California.

It is a sense of cultural inferiority, real or imagined, that often provides the stimulus for an art museum. This was certainly the case with the American South, which H. L. Mencken described in a notorious 1917 essay, "The Sahara of the Bozart":

> There are single acres in Europe that house more first-rate men than all the states south of the Potomac. . . . If the whole of the late Confederacy were to be engulfed by a tidal wave tomorrow, the effect upon the civilized minority of men in the world would be but little greater than that of a flood on the Yang-tse-kiang. It would be impossible in all history to match so complete a drying-up of a civilization. . . . In

all that gargantuan paradise of the fourth-rate there is not a single picture-gallery worth going into, or a single orchestra capable of playing the nine symphonies of Beethoven, or a single opera house, or a single theater devoted to decent plays, or a single public monument that is worth looking at, or a single workshop devoted to the making of beautiful things. . . . Nor a historian. Nor a philosopher. Nor a theologian. Nor a scientist. In all these fields the South is an awe-inspiring blank—a brother to Portugal, Serbia, and Albania.[21]

There was just enough truth in what Mencken said to provoke some useful soul-searching as well as denunciation. During Mencken's heyday, in the 1920s, the South was just beginning to assert itself as a national cultural force. One manifestation of its rebirth was the fresh interest it took in museums; indeed, 24 percent of museums of all kinds in the southeastern states were founded between 1920 and 1939.

In 1926 a North Carolina Art Society was organized in Raleigh, capital of a southern state particularly sensitive to any suggestion that it was a cultural backwater. A primary aim of the society was the creation of a state art museum. Gifts of money and art began flowing to the society; they included an important collection and $1,000,000 contribution from industrialist Robert F. Phifer. During the 1930s a gallery was opened in Raleigh in improvised quarters, financed partly through the WPA arts project. When the WPA program was terminated, the North Carolina legislature voted maintenance expenses for the art museum, thereby establishing a precedent for direct state subsidy.

Fortuitously, with the outbreak of World War II, an expatriate came home to Raleigh with his French wife—an ebullient lawyer by the name of Robert Lee Humber, who had been living in Paris for seventeen years. He became active in the North Carolina Art Society and was also elected to the state legislature. A devotee of causes (he was a founding member of the World Federalists), Humber believed that North Carolina should have an art museum worthy of the Tar Heel State. In the course of his legal work, he had come to know Samuel H. Kress, who had spent a large part of his dime-store fortune on art. Kress had established a family foundation to assist art museums in every part of the United States. (More than a score of art museums has benefited from the major Kress donations.)

Humber proposed that, if Samuel Kress pledged a $1,000,000 cash gift to North Carolina, he would ask the state legislature to vote a matching amount as a direct appropriation for a larger museum. Kress agreed, but fearing a rush of supplicants if his generosity were

ever publicized, he insisted on anonymity. In 1947 the necessary legislation was approved in Raleigh, something of a feat since Humber was honor-bound not to identify the donor. Then, unexpectedly, Kress fell ill, and became incapacitated. The arrangement between them had been verbal, and now Humber had to approach the collector's younger brother, Rush. When he and the Kress Foundation balked, Humber came up with another idea: Let the gift consist of $1,000,000 worth of art. Despite arguments about how the market value of the art would be established, the North Carolina legislature adopted a bill approving the new arrangement. In 1951 North Carolina became the first American state to vote $1,000,000 for the establishment of an art museum.

Space was found in a vacant Highway Department building, located a few blocks from the Capitol in downtown Raleigh. The brick structure, originally built by prison labor, cost relatively little ($345,000) to renovate. A respected scholar and museum professional, Dr. W. R. Valentiner, was appointed director; thus ended an era in which talented amateurs had guided collection growth.

In April 1956 the new North Carolina Museum of Art had its grand opening. *Art News* dedicated its April issue to celebrating Raleigh's arrival on the art scene. The Kress Foundation had meanwhile increased the size and scope of its promised gifts to seventy-three works with an appraised value of $2,500,000. With the warm endorsement of Governor Luther Hodges, the state continued to appropriate money for both maintenance and new acquisitions. Through gifts and purchases, the collection grew impressively. A Giotto altarpiece was acquired in 1961, as well as a bronze attributed to Cellini, and in 1973 a new area of collecting was opened up with the acquisition of more than 200 pieces of African, Oceanic, North American, and pre-Columbian ethnographic art.

For a small-city gallery, attendance at the North Carolina Museum of Art was high, averaging around 100,000 a year. With some justification, the state was proud of its creation. A museum leaflet took care to note that North Carolina was the first state in the nation to set aside public funds to found an art collection for its people. But as the collection grew, the unpretentious downtown building came to seem hopelessly inadequate. Justus Bier, Valentiner's successor as director, estimated that the existing exhibition space of 28,000 square feet would have to be doubled before important works kept in storage could be displayed to the public.

In 1967 the state legislature created an Art Museum Building

Commission empowered to find a new site "on land which has been denominated as Heritage Square," a four-block area in downtown Raleigh. The governor appointed as chairman a former state senator, Thomas J. White, a lawyer, lobbyist, and sometime adversary of Robert Lee Humber. White felt that the city location was too confining, and with a minimum of publicity, he managed to secure passage in 1969 of a rider deleting the original legislative restriction. With just as little publicity, the building commission hired a private consulting firm to recommend a museum site; the firm proposed a spacious setting on state-owned land four or five miles west of downtown Raleigh.

There was no competition for the design commission; it was unilaterally assigned to Edward Durell Stone, whose work White admired. Stone submitted a startling sketch for a museum with 400,000 square feet, then about the size of the National Gallery of Art, to consist of a series of one-story modular pavilions, each with a roof garden, laid out around artificial pools. The total cost of the building was projected at $10,000,000, all of it to be provided by the state legislature.

The press took exception both to the design and to the secret deliberations of the building commission. The Raleigh *News and Observer* accused the Art Museum Building Commission of being "hell-bent on bigness" and of having approved, without announcing a design competition or holding adequate hearings, an extravagantly large museum in an inconvenient location.[22] It was revealed that the commission had not fully consulted with other state officials and had neglected to calculate future operating costs. Questioned by the *News and Observer*, the museum director estimated that an annual budget of $2,000,000 would be necessary to operate the new facility, compared with the $868,150 voted in 1973–74 for the existing museum. Commission members at first excused their dereliction by saying that future costs were impossible to project but then admitted that they had not even asked the museum staff to submit estimates.

A taxpayer suit was initiated against the commission by a retired stockbroker, McDaniel Lewis of Greensboro, who contended that it had far exceeded the authority vested in it by the State of North Carolina. The suit was eventually dismissed by the State Supreme Court, but in the meantime, building costs had risen, and the $10,750,000 allowed the museum was no longer sufficient. Reluctantly the commission modified the original plan—eliminating the rooftop gardens and reducing the building by 153,000 square feet. But White was to

The late Edward Durell Stone,
an apostle of impact

have his way: Ground was broken for the new structure in 1976.

The North Carolina episode dispels once and for all the notions that private boards are the only agencies given to *folies de la grandeur* and that government control can of itself assure greater accountability and fuller disclosure. The Art Museum Building Commission was an official body, appointed by the governor, with every penny in its coffers deriving from taxpayers. But its operations were as secretive, and its schemes as grandiose, as those of any private museum board. The whiff of mortar and the allure of the museum-as-monument seem to stir impulses that can transcend charters, constitutions, and the edicts of state legislatures. In the end, the impulse can even destroy an institution, which is what happened to the Pasadena Museum of Modern Art.

ARCHITECTURE AS DESTINY

To suggest that the Pasadena story is in any way representative of the American experience in managing art museums would be both unfair and inaccurate. Like so much else that happens in Southern California, like the communes in Little Venice, the John Birchers in Orange County, and the immured dead at Forest Lawn serenaded by tape recordings of Bach, it is the extreme expression of the problems of an age. But just as these phenomena tell us something about the way we live, so too does the transformation of the Pasadena Museum

The North Carolina Museum of Art, in Stone's original conception, since reduced in size

of Modern Art (PMMA) into a provisional home for the Norton Simon collection.

Whatever the attractions of the Norton Simon Museum of Art at Pasadena, as PMMA is now known, it is not an invigorating presence on the West Coast. Rather, it is yet another monument to one man's taste and fortune. In the case of Pasadena, architecture was destiny. It was the sheer extravagance involved in building a new museum that finally placed its trustees in the untenable position of having to choose between closing it down and allowing it to be taken over. The board is to be blamed less for adopting the latter course than for the series of misjudgments that made the Hobson's choice unavoidable.

Pasadena was settled in the 1870s and soon became a Pacific retreat for well-to-do easterners and midwesterners. The community shared in the dramatic rise in property values in Southern California, acquiring a local reputation as a prosperous Los Angeles suburb inhabited by wealthy widows and divorcées and by eccentric millionaires. Nationally, of course, Pasadena became known as the home of the football Tournament of Roses.

Typical of the high-minded early residents were Ezra S. and Jeanne Carr, amateur horticulturalists who, with the advice and encouragement of their friend John Muir, turned a hilltop tract into Carmelita Park, a garden of Mexican limes, cypresses, Cherokee roses, myrtles, purple barberries, and Teinturice grapes. When in 1924 a Pasadena

Floreat California: the Pasadena Museum of Modern Art, as it
was upon its opening in November, 1969

Art Institute was founded, the Carr estate offered it a redolent pro-
visional home. The park, on a ravine with dramatic vistas all around
it, seemed such an attractive permanent location for a new museum
that although there were no funds available for construction, the in-
stitute took a twenty-year option to build there.

In 1942 the museum moved to the Grace Nicholson Chinese House
in downtown Pasadena, another early-settler curiosity, picturesquely
gabled in imitation of an Oriental house. The two-story structure had
the distinction of being a civic landmark as well as a usable museum
structure.

The Pasadena Museum, which already owned a miscellany of
American and Oriental works, came unexpectedly to national promi-
nence in 1951, when a German-born child psychologist, Dr. Galka
Scheyer, bequeathed it what became known as the Blue Four Col-
lection, including 66 Klees, 5 Kandinskys, 150 Jawlenskys, and 43
Feiningers. Along with the paintings, drawings, and etchings there
were letters from the artists to Dr. Scheyer.

The Blue Four gift happened to coincide with a change in the
cultural aspirations of Pasadena. Like the American South before it,
Southern California resented being condescended to by easterners as
a bastion of aesthetic vacuity. The Los Angeles area consisted of more
than the Avenue of the Stars, freeways, kidney-shaped swimming
pools, and Disneyland; during the 1950s it had emerged as a market
for avant-garde art second only to New York, and it harbored such
residents as Norton Simon and Armand Hammer, both of whom

would soon rank as world-class collectors of Old Masters and School of Paris works.

In Pasadena, museum trustees seized an opportunity for growth. Why should we limit our horizons? they asked themselves. Why should the community not sponsor a West Coast equivalent of the Tanglewood Festival in the Berkshire hills of Massachusetts, with its own dance and drama festivals? To this end, the board invited Edward Durell Stone in the early 1960s to submit a design for a new Pasadena Museum in Carmelita Park that would include facilities for a theater and concert hall. Stone produced a rendering fully equal to the board's dream but exceeding the capacity of its purse.

Chastened by the projected costs, the Pasadena board turned down the Stone proposal and shelved the plan to include extra facilities. It began looking for another architect. The commission, in due course, went to Thornton Ladd and John Kelsey, California architects whose idiom was conventionally modern and who had come recommended by one of the Pasadena trustees, Virginia Steele, a potential donor who headed a family foundation. Ladd and Kelsey's plan for the museum featured modular globules arranged in an H-shaped pattern flanked by a long pool and a parking plaza. The plan also entailed slicing into Carmelita Park, a price the museum board decided it was willing to pay.

None of the original cost estimates proved accurate. The Stone proposal, rejected as absurdly expensive, had been estimated at $9,000,000; the Ladd and Kelsey building, when all the bills were in, came to $8,500,000. Also, estimates of contributions proved to have been too optimistic, and in one case the museum had to resort to suing a donor who defaulted on a promised gift. As a result, when the new building finally opened its doors in 1969, the museum was $850,000 in debt.

Still, the Pasadena Museum of Modern Art created as much of a sensation as its sponsors had ever hoped. The PMMA saw itself as the West Coast MOMA, and the idea was more than notional. Its openings were national events; their spirit was jauntily avant-garde —every kind of Pop Art, Abstract Expressionist, and Color-Field Art was given a Pacific showcase.

The achievement was the greater in the face of almost continuous staff discord. There were five directors in less than a decade, and curators came and went at almost newsreel speed. A major source of contention was the building itself. The museum staff resented not having been consulted on the design, as well they might: The structural

limitations were formidable—too many guards were needed, traffic flow was awkward thanks to the H shape, and installation was made difficult by design inflexibility and the rounded cupolas.

But the most serious problem presented by the new building was financial. Operating costs exceeded both the estimates and the means of the museum. By 1973–74 the annual operating budget had reached $665,000, not including $75,000 in fees to finance the building debts. Since revenues that year amounted to only $264,000, the net deficit was $390,000. The City of Pasadena was providing only a token annual contribution of $25,000, so that the financial burden fell on museum trustees, who were for the most part not prodigiously rich. The need for money was so acute that the museum began deaccessioning works at bargain-sale prices; twenty-four American paintings, most of them nineteenth-century, were sold to a Los Angeles dealer for $44,850 in 1969, just before market prices for period American art began to soar.

Another museum practice, even more questionable than hasty deaccessioning, was the sale of gifts from living artists, which put the museum in the position of undercutting the market for working artists. In 1972 the museum president, Alfred M. Esberg, was sharply reproached by June Wayne, a Los Angeles artist who had been asked to make a gift of several key works by a fellow artist for a retrospective show. "Imagine my distress," she stated, "when, a few years later, the same works were sold off in a rummage sale, bought for pennies on the dollar by people known to me. Is this why the gift was solicited? Would I have given it to such a purpose?" [23]

Esberg replied that careful review procedures had been instituted in 1970 for the deaccessioning of art and that he was inquiring into the sale she had protested. As for the deaccession policies of the museum, he asserted:

> [All] of us on the Board of Trustees have been most reluctant to sell any art belonging to the museum, whether acquired by gift or otherwise. However, during the past year or so we have been engaged in a desperate fight to save the museum from financial disaster, and we have reluctantly been forced into a position of selling off works of art which are of peripheral interest to the main thrust of our museum.[24]

As museum debts mounted, the Pasadena board began to weigh salvage measures. At one point a merger with the Museum of Modern Art in New York was considered, with the idea of creating a national contemporary arts museum that would pool its resources and pay its way by renting works to other museums. But MOMA, preoccupied

with its own growing deficit, gave no encouragement to the scheme.

A sounder suggestion found a sympathetic response: merging the Pasadena Museum with the Los Angeles County Museum of Art (LACMA). From the very day its $12,000,000 building opened on Wilshire Boulevard in 1965, LACMA was acclaimed the leading art museum on the West Coast. With the support of a private board notable for its great wealth, the new museum acquired so much art, extending from ancient to contemporary, that by the 1970s there was already a space problem. The Pasadena board proposed that the PMMA become the contemporary art gallery of LACMA, in the same way that The Cloisters is the medieval extension of the Metropolitan Museum of Art.

Franklin D. Murphy, then president of LACMA, was at first favorably disposed to the idea and saw no insuperable obstacles to the museum's assuming PMMA's debts. What killed the plan was the possibility that LACMA's charter would have to be changed. The founders of LACMA had negotiated what from the museum's vantage seemed near-ideal terms: All maintenance expenses were to be borne by the county, while the LACMA board would raise funds for the construction of the museum building and for acquisition of art; there were to be no ex officio public members on the board, which would therefore be wholly private. No city museum of similar size had ever been able to obtain full maintenance support while yielding so little in terms of public representation.

During discussions about the Pasadena merger one of the Los Angeles county supervisors demanded that the LACMA charter be amended to provide for ex officio public seating on the board. "That," Murphy stated in an interview with the author, "we were not prepared to do." [25]

The alliance with LACMA ruled out, the Pasadena board turned to a risky if tempting new possibility: an arrangement with Norton Simon, a West Coast industrialist with a large and homeless art collection—and a reputation for always getting his way.

One of the biggest spenders in the world art market, Norton Simon is in some ways the typical outsized magnate-turned-collector, shrewdly applying his talents as a conglomerateur in dealing with museums, scholars, foundations, and the IRS. Explaining his approach to business to a *New York Times* reporter, Steven V. Roberts, Simon could not have been more frank: "My methods are always within the legal framework. They're just outside the accepted social

Norton Simon, tycoon and collector, here besieged at a Christie's auction in March, 1965, after paying $2,240,400 for Rembrandt's *Titus*, using a bidding system that momentarily baffled the auctioneer

framework. 'It isn't the way we play cricket here at the club.' But I would always try first to get them within their own rules. It's always more fun beating a person within his own game." [26]

Simon was born in 1907 in Portland, Oregon, where his father ran a small department store. Simon's family later moved to San Francisco and he attended the University of California at Berkeley for six weeks ("I was a dropout from college way before this age of dropouts"). He began his career by making a $7,000 investment in a bankrupt orange juice plant in 1929 and within ten years had increased the firm's annual sales from $43,000 to $9,000,000. With the profits earned from selling the plant, he subsequently invested heavily in Hunt Brothers Packing, a medium-sized canner in the Bay Area; in 1943 he acquired control and changed the company's name to Hunt Foods. By 1970 Hunt Foods and Industries, Inc., which Simon had relocated in Fullerton, California, was a $1 billion-a-year conglomerate with ten divisions producing everything from tomato sauce to cosmetics, soft drinks to women's magazines.

Simon's collecting interests go back to 1954, when he was furnishing a new home. At the urgings of his first wife, Lucille, who had a deep interest in art, he made his first purchases: "I bought three, a Gauguin, a Bonnard, and a Pissarro," he reminisced. "I was hooked. I've studied and read everything possible since. I guess I read five books a week on art for a while there." [27]

In 1964 he made a fittingly spectacular entry into the international

art scene by buying up the entire stock, as well as the Manhattan town house it was in, of Duveen Brothers Art Gallery, valued at $15,000,000 and including 146 Old Masters, an abundance of sculpture, porcelain, tapestries, antique furniture, and rare art books. The next year Simon turned up at Christie's in London to bid for Rembrandt's *Titus;* his bidding technique was so complicated that at the closing bid not even the auctioneer realized he was still in the running. In a rare occurrence, bidding was then reopened and Simon purchased *Titus* for $2,240,400, only $65,600 less than the record-breaking sum the Metropolitan Museum of Art had paid for Rembrandt's *Aristotle* four years before.

In 1972 Simon purchased a Raphael *Madonna* from Wildenstein & Company in New York for a price reported to be in excess of $3,000,000. All together, he has bought an estimated $100,000,000 worth of art. He has become a major seller as well; between 1971 and 1973 he divested himself of approximately $13,000,000 worth of Impressionist and Postimpressionist works, startling many in the art world and leading some to question his seriousness as a collector.

Most of the works purchased by Simon did not become his personal property. They became the property of the Norton Simon Foundation, incorporated in 1952 and having assets valued at $65,000,000 in 1972, or of the Norton Simon, Inc., Museum of Art, incorporated in 1954 and having assets valued at $32,000,000 in 1972. Officers and trustees of both foundations consist of Simon's relatives and close business associates.

Works of art given to the Simon foundations qualify as charitable deductions. In papers filed with the IRS, as required by federal law, the Norton Simon Foundation listed the total value of art purchases through December 31, 1973, as $44,787,344. During 1973 he purchased seventy-five works and gave them to the foundations. He was thus able to deduct up to half the works' total purchase price from his 1973 taxes and at the same time retain control of the art.

With his foundations as conduits, Simon has engaged in a systematic loan program to leading museums, thereby both providing a home for his collection at modest expense and obtaining the benefit of museum scholarship and validation. The Simon foundations have normally paid transportation expenses, and the museums have normally been responsible for insuring and guarding the art and for preparing the catalogue.

At any given time in recent years, works of art from the Simon collection have been on loan to a dozen museums in every area of the

country for varying periods of time. Sometimes new Simon purchases may be "parked" in a museum for six months or longer since the California laws exempt from sales tax any work of art that has been displayed outside the state for at least half a year. In other instances, Simon retains the right to terminate a loan on short notice and has on occasion done so in order to sell the art. In 1972, for example, he lent more than 100 works covering five centuries to the Princeton University Art Museum, where studies of individual objects were to be prepared by graduate students and faculty. Although the university was under no illusion that the loan might become a gift, the press dwelled on that tantalizing possibility.

A few months after the opening of the loan exhibition the director of the museum was informed by the Norton Simon, Inc., Museum of Art that it wished to remove an important painting by Picasso in order to offer it for sale. The museum was given less than a week to prepare the painting for shipment.

There was difficulty with the Metropolitan Museum of Art as well. In the 1970s Simon became a major buyer of Asian art, and in 1972 he acquired for $1,000,000 a bronze statue of Nataraja. When it became known that the idol had been stolen from an Indian temple and smuggled into the United States, India made a formal claim for its immediate return. The incident was widely publicized just prior to a Metropolitan show, "Masterpieces of Asian Art," drawn largely from the Simon collection; the catalogue featured the Nataraja on its cover. Thomas Hoving asked Simon to withdraw the disputed bronze, and the collector refused, threatening to sue the museum for breach of contract. In the end Simon canceled the show. A year later he reached a provisional agreement with India that provided for the return of the statue after a decade of public exhibition in the United States.

But Simon's most acrimonious dispute with a museum occurred in Los Angeles, where he was a founding trustee of the new Los Angeles County Museum of Art, which had displayed a major portion of his collection on its opening in 1965. It was widely assumed that LACMA would one day be given a considerable part of the Simon collection. However, Simon was unhappy with the museum's installation of his art and opposed LACMA's policy of constantly shifting works he felt should be on permanent display. Following a quarrel with other collector-trustees, he resigned from the board and had most of his art removed.

Then, in early 1974, Simon was approached by the insolvent, and improvident, Pasadena Museum of Modern Art.

After preliminary talks, Simon agreed to pay the Pasadena Museum's building debt, meet its operating deficit, refurbish the deteriorating galleries, mend the leaking roof, and assign a full quarter of museum space for modern works from its permanent collection (the balance of the space—a lion's 75 percent share—was to be used for Old Masters and modern art from his two foundations); the agreement was to run for five years; the old museum board was to be restructured into a ten-member body, four of whose members would be chosen by the Simon interests, and three of whom would be public members nominated by Simon. (The balance were to be holdovers from the old PMMA board.)

These terms were formally embodied in a letter of agreement dated April 22, 1974. The Pasadena trustees believed that they had saved their ailing museum, at the admitted cost of having its name shortened to the Pasadena Museum of Art and its character altered.

The arrangements were clearly to Simon's advantage. In return for picking up a building debt, assuming responsibility for the operating deficit, and agreeing to the renovation of a recently built structure, he was acquiring effective control of a building and collection with a combined value of at least $15,000,000—and at the end of five years he could exercise the option to pull out. The reality of the takeover was brought home when the new board appointed as acting director a former Protestant clergyman without a professional museum background who had worked for Simon.

In his *New York Times* profile of Simon, Steven V. Roberts quotes an old friend of the industrialist's: "Norton was never a raider in the sense that he drained a business and ran away. He would take a poorly managed business, move in, get good management and get it operating on a profitable basis. . . . In every instance, shareholders benefited from his presence." [28] Save for the fact that the Pasadena Museum was not a profit-making institution, Simon's approach was the same, and the moving-in process was bound to be as painful.

When the refurbished building opened in March 1975, the initial reaction was favorable. Simon had spent a reported $1,000,000 on renovations; his collection, encompassing works of art ranging from Raphael to Brancusi, was outstanding. And he had made good on his promise to devote at least a quarter of the gallery space to works from the old PMMA collection. The museum was now called the

Pasadena Art Museum. The admission fee was raised by a third to $1.50, but each visitor, as a bonus, was given a choice of a free reproduction of a museum masterpiece.

But in October the restructured museum board was asked abruptly to vote on a motion to change the name of the institution to the Norton Simon Museum of Art at Pasadena. This proposal to rebaptize the museum came as a shock to holdover members of the board. Nevertheless, the motion carried 6 to 3, with the four Simon representatives and two of the three public trustees joining to form a majority.

Robert S. McFarlane, Jr., then board president and Simon foundation employee at the Norton Simon, Inc., Museum of Art, gave a sonorous explanation for the name change:

> The new name symbolizes the future direction of the Museum. We hope to make the Norton Simon Museum a focal point for most of the art of the internationally renowned Simon collection. The very best portions of the former Pasadena art collection including important selections from the Galka E. Scheyer collection will also be on exhibition much of the time. This expanded art program when supplemented by further improvements and expanding of the building and landscaping will allow the Museum to move toward the goal of becoming one of the select handful of outstanding museums in the United States.[29]

Simon put it more simply. The change of the name, he told the *Los Angeles Times,* was "to clarify unmistakably that the museum is to become an institution of the type of the Frick Collection in New York."

The Pasadena Museum's identification with a single collector became still more pronounced in 1977, when Norton Simon himself was named director, his second wife, actress Jennifer Jones, widow of producer David O. Selznick, was named chairman of the board, and Alvin Toffel, one of Simon's business associates, was elected president.

It is not unfair to conclude that Norton Simon had found a provisional solution to his housing problem at distress sale prices. There is almost unanimous agreement that the Simon collection is of world importance and that it has been impeccably installed. It is well on its way to becoming the West Coast Frick Collection, but a Frick Collection is an essentially static thing—a far cry from a museum willing to take chances on new artists.

Yet the ultimate responsibility for the loss of the PMMA does not rest with Simon, who seized an opportunity when it was presented to him and who has provided Pasadena with an outstanding museum,

albeit a conventional one. The responsibility lies with the Pasadena trustees, who built worse than they knew.

ALTERNATIVES

The problem of museum design is not that a contemporary style is unsuitable or that architects wish at any cost to create original building. Rather, it is that the building, in Gropius's words, can become the end, not the means.

Some years ago art critic Katharine Kuh was struck by the similarity in spirit between Frank Lloyd Wright's Guggenheim and Miës van der Rohe's Cullinan Hall at the Houston Museum of Fine Arts:

> In each case, despite or because of the functional liberties taken, architecture of unique excitement results. The buildings themselves become works of art and monuments to their distinguished designers. But paintings and sculpture often demand submissive surroundings where introspection and privacy are possible, where the process of looking is more important than the experience of seeing. Both buildings, based on bold projections of space and dramatic juxtapositions of scale, curiously recall but in no way resemble the overpowering palace architecture which familiarly enshrined art museums of the past. What one misses perhaps is a human dimension, an intimacy sympathetic to personal and poignant visual experiences.[30]

That an architect can achieve such an effect is borne out by the work of the late Louis Kahn, former dean of the Yale University School of Architecture. None of the three museums Kahn designed relies on an intimidating use of sculptured space, and all of them meet the most practical of requirements—that visitors can look as well as see.

In the Yale University Art Gallery in 1953, Kahn succeeded in blending a new structure with an older building executed in Ivy League Gothic. Far more spectacular is his $7,500,000 Kimbell Art Museum, located in a bare park landscape in Fort Worth, Texas, a low-scaled structure with a cycloid roof and ingeniously arranged display areas. What immediately strikes the visitor is the silver luminosity of the lighting, which Kahn achieved, after much trial and error, by deflecting the sun through the curved roof.

A small "family" museum, the Kimbell collection embraces the entire range of art, from Egyptian antiquities to Color-Field painting. In designing the gallery, Kahn worked closely with the director, Richard Brown, to produce special alcoves where the smaller works are highlighted. (Brown, it is worth noting, had come to Fort Worth

Kahn's Kimbell.
The south galleries
are illuminated,
as is the rest
of the museum,
by natural light.

following his resignation as director of the Los Angeles County Museum of Art, where he had warred incessantly with his board over plans for the new museum building.)

In the Yale Center for British Art, which was completed in 1977, after Kahn's death, the architect was faced with the challenge of designing a building that would be situated on a cramped and crowded main street facing the Yale University Art Gallery. As a condition for approving the building, New Haven officials stipulated that shops be incorporated at street level to compensate for the loss of tax-producing land. Storefronts and a small plaza are therefore an integral part of the museum, which is coated in a dull-surfaced stainless steel to mute the intrusion of modernism.

The center houses the collection of British art assembled in not much more than fifteen years by Paul Mellon, who also underwrote most of the $10,000,000 construction costs, but who, like his father, Andrew W. Mellon, the founder of the National Gallery of Art, declined to have the building named for him. To display the art, Kahn re-created—in contemporary idiom—the atmosphere of a country manor house: The windows open on an inner court, and the galleries form a maze of wood-paneled rooms. A suite is set aside for the permanent display of the entire reserve collection, an important innovation that makes it possible for visitors to see the lesser works. As at the Kimbell, the lighting is diffused, lambent, and alive: A system of moving louvers illuminates the upper floor, with the result that the paintings take on different hues at different times of the day.

There are other outstanding examples of museums that utilize the contemporary idiom: the multipurpose and labyrinthian Oakland Museum (Roche & Dinkeloo), which melds art, science, and history; the intimate pre-Columbian wing at Dumbarton Oaks (Philip Johnson), which provides a jewel-case setting for small objects; the spacious, yet highly personal Walker Art Center in Minneapolis (Edward Larrabee Barnes), which is an almost faultless setting for contemporary art; the elegant Education Wing (Marcel Breuer) of the Cleveland Museum of Art; and the Herbert F. Johnson Museum at Cornell University (I. M. Pei), which makes superlative use of the landscape. Pei, of course, was also responsible for the magnificent East Building of the National Gallery of Art, in Washington, D.C., which, from the moment of its opening in the summer of 1978, was universally acclaimed as a modernist triumph.

The problem of museum design lies not in the modernist idiom, but in its abuse. In nearly every case where museums have been successful as buildings, it is because the architects have been in continuous discussion with museum staffs.

The worst excesses in museum design were committed during the 1960s. A number of galleries already have a period air. In the 1970s the reuse of historic or landmark buildings became popular: Courthouses were turned into libraries, railroad stations into art centers, warehouses into theaters, and empty cinemas into concert halls. One of the attractions of adaptive use, at least in the case of art museums, is that it is often much less expensive to recycle a building than to construct one.

In 1976 the Advisory Council on Historic Preservation studied thirty-one adaptive reuse projects, including two museums. The San Francisco Museum of Art found quarters in a 1934 government office building; the cost of renovating 65,000 square feet for galleries and offices was $1,350,000, or $25.33 per square foot, a reasonable figure for construction in 1975, when the project was completed. The second museum in the study was the Cooper-Hewitt Museum of Decorative Arts and Design in New York, where in 1976 a total of 55,000 square feet was turned into museum space at a cost of $1,750,000, or $31.81 per square foot.

There are three other museums, also operated by the Smithsonian Institution, located in landmark structures. The National Portrait Gallery and the National Collection of Fine Arts both have been installed in the old Patent Office building, a classic revival relic from

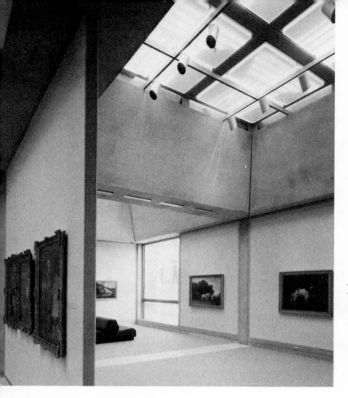

Kahn's Yale Center
for British Art: a
typical upper gallery with
natural light filtered
by a coffered roof

the Civil War era in the capital. The renovation of 374,000 square feet was completed in 1968 at a cost of $7,000,000, or about $18 per square foot, a figure substantially below prevailing costs for new public buildings. The Renwick Gallery, which had been used as a courthouse, was renovated in 1972 at $53 per square foot. By comparison, the Joseph H. Hirshhorn Museum (1974), designed by Gordon Bunshaft and including a sculpture garden, came to $90 a square foot, and the 1976 National Air and Space Museum, designed by Hellmuth, Obata & Kassabaum and consisting of three immense glass bays flanked by even larger marble cubes, came in at $41,400,000 or $63 a square foot.

The imaginative recycling of older buildings is desirable not just on financial grounds. Such structures often provide an appropriate setting for art: Their scale tends to be intimate, their design unintimidating, their patina of age sympathetic to noncontemporary art. Interestingly, as the author discovered, most museumgoers, when asked to name their favorite gallery, single out a small museum in a residential setting, such as the Phillips in Washington, the Gardner in Boston, or the Pierpont Morgan Library in New York. These are places that inspire affection rather than awe, a quality that the museum-as-monument too often fails to achieve.

V

"THE HARD COIN OF ART"

To things of sale a seller's
praise belongs.

—WILLIAM SHAKESPEARE,
Love's Labour Lost

THE MARKET FLYPAPER

A PECULIAR CHARACTERISTIC OF THE ART MUSEUM IS ITS BEDEVIL-
ing link to the marketplace; no other cultural institution is so in-
timately involved with price movements. An opera company's choice
of repertory, for example, has negligible bearing on the auction value
of a musical manuscript, whereas a museum's purchases and exhibi-
tions can decisively influence the value of an art dealer's stock or a
collector's treasures. But short of ceasing to be a museum, there is
no way in which a public gallery can disentangle itself from com-
mercial considerations.

Always a source of concern to the conscientious museum profes-
sional, the art museum's entanglement in the flypaper of commerce
has become a far more acute problem as a result of the postwar boom
in art prices and the rise of a new middle-income clientele interested
in "collectibles" of every imaginable variety. Since these new buyers

tend to be uncertain in their taste, they look to dealers, auction galleries, and art museums for authoritative guidance. Curatorial opinions have become a vital ingredient in the ever-changing consensus about the real worth—aesthetic and monetary—of objects or the work of individual artists. In short, what was once a specialty market catering to, and regulated by, the tastes of a wealthy handful of often discerning collectors has acquired a radically different character as a mass consumer market with a profit potential emblazoned in headlines.

The role of the American art museum, both as tastemaker and evangel, cannot be understated in appraising this new market. Long before the postwar boom, American galleries had established themselves as pace-setting buyers in the international bourse. In *Merchants of Art*, a memoir about himself and his famous art dealer father, Jacques, Germain Seligman paid tribute to the rise of the American museum in the period between the wars as a "new and formidable buying power in the art market":

> If, occasionally, the art dealer is nostalgic for the days of the millionaire private collector who could, and did, buy any rare item which took his fancy, regardless of price and without lengthy consultations with experts and trustees, those moments are quickly forgotten in his pride and pleasure in the role he has played in the enrichment of American museums. Their astonishing growth, both in size and number, in the last forty years is a phenomenon unique in the world and in history; unique because it has come about almost entirely through the generosity of private citizens.[1]

Seligman went on to remark that the art dealer took particular satisfaction in placing objects in museums—even though profits might be lower—because this constituted "an official recognition, so to speak, of his knowledge and taste."

For auction houses as well, museum purchases have served an indispensable validating function. In what retrospectively appears to have been a watershed, the Metropolitan Museum of Art in 1961 paid $2,300,000 for Rembrandt's *Aristotle Contemplating the Bust of Homer*, at the time the record auction price for any work of art. Mesmerized by the string of zeroes, the press carried the news to the four corners of the globe. *Time* gave *Aristotle* its highest accolade, a cover (publisher Henry Robinson Luce was a Metropolitan trustee), and unblushingly titled its story "The Solid-Gold Muse."

The effect on auction prices for all Rembrandt works was immediate and lasting. During the 1950s four-figure bids had been the

rule for Rembrandt engravings; now five-figure bids were the minimum—in 1966 a record $84,000 was paid in London for a third-state impression in fine condition of Rembrandt's *Three Crosses.* The market value of Old Master prints jumped thirty-seven-fold between 1951 and 1969 (as compared with a fivefold increase in the value of industrial stocks during the same period), according to the calculations of Geraldine Keen, a British statistician who for a decade has been the auction salesroom correspondent for *The Times* (London). Although Miss Keen's tables have been faulted on the ground that every important work of art is unique and thus unquantifiable, they have been used as a rough yardstick by dealers and auctioneers to underline the investment gains possible on works of art. Keen has offered this interesting assessment:

> The rapid rise in the value of old prints has been largely due to new museums building up print collections, especially musuems in America. In the main, it is the trustees of museums who are prepared to pay prices of $12,000 and upwards which are now frequently recorded for good impressions of old prints, and it is their ability to find large capital sums which can drive important and rare impressions up to very high prices.[2]

As buyers of art, museums have a weight and influence comparable to those exercised by pension funds in the securities field. Decisions, although made exclusively on aesthetic grounds, may have important financial consequences. But the market involvement has yet another dimension: By buying—and thereby reducing—the number of works in private hands, museums swell the potential market value of examples of the genre still available for purchase. In art, as in any other market, prices are established by supply and demand. Whenever a Renoir passes into public ownership, the value of all other Renoirs still on the market necessarily increases.

The dilemmas of the art museum derive from more than purchases. Even a temporary loan show may have market implications; a major exhibition is a kind of *Good Housekeeping* seal certifying the importance of an artist or an art form. Whatever museums do, whichever way they turn, someone gains and someone loses.

It would take a chiaroscuro brush to portray the art market in all its particularities and adumbrations. At its darkest, it is unregulated, corrupt, and collusive—a sinister jungle filled with traps for the unwary, who may buy works that turn out to be fake or to have been artificially inflated in price by insider manipulation. The art world abounds in speculators who, in Wilde's phrase, know the price of

everything and the value of nothing. Secretive to the core, it thrives on rumors, tips, hucksterism, and fads.

The art market does have its redemptive virtues. It can, for instance, be distinguished from the Chicago pit or the Zurich bullion exchange in one very obvious respect: Any number of its most important customers are motivated by a passionate love for the work of art itself. It is not gourmets who determine the price of cocoa futures any more than it is the elegance of a banknote that carries weight with currency speculators. In the art market, by contrast, it is the aesthetic preferences of a handful of discerning buyers that may send soaring the prices of hitherto-unfashionable art. This was certainly the case when Paul Mellon began his spectacular purchases two decades ago of English eighteenth- and nineteenth-century paintings.

Mellon is typical of the traditional connoisseur-collector who is indifferent to speculative gain, although, like all men of affairs, he can drive a hard bargain with dealers. The roll of such collectors is long and illustrious: J. P. Morgan, Walter Arensburg, Jules Bache, Isabella Stewart Gardner, Katherine Sophie Dreier, and Duncan Phillips. In notable instances, collectors such as Gertrude Vanderbilt Whitney and John Quinn have not merely bought pictures but also have championed controversial and impoverished artists. The taste and prestige of these collectors have served as a fail-safe mechanism assuring a disinterested standard of judgment and keeping market excesses within bounds.

The dealer, too, has traditionally played an indispensable role as patron and tastemaker. Thanks to him, artists have been liberated from the dictates of both the aristocracy and the oppressive academies. Without the financial support and skillful promotion of leading dealers, any number of major artists would have been without either a livelihood or a reputation. Dealers, although obviously—and naturally—prompted by hope of gain, have taken care to provide artists with an assured income and access to buyers.

Nevertheless, the postwar art boom, by flooding the market with dollars, has all but shattered the older art world structure with its intricate array of checks and balances. In the early 1960s big-money auctions began to receive the kind of media attention usually reserved for Miss America contests; at the same time the discrimination of the connoisseur-collector began to be countered by the impersonal calculations of syndicates, investment trusts, and international consortiums incorporated in places like Liechtenstein. The

value of the Japanese yen became as much a factor as anyone's taste in setting art prices. Museums that had once mediated between the claims of scholarship and those of commerce now found themselves manipulated accessories of the art market. And bewildered artists were more than ever victims of a feast-or-famine cycle exacerbated by the critics' uncertainties about the nature of their art.

In a jeremiad written some months after the Robert Scull auction in 1973, art critic Harold Rosenberg protested in *The New Yorker*:

> The texture of collaboration between dealers, collectors and exhibitors has become increasingly dense, to the point at which the artist is confronted by a solid wall of opinion and fashion forecasts constructed, essentially, out of the data of the art market. The presence of this potent professional establishment has radically affected the relation, once largely regulated by the taste of patrons, of the artist to society and to his own product. He has been forced to recognize that the market-centered complex which determines values in art is a realm of chance, since the standards it sets are often influenced by conditions having nothing to do with art—for example, by the rise and fall of currencies—and that therefore success as an artist is both fortuitous and transitory. . . .
>
> Certainly art will not end as long as it is a trade in which it is possible, at no matter what odds, to do well. The market has its own mysteries and an accompanying glamour; an object made by hand which fetches more than five million dollars is a sacred entity in a money-venerating society and deserves to be worshipped for that reason alone; the crowds that line up for blocks at the doors of a museum to get a glimpse of a newly acquired masterpiece priced in the newspapers bear witness to a profound truth of our time. The convertibility of a Van Gogh or a Rembrandt into cash represents the essence of contemporary feeling about it. It may be that it is time to abandon not art but art criticism, which has anyway become little more than a shopping guide.[3]

As Rosenberg asserts, the rise and fall of currencies have had a great deal to do with the attraction of art as an investment hedge against inflation. When Impressionist and Postimpressionist paintings were first seen to fetch record prices, at a famous Paris auction in 1952, knowledgeable investors quickly seized the new opportunities. As early as 1955 *Fortune* magazine was advising its readers that art "can be the most lucrative investment in the world." [4] In a two-part series, "The Great International Art Market," the first major one of many such analyses, Eric Hodgins and Parker Lesley called attention to the profit potential and the tax advantages in purchasing art. One of the article's teasers summed up: "Calculating dealers, sure-eyed experts, believing buyers, combine with the majestic bene-

dictions of great museums to set values on the world's most precious art. Death and taxes come into it, too." [5]

Fortune divided the painting portfolio into "gilt edge," "blue chip," and "growth" or "speculative" issues. Heading the list of blue-chip artists was Picasso; his paintings, the article noted, had once gone for the franc equivalent of $100 but by 1952 were fetching as much as $60,000 to $75,000 apiece. Subsequent astronomic increases in the market value of Picassos confirmed the soundness of *Fortune*'s advice.

Few realize that it was not until the postwar art boom that Picasso's market worth came to approximate his reputation. According to the terms of his first contract, signed in 1912 with the dealer Daniel-Henry Kahnweiler, his paintings went to the gallery for 250 to 3,000 francs each (a franc was then worth about 25 U.S. cents), depending on size. Even in the period between the wars, when his preeminence in the School of Paris was universally acknowledged, he was not yet blue chip ("It's hard to get $20,000 even for the most beautiful Picasso," complained Paris dealer René Gimpel [6] in 1930).

In the 1950s Picasso's prices began to soar, culminating in 1968 in a record-breaking sale of seven of his paintings—telecast live in color—for a total of £427,000 at a London auction. A BBC correspondent rhapsodized, "Probably no artist in his lifetime has acquired the eminence, the stature, the wealth. . . . He has transcended the need for money." Three years later the National Gallery of Art in Washington paid a reported $1,100,000 for a Cubist painting by Picasso, said at the time to be the highest price ever paid for any work by a living artist.

The question of how much Picasso's Picassos were worth was addressed in a 1961 article in *Horizon* by Alfred Frankfurter, the editor of *Art News*. He put the value of Picasso's holdings of his own work —some 550 paintings at his Cannes estate and another 500 or so elsewhere—at a minimum of $10,000,000. [7]

By the time the painter died in 1973, at the age of ninety-one, Frankfurter's estimate proved to have been hilariously conservative. Maurice Rheims, France's leading appraiser, conducted an extensive inventory and came up with a figure for the estate of 1,251,673,000 francs, or approximately $250,000,000. Included in this total was the current market worth of some 45,247 objects, among them 1,876 paintings, 1,355 sculptures, 2,880 ceramics, and approximately 39,000 prints and drawings. For all his roots in the anarchosyndicalist tradition of Spain—and its dedication to the idea that property is

theft—Picasso wound up leaving an estate comparable to that of a Howard Hughes or a J. Paul Getty.

Certainly by comparison with his most famous contemporary creators—Chaplin, Mann, Stravinsky, Malraux, and Hemingway—Picasso demonstrated that even without benefit of royalties an artist could amass a far greater fortune than could writers, composers, or actors. Better than anyone, he had demonstrated the soundness of what *Fortune* called "the hard coin of art." Yet as Picasso would surely have been the first to agree, that quarter-billion-dollar figure told less about his importance as a painter than it did about the radical transformation of the art market.

FROM ACADEMY TO AUCTION

The art market has a long history but lacks a historian. To fix even the simplest facts requires scavenging in monographs and memoirs—which itself tells something about the curtained reticence of the art world. In 1967 a French sociologist, Raymonde Moulin, published an impressive analysis of the Paris arts economy, *Le Marché de la peinture en France*, but no such book has been published about London or New York.

However, two American scholars, Harrison C. White, a Harvard sociologist, and his wife, Cynthia, a Radcliffe-trained art historian, have analyzed the emergence of the French market as we now know it in *Canvases and Careers: Institutional Change in the French Painting World* (1965). The Whites ransacked the biographies of hundreds of artists in order to show how the present dealer system evolved and took form in nineteenth-century Paris as a consequence of the breakdown of the old academy tradition.

The Whites point out that until the beginning of the seventeenth century in France, the production of art was the jealously guarded prerogative of medieval guilds, which took care to monopolize the training of artists and the sale of their works. With the dismemberment of the feudal order by the ascendant nation-state, the old guilds were first challenged and then supplanted by a Royal Academy founded in Paris in 1648 and soon to be the capstone of a system of provincial academies. Academicians were recruited and ranked by a vigilant royal bureaucracy, and in time their work was exhibited regularly at juried salons; by the 1740s the first art criticism began to appear in newspaper articles and books (Diderot was to become the

most distinguished of salon critics). A centralized structure was thus already solidly established when the French Revolution infused the academy with a fresh dynamism.

Realizing the propaganda potential of art and eager to assert France's primacy in all fields of culture, Napoleon reshaped the academy into a superb machine for the production of art. Jacques-Louis David, a former member of the Royal Academy and an ardent Bonapartist, was one of the governing elite who spurred artists to glorify France in paintings depicting classical themes or the battles and heroes of the day. There was a prescribed ladder of advancement in the Ecole des Beaux-Arts, successor to the prevolutionary Ecole du Louvre, and an array of prizes and commissions to encourage spirited competition. The central proving ground was the Paris Salon, and as the decades passed—with France moving through successive empires, monarchies, and republics—the number of entries multiplied and the small army of artists swelled.

By 1863, according to the scrupulous census taken by the Whites, there were no fewer than 3,000 French artists who enjoyed some degree of national recognition. Not only was the prestige of Paris as the world capital of art acknowledged everywhere, but the total *oeuvre* of French artists was enormous. In each decade after 1850 some 200,000 canvases were produced by reputable French painters—an abundance that all but burst the capacity of the academy machine. Artists by their very fecundity had precipitated their own economic crisis.

(In their table detailing the production of paintings by four leading Impressionists, the Whites lend statistical eloquence to an endemic problem: The prolific Pissarro, in forty-eight years, turned out, 1,267 oil canvases, or an average of 26.4 a year; Sisley, 26.8 oil paintings a year; Manet, 9.9 oils; and Degas, 8.6 oils and pastels.)

The dealer system, as we know it, can in large part be attributed to the glut of paintings on the Paris market. Beginning in the 1860s, the Impressionists rebelled not merely against the aesthetic tyranny of the academy machine but also against its inadequate economic rewards. Just as the academy had displaced medieval guilds, so dealers would now displace the academy. According to a directory published in 1861, there were 104 dealers in Paris, about half of whom were grouped in the area around the Louvre. Of these dealers, the most farsighted were the Durand-Ruels, *père et fils*.

Jean-Marie Durand-Ruel (d. 1865) had opened shop in the 1820s as a vendor of artist materials, but very early on he became the ex-

clusive agent for the sale of the Barbizon landscapists and for Delacroix and Constable. Upon his death, his son Paul (1831–1922) expanded the business into an international operation with branches in London, Holland, Belgium, and Germany and later, as of 1886, in New York. Enlarging on the firm's past interest in antiques and *objets de luxe*, he concentrated on paintings and became the patron of the insurgent artists who, following the rebellious *Salon des Refusés* in 1863, came to be known as Impressionists.

Paul Durand-Ruel devised a new system in which he acquired the total output of a given artist—paying a fixed amount per canvas. His stable came to include Manet, Degas, Pissarro, Monet, Renoir, Sisley, and Cézanne. In promoting their work, he mounted elaborate shows, cultivated the critics, and persuaded the *haute bourgeoisie* that the Impressionists were not only great artists but also sound investments. By providing artists with an alternative to academy patronage, Durand-Ruel helped make possible the entire modernist movement. The Whites remark, "It was probably the sample of financial independence given them by Durand-Ruel from 1871–1873 that encouraged the Impressionists to disdain the Salon," [8] an observation corroborated by John Rewald in his definitive history of the Impressionist movement.

By the turn of the century, with the academy machine in fatal disrepair, dealer patronage was clearly in the ascendance. The tradition of Durand-Ruel was continued by Ambroise Vollard (1865–1939), champion of the Postimpressionists, and by Daniel-Henry Kahnweiler (1884–), champion of the Cubists. The accepted arrangement now was for a dealer, in exchange for exclusive control of the artist's output (the commission on sales was usually 30 percent), to furnish the artist with a fixed annual income, organize his shows, publish his catalogues, and plan his marketing strategy. The artist was thereby given a degree of economic security and the guarantee that his work would come to the attention of an informed, if not infallible, audience of patrons, collectors, critics, and scholars.

In the postwar era, however, the signs were unmistakable that the primacy of the dealers in the art world market was being threatened by the emergence of the auction galleries.

The art auction as an institution dates back to imperial Rome and was already a familiar occurrence in seventeenth-century Europe. As early as 1690 the first periodic sales were being conducted at Covent Garden in London. In 1766 the energetic James Christie founded the house that still bears his name, and in Paris auctions were already

well established. By the beginning of the nineteenth century the art auction had become the equivalent of the stock exchange for works of art. Since all transactions are public and all prices are meticulously recorded, the auction sale seemingly offers the most objective monetary appraisal possible of a work of art.

I say "seemingly" because anonymity, when desired, is customarily granted to sellers or buyers. Even if this practice did not exist, surrogates could always be employed to plant objects for sale or to stimulate a bidding competition. Dealers and collectors long ago discovered the value of using auctions to escalate prices, and record bids can be the result of a charade; by the same token, bidders can conspire to keep prices down (auction rings have flourished almost as long as auctions, but their existence is extremely difficult to prove).

Partly to protect clients from bidder conspiracies, auction galleries have agreed to fix reserve prices, whereby a consignor can set a minimum value on the object up for sale. The existence of a reserve price is nowadays generally made known, although the exact figure is seldom disclosed. When a lot fails to meet the reserve, the auctioneer plucks an invisible bid from the wall, without anyone present knowing that there has been a house buy-in, in which the lot reverts to the owner, minus the commission. (Both Sotheby Parke Bernet and Christie's deduct these buy-ins from their annual reports of total sales.)

Another hazard of using auction prices as an objective yardstick is the limited warranty as to their authenticity. Until recently auction galleries offered no guarantees and, in some well-publicized instances, have advised buyers saddled with fakes to resell them as original works. Reforms have since been instituted in London and New York; Sotheby Parke Bernet now provides a five-year guarantee on the authenticity, including authorship, of every item it sells, with the notable exception of paintings and drawings executed before 1870 (on these works the gallery warrants only that the art is an authentic product of the period and that any specific attributions represent no more than the best judgment of its appraisers).

Beyond these familiar caveats about auctions, there is another one less widely understood—that the galleries themselves have become active promoters of genres of art, ranging from photography to Victoriana and vintage automobiles. In new fields, then, auction firms can be found exploiting the apparatus of art historical scholarship in order to give the humblest object the semblance of uniqueness.

* * *

Among auction house pioneers in the new strategy was the English-born, Cambridge-educated Leslie A. Hyam, president of Parke-Bernet from 1950 to 1963. He knew little about art when he was hired in 1924 as an assistant cataloguer in the American Art Association, the firm that was to become Parke-Bernet. He quickly mastered the esoteric vocabulary of art history, partly by spending many of his off-duty hours in the library of the Metropolitan Museum of Art. During the 1930s he helped transform the Parke-Bernet catalogue into a lavishly illustrated affair replete with scholarly references.

In 1950 Hyam was named president of the gallery, which, although preeminent in New York, lagged far behind both Christie's and Sotheby's in worldwide sales. "Seventy-five percent of the great world fortunes are in the United States," Hyam complained to the press. "It's Americans who buy the great paintings in London and who set the prices. The idea that sellers get higher prices in London is British propaganda." [9]

Hyam saw an opportunity to prove this point in the 1961 sale of the estate of Mrs. Alfred Erickson, widow of the founder of McCann-Erickson, one of the largest advertising agencies in the world. Mrs. Erickson's will stipulated that her estate be divided into ninety equal parts—which gave her executors little choice but to put her celebrated art collection up to auction. Competition among galleries the world over was intense, but Hyam won out because he agreed to accept less than the standard 20 percent commission (the exact terms have yet to be divulged). He wanted and needed this sale to confirm the primacy of New York in the world art market.

By far the most important work in the Erickson collection was *Aristotle Contemplating the Bust of Homer*, Rembrandt's masterpiece that virtually epitomized Western cultural history. Its provenance was faultless: Commissioned in 1652 by a Sicilian grandee for 500 florins (about $8,000), it hung first in a palace in Messina, then in the castle of a British baronet, then in the Paris town house of a businessman whose fortune derived from South African investments. The great Duveen next acquired possession; he sold *Aristotle* to Mrs. Collis P. Huntington, the widow of the California railroad millionaire, and upon her death her son resold it to Duveen. In due course, it passed to Alfred Erickson, whose wife teased a generation of museum directors with the hope that the Rembrandt might eventually come their way. In that *Aristotle* provided a veritable synopsis of changing traditions in arts patronage, it was only fitting that it should find a final home in an American museum.

From painting to icon: crowds gaze at Rembrandt's *Aristotle* at its Metropolitan debut, following its purchase by the museum for a record $2,300,000 at a 1961 Parke-Bernet auction

On November 15, 1961, the Erickson collection went on the block. Again and again, the black-tie audience rose from their seats clapping as one auction record after another was broken. *Aristotle* was knocked down for $2,300,000, exceeding the auction record of $875,000 set the same evening by the sale of Fragonard's *La Liseuse* to the National Gallery of Art. In only an hour of bidding, the Erickson art had realized $4,679,250. Significantly, of the four final bidders for the Rembrandt, three were representatives of museums: the Metropolitan, the Cleveland Museum of Art, and Pittsburgh's Carnegie Institute (the sole private bidder was Baron von Thyssen, of Lugano, Switzerland).

But Hyam was less than elated. He made this remark to a writer preparing a history of Parke-Bernet:

> Who needs to care, since the outcome is inevitably successful? As long as we get the collections, the prices are like space mileage. And yet I continue to care about the outcome of sales, though there is something faintly deadly about it—atrophying, like the numbing effect of continually listening to an air hammer pulverizing asphalt. At the beginning, the money aspect was a kind of pestilence one endured. Later, it became ossifying. But I suppose the sound of an air hammer is only an amplified heartbeat against the thuds of the hammer's supposedly delicate ivory and the screams of the bid callers. To bear such anxiety indefinitely leaves one a cinder.[10]

Not quite two years later, on September 10, 1963, Hyam was found dead of carbon monoxide poisoning in a closed car. Within the year Sotheby's of London, which since 1949 had been attempting to buy out Parke-Bernet, finally acquired control. Presently a British staff moved in, and the restructured firm of Sotheby Parke Bernet soon became the single most important force in the world art market.

Sotheby's was by this time eclipsing its traditional London rival, Christie's, in annual sales, partly because of its adroit exploitation of the "£100 Rule." The rule had been framed in the 1950s by Stanley Clark, a salesroom correspondent for the London *Daily Telegraph,* who in examining auction statistics had discovered that about 60 percent of the winning bids at any auction went to lots costing less than £100. Clark resigned from the newspaper and joined Sotheby's as a publicist in 1959, not long after the appointment of a new chairman, Peter Wilson, an auctioneer renowned for his skill in stimulating bidders to feats of extravagance. Clark has remarked of that early period:

> Most people back then had never heard of Sotheby's of Bond Street. People who had wouldn't dare come in the door. They were afraid of art. Art was for Paul Mellon and J. Paul Getty. People didn't know that they could afford it. They had to be told. We had to go out and get collectors. Well, I suppose nobody had thought of it that way, and Peter Wilson put the principle into effect. We began to give importance to the £100 lots.[11]

Under Clark, Sotheby's vigorously publicized the lucrative returns possible on treasures lying in old attics, and a new, inviting nonelitist image of auctions took hold in the public consciousness. In 1971 the gallery opened another branch in the Belgravia section of London— involved with the sale of Victoriana, Art Nouveau, and Art Deco. According to the Sotheby Parke Bernet yearbook for 1970–71:

> What is intended is a sale room dealing in all aspects of Victoriana without prejudice, where pieces which are usually relegated in obscurity to poor sales, will receive the sympathy and crucial attention they deserve. The thoroughly unworthy equation of Victoriana with junk will, through the consistently high quality of the works sold at Motcomb Street, be shown to be inarguably false.[12]

At the Belgravia gallery the humblest items were dressed up in the formal parlance of art historical catalogue listings, such as:

A COLLECTION OF APPROXIMATELY SEVENTY TITILLATING POSTCARDS, Christmas Cards, etc., including three mobiles of girls with elevating legs, and various others with themes on sex and lust, also a view of the interior of Maison Frida, Budapest, *the majority coloured,* c. 1900–1915.

CRACKERS. A collection of thirty-three Boxes of Crackers, of various themes and seasons, including an unused Box of Gay Gordon Tin and Paper Crackers, Japanese Crackers and rare Emancipation Movement Crackers.

A WOVEN SILK SOUVENIR HANDKERCHIEF, entitled Exposition

Universelle d'Anvers en 1894, woven in orange silk and showing the front view of the Exhibition Buildings in Antwerp, contained within an envelope labelled *Tisse pure soie par Thomas Stevens, Stevengraph Works, Coventry (Angleterre).*[13]

By means of such cataloguing devices, which came to be widely emulated, Sotheby's was able to confer the prestige of art on objects the price of which made them accessible to a new collecting public. Bonnie Burnham, one of the few art historians to deal seriously with this phenomenon, remarks in her book *The Art Crisis*:

> An interesting feature of the new class of art buyers is their heavy dependence on the auction room to direct their taste. The dealer or adviser who counsels the major collector and trains his eye does not exist for the average new collector of firearms, Japanese prints, and netsuke. Instead, this collector learns to read the coded judgments of the auction house's experts and depends greatly on this expertise while his own connoisseurship develops. Thus he is most likely to expand his collection in the direction in which the auctions are increasingly placing their sales promotions. The auction house, which only fifteen years ago began to assimilate the non-professional, is today the undisputed center of the art market . . . and now surpasses the dealer in setting the market's new trends.[14]

There is an almost demonic genius in the auction-gallery sales strategy. On one level, there are the heavily publicized supersales at which price records are routinely broken and the belief is encouraged that art is truly the solid-gold muse, a fail-safe repository for the wealth of those anxious about taxes, international currency fluctuations, and the languid performance of common shares. At the same time, on another level, there are the sales that attract middle-income buyers, at which it is suggested that even a cracker box is a work of art and that the pleasures of connoisseurship are not the exclusive province of the rich. In mingling—some would say "confusing"—commerce and aesthetics, the auction house is at once democratizing and parodying the tradition of art historical scholarship.

THE UNIQUE COMMODITY

Art history as an academic discipline scarcely existed a century ago. Aesthetic theory was the province of amateurs such as James Jackson Jarves or of brilliant generalists such as John Ruskin. Attributions were so proximate that a prevalent joke held that Corot had painted 2,000 works, of which 5,000 were in the United States.[15] Moreover, museums everywhere proudly displayed plaster casts of

famous sculptures, some of which can still be found in dozens of their storerooms.

The perception of art changed as a result of an intellectual revolution most spectacularly personified by a single art historian, Bernard Berenson, and a single art dealer, Joseph Duveen, later Lord Duveen of Millbank. The two were symbiotically linked. Duveen joined the family art firm in 1887, and by the time of his death, in 1939, his name had become synonymous with the Old Master market. Through much of his career he sought to impress two facts on his clients: that only he had access to the greatest treasures and that only he had access to the expertise of Bernard Berenson.

Berenson, born in Lithuania, emigrated, along with his parents, to Boston in 1875. His precocity was already apparent at the famed Boston Latin School, and as an undergraduate at Harvard he quickly found patrons to finance a *Wanderjahr* in Europe. On a visit to Italy in 1888, he discovered his vocation: He would determine the authorship of Renaissance paintings and thus bring order out of chaos. In this, he was influenced by the pioneering work of Giovanni Morelli, an Italian scholar who had attempted to use systematic techniques in identifying the styles of various masters. In 1894, not yet thirty, Berenson published the first of a series of volumes on Italian art with an appended list of specific attributions.

Berenson thus became "that equivocal thing, an 'expert,' " meaning, as he remarked in his *Sketch for a Self-Portrait*, "I soon discovered that I ranked with fortune-tellers, chiromancists, astrologers and not even with the self-deluded of these, but rather with the deliberate charlatans. . . . I was supposed to have invented a trick by which one could infallibly tell the authorship of an Italian picture." [16]

In the best academic tradition, Berenson made his name by igniting a furious controversy. After examining an exhibition of Venetian art in London in 1895, he proclaimed that of the thirty-three paintings on display attributed to Titian, only one was by the master himself and that of the eighteen paintings attributed to Giorgione, not one was authentic. The furor caused by his verdict made it clear that Berenson was indeed someone to be reckoned with. The attendant notoriety was of considerable help to him since he was at the time serving as a scout for American collectors, most notably for Isabella Stewart Gardner of Boston (with his counsel, she assembled at bargain prices a collection of masterpieces of world importance).

In 1907 Berenson, by then married, purchased I Tatti, an imposing Renaissance villa at Settignano overlooking Florence, and his ex-

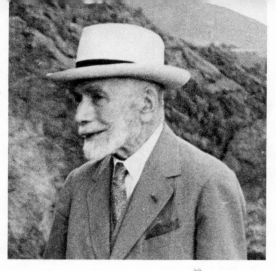

Bernard Berenson, during a
Sicilian holiday in 1955,
a legend at twilight

penses necessarily increased. After meeting Duveen the following
year, Berenson was soon providing him with advice for substantial
fees. It is not easy to determine the precise financial arrangements.
According to Sylvia Sprigge, a biographer of Berenson, the scholar
received a salary of £20,000 a year plus a 10 percent commission
on every picture sold that he had authenticated. The source given
for this is Duveen's daughter, Mrs. Dorothy Burns, but a different
account is offered by Edward Fowles, who spent a lifetime working
for the dealer and who inherited control of the gallery following
Duveen's death. In *Memoirs of Duveen Brothers*, appearing posthu-
mously in 1976, Fowles says that Berenson received a share of the
firm's profits on the sale of Italian paintings, the total in the single
year of 1927 netting him £38,600, or $190,000. However, Berenson
was unhappy because some paintings had been sold at a loss, and
pressed in that year for an annual retainer of £10,000 ($50,000),
with an additional 10 percent on the price of any Italian paintings
bought by Duveen, with the exception of certain Titians and Ra-
phaels, on which he would accept a lower fee.

The rewards were in any event princely, and with this money
Berenson was able to turn I Tatti into a cosmopolitan shrine, to which
over the years the great and cultivated of the world came like pil-
grims.

Ironically, although he owed his fortune in large measure to his
uncommon skill at making attributions, Berenson came to care in-
creasingly less about the specific authorship of a painting and more
and more about its intrinsic quality. Yet he himself had been a great
influence in convincing collectors of the importance of an artist's
name attached to a particular painting. It was over this issue that he
broke with Duveen in 1935. The dealer had been trying to persuade

Andrew Mellon to buy *The Adoration of the Shepherds*, which he claimed was by Giorgione; Berenson insisted with equal vehemence it was by Titian, whose works were far less rare, and Mellon decided not to buy. (The *Adoration* was subsequently purchased as a Giorgione by Samuel H. Kress and today hangs in the National Gallery of Art over Giorgione's name.)

Berenson's discomfort about his dependence on Duveen can be gauged from the fact that nowhere in any of his writings did he mention Duveen's name. When interviewed by S. N. Behrman, who was writing a biography of Duveen, he remarked icily that the art dealer had stood at the center of a vast nexus of corruption reaching from the lowest-level employee of the British Museum to the Buckingham Palace itself. However, this characterization did not appear in Behrman's masterful biography but rather in *People in a Diary* (1972). The author, recalling that he was "rather shocked," went on to remark: "After all, he was describing his partner. When your partner is at the center of a corrupt nexus how then do you keep yourself free of centripetal suction?" [17]

The nature of Berenson's relationship to Duveen and the art market remains unclear, even though a good deal has come to light since Berenson's death at the age of ninety-four in 1959. Two of his protégés, Kenneth Clark, now Lord Clark of Saltwood, and John Walker, have given different accounts of the relationship between Berenson and Duveen, suggesting how ambiguous the art market can look when viewed from the perspective of the museum professional.

The young Kenneth Clark, newly down from Oxford, went to live at I Tatti in 1926 upon becoming Berenson's assistant. Within a decade he was serving as director of the National Gallery in London. In his memoirs, *Another Part of the Wood*, Clark depicts Berenson as flawed and compromised:

> We may charitably suppose that when he began working for dealers, Berenson did not realize what kind of a jungle he was entering. Perhaps he imagined that, with his superb intelligence, he could look after himself, just as a great rifle shot might believe he could penetrate the Mato Grosso. He could not have foreseen the density of the forest, the hidden pitfalls and the poisonous tendrils that were to enmesh him, and make freedom of action almost impossible.[18]

John Walker, just out of Harvard and with the warm endorsement of Paul J. Sachs, succeeded Kenneth Clark in 1931 as Berenson's assistant. Later he joined the National Gallery of Art in Washington, D.C., where he proceeded to make his whole career, first as a curator

and then as the director until his retirement in 1969. In his memoirs, *Self-Portrait with Donors*, Walker all but ignores both the jungle and Berenson's part in it:

> From frequent conversations with him on this subject [the art trade] I believe, apart from Mrs. Gardner and possibly a few early commissions, he had nothing to do directly with the sale of works of art. There may have been exceptions to this statement, but I know of none. He did, however, receive from Duveen Brothers a retaining fee, as a lawyer would from a client, and for this remuneration he advised on the purchase of Italian paintings and wrote "certificates" authenticating and sometimes unduly praising these pictures.[19]

The pity is that Berenson himself never wrote of the ethical complexities of his position; when it comes to the art trade, there is a large, loud silence in his writings, even in his private diaries, at least as they exist in their published form. As the most celebrated art historian of his time, working with the most celebrated art dealer, Berenson powerfully encouraged the belief that a scholar's imprimatur was necessary to confirm the authenticity of a work of art. This expectation is now so widely held that auction catalogues, as we have seen, take care to provide the simulacrum of art historical scholarship, bestowing the prestige of uniqueness on every lot. Buyers wish to believe that a work of art is genuine and that it fits somewhere in an ordered canon of scholarship stretching back to the painted cave of Lascaux.

Neither by precept nor in his books did Berenson furnish a guide for the scholar and curator seeking to limn the boundary between proper collaboration and improper complicity with the art trade. Museum curators have had to learn, through trial and error and often at some cost, about the continuing moral quandaries that may arise from their institution's link to an expanding art market.

DEALERS OR COLLECTORS?

There is a long tradition of honorable collaboration between private art dealers and public galleries. Without the assistance of dealers, who are often the only ones to have a full record of works of art in private collections, many important exhibitions could never have been organized. Dealers also have been generous in lending their own stock-in-trade for special shows (although they benefit plainly from museum validation) and in providing curators with information. Moreover, they have in their day made spectacular benefactions: Duveen, for one, underwrote the construction costs of entire galleries

at the British Museum, the Tate Gallery, the National Gallery, and the National Portrait Gallery in London. (His generosity nonetheless piqued Osbert Sitwell to demur: "It is an ironical reflection that while Lord Duveen's magnificent gifts to the nation stand as a memorial to his name, much of the money that paid for them was earned by the sale to the United States of the flower of eighteenth-century and early nineteenth-century English paintings. We have the galleries now, but no pictures to hang in them." [20])

By and large, museums have been wary of speaking publicly about their collaboration with dealers. In 1974 Thomas Hoving broke with this tradition by mounting a Metropolitan show called "The Grand Gallery," which featured the wares of 137 dealer-members belonging to La Confédération Internationale des Négociants en Oeuvres d'Art (CINOA). In the catalogue preface, Hoving paid tribute to dealers as "patrons, researchers, gamblers, detectives, and performers," whose services were of great and lasting value to museums. Shortly afterward he announced that the Metropolitan was changing its policy and would from then on divulge the identity of dealers in the published provenance of the works it acquired.

But not all dealers are members of CINOA and as such clearly distinguishable as merchants of art. An adage in the trade worth paying attention to is that every collector is a potential dealer; indeed, the boundaries between collector and dealer have blurred as soaring prices tempt the collector to realize windfall gains.

In 1971, for example, Jonathan Holstein, a leading collector of American folk quilts, paid a visit to the Whitney Museum of American Art and showed curators a packet of color slides of his collection. Intrigued by the abstract patterns of the quilts, which seemed to foreshadow various modernist styles, the Whitney staff agreed to sponsor an exhibition of quilts drawn primarily from Holstein's collection.

But Holstein is a dealer as well as a collector, and the Whitney show was therefore of inestimable importance in establishing folk quilts as a desirable art form to collect. In *Quilts in America*, Patsy and Myron Orlofsky remark of the show: "An impetus to the new status of quilts was given by the Whitney Museum of American Art in 1971, in an exhibition of quilts from the collection of Jonathan Holstein and Gail van der Hoof. . . . The success of the Whitney show was repeated in 1972 in major museums throughout Europe. Europeans are enjoying and collecting American quilts as avidly as Americans." [21]

Questioned about the quilt show, Thomas Armstrong, director of

the Whitney, told the author: "It was a summer show, a throw-away. None of us at the museum owned quilts, or knew much about them, and this couple walked in with color slides. The show got no attention at all until the fall." [22] A Whitney trustee (and biographer of Jackson Pollock), B. H. Friedman, enlarged on the matter: "To some extent in the quilt show, maybe the Whitney was used. But I object more to the pressure to show private collections. The public interest was served in the quilt show, at least in the broad sense. The catalogue made it clear that it was a private collection. The museum staff allowed itself to be exploited. Private collections are another, and bigger, problem—I know museum people who are working almost full time to help form art collections, with their eyes open." [23]

All things considered, the quilt show was significant as a portent of the pressures that an expanding art market has imposed on the museum. As fields of collecting widen and potential buyers feel the need to be reassured that such items as Navajo rugs, Victorian photographs, Tiffany lamps, and "tramp" art are worthy of scholarly attention, the issue of museum validation becomes acute. For this reason, auction galleries try to time major sales to coincide with museum exhibitions; a good example is the 1971 Parke-Bernet sale of the Green Collection of American Indian Art, which took place just as the Whitney Museum was opening "Two Hundred Years of American Art," the largest show of its kind held in New York since 1941.

B. H. Friedman called attention to a museum's problems in dealing with difficult collectors, but he was reluctant to name names. But museum professionals in private conversation single out Robert C. Scull, operator of a New York City taxi fleet, whose museum-validated art collection realized $2,242,000 at a circuslike Sotheby Parke Bernet auction in 1973. During the 1960s Scull and his wife, Ethel, attracted attention by their venturesome patronage of New York artists who were just then becoming known. The Sculls were good newspaper copy—bright and flashy and totally infatuated with contemporary art. They were courted as well by museum curators, who petitioned them for loans from their growing collection and also offered tips on promising new artists.

The Metropolitan Museum invited a critical squall in 1968, when it exhibited, next to David's *Death of Socrates* and Poussin's *Rape of the Sabines,* James Rosenquist's *F-111,* an enormous panel painting expressing the artist's disgust with the military-industrial complex. The painting was owned by the Sculls, and the Metropolitan went so

Robert Scull, entrepreneur
and sometime patron,
with Alfred Leslie portrait

far as to allow Scull to expound his views on art in its *Bulletin*. The following year, for "New York Painting and Sculpture: 1940–1970," the museum borrowed extensively from the Sculls' art holdings; of 408 works chosen for the show by Henry Geldzahler, chairman of the museum's department of twentieth-century art, 18 were from the Scull collection. More and more museums requested loans, and Scull, realizing as never before that he owned a fortune in art, decided to sell the entire collection for $2,000,000. A Munich art museum was interested—so was the Metropolitan—but the funds could not be found, even though Scull had offered to accept payment over a ten-year period.

Still lacking a museum buyer in 1973, Scull put fifty of the best works in the collection up for sale at Sotheby Parke Bernet. The ensuing auction captured worldwide attention and set a sale record for contemporary American art (it also became the subject of a documentary television program backed by Robert Scull). Two ale cans by Jasper Johns, for which the Sculls had paid $960, went for $90,000, and a Johns painting, *Double White Map*, for which they had paid $10,200, went for $240,000. Behind the sale were months of planning; a precise seating arrangement for invited bidders had been worked out with gallery experts so that likely contenders would be literally pitted against one another.

Most artists whose work the Sculls had collected refused to attend. But immediately after the sale, one of them, Robert Rauschenberg, stormed across the auction room and struck Scull in the stomach. "I've been working my ass off just for you to make that profit," Rauschenberg exclaimed (one of his works for which the Sculls had paid

Scull auction at Parke-Bernet in 1973

$900 in 1960 had just been sold for $90,000). Scull's reply—that in the end all artists would benefit from the publicity the sale was sure to receive—made no converts to his side.

But if anyone had been working "their asses off" for Scull, it was the curators and directors of leading museums, who had opened their collections to the collector. Sotheby Parke Bernet had taken care to record in the sale catalogue the name of every museum that had ever exhibited a Scull loan, and a majority of the art on the block had been shown at one or more art museums. A total of $550,000 was realized for seven works exhibited at the Metropolitan's "New York Painting and Sculpture" and ten works that had been exhibited at MOMA fetched a total of $487,500. Eight works that had graced the Whitney Museum were knocked down for a total of $269,500. The gross for works shown at these three museums was $1,607,000.

Museum curators, not being mind readers, are at as much of a loss as other people in trying to distinguish between the serious collectors and the dealers *manqués*. The only trouble is that curators, in an excess of enthusiasm, may fail to take adequate precautions, one instance being the Metropolitan Museum's decision to sponsor the 1973 exhibition of Allen Funt's Alma-Tademas.

Funt, creator of television's *Candid Camera*, was in the process of redecorating his New York apartment when he serendipitously came upon the long out-of-fashion canvases of Sir Lawrence Alma-Tadema (1836–1912). When he had bought his first Alma-Tadema, *The Voice of Spring*, a typical overblown and sentimentalized Roman bath scene, he discovered that Ruskin had once called Alma-Tadema the worst painter of the nineteenth century. "How did it happen,"

Robert Scull, entrepreneur
and sometime patron,
with Alfred Leslie portrait

JACK MITCHELL

far as to allow Scull to expound his views on art in its *Bulletin*. The
following year, for "New York Painting and Sculpture: 1940–1970,"
the museum borrowed extensively from the Sculls' art holdings; of
408 works chosen for the show by Henry Geldzahler, chairman of
the museum's department of twentieth-century art, 18 were from the
Scull collection. More and more museums requested loans, and Scull,
realizing as never before that he owned a fortune in art, decided to
sell the entire collection for $2,000,000. A Munich art museum was
interested—so was the Metropolitan—but the funds could not be
found, even though Scull had offered to accept payment over a ten-
year period.

Still lacking a museum buyer in 1973, Scull put fifty of the best
works in the collection up for sale at Sotheby Parke Bernet. The en-
suing auction captured worldwide attention and set a sale record for
contemporary American art (it also became the subject of a docu-
mentary television program backed by Robert Scull). Two ale cans
by Jasper Johns, for which the Sculls had paid $960, went for
$90,000, and a Johns painting, *Double White Map*, for which they
had paid $10,200, went for $240,000. Behind the sale were months
of planning; a precise seating arrangement for invited bidders had
been worked out with gallery experts so that likely contenders would
be literally pitted against one another.

Most artists whose work the Sculls had collected refused to attend.
But immediately after the sale, one of them, Robert Rauschenberg,
stormed across the auction room and struck Scull in the stomach.
"I've been working my ass off just for you to make that profit," Rau-
schenberg exclaimed (one of his works for which the Sculls had paid

Scull auction at Parke-Bernet in 1973

$900 in 1960 had just been sold for $90,000). Scull's reply—that in the end all artists would benefit from the publicity the sale was sure to receive—made no converts to his side.

But if anyone had been working "their asses off" for Scull, it was the curators and directors of leading museums, who had opened their collections to the collector. Sotheby Parke Bernet had taken care to record in the sale catalogue the name of every museum that had ever exhibited a Scull loan, and a majority of the art on the block had been shown at one or more art museums. A total of $550,000 was realized for seven works exhibited at the Metropolitan's "New York Painting and Sculpture" and ten works that had been exhibited at MOMA fetched a total of $487,500. Eight works that had graced the Whitney Museum were knocked down for a total of $269,500. The gross for works shown at these three museums was $1,607,000.

Museum curators, not being mind readers, are at as much of a loss as other people in trying to distinguish between the serious collectors and the dealers *manqués*. The only trouble is that curators, in an excess of enthusiasm, may fail to take adequate precautions, one instance being the Metropolitan Museum's decision to sponsor the 1973 exhibition of Allen Funt's Alma-Tademas.

Funt, creator of television's *Candid Camera*, was in the process of redecorating his New York apartment when he serendipitously came upon the long out-of-fashion canvases of Sir Lawrence Alma-Tadema (1836–1912). When he had bought his first Alma-Tadema, *The Voice of Spring*, a typical overblown and sentimentalized Roman bath scene, he discovered that Ruskin had once called Alma-Tadema the worst painter of the nineteenth century. "How did it happen,"

Funt wondered aloud, "that I should have selected a painter, without advice or guidance, and come up with the work of a guy who ranked last of all the artists of his time?" [24]

Two of Alma-Tadema's most famous works, *The Finding of Moses* and *The Roses of Heliogabalus*, had brought only £250 and £105 at a Christie's auction in 1960. But the English scholar Michael Levey, noting that interest in Victoriana was rising, made this shrewd forecast in 1965: "Alma-Tadema has undergone a slight, scholarly regeneration; and his stock will probably rise. Indeed, it needs only a couple of museums or collectors to start a sale-room duel over some bit of posturing classical tushery by him, and one's own Alma-Tadema in the attic may well become a thing of beauty, gilt-edged." [25]

Funt proceeded to acquire more and more of the artist's work; soon enough, publicity being what it is, there were newspaper features describing his hobby, and Funt had become the unlikely agent of Alma-Tadema's rehabilitation. Still, he was astonished to be asked in 1972 to lend his collection for a full-scale show at the Metropolitan. In the considered opinion of Everett Fahy, then the museum's curator of European paintings and now the director of the Frick Collection, the benefits to be derived from bringing together in one gallery a number of works by a forgotten artist outweighed the possible embarrassments. The main risk was that Funt would turn around and immediately sell his collection; this, in fact, he did (in all fairness, he needed the money since he had recently been defrauded of $1,200,000 in *Candid Camera* profits by his longtime accountant, who later committed suicide).

"I had been thinking of selling them," Funt has said of his Alma-Tademas, "but this sweetened it. An exhibition at the Met, wow!" [26] Funt, in fact, had volunteered to pay part of the cost of producing the forty-eight-page exhibition catalogue. Six months later he dispatched thirty-five Alma-Tademas to Sotheby's Belgravia gallery. They were hammered down for $570,000. To fill the gaps they had left on the walls of his New York apartment, he commissioned photographic blowups of them. He later maintained that the copies were every bit as satisfactory to him as the originals had been.

A CONFUSION OF VALUES

With the Scull sale and the Funt comedietta very much in mind, Harold Rosenberg lamented in *The New Yorker* in 1973 that "art exists, but it lacks a reason for existing except as a medium of ex-

change, a species of money." On the responsibility of scholars and curators, Rosenberg had this to say:

> Since the rise of art history, in the nineteenth century, art historians have been directly linked with the market prices of paintings and sculptures because of their authority in deciding attributions. By the 1970s, art history, having achieved the leading role in the day-to-day life of art, had overgrown all its theoretical boundaries and gone to seed; it was now prepared to put the stamp of value on anything, not excluding publicized fakes.[27]

At bottom, there is an unfortunate confusion of values surrounding every aspect of art museum operations—a confusion to which the museum profession is only belatedly beginning to address itself in a systematic manner. The plain and simple fact of the matter is that the art museum is not a department store and that although many in the marketplace may view art as "a species of money," the museum can only betray its mission by encouraging such an attitude. The market is there, and the museum cannot possibly divorce itself completely from it. But the museum must strive both to keep an arm's-length distance from commerce in art and to avoid even the appearance of lending its prestige or imprimatur to speculation in art.

If these admonitions are accepted as policy goals, the implications will extend to sensitive areas of museum administration, including the limitations that should be placed on collecting by museum personnel and on an institution's negotiations with art dealers.

For decades the matter of collecting by curators has been the subject of anxious debate within the museum profession. If a curator collects in the same field as the department in which he works, he is obviously wearing two hats. He encounters the same dealers in his private life as he does in his institutional capacity—and it would be asking too much to expect the dealer to overlook the strategic circumstance. The dealer on his part, concerned with winning the goodwill and patronage of the institution, is usually no less eager to cultivate the curator. Thus, the curator may find himself in a position to enlarge his personal collection at bargain prices.

A still unresolved lawsuit in New York underlines the seriousness of this kind of conflict of interest. In early 1978 a civil conspiracy suit was filed by the New York Attorney General's Office against Michael Kan, former acting director of the Brooklyn Museum, and three Manhattan art dealers, James Economos, Robert Taylor, and Douglas Ewing; it was charged that Kan, in his earlier position as curator of primitive art at the museum, had traded to dealers museum

art appraised at approximately $750,000 for new accessions appraised at only $35,000. Kan, who left Brooklyn in 1976 to become deputy director of the Detroit Institute of Arts, entered a categorical denial of all charges, as did the three dealers named in the suit. It should be noted that the Chinese-born Kan is respected by museum professionals for his curatorial expertise and, further, that the case against him was developed by Joel Cooper, the assistant attorney general who had successfully prosecuted the case against the Museum of the American Indian.

Not in dispute is the fact that Kan, a collector of ethnographic art, had dealt privately with Economos, the chief beneficiary of the three trades involving thirty-eight American Indian artifacts, which Kan had negotiated on behalf of the museum in 1972–73. Appearances were not favorable to Michael Kan.

By coincidence, as the Kan case became public, a Committee on Ethics of the American Association of Museums was completing its recodification of professional standards for submission to the annual AAM meeting in May 1978. The existing code of ethics had been adopted in 1925, an era of genteel collaboration between museums and the art market. In 1974 the AAM had established a Committee on Ethics, later expanded to represent the full spectrum of museums. Prominent art museum figures on the twenty-member committee, chaired by Giles W. Mead, director of the Natural History Museum of Los Angeles County, included Thomas Messer, director of the Guggenheim Museum; Michael Botwinick, director of the Brooklyn Museum; Charles C. Cunningham, Jr., a trustee of the Boston Museum of Fine Arts; and William A. Fagaly, chief curator of the New Orleans Museum of Art. The legal editor was Alan D. Ullberg, associate general counsel of the Smithsonian Institution.

The AAM Committee on Ethics arrived at the following formulation in regard to curatorial collecting:

> The acquiring, collecting and owning of objects is not in itself unethical, and can enhance professional knowledge and judgment. However, the acquisition, maintenance and management of a personal collection by a museum employee can create ethical questions. Extreme care is required whenever an employee collects objects similar to those collected by his museum, and some museums may choose to restrict or prohibit personal collecting. In any event, the policies covering personal collecting should be included in the policy statements of each museum and communicated to its staff. . . .
>
> Museum employees must inform the appropriate officials about all personal acquisitions. They also must disclose all circumstances regard-

ing personal collections and collecting activities, and furnish in a timely manner information on prospective sales or exchanges.

A museum's policy on personal collecting should specify what kind of objects staff members are permitted or not permitted to acquire, what manner of acquisition is permissible, and whether different types of employees have different rights. Policy should specify the method of disclosure required for the staff member. . . .

No museum employee may use his museum affiliations to promote his or any associate's personal collecting activities. No employee may participate in any dealing (buying and selling for a profit as distinguished from occasional sale or exchange from a personal collection) in objects similar or related to the objects collected by the museum. Dealing by employees in objects that are collected by any other museum can present serious problems. It should be permitted only after full disclosure, review and approval by the appropriate museum official.[28]

The code is quoted here *in extenso* because it constitutes the fullest and most authoritative expression by the museum profession on a question that boards of trustees have by and large been wary of confronting directly. One outcome of adopting a museum policy on staff collecting, as the AAM committee is urging, would be to force trustees to consider their own collecting activities in a new light.

All too familiar a process in the art world is the election of a prominent collector to a museum board; the museum in question is, of course, not without hope that it will eventually acquire all or part of the collector's treasures. Trustee-collectors, simply by participating in museum deliberations about purchases, exhibitions, and deaccessioning proposals, are privy to inside information about the art market. Furthermore, the museum staff as general practice furnishes advice to trustee-collectors, in the expectation that such aid will be remembered when it comes time for the trustees to dispose of their collections.

Dealers are rarely elected to museum boards—and with good reason. The possible conflict-of-interest hazards were amply in evidence when Duveen served as a trustee of the National Gallery in London during the 1930s. Kenneth Clark, the director at the time, relates:

He saw all the pictures sent in to the Gallery for us to consider. If they came from rival dealers he was naturally hostile to them, and in consequence dealers were unwilling to submit them, and several very famous pictures were lost to us. If they came from private collectors his professional interests were aroused. A man of great detachment and integrity would have seen the difficulties of the position, but Duveen was controlled solely by instinct and appetite, and was confident that his charm and generosity would get him out of any troubles.[29]

Clark goes on to describe how Duveen, acting resourcefully in his own interests, intercepted an offer to purchase seven Sassetta panels from collector Clarence Mackay. After this, Clark set out to prevent the reappointment of Duveen to the board in 1936, in the end taking the case to Prime Minister Neville Chamberlain; Duveen was not reappointed.

But trustee-collectors pose even more difficult policy questions than do trustee-dealers. It would be an almost mortal affront to the connoisseur-collector to imply that in acquiring art, he was in any way motivated by a desire for gain. Nevertheless, museum boards must define the degree to which curators may advise trustees on acquisitions, and they must also codify the restraints that trustees should impose on themselves in negotiating with dealers.

Some trustee-collectors themselves are confused. Oil centimillionaire Charles B. Wrightsman is a good example. Wrightsman and his second wife, Jayne, have served successively as Metropolitan trustees since 1956, and each has been a member of the acquisitions committee. The couple has assembled an impeccable collection of the decorative arts and over the years the Wrightsmans have given generously to museums, especially the Metropolitan. (John Walker devotes a fulsome chapter of his memoirs to the Wrightsmans, in which he characterizes Mrs. Wrightsman's instinctive love of beauty as "a spark ready to burst into flames." [30])

In 1963 the Wrightsmans sued for a refund of $34,309 on their federal income taxes for 1960 and 1961 on the unprecedented grounds that their art purchases were an investment, not an avocation. What they were seeking to establish was that all maintenance and incidental expenses connected with collecting should qualify as deductible items. (One of the deductions claimed was the purchase of flowers for $16.38 and presented to John Walker.) A trial commissioner upheld the claim for deductions in the amount of $24,273. In 1970, however, the claim was overturned in a court of claims ruling.

In *Wrightsman* v. *the United States*, Judge Don N. Laramore took note of the trial record, which clearly documented that the Wrightsmans had gone to considerable expense in the care, cataloguing, and display of their collection in their New York and Palm Beach houses. He took note as well of the amount of time they had devoted to assembling the collection and to educating themselves on the minutiae of French eighteenth-century furniture and other specialized fields. He further noted that the Metropolitan Museum was in the process of publishing a five-volume work on the Wrightsman collection. Judge

Laramore conceded that there was solid evidence that Wrightsman saw in art a sound hedge against inflation and currency devaluation. Nonetheless, he concluded that even if there were *an* investment purpose, "the evidence does not establish investment as *the* most prominent purpose for plaintiffs' acquiring and holding works of art. The complete record *does* establish, to the contrary, personal pleasure or satisfaction as plaintiffs' primary purpose." [31]

Ironically, the honor of the Wrightsmans, and by implication of other trustee-collectors, was upheld by their losing rather than winning a court case. If the tax commissioner's initial ruling in their favor had been upheld, every trustee-collector would have been placed ipso facto in an indefensible conflict-of-interest position; in the eyes of the law, their status would have been diminished to that of speculators.

Another area of confusion concerns the museum's relations with dealers. The essential problem was underscored in the most sensational of modern lawsuits involving art, the "Matter of Rothko." In December 1975, New York Surrogate Millard Lesser Midonick handed down an eighty-seven-page decision in the Rothko case, upholding the claim of Rothko's daughter, Kate, that the assets of the estate had been wasted by executors, who had negotiated a contract with Marlborough Galleries that was riddled with self-dealing. The surrogate ordered the removal of the three executors, voided the agreement with Marlborough, and assessed the defendants jointly and severally a total of $9,252,000 in damages, including a $3,300,000 fine (later increased to $3,800,000) against Marlborough, and its head, Frank Lloyd, for violating a court order in illegally shipping art out of the United States.

The Rothko case was as tangled, complex, and interminable as *Jarndyce* v. *Jarndyce* in Dickens' classic attack on legal obscurantism in *Bleak House.* But from the innumerable articles and Lee Seldes's day-by-day account of the trial, *The Legacy of Mark Rothko,* one point seems clear—a point borne home by the author's own conversations with curators and dealers—namely, that the nominal culprits were stunned by the verdict because they had felt they were playing by the accepted rules of the game. In the higher reaches of dealing, a measure of collusiveness is taken for granted; that a New York judge would literally apply strict conflict-of-interest standards was seen by many insiders as absurdly purist and meanly vindictive.

For all his flamboyance, Frank Lloyd is different in degree but not in kind from his sometimes no less flamboyant predecessors,

such as Duveen. What Lloyd has done is to employ on a grander scale many of the devices pioneered by earlier dealers, beginning with the Durand-Ruels. A Viennese refugee who wound up in London, Lloyd in 1946 teamed up with a fellow émigré, Harry Fischer, to found an Old Bond Street gallery that they called Marlborough, after the duke. (Very shortly, the gallery had as a director Lord David Somerset, the nephew of a real duke, the Duke of Beaufort.)

Originally, Marlborough concentrated on the Old Master field, but in the 1960s, fearing that supplies were dwindling, Lloyd made a spectacular entry into the market for contemporary art. Marlborough snapped up such modern masters as Henry Moore, Francis Bacon, Graham Sutherland, and Barbara Hepworth in England, and later came to represent such major American artists as Larry Rivers, Morris Louis, and Mark Rothko, and the estates of Jackson Pollock and David Smith. To clients, Marlborough offered the attractive inducements of generous annual payments (staggered, if needed, by way of Swiss banks), lavishly produced catalogues (with prefaces by eminent scholars), and international exposure in a chain of galleries that very soon extended from Tokyo to Toronto, Rome to Zurich, London to New York. Each entity was within an interlocking pyramid of holding companies with corporate roots in Vaduz, Liechtenstein (for his part, Lloyd, partly for tax reasons, made his home in Paradise Island, in the Bahamas).

In person, Lloyd, not unlike Duveen, liked to play the buffoon. A famous one-liner attributed to him—"I collect money, not art" —disguised the more complicated truth, that he had an eye for quality but was also aware that many of his customers, unsure of their own taste, were receptive to such calculated self-mockery. Moving in a world where hundreds of thousands of dollars changed hands with an informal handshake, the dealer was frankly insensitive to abstract notions of self-dealing or conflict of interests.

As the Rothko case demonstrated, Lloyd did not think it improper to arrange for the purchase of works from the artist's estate —Rothko had committed suicide in 1970—from one executor who was a Marlborough artist, and from another who was an officer in the firm's New York gallery. That the arrangement misfired was due to the accident of a daughter's stubborn legal challenge. Rothko, for reasons that still remain obscure, bequeathed the bulk of his estate to a foundation, and thus the case also came to involve as co-plaintiff the Office of the Attorney General of New York State,

Frank Lloyd, dealer extraordinaire

JACK MITCHELL

an unfortunate circumstance for Lloyd, since that office took an active role in the litigation.

Lloyd's insensitivity cost him dearly. On the heels of the surrogate's decision, in March 1977 New York City District Attorney Robert M. Morgenthau announced that a grand jury had found the dealer indictable on two counts of tampering with evidence, and that a warrant had been issued for his arrest. Lloyd's last known public appearance in New York was at the March 1975 opening of a Francis Bacon exhibition at the Metropolitan Museum of Art, only one of the many shows that had involved museum collaboration with Marlborough.

The risks of serious embarrassment in museum collaboration with high-rolling dealers in an exuberant market were dramatized by the Rothko case. In the wake of the verdict, some contended that Lloyd's behavior demonstrated the need of establishing something like a Securities and Exchange Commission to regulate the commerce in art. The trouble with the argument is that the creation of any such body would be the final vindication of what Frank Lloyd personifies—the notion that art is a negotiable security, its worth measured by dollars. In effect, museums are, or should be, a force for restraint, sustaining the contrary approach: that in art, what is good is not necessarily what sells. Embroiled in an art market as they are, museums need not lend their prestige to its excesses, or succumb to the *Zeitgeist* of collusion.

CHAPTER

⚜ VI ⚜

THE SOVEREIGN COLLECTION

═══════════════════════════

> The chase and the capture of a great work of art is one of the most exciting endeavors in life—as dramatic, emotional, and fulfilling as a love affair. And love affairs, at least some of them, should be told about.
>
> —THOMAS HOVING (1975)

LA CHASSE

AS A COLLECTING INSTITUTION, THE AMERICAN ART MUSEUM CAN be described only in the superlative degree. There is no parallel in history for the accumulation of so much art by so few for the pleasure of so many. To be sure, the kings and princes of Europe through plunder and purchase assembled fabulous collections, but they did so for the diversion of their courts and the glory of their dynasties. That the mass of their subjects had any inborn right of access to these collections was a notion that would not have amused. Even today in democratic Europe, vestigial monarchies hold private title to their art (when works from the British royal collection are exhibited or reproduced, it is always by gracious permission of Her Majesty the Queen).

In some cases, royal collections are dispersed without the knowledge, much less the permission, of the nations concerned. Prince Franz Joseph II of Liechtenstein, the last reigning Hapsburg, has for years been discreetly divesting himself of his holdings, the most sensational instance being his private sale of Leonardo's *Ginevra de' Benci* for perhaps $6,000,000 (the exact amount, by agreement with the prince, has never been divulged) to the National Gallery of Art in Washington, D.C. The sale was the culmination of a sixteen-year pursuit that almost cost the life of John Walker, the gallery's emeritus director.

As Walker relates the Graustarkian tale in his memoirs, *Self-Portrait with Donors*, he first glimpsed the Leonardo as a student on a visit to examine the collection in the prince's castle in Vaduz in 1931. Obsessed by the Da Vinci, Walker kept worried track of its movements during World War II, when it had to be stowed in the castle's wine cellar as an air-raid precaution. In 1951 he saw it again when it was on temporary loan to the National Gallery in London, and his wish to acquire the portrait for *his* National Gallery led to his making cautious inquiries in Vaduz. Nine long years later he was given permission to inspect the Leonardo again. He found it hanging on a nail in the deepest subcellar of the castle, in the company of other Hapsburg treasures deemed too precious to place on public view. On his return ascent of the stone stairway, Walker misjudged a step and plunged backward: "I had an instantaneous vision of my mangled body picked up just under Ginevra's portrait." [1] Instead, he was caught by the prince's curator, whom he credits with literally saving his life.

In the years that followed, there were rumors that the Leonardo was being sold—according to one report for $10,000,000. "We said immediately that this price was unrealistic," writes Walker. "A short time afterward we were told that the portrait could be bought at a somewhat lower figure. Then serious negotiations began, which lasted several years." [2] Finally, in 1966, a deal was struck, and the Leonardo portrait was placed in a container lined with Styrofoam, to cross the Atlantic by jet. A cabled message in code, "BIRD FLIES," alerted the National Galley to the painting's departure for JFK International Airport in New York. Soon the 210 square inches of painted wood, the most costly square inches in existence, were safely ensconced in the National Gallery. It was only when Walker made the announcement of the purchase that the people of Liechtenstein knew that their principality was minus a Da Vinci.

What might seem a matter for general rejoicing among American

museums caused gloom at the Metropolitan Museum; director Thomas Hoving remarked in 1967 to John McPhee of *The New Yorker*:

> When I learned the other day that the National Gallery had bought that Leonardo—the *Ginevra de' Benci*—for six million dollars, I couldn't sleep all night. We should have reached for it. The reputation of the Metropolitan has always been based on its power to acquire things without reserve. . . . If you lose that *one* day of going for the great thing, you can lose a decade. Any trustee should be able to write a check for at least three million dollars and not even feel it.[3]

The story of the Da Vinci crystallizes both the desirable and the questionable aspects of the art museum's preoccupation with *la chasse*. On the one hand, works of supreme importance that would otherwise be seen only by a favored few are made the common property of mankind. On the other hand, American art museums, buttressed by immense private resources and stimulated by tax incentives, despite an ostensibly common purpose, are impelled to vie like rival suitors for the favors of the all-too-fickle collector.

John Walker, speaking very much for his whole generation of museum professionals, acknowledges in his memoirs: "The greater part of my adult life has been spent collecting collectors who would, I hoped, become donors. This was my principal job as a museum curator and later as a museum director, positions I held for over thirty years." [4]

In 1970 the monthly journal of the American Association of Museums (AAM) published a "Museum Manifesto" by Joseph Veach Noble (subsequently director of the Museum of the City of New York and national president of the AAM), which he said was a rough consensus on institutional objectives.

Noble's paper placed acquisition first ("our lifeblood, our *raison d'être*")—ahead of conservation, study, interpretation, and exhibition.[5] The museum that shirked collection building, it went on to say, could be a useful exhibition gallery, but was not a museum. From the public vantage, there is surely a powerful case to be made for this belief.

Whenever a great work of art passes from private to public hands, it automatically becomes common patrimony, accessible to everyone both in its original form and through readily obtainable reproductions; the risk of loss or damage through theft or negligence is minimized, if not eliminated; and the work can be seen in an agreeable setting in a gallery that normally displays other objects of the same kind or period. Once in a museum, a work of art is a source of pride

to the community, of inspiration to the artist, and of nourishment to the scholar.

A further important argument for continuous collection growth is that the concept of excellence is never static. The fashionable art of one generation can seem an ugly curiosity to the next, and vice versa. To freeze a collection is to condemn it to sterility, to turn it into an ossified souvenir of yesterday's taste. If art is life-enhancing, it should be treated with the reverence due any living thing. A museum that ceases to grow is more a mortuary than a museum.

Still another consideration for many museums is the public gallery's obligation to recognize and encourage the superior art of the present. Given the importance of museum validation, a refusal to take chances on contemporary art amounts to a moral abdication. To this, there is a practical corollary: By buying when prices are low, a museum may hedge against a time when the works command exorbitant prices. (This can work both ways, of course: A museum may absurdly overpay for art whose prices have been inflated by fashion.)

At the same time, however desirable acquisition may be as the cardinal museum objective, there are psychological truths involved that must be taken into account. If few trustee committees are as popular as the one devoted to acquisition, it is in part because many board members are collectors and are therefore all the more inclined to impose their tastes on the museum. As for the curator, if he is career-minded he very rapidly discovers that his advancement may hinge on a spectacular acquisition.

The rise of Thomas Hoving can be dated from his success—at the time he was chief curator of The Cloisters—in persuading the Metropolitan's trustees to pay a reported $600,000 for an ivory cross he attributed to Bury St. Edmunds. In *The Chase, The Capture: Collecting at the Metropolitan*, Hoving described how he made the case for purchase to the board's acquisitions committee:

> My summation to the Committee was emotional. I spoke of how I had lived with the object for more than two years, of how my period of doubt had evolved to a period of no doubt at all. And I expressed my deep belief that the eccentric owner would not come down one penny from his price. Go for it, I pleaded. If you do not, this will constitute, without question, one of the darkest, most lassitudinous moments in the history of a great institution, one that has continually pledged itself to the acquisition of the finest works of art available in the world. . . . Then it was time for the Trustees to speak. Henry Luce expressed himself as convinced. "Let's take the opportunity," he

said. "Don't throw caution to the winds, but let us not, on the other hand, descend to hair-splitting. It's a summation, this cross, of an entire epoch of man's achievement both good and bad. It's an honest and splendidly frank thing. I'm for it." (Hurrah!) [6]

The committee approved, and the cross was purchased, despite doubts about its still-mysterious provenance.

So great is the pressure to make spectacular acquisitions that museums of the most august probity have taken unbecoming risks, the best-known instance being the purchase by the Boston Museum of Fine Arts in 1969 of a portrait attributed to Raphael. The painting was imported into the United States in violation of both Italian and American laws by the museum's director, Perry T. Rathbone, and a senior curator, Hanns Swarzenski, with the concurrence of key museum trustees. Only when these activities were shown to be violations of law—following the portrait's debut at a museum centennial show—was the work returned to Italy, and only then was Rathbone's resignation requested. (There were no resignations by members of the board.)

Just before Rathbone's departure the museum mounted a show in homage to him; it was grandly called "The Rathbone Years," and—bringing things full circle—the preface to the catalogue had been written by Swarzenski. "It is a fine, well-established custom to honor a retiring director of an art museum with an exhibition of his outstanding acquisitions. 'By their fruits ye shall know them.' The curatorial staff of the Boston Museum enthusiastically followed the tradition. This show and its accompanying catalogue represent a work of love, a tribute to Perry Rathbone," and so forth.[7]

The Raphael affair received ample publicity; far less attention has been paid to the fact that even without spectacular acquisitions, many museums now cope with an *embarras de richesse*. According to *Museums USA*, 44 percent of all art museums in the United States lack proper facilities for the preservation and conservation of the works of art in their permanent collections, yet, the flow of art to them is unceasing.

A case in point is the Museum of Modern Art, the only contemporary art institution in the world that has at least one significant work by every major artist in every country that has contributed to the modernist movement. Indeed, two first-rate museums could be established by tapping MOMA's storeroom. For all these art riches, the museum has been running an annual deficit averaging $1,000,000.

According to critic Thomas B. Hess, who, before his death in 1978, served as successor to Henry Geldzahler as chairman of the department of twentieth-century art at the Metropolitan:

> Trustees and friends, swayed by sage MOMA advisers, over the years have pledged cellarsful of Cubism, silos of Surrealism, acres of abstractions. And as the museum approaches the summer of 1979, its fiftieth anniversary, many of the bequests are falling due. Curators at MOMA look grave as they tell you how they are bracing themselves against the imminent influx of masterpieces. And from the muscle tics on their jaws, you can't tell whether they're bragging or complaining.[8]

MOMA's curator of paintings, William S. Rubin, said in an interview: "Some of our donors are in their sixties and seventies. If all those paintings flooded in, God knows what we'd have to do to show them. No museum in the world with a comparable collection has the same space restrictions." [9] Rubin went on to point out that although MOMA possesses 4,500 square feet of Picassos worthy of permanent display, it has the space to exhibit only 2,000 square feet of them, that two-thirds of MOMA's Miros remain in storage, and that an additional 3,000 square feet would be needed to show them. According to Rubin, of the fully 3,000 works in the entire collection deserving of permanent display, only 500 to 600 can be hung at a given time in the museum's galleries. Other MOMA department heads also cite a lack of exhibition space.

Small wonder, then, that museums with similarly congested storerooms yield to "deaccessioning," the jargon term for the selling or exchanging of works from the permanent collection. The temptation to sell can be all but irresistible in financially hard-pressed institutions, which, in disposing of unwanted assets, can repay debts or make new acquisitions. Indeed, the practice of deaccessioning is now so widespread that it can be viewed as another consequence of unceasing growth.

Both within the museum profession and among art historians, there is an increasing disposition to weigh the delights of *la chasse* more judiciously. Most museum people feel strongly that growth should be selective as well as continuous and that there should be a greater pooling of the art already in public hands.

There is a consensus as well that the age of excessive deference on the part of the curator to the self-inflated collector should draw to a close. A cautionary tale in this regard is the demeaning courtship— by all too many museums—of Chester Dale (1883–1962).

CHESTERDALE

Few American collectors have flirted with so many museums over so long a period as did Chester Dale, half-affectionately nicknamed Chesterdale. Starting out as a $5-a-week runner on Wall Street, Dale proceeded to make a fortune in utility stock and municipal bond transactions, much of which he spent on art.

His dalliance with museums followed a pattern: A special exhibition of his art would be organized at a museum; Dale would be named to the board; some of his works would then be installed on extended loan and, the minute he felt he was being taken for granted, abruptly withdrawn. New courtiers would rapidly materialize, and Dale in turn would whet *their* appetites. Not until his death in 1962 did the National Gallery of Art, which had elected him its president nearly a decade before, learn that it had inherited the dowry.

Dale served at various times as a trustee of the National Gallery, the Metropolitan Museum of Art, the Museum of Modern Art, the Art Institute of Chicago, the Philadelphia Museum of Art, and the Museum of French Art (now the French Institute). He teased each of these institutions with great expectations of inheriting his collection. According to Daniel Catton Rich, a former director of the Chicago Art Institute, Dale did more than merely tease:

> Chester Dale was very difficult. He promised us his collection, though never in writing. He was a liar. I was a friend of Chester's and Maud's from the early 1930s, and I persuaded Chester to lend a selection of twenty paintings to three museums, giving us first choice. . . . Mrs. Dale helped plan the installation in Chicago, and Chester was very pleased. He said to me, "It's in my will. These are coming to you if I die tomorrow." He was very expansive on that.[10]

Dale had become interested in art thanks to the proselytizing of his first wife, Maud, an amateur painter. Once a convert, he applied to his hobby not only the talents he had acquired on Wall Street but also the zest he displayed during an interlude as a professional fighter. Discovering in the 1920s that it was insiders in the art market who had the clear advantage, he bought stock in Galerie Georges Petit, a leading Paris firm, and became a member of its board. He made his major purchases in the 1920s and 1930s; the prices for School of Paris masters were low, and he was easily able to acquire important works by Picasso, Matisse, Renoir, Modigliani, Manet, Van Gogh, Gauguin, and other titans.

As his art holdings swelled, he found that there was insufficient space for displaying them in his New York town house, his Palm Beach residences, or the suite he later rented in the Plaza Hotel. Extended loans to museums helped solve the space problem and freed him as well from having to bear the costs of insurance and protection.

Unquestionably, Dale, with the advice of his wife, had purchased shrewdly, but as the years passed, he came to believe that he had an infallible instinct for the discerning of genius. In 1954 he visited an exhibition of new works by Salvador Dali at the Carstairs Gallery in New York and was overwhelmed by a huge canvas titled *Corpus Hipercubus*, depicting the artist's wife, Gala, gazing at the crucifixion of a beardless Christ. Dale at once invited Dali to dinner, during which he wrote out a check for the picture. The next morning he offered it as a gift to the Metropolitan, on whose board he was then serving. Whatever doubts the museum may have had about the Dali, it was not about to offend a major trustee-collector by rejecting the gift. Within a week of its purchase by Dale—a swift period by museum standards—*Corpus Hipercubus* was being given a full-dress debut at the Metropolitan.

Next, Dale commissioned Dali to paint a Last Supper, the traditional *chef d'oeuvre* of a master, which Dali completed, in a style he called "Pythagorean instantaneousness," in nine months. As soon as *The Last Supper* arrived at the Dale suite in the Plaza Hotel, the ecstatic patron was on the telephone summoning John Walker, director of the National Gallery of Art. In due course Walker arrived, and Dale then and there offered the Dali ("a picture for all time," he called it) to the country's official art museum.

At the time, the National Gallery had an informal policy of not accepting as gifts works by artists dead less than twenty years. In the case of *The Last Supper*, the painting was accepted as a loan but installed in its own alcove and welcomed with a grand opening that was accorded lavish publicity. The average visitor could reasonably assume that the National Gallery of Art was officially certifying Dali's standing as a supreme modern master. (The painting became gallery property following Dale's death.)

Art critics were on the whole unimpressed by the Dalis that Dale had purchased. Alfred Frankfurter, editor of *Art News*, in an article titled "How Great Is the Dale Collection?," concluded that it was indeed first-rate, with the marked exception of *The Last Supper*, which touched the "nadir of banality." [11]

All during his board presidency of the National Gallery, Dale con-

tinued to conceal his intentions about the eventual disposition of his collection. For all that, he took to calling Walker daily; the director later confessed that holding the receiver on these interminable telephone conversations caused him to develop bursitis. When Dale died, in 1962, Walker discovered that his sufferings had indeed been rewarded: The bulk of the Dale collection, consisting of 240 paintings, 7 sculptures, and 22 graphic works, had been bequeathed to the National Gallery, along with a modest endowment. The collection was subsequently installed in eighteen galleries, each bearing the name of Chester Dale.

The Last Supper was eventually moved from its shrine in the alcove; after being hung or stored in a variety of other places in the building, it has wound up in the museum shop along with the reproductions of various gallery masterpieces. In 1976 a comprehensive volume on the National Gallery collection, with a text by John Walker, was published by Harry N. Abrams, Inc., in which the Dali painting, by a not-so-curious oversight, is nowhere mentioned. But if, in Henry of Navarre's famous phrase, "Paris is worth a mass," the National Gallery can always claim in extenuation that the Dale collection was worth a Last Supper.

In Dale's case, as in the case of other difficult collectors, museum directors can always console themselves with the belief that art is long and life is short. Sometimes, however, life can seem almost as long as art, as the City of San Francisco discovered in its dealings with a capriciously willful octogenarian, Avery Brundage.

AN ART OLYMPICS

The French aphorist La Bruyère once said of collecting, "It is not a pastime but a passion, and often so violent that it is inferior to love or ambition only in the pettiness of its aims." [12] And Kenneth Clark has written: "Why do men and women collect? As well ask why they fall in love: the reasons are as irrational, the motives as mixed, the original impulse as often discolored or betrayed." [13]

Freud was an obsessive collector of antiquities but, to our loss, failed to address himself to the sources of his obsession. Studies have shown that children readily develop a taste for collecting objects in series, be they bubble-gum cards or postage stamps. But for reasons that no one has yet been able to fathom, the passion afflicts adults more randomly and more strongly than it does children.

In collecting, as in other modes of behavior, distinctive patterns

can be discerned. A number of great collectors have been childless and have treated their prized objects as surrogate children (more congenial than real children, of course, because objects by nature are passive and undemanding). In a familiar pattern the great collector, estranged from his children, turns for solace to a silent substitute family of masterpieces with a glorious lineage.

Many collectors are self-made, and for them, art may be a kind of social passport, providing entry to a realm of pedigree and privilege. Yet there are so many exceptions that it would be facile to fix a rule. Nelson Rockefeller as an avid collector fits into no pat category, nor, for that matter, do Cardinal Mazarin, Catherine the Great, James Jackson Jarves, Henry Ford, the Collier brothers, Lord Hertford, Andrew W. Mellon, or Franklin D. Roosevelt and King George V, both of whom were ardent philatelists.

Neurosis or hobby or just plain rewarding diversion, collecting eludes explanation and defies predictability. Who, for instance, could have foreseen that Oriental art, requiring as it does both erudition and a refined sensibility, would powerfully appeal to a sports-obsessed Chicago entrepreneur named Avery Brundage, president of the International Olympics Committee (IOC) from 1952 until 1972. (In 1975 he died at the age of eighty-seven.)

Brundage's track-and-field performance as an undergraduate at the University of Illinois won him a place on the 1912 United States Olympic team. Later he founded a construction firm, the Avery Brundage Company, and made a fair amount of money during the 1930s. By 1936, when he was elected to the International Olympic Committee, he was already exploring the mysteries and delights of Oriental art.

Very quickly Brundage became known for his ability to judge the quality of Eastern art. Wherever he went on Olympic business, he cultivated scholars and dealers. His official position was anything but a disadvantage; abroad he would seek advice (on where bargains might be obtained) from host governments, and they in turn would invariably be anxious to please the IOC chairman.*

* Brundage seemed unaware of the confusion that his dual role might cause. In a 1960 *New Yorker* profile, Robert Shaplen wrote of him: "Two years ago, when he went to Japan for an IOC meeting, he was able, he feels, to achieve the perfect synthesis of sports and art that to him represents the true Olympic spirit. He arranged in advance to be met at the airport by four Japanese, two of them Olympic officials and two leading Oriental art experts, and during the next few days he escorted the sportsmen to museums they had never seen and the art specialists to sports they had never seen. 'It was great fun,' says Brundage, 'and when I saw the Emperor afterward and told him what a service I had done for Japan, he agreed.' "

Avery Brundage, amid his prizes at a fete in his San Francisco museum celebrating the city's 196th birthday in 1972

As early as the 1940s the Brundage collection was attracting the attention of the Art Institute of Chicago. "I got Brundage on the board," said Daniel Catton Rich, the institute's director at the time. "His collection paralleled many of the things we already had, and I went to Brundage and asked him for part of it. But he wanted a separate series of galleries. We kept his idea in mind, but, meanwhile, San Francisco came along, and I advised Brundage to put his collection on the West Coast—to the great annoyance, I may say, of Charles Keeley, one of our curators, who had been helping Brundage on acquisitions." [14]

San Francisco "came along" as a result of a deliberate campaign begun in the 1950s by the Berkeley art historian Katherine Caldwell, an enthusiast of Oriental art. A graduate of Paul J. Sachs's "museum course" at Harvard, Mrs. Caldwell saw in the Brundage collection an opportunity to fill an embarrassing gap in the Bay Area museum constellation. Despite its large Chinese and Japanese communities and despite San Francisco's reputation as the "Gateway to the Orient," there was no local museum collection of Oriental art of any significance.

Pragmatically, Mrs. Caldwell realized that city hall would become interested only if it were approached by a committee of socially

prominent Bay Area residents, and she proceeded to organize just such a group. The target was George Christopher, the liberal Republican who was then mayor of San Francisco.

Christopher, impressed by the high-powered appeal, arranged for Brundage to be named an honorary citizen of San Francisco. Then, with Gwin Follis, board chairman of Standard Oil of California and also a collector of Oriental art, he visited Brundage at his winter retreat near Santa Barbara. Christopher and Follis arrived on a private aircraft, a touch the mayor felt would lend the required drama to the occasion.

At dinner Brundage talked about everything except art. Over coffee, the mayor, unable to contain himself any longer, blurted out, "Mr. Brundage, Chicago is a great city, Mayor Daley is a great friend of mine, but your collection is too important to go to an already-constructed museum. San Francisco is the Gateway to the Orient, it has large Oriental communities, but we don't have any Oriental art to speak of. I want you to give this collection to us and to see that it is displayed in the way you think best." [15]

Brundage agreed to donate his collection to a new museum that would adjoin the M. H. de Young Memorial Museum in Golden Gate Park. All the construction costs would be borne by the City of San Francisco. In due course, the City Council approved a bond issue for $2,725,000, which was submitted to a referendum in June 1960. To assure a favorable vote, advocates of the museum, Gwin Follis among them, engaged the most sought-after political publicists, Whitaker & Baxter. The firm came up with a film presentation, the concluding words of which were: "It is our great good fortune that this wonderful gift of world treasure—one of the great gifts of all time—is *ours* for the voting!" [16]

The bond issue was passed by a substantial majority, and two days later Brundage was initialing preliminary plans for the new gallery. But after the wing formally opened in 1966, it became public knowledge that according to the terms of the contract signed in 1959, half the collection remained Brundage's property or the property of the Avery Brundage Foundation. This moiety was partly attributable to tax laws; since the allowed charitable deduction for works of art cannot by law exceed 30 percent of a donor's annual income, there were palpable benefits in stretching a gift over a twenty-five-year period. But this meant that Brundage could at any time legally withdraw half his collection (the situation was further complicated by the fact that

there was no agreed inventory of works added to the collection since 1959).

Brundage cannot be blamed for taking advantage of a muddle. He protested that it was he, not the city, who was paying the salary of his handpicked director, the French-born Orientalist René-Yvon Lefebvre d'Argencé, and he insisted that the museum be put under the control of a separate board of trustees. At the same time he complained that his collection was being jeopardized by deficient humidity controls.

He had other grievances as well. During one of his Olympics visits to the Far East he arranged for art from Japan, South Korea, and Taiwan to be lent to San Francisco; however, he did not make arrangements for the city to pick up the transportation costs. When San Francisco refused to pay the shipping bills, amounting to approximately $60,000, he had the art returned in unopened cases to the countries of origin.

George Christopher's successor as mayor was the colorless John F. Shelley, who flew in vain to Chicago in 1967 to appease Brundage. Later that year, a more charismatic mayor, Joseph L. Alioto, was elected. Having received a telegram from Brundage stating that he intended to give half the art in the museum to Los Angeles, Chicago, or Kansas City, the mayor-elect took the next plane to Chicago. When Alioto entered Brundage's suite in the La Salle building, the first thing he noticed was a framed document proclaiming Brundage an honorary citizen of Los Angeles. "All right," Alioto said, "I've seen the certificate, you can take it down now." [17] After this bold opening, the mayor-elect gave way to Brundage on every essential point.

Alioto agreed to the formation of a separate twenty-seven-member board to administer the Brundage collection as an autonomous entity within the De Young Museum; he also accepted the responsibility for raising an additional $1,500,000, three-fourths of which would be borne by the City of San Francisco, for the enlargement of the collection.

It must be remembered that it was not Alioto who had entered into the original agreement with Brundage and that the mayor could have blamed his predecessors and rebuffed the collector—with negligible political losses. In conceding so much to Brundage, he was assuring San Francisco title to an important collection, a fact that would be remembered long after the haggling was forgotten.

The civic-minded intentions of Mayors Christopher and Alioto cannot be faulted, and the city's voters had been given the chance

to approve the bond issue for the museum. However, city officials had failed to read the fine print of an agreement that gave a collector renowned for his bullying tactics the legal right to dismember the museum unless he was given his way on every point.

The result was that San Francisco was bearing the entire financial burden of a museum that had Brundage's name on it. These were far better terms than Brundage could have expected from any other city, and he knew it. His threats to uproot half the collection were mainly bluff (which Christopher and Alioto, had they troubled to inquire in Chicago, Los Angeles, and Kansas City, might have discovered for themselves).

Other city governments have been no less gullible. Mayors, city managers, and city councils know little about art and tend to be awed by the extravagant claims a collector is all too likely to make for his collection. Occasionally the result verges on farce, as in a case in Miami Beach.

In the early 1960s the city was approached by John Bass, a wealthy sugar speculator, who claimed to possess a distinguished array of Old Masters and modern works with a value of approximately $1,500,000. Bass maintained a winter residence in the resort city and was a friend of the city manager's. A contract was signed in 1963 establishing a museum for the Bass collection in a handsome library building, which was then renovated at city expense. The Bass Museum was to be maintained by the city and governed by a five-member board with Bass and his wife, Johanna, as lifetime members who would be succeeded on their deaths by their sons; the three other board members were, ex officio, the city manager, the chairman of the library board, and the president of the Miami Beach Chamber of Commerce.

No concerted effort was made to obtain an independent opinion of the quality of the Bass collection. After the contract was signed, the city learned that in 1962 Bass had attempted to sell major works from his collection at auction at Parke-Bernet in New York. One of the items was a self-portrait attributed to Vermeer, which, if authentic, would have fetched millions. But no bidder had taken the attribution seriously enough to offer more than the reserve price of $90,000, and the self-portrait was withdrawn from the sale; it was now one of the prized Miami Beach possessions.

The city was now forced to take action. It invited the Art Dealers Association of America to appraise the collection. A team of experts concluded that of fifty-three works described as Old Masters, 66

percent were questionable and that of the modern works, 41 percent had either been forgeries or been incorrectly attributed. In 1973, five years after these findings were made public, the Bass Museum was closed; when it opened some months later, the labels of many disputed works bore the qualifying term "attributed to" before the artist's name.

Bass claimed that he was the target of a dealer conspiracy; he unearthed bales of certificates in an attempt to prove that all the attributions were based on reputable scholarship. But he refused to permit the museum to hire a qualified professional curator, and he vigorously opposed efforts to broaden the museum board. "We have a contract that is ironclad. Not one i-dot can be changed," he announced, and subsequent legal challenges bore out his boast.[18] Not only had the City of Miami Beach neglected to obtain expert advice on the merits of the Bass collection, but it also had left itself no escape clause in the ludicrously one-sided contract it had entered into with the donor.

It would be unduly optimistic to contend that the era of one-sided contracts is over and that the irascible collector will no longer be able to bluff and bully the unknowing city official. What can be contended is that conscientious museum professionals will not sanction "sweetheart" deals, although their refusal to do so may pit them against both their own trustees and city hall.

Through trial and error, a consensus has evolved. When a single donor's name and taste are being memorialized, a museum or a city has the right to insist that he set aside an endowment to help meet projected maintenance expenses. Binding restrictions on the display of a collection and demands for establishment of a separate board should be rejected out of hand. Every time a museum or a city yields on these principles, the pressure on all museums and all cities to make similar concessions becomes greater.

One earnest of this consensus was the refusal of the Cleveland Museum of Art to accept from a local industrialist what he described as "the world's largest Dali collection." A. Reynolds Morse, president of the IMS Company, an engineering firm, became an ardent Dali enthusiast after meeting the artist in 1943. Within a few years he acquired 90 Dali oils, 200 Dali drawings, and a set of 500 Dali graphic works, with an aggregate value, according to Morse, of $70,000,000. He made soundings about a gift of the collection to the Cleveland Museum, with the stipulation that it be kept intact in a special gallery. On the advice of the museum director, Sherman Lee, the board turned down the offer, although Lee felt that some of the early Dalis

were of high quality. Morse went on to found a Dali Museum in 1971 in provisional quarters within his corporation's headquarters in Beachwood, a Cleveland suburb. There visitors may see such masterworks as the enormous *Dream of Columbus* (purchased from Huntington Hartford in 1971) and *The Ecumenical Council,* a religious work commemorating Pope John XXIII.

"EVERYBODY DOES IT"

A consensus also is evolving among reflective museum professionals on the touchy question of selling surplus art. Faced with a lack of space as collections continue to expand and ever eager to acquire new and better works, American art museums have for decades been discreetly returning to the private market objects that were donated for the public's pleasure.

Customarily, a work is deaccessioned only on the express recommendation of both a curator and the museum director—and with the approval of the board of trustees. Every museum possesses objects, of minor importance acquired in times long past, that can be prudently removed. Or a museum may have too many examples of a single genre of art, which can be thinned out to strengthen holdings in another field.

It is another matter, however, when major works of art, only recently acquired or bequeathed and worth large sums of money, are sold or exchanged without any public announcement. That this has been a practice came to light as a result of grudging disclosures made by the Metropolitan Museum of Art concerning the disposal of approximately $4,500,000 worth of art in 1971–73.

The sales caused an uproar, at the height of which Hoving insisted, in an interview with the art critic of the Washington *Post,* that the deaccessioning process was time-honored and universal. "Everybody does it," he exclaimed. "Boston, Chicago, the Guggenheim, the Whitney, the Phillips—everybody sells except the National Gallery of Art." [19]

Undeniably, many museums had been selling, but to suggest that this was general knowledge at the time was, to put it mildly, disingenuous. Museums had found that the public tended to react emotionally to the disclosure of sales and that—far more important—potential donors would be less likely to make generous gifts if they suspected that their treasures might be treated as negotiable securities.

For these reasons, deaccessioning programs in recent years have been unpublicized.

During the 1950s, for example, the director of the Minneapolis Institute of Arts, Richard Davis, was persuaded by dealers that the money he needed to buy the paintings by Munch, Beckmann, Poussin, and others, which he coveted, could be raised by discreetly pruning from the museum storeroom. With board concurrence and no public announcement of any kind, the institute proceeded to dispose wholesale of many important works in its so-called permanent collection.

The works offered for sale included paintings by Pieter de Hooch, Giovanni di Paolo, Veronese, Guercino, and Canaletto. One of the dealers journeying to Minneapolis was Julius H. Weitzner, an American based in London who was celebrated for his acumen in spotting bargains. Weitzner wound up buying some fifty works from the institute. Fifteen years later he admitted to John Hess of *The New York Times*: "The only picture I didn't get I offered too much for. It was a Titian. I offered $30,000, and they pulled back. If I'd offered $1,500, I'd have got it." [20]

To this day the Minneapolis Institute has no official inventory of the works sold and the prices paid for them. The extent of the losses was suggested by Anthony M. Clark, one of Davis's successors as director, in the preface to a catalogue of institute masterpieces:

> A very large disposal of paintings . . . took place, with the intentions of reducing the holdings to a masterpiece collection and of gaining funds for further important accessions. The loss . . . proved unwise, because, with the exception of the Renoir and the Sisley, the works sold were thought by the vendor [that is, Davis] to be irretrievably unfashionable, a situation not at the time true and since hilariously reversed.[21]

Taken simply as a commercial transaction, the deaccessioning of art involves high risks for a museum. There is no known instance of a dealer's being bested in a transaction with a museum. His livelihood depends on his acuity in buying art and in knowing how much a prospective client may be willing to spend.

Commercial considerations aside, the wholesale disposal of art has become an exasperating problem for scholars. It has been the practice to delete all references to deaccessioned art from museum archives, with the lamentable result that a museum often has no idea of the eventual whereabouts of the art it has sold. Art historians have had to double as detectives in tracking down works that were once nominally in public hands.

An intrepid example of the scholar-as-detective is John Rewald, author of standard histories of Impressionism and Postimpressionism. Time and again Rewald has discovered that art can vanish from a museum without leaving a trace. On one trip he stopped in Hawaii to examine an important Cézanne at the Honolulu Academy of Art—only to find the painting gone (he later learned that it had been sold a few years before to the New York art-dealing firm of Knoedler's).

Of all the dossiers that Rewald has compiled, one of the most colorful involves the peregrinations of Picasso's *La Vie*, a Blue Period painting acquired in 1937 by the Rhode Island School of Design. *La Vie* was sold during World War II to a New York dealer for $20,000. While it was being shipped from Providence, it was caught in a hurricane; in a wooden crate on an open station platform, it was as vulnerable as it could ever be to the elements, but it managed to escape damage. Later it was sold to the Cleveland Museum of Art and so remains in public hands.

During the controversy over the Metropolitan sales Rewald wrote an article for *Art in America* calling for Hoving's dismissal and attacking the slackness of museum deaccessioning procedures in general. His was not the lone voice. In November 1973 a resolution censuring the Metropolitan was approved by the College Art Association (CAA), the leading national organization in the field of art scholarship. The CAA board urged that procedures for the sale or exchange of art be made more stringent than those applying to acquisitions, on the ground that once a work is disposed of, there can be no reconsideration; that a two-thirds vote in favor of deaccessioning by a museum board be the minimum requirement for proceeding. Consultation with outside experts should be the rule, the CAA further declared, and art museums should not allow themselves to be swayed by changing tastes or fluctuations in market prices. In closing, the CAA urged:

> It is important that the disposal of works of art should not inhibit the advancement of scholarly knowledge. When a work, after due consideration, has been removed from a museum collection, that museum should retain a full file of the work and continue to make it available to scholars on request. Each file should include photographs, laboratory reports, and full information on the disposition of the work. . . . Further, informative statements concerning the sale or exchange of works of art should routinely be included in the periodic public reports of museums.[22]

Implicit in this resolution is a premise that may appear to be a given—that the museum is the legal steward, not the owner, of the works of art in its possession. This is a premise, however, that some boards of trustees, through ignorance, zeal, or even mendacity, have overlooked.

WHO OWNS MUSEUM ART?

The case for absolute museum proprietorship was made most sweepingly by Thomas Hoving when he declared, during the furor over the Metropolitan deaccessioning, that the charter of the Metropolitan Museum states that "every work of art is entirely owned by the trustees." [23] The statement, not to put too fine a point on it, is incorrect. As one Metropolitan trustee, the distinguished lawyer Francis T. P. Plimpton, who also happened to be head of the city's Board of Ethics, said at a New York City Bar Association conference, "If Mr. Hoving ever said that the art in the Met belongs to the board of trustees, he's out of his mind." [24]

A museum does not "own" but, rather, is the steward of the art it possesses. On this point, common law is explicit: No charitable institution may "own" corporate property. A director is accountable by law to his shareholders, and if he is shown to be negligent in managing their property, there are legal consequences to be paid. In a museum, it is the public that are the shareholders and museum trustees are legally accountable for any malfeasance.

In English common law the concept of a trustee derived in part from the seizure of Roman Catholic abbeys and other church property during the reign of Henry VIII. No legal mechanism existed for administering such charitable institutions as hospitals and colleges or the religious establishments of which they were a part. A device, the charitable trust, was invented, in which a board was charged with fostering the purposes of what had been clerical property.

With passing centuries the same principle was applied to museums. From its founding, in 1753, the British Museum was managed by a board appointed by the king on the recommendation of his ministers. The American colonies followed English practice in the charters drawn up to establish colleges, hospitals, libraries, and charitable trusts. English common law gave the attorney general the task of overseeing all such trusts, and American law has assigned to the attorney general of each state the same duties. In theory, every trust is bound

by the terms of its charter, and every trustee is subject to the re-
straints against self-dealing and conflict of interest that apply to the
directors of a corporation.

In practice, however, attorneys general and the courts have inter-
vened in the management of charitable trusts only in extreme circum-
stances. By and large, trustees are distinguished citizens who serve
without compensation, and their deliberations are private. Litigation
usually results only when an aggrieved insider seeks revenge in court.
Still, by gradual degrees, a body of case law has developed that
provides strong sanctions against the occasionally wayward board.

A landmark decision, the Sibley Hospital case, was handed up in
1974 by a U.S. district court in Washington, D.C. Plaintiffs contended
that large amounts of money managed by a leading metropolitan
hospital had been deposited in interest-free accounts by board mem-
bers associated with certain banks. In 1971, for example, the hospital
had $4,000,000 available for investment, a third of which had been
placed in a checking account paying no interest, at a financial institu-
tion of which a board member was a director.

Judge Gerhard Gesell ruled that although there was no conspiracy,
as the plaintiffs had alleged, the trustees were clearly in default of
their fiduciary obligations in that they had failed to make better use
of the hospital funds in their charge. (The word "fiduciary" derives
from the Latin term for trust; in legal parlance, a fiduciary relation
is one in which a person justifiably reposes faith and confidence in
another person.) The court ordered the Sibley Memorial Hospital
board to form and issue a policy statement dealing with investments
and cash deposits; it ordered each trustee to disclose any affiliation
he had with banks, savings and loan institutions, and investment firms
engaged in business with the hospital; it ordered that an annual audit
of the hospital be made available for public inspection; and finally,
it required that each trustee read the court decision and so attest.

The lack of strong precedent for the case partly accounted for the
mildness of the judicial remedy. However, what the decision clearly
implied was that all trustees of charitable organizations risked similar
challenge. Kyran M. McGrath, then executive director of the Ameri-
can Association of Museums, wrote in *Museum News*: "This opinion
serves notice on all nonprofit institutions that their financial opera-
tions are becoming increasingly subject to public scrutiny, and that
their trustees are expected to shoulder the responsibility of the in-
stitution's strict accountability to the public." [25]

For museums, the changing standards of accountability were even

more explicitly spelled out in a case in New York City involving the Museum of the American Indian, Heye Foundation.

INDIAN GIVING

The case against the museum was brought by Louis J. Lefkowitz, attorney general of New York State since 1957. A self-styled champion of consumer interests, Lefkowitz has long taken an active and particular interest in the art world. During the 1960s he questioned the deceptive casualness of auction catalogue attributions, and in 1968 the state legislature, at his repeated urging, adopted a measure requiring auction galleries to give buyers firmer warranties. Concerned by the Metropolitan Museum deaccessioning, Lefkowitz ordered an investigation to determine whether the museum had violated its fiduciary obligations by deliberately ignoring donor rights. Also, his office had seen fit to join as a plaintiff in the Mark Rothko case on the ground that the executors of the Rothko estate were trustees of a foundation incorporated in New York and therefore subject to the attorney general's scrutiny.

Of all the initiatives taken by Lefkowitz in the field of art, the boldest was his action against a museum accused of the wholesale depletion of its collection. The Museum of the American Indian chose, in the end, not to contest the attorney general; under a 1975 consent decree, its board was dissolved, and the museum was placed under the direct supervision of the Office of the Attorney General. This was the first time in American legal history that so extreme a remedy had been imposed by the courts on a cultural institution. The message was unambiguous: Museum art is a public resource and cannot with impunity be treated as the private property of a board of trustees.

The Museum of the American Indian comprises what is said to be the world's largest collection of the art and artifacts of the original inhabitants of our continent. It opened in 1922 in a creamy white marble building in Audubon Terrace, an enclave at 155th Street and Broadway occupied by a cluster of nonprofit institutions, including the Hispanic Society of America, the American Numismatic Society, the American Academy of Arts and Letters, and the American Geographical Society. All the institutions in the terrace have been hurt by a prevailing impression, however ill-founded, that the area is unsafe, and in 1975 the American Geographical Society decided to relocate in Milwaukee.

George Gustav Heye, a mining engineer who amassed a fortune

through oil investments, founded the Museum of the American Indian. Until his death in 1957 at the age of eighty-two, he kept aggressively adding to the collection he had begun while supervising the building of a bridge in Arizona at the turn of the century. Prices were low when he started buying, and he was able to collect the astronomic total of 4,500,000 objects, including beads, shields, arrowheads, pottery, canoes, totem poles, masks, wampum belts, and all the other miscellany of a devastated culture. The bulk of his collection was stored in a Bronx warehouse in a profusion of cartons that had been only vaguely catalogued.

Heye ran the museum as a one-man show, hiring and firing capriciously; at the time of Heye's death, the director was his wife's foot doctor. A board consisting of Heye's friends and business associates then took charge and, in a creditable attempt to raise museum standards, named the Arizona-born, Dartmouth-trained ethnologist Frederick J. Dockstader as director in 1960. Professionally competent but, as was to become clear, indulgent to a degree when it came to his trustees, Dockstader found himself working for people who regarded the collection, as one of them later described it, as "a kind of Bloomingdale's basement."

In order to fill gaps in the collection, Dockstader made exchanges with dealers; invariably, as he later conceded, the museum came out second best. He allowed trustees to borrow museum objects to decorate their homes. Friends of the museum were given special privileges. One of them was Dick Cavett, a television talk show host who collected Indian art. When a dealer had a desirable Indian object, Dockstader would call Cavett; the latter would buy the object for the museum; and the museum in turn would overgenerously appraise the gift for Cavett's tax purposes. According to court papers, Cavett, over a five-year period, donated to the museum objects that had cost him $17,700 but that the museum had appraised at $39,735. In return for his gifts, the museum presented Cavett with such items from its collection as a Sioux war shirt, an Oto buffalo robe, and an eagle-feathered red shield. (Though he denied any impropriety, Cavett returned all disputed art to the museum.)

In 1972 the board of the Museum of the American Indian elected to trusteeship Edmund S. Carpenter, an anthropologist and a leading authority on Northwest Coast Indian and Eskimo art. In 1973, in his capacity as consultant to the De Menil family of Houston and New York, heirs to the huge Schlumberger oil-drilling fortune and owners of a renowned collection of modern and ethnographic art, Carpenter

received a letter from a dealer offering, at $130,000, Kwakiutl house posts that Carpenter recognized as belonging to the museum (photographs of the house posts were enclosed). A short time later Dockstader proudly informed Carpenter that a dealer was offering $55,000 for the same house posts. Carpenter exclaimed to a *New York Times* inquirer, "Imagine asking me to approve a sale for $55,000 when I knew a dealer was selling—and possibly had already sold—the work for $130,000. And how did they get those photographs?" [26]

Carpenter's grievances came to the attention of Attorney General Lefkowitz, who assigned one of his young assistants, Joel Cooper, to inquire into them. In due course, a formal complaint was lodged against the museum, and in July 1975 a petition ordering major changes was approved by a State Supreme Court judge. All transactions that smacked of self-dealing were retroactively declared null and void, and Dockstader was forced to resign. An inventory of the entire collection was ordered. Furthermore, the trustees were found to be liable for any damages that the court might assess after the inventory was completed.

If there were doubts about a board's legal accountability for its stewardship of a collection given for public purposes, the case of the Museum of the American Indian should have dispelled them.

An outré variation of the same problem came to light in Chicago in 1976, when the city discovered that its only important collection of antique musical instruments was being dispersed at auction by the George F. Harding Museum, founded in the 1930s by a prominent Republican who had once been treasurer of Cook County. The eccentric collection of 2,500 objects, ranging from Old Master paintings and ship models to antique instruments and medieval armor, was originally housed in a simulated castle of Harding's in Chicago's Hyde Park. After his death the board, composed of his friends, had the collection moved to an upper floor of a downtown building. Although the museum was operating on limited funds, it managed to pay its board chairman, a Chicago banker, $38,000 a year. (The chairman's wife also was on the museum payroll, at an annual salary of $22,000.)

Without any prior announcement, in 1976 the Harding Museum consigned most of its antique instruments to Parke-Bernet in New York. In what the auction gallery described as its first major sale devoted to rare musical instruments, a Stradivarius fetched $80,000, the record for the sale, and a double virginal brought $65,000, the highest auction price ever paid for a keyboard instrument. When an

indignant insider leaked news of the deaccessioning, musical organizations across the state protested. Meanwhile, Illinois Attorney General William J. Scott had opened an inquiry during the course of which he learned that a second lot of Harding works, comprising Old Master paintings, also had been consigned to Parke-Bernet for auction that December. Scott attempted to enjoin the sale, but a circuit court judge ruled that the auction could take place, provided that the monies realized were held on deposit until all charges against the museum had been resolved. Approximately 200 Harding pictures, including a Delacroix, which fetched $135,000, were sold to bidders who had been warned that their purchases would be held up pending a court decision.

The dispute is still before the courts, but the implications were clear enough for a Chicago *Tribune* editorial to warn:

> Trustees are not the owners of assets of the institutions they administer. They are not properly entitled to dispose of those assets for private and personal reasons rather than public and institutional ones. The unpaid trustees and curators of most museums always give the impression of at least intending to act in the public interest. But questions about the Harding Museum are serious enough to warrant Attorney General Scott's challenge.[27]

IN QUEST OF A CODE

Few museum professionals would wish to see their institutions adopt the European practice of prohibiting all deaccessioning of works in their permanent collections. Many European curators regard with envy the more flexible policies of American art museums. But there is surely not a conscientious museum worker anywhere who would question the need for restraining safeguards when it comes to culling the chaff from the storeroom. There is, however, much less agreement on what form those safeguards should take.

When Attorney General Lefkowitz concluded his inquiry into the Metropolitan Museum, he found no cause for legal action, but he was troubled by the lack of guidelines. At his very determined suggestion, the Metropolitan announced new guidelines intended to ensure that no work of substantial value would be removed from the permanent collection without adequate public notice and a diligent inquiry into the wishes of donors or their heirs. Lefkowitz proposed that all museums in New York State volunteer to follow similar procedures. His suggested guidelines were distributed, and a public hearing was called.

The attorney general could not have been more conciliatory in his opening remarks:

> You are all, of course, charitable institutions, organized and operated as such under both state and federal law. To maintain your status, to have gifts made to you, for example, deductible in the income tax returns of the donors, to have your own income (on those rare occasions when you have any) exempt from taxation, you must follow certain rules and regulations governing your operations.
>
> But it is not the fact of your exemption from taxation that gives my office a great measure of responsibility with respect to your activities. I do not mean "second guess," I do not mean "supervise," or "operate," or "run." I mean that my office has been given by law, long antedating the independence of our country, the high duty of representing the people for whose benefit you hold charitable and educational assets and to ensure that their interest in those assets is not adversely affected. It is for this reason, and not because you are tax exempt or because you may get some small help from public funds, that my office is concerned with your activities.[28]

The mildness of Lefkowitz's approach notwithstanding, the museums represented at the hearing rejected almost with a single voice the notion of adopting a voluntary code. Among those testifying was Frederick J. Dockstader, the soon-to-be dismissed director of the Museum of the American Indian:

> I feel that with the deaccession and problems developed out of the Metropolitan situation there does have to be some looking into the preservation and integrity of collections. However, I must admit that I am quite seriously frightened by the amount of paperwork which this could develop. I daily come into a snowball hill of paper which I am never able to keep up with. . . . I honestly feel we should try to establish a standard of procedure which the Attorney General would be able to act upon wisely, and I do not question his right to do so. . . . On the other hand, I recognize that not all of my colleagues wear the same halo I do. Once in a while we slip from grace.[29]

Since that hearing, and thanks in no small part to Dockstader's subsequent fall from grace, there has been a good deal of self-criticism within the museum profession about lax deaccessioning procedures. Rightly and reasonably, most museum workers reject the idea of legislatively imposed guidelines. At the same time they realize that no object should be deaccessioned without extensive consultation and the fully certified assent of curator, director, and board of trustees.

Of the more specific reform proposals that have been put forth, none is more ingenious than that formulated by J. Michael Montias, a professor of economics at Yale University and a serious art collector.

In a 1973 article in *Museum News*, "Are Museums Betraying the Public's Trust?" Montias defends the permissive approach to deaccessioning, at the same time acknowledging that this approach would make it difficult to justify a tax deduction. His resolution of the dilemma:

> One idea would be for Congress to amend the present tax laws to require that all donated works that donors wished to deduct from income taxes be sold at auction. After deduction of a certain percentage paid to the auction house, the sum of money a work of art would realize at auction would accrue to the public institution designated by the donor. If this institution was the highest bidder for the item, it would acquire the work at a net cost equal to the share of the auction house in the gross proceeds of the sale (say, 10 or 12 percent of the highest price bid). In this manner, the institution receiving the donation could obtain a sought after work at a nominal price, but the museum could also let the work go to another museum that would make better use of the acquisition if the recipient of the donation had a better way to spend the money. An important side benefit of the proposed scheme would be to provide an objective basis for the valuation of works of art for tax purposes. . . .[30]

Such a scheme would assuredly involve a reappraisal of tax policy and of our entire system of indirect subsidies to art museums. A reappraisal of this kind is long overdue, and possible reforms are discussed in more detail in Chapter VIII.

CHAPTER

⚜ VII ⚜

MIDWAY TO PROFESSIONALISM

We must educate our masters.

—Viscount Sherbrooke (1867)

GENTLEMEN V. PLAYERS

From the time of its origin more than a century ago, the American art museum has been the demesne of the amateur. Museums large and small owe their continued existence to the enthusiasm of nonprofessionals who without compensation serve as docents in the gallery and as members of governing boards. Although American museums usually lack the deadly official air of European galleries, this reliance on volunteers, as we have seen, can be a source of a chronic confusion of public and private purposes. The perplexities are all too apparent in museum management.

It is a very American trait to believe that nothing, not even the Byzantine obscurities of art, should be beyond the competence of the average citizen. In the 1830s Tocqueville marveled at the American temperament:

As they perceive that they succeed in resolving without assistance all the little difficulties which their practical life presents, they readily conclude that everything in the world may be explained, and that

nothing in it transcends the limits of the understanding. Thus they fall to denying what they cannot comprehend; which leaves them but little faith for whatever is extraordinary and an almost insurmountable distaste for whatever is supernatural.[1]

Museum decisionmakers have also been influenced by the amateur ideal as inculcated by the great English public schools during the Victorian era. Attending schools directly inspired by English models, our men of fortune and estate have striven to be all-rounders. Theodore Roosevelt—lawyer, soldier, public servant, man of letters, explorer, naturalist, Nobel laureate, and bagger of elephants—was also a lover of museums (it was on behalf of the American Museum of Natural History that he led expeditions into the jungle, and he took the time to serve as a trustee of the Metropolitan Museum of Art from 1870 to 1878).

The notion that art held any impenetrable mysteries did not occur to early-day museum trustees. To be sure, the museum profession had not yet been invented, and nobody thought it at all odd that two erstwhile Civil War generals should have served as the founding directors of the Metropolitan Museum and the Boston Museum of Fine Arts. When, after the turn of the century, the Metropolitan began seeking out professionals, the results verged on opéra bouffe. In 1905 the museum invited the fastidious English scholar Roger Fry to serve as curator of paintings under Sir Caspar Purdon Clarke, who had resigned his post as director of London's South Kensington Museum to take over the directorship of the Metropolitan. Both Englishmen found themselves having to cope with an intractable Metropolitan president: J. Pierpont Morgan.

According to Calvin Tomkins's centennial history of the museum, *Merchants and Masterpieces,* Fry, on assuming his post, found the Metropolitan in a "state of chaos."[2] Many Old Masters had false attributions attached to them, and the picture collection was on the whole mediocre: "Only one aspect of the art . . . is adequately represented, and that is the sentimental and anecdotic side of nineteenth century painting. . . . We have as yet no Byzantine paintings, no Giotto, no Giottoesque, no Mantegna, no Botticelli, no Leonardo, no Raphael, no Michelangelo. The student of the history of art must either travel in Europe or apply himself to reproductions."[3] Yet, as Fry was to complain, the Metropolitan board was mainly interested in "exceptional and spectacular pieces" and showed little inclination to acquire such (then) unfashionable art as the French Impressionists.

A great problem for Fry and Clarke was that Morgan would go off on imperial buying sprees without bothering to follow the professionals' advice. "I don't think he wants anything but flattery," Fry confided in a letter. "He is quite indifferent to the real value of things. All he wants experts for is to give him a sense of his own wonderful sagacity. . . . The man is so swollen with pride and a sense of his own power that it never occurs to him that other people have any rights." Eventually and inevitably the two Englishmen departed in 1910, with no love lost between them and the museum.

Morgan and the Metropolitan board may have had legitimate grievances of their own: The waspish Fry neither liked nor understood Americans, and Clarke, for his part, had proved to be an inept administrator. Their departure presaged an era of conflicts between gentlemen and players—of combats sometimes waged with all the ferocity of scorpions in the same bottle.

Contributing to the distemper is the fact that both art as a discipline and the museum as an institution have ceased to be—if they ever were—readily grasped conceptions. As historical scholarship has become more exacting and the avant-garde ever more bewildering, the gap between laymen and professionals has widened. Public galleries, at least the large ones, have evolved into sprawling bureaucracies with huge annual budgets and in many cases rising annual deficits. Museums that were once proud of being self-sufficient are now having to plead for direct government aid; at the same time they are being systematically subjected to demands for disclosure, accountability, and "relevance." Within the museum itself, campaigns have been initiated for greater staff rights, higher pay, improved professional standards, and sometimes even the once-unthinkable, unionization.

Museums USA lists 84 percent of American art museums as having annual budgets of less than $500,000 in 1971–72 (clearly, many of these institutions could not remain open if they were fully staffed by professionals). Our concern here is not with these small public galleries, most of which have to rely on volunteers and semiprofessionals, but rather with the 16 percent of American art museums that have annual budgets of more than $500,000.

The most obvious symptom of disarray in the museum profession is what Kenneth Clark has called "the great American sport," the firing of directors.[4]

Before World War II the director's post was virtually a sinecure,

and a dismissal was so rare as to arouse shocked comment. From 1879 to 1954 the Metropolitan Museum had only five directors, one with a tenure of twenty-five years, one with a tenure of twenty-one years, and three who remained fourteen years. Directors at the Boston Museum of Fine Arts from 1876 to 1955 averaged about sixteen years. But in the last twenty years at both museums a tenure of even a decade has been considered remarkable, and during one stormy five-year period at the Boston Museum there were three directors and one acting director.

In an attempt to numerate the turnover, Richard F. Brown, director of the Kimbell Museum of Art in Fort Worth, consulted the membership rolls of the Association of Art Museum Directors (AAMD), made up of heads of institutions with annual budgets of more than $250,000. From 1969 to 1975 the average number of AAMD members was ninety, of which no fewer than thirty-eight had been dismissed at one time or another—in Brown's formulation, a "mortality rate, or, as some would put it, a 'decapitation' rate, of well over 40 per cent . . . higher than the national divorce rate." Brown could find no discernible pattern in the decapitations, which had occurred in the oldest and the newest, the stuffiest and the trendiest, the largest and the smallest, the richest and the poorest museums in the AAMD universe. The question remained: Why had museum marriages proved to be so fragile?

Brown, himself forced to resign in 1966 as director of the Los Angeles County Museum of Art, could offer no easy explanation. Of the thirty-eight dismissals, he attributed five to downright incompetence, four to alcoholism, and one to dishonesty. As for the rest: "An ambiguous kind of smoke-screen is laid down . . . which vaguely has to do with 'lack of administrative ability,' or 'unreconcilable differences of opinion about program,' or 'inability to project the desired image' (the latter often means simply the failure to extract enough money from the expected sources, whether it be the city fathers, membership, or the eighty-two-year-old widow)." [5] In most cases, he noted, neither the museum members nor the general public ever did find out what had happened.

Brown was addressing a trustee committee of the American Association of Museums, and he may have been too polite to stress a factor that applies to nearly all the largest art museums in the United States—their governance by private boards composed of the established rich who have been operating with limited accountability and who have on occasion demonstrated minimal sophistication about

the arts. In enough cases to warrant a generalization, the decapitation of the director has been a ritual sacrifice on the altar of his board's incompetence.

Changing times have greatly strained the traditional structure of museum management, but many—if not most—boards have been reluctant to move with the times, so that the old patterns stubbornly persist. Directors and staff often have to struggle with an archaic system in which a single powerful trustee operates like a feudal baron, with favored lieges in departmental fiefs. Then, too, boards may make grand declarations of policy when they really mean something quite different—it is usually left to the baffled museum worker to figure out what is truly wanted. In extreme cases, museum boards deserve the reproach aimed by Stanley Baldwin at the press lords of England: that they seek power without responsibility.

In short, of the many obstacles to raising professional standards within the museum, the most conspicuous is that impregnable redoubt of amateurism, the board of trustees.

TRUSTEESHIP

To the legal theory of trusteeship, there is a copybook clarity that is regrettably lacking in practice. A trustee is by definition a person in whom one reposes trust; he is the assigned surrogate of the public, whose interest a museum or any other charitable trust is intended to serve. He is legally obliged to see to it that a museum adheres to its charter and that it respects the rights and wishes of those who donate money or art for public purposes. Furthermore, the board of trustees is charged with managing a working organization. "The trustee's duty," in the words of museum historian Laurence Vail Coleman, "is to have the museum run, not to run it." [6]

But the line to be drawn between having the museum run and running it is very fine indeed. How much responsibility should be given to the director, the museum president, and the executive committee for making day-to-day decisions? At what point should the board, or any of its members, second-guess the professional judgment of the director and the staff? And finally, what is the board's obligation to assure the public that museum decisions are reasonable and well informed?

Most museum professionals do not so much challenge the authority of the board as fault the manner of the exercise of that authority. Ideally, trustees' decisions should be consistent, their procedures

businesslike, and their deliberations for the most part open to scrutiny. Also—and no complaint is more often heard—boards should be, to a far greater degree than they now are, representative of their constituencies.

According to *Museums USA,* eight out of every ten art museums are governed by boards of trustees, the average size of which is twenty-three members. Not surprisingly, 63 percent of the roughly 8,000 art museum trustees in the United States are white males and 44 percent are at least fifty years old. In ancestry, education, club memberships, and dynastic and business affiliations, they are strikingly alike.

A Twentieth Century Fund analysis of the biographies of 156 art museum trustees carried out in 1969 confirmed this essential homogeneity. Of these, 60 percent were graduates of Ivy League schools, roughly 33⅓ percent were bankers or financiers, and 20 percent were lawyers; nearly 40 percent were Episcopalian; and almost 60 percent were at least sixty years old.[7]

Boards do not elect new members; they clone them. They choose, in the words of the late Walter Muir Whitehill, longtime director of the Boston Athenaeum, "the nearest possible facsimiles of the trustees who have just died."[8] In his centennial history of the Boston Museum of Fine Arts, on the board of which he served for thirty years, Whitehill records an unfailing procession—almost a litany—of the same Back Bay names: Coolidge, Lowell, Saltonstall, Cabot, Gardner, Endicott.

At the Metropolitan Museum, money runs as thick as blood. Over the years the scions of great American fortunes have succeeded to dynastic seats. The "Morgan seat" was established by the formidable J. P., Sr., who served on the board from 1888 to 1913, held by his son, J. P., Jr. (1910–43), then by his grandson Henry Sturgis Morgan (1930–1946; 1954–1971), and is currently occupied by his great-grandson, Robert Morgan Pennoyer (1966–). By the same token, there is an Astor seat, a Whitney seat, a Lazard Frères seat, and a Rockefeller seat, the latter two sometimes also occupied by representatives of family interests. The Lazard Frères seat was held successively by George Blumenthal and André Meyer, and the Rockefeller dynasty has been represented by Nelson A. Rockefeller (1932–51), his daughter Mary Rockefeller Strawbridge Morgan (1973–), J. Richardson Dilworth, head of the family's financial interests (1961–), and, collaterally, Henry Kissinger (1977–).

There also is what can be called a media seat. Proprietors or man-

agers of local newspapers and television stations have served on museum boards in Philadelphia, Chicago, Minneapolis, San Francisco, Kansas City, Houston, Los Angeles, and Boston. At the Metropolitan Museum, *The New York Times* has been represented by two generations of Sulzbergers, and the now-defunct *Herald Tribune* by two generations of Reids; for almost twenty years another Metropolitan board ornament was *Time-Life* cofounder Henry R. Luce. At the Museum of Modern Art, former *Tribune* publishers John Hay "Jock" Whitney and Walter Thayer, former *Look* publisher Gardner Cowles, and CBS chairman William S. Paley continue to occupy major board positions.

To be sure, a token leavening has taken place in recent years as boards, yielding to both public criticism and the need for government aid, have elected to membership a handful of blacks, "ethnics," and community leaders. This democratization rarely extends to the key decisionmaking committees, whose recommendations the full board normally ratifies. Of the fourteen members of the Metropolitan Museum's executive committee in 1978, eight were listed in *Who's Who*. Their average age was sixty-two, the youngest being Robert M. Pennoyer, fifty-three. With the single exception of Francis Day Rogers, an architect, all males listed were bankers, lawyers, or businessmen. Five of the eight had attended Harvard, Yale, or Princeton, and only one (Richard M. Paget), a Northwestern alumnus, had attended a school elsewhere than the Northeast. Five of the eight were members of Links, and three listed the Century Association. Unlisted in *Who's Who* were three women members (Mary L. Bundy, Mrs. Charles W. Engelhard, and Mrs. Charles Wrightsman). Also unlisted was the sole "minority" member, Arnold P. Johnson, a Harlem civic leader, who had been named to the committee two years before. Other names on the executive committee were very much in line with Metropolitan tradition: C. Douglas Dillon, chairman; J. Richardson Dilworth, investment banker; Daniel Pomeroy Davison, banker; Ralph Manning Brown, Jr., insurance company executive; Richard Moscrop Paget, management consultant; Richard Sturges Parkins, company director; Roswell L. Gilpatrick, attorney, and Mrs. Vincent Astor.

It is not written in the tablets of Moses that museum boards should be so narrowly constituted. Why, for example, should so little recognition be given to intellectual and artistic distinction? The Metropolitan board in its 108 years of existence has made room for only one celebrated American writer, William Cullen Bryant, and for

only one artist of national standing, Daniel Chester French; no professional art historian has ever been invited to serve as trustee (although the late Millard Meiss of Columbia and Harvard was elected an honorary trustee in 1968—without voting rights).

In Great Britain, by contrast, current or recent trustees of the British Museum include art historians Lord Clark of Saltwood and Sir Ernst Gombrich, archaeologists Kathleen Kenyon and Sir Max Mallowan, and the noted academic Lord Annan. Recent trustees of the Tate Gallery include the historians Sir Alan Bullock and C. V. Wedgwood, the artist John Piper, and the economist Lord Robbins. One could look long and hard for their equivalents on the boards of leading American art museums.

Differing national cultural traditions aside, financial realities must be taken into account: American art museums rely far more heavily on private contributions than do their British counterparts, which are for the most part state-supported. Louis Auchincloss, the attorney and best-selling novelist who for a decade has been president of the Museum of the City of New York (and who is thus that rara avis a trustee with literary distinction), put the matter frankly in a letter to *New York* magazine:

> Rich people, or people with access to large funds, are like everyone else—they hate to feel "done." And they feel "done" indeed when they find themselves alone on a hungry board, surrounded by the less pecunious, who regard them as the chosen "fat cats" from whom only one thing is expected. Nothing is more conducive to purse-closing. On the other hand, if they look down a board table and see that a good portion of those present are able and willing to do as much or more than they, they become relaxed and comfortable.[9]

But a high price is exacted for this relaxation and comfort. Not having to endure the hungry stares of the less pecunious and very much at home with one another, trustees sometimes begin to feel that they not only run but also figuratively own the museum entrusted to their charge by public law. The psychology of board proprietorship is described temperately and tactfully by Richard Brown, a middle-roader in museum politics:

> The board's absolute power is logically, legally, morally, and practically justifiable. But it must be constantly questioned to remain beneficial. Board members seldom engage seriously in such exercises, and directors hardly ever *dare* to do so. Thus, the unquestioned self-perpetuity of this power, without fully understanding its nature and, therefore, its possible detrimental effects, has led to a pervasive attitude of *ownership* on the part of the trustees—ownership as of private property. A

propriety interest on the part of the trustees for their museum is a heart-warming thing to see because it evinces sincerity and ardor in their commitment. But the *public* owns the museum, even those supported entirely by a private foundation. That is what "trustee" means. The sense of private ownership makes it too easy to commit, among other things, "sudden termination." But way beyond that, on a much broader social and political level, this faith in a privately held power by trustees of public institutions is antithetical and increasingly untenable in our nation's progressive transition into a mass society.[10]

Indisputably, the outlook Brown describes has exacerbated the art museum's relations both with its staff and with the public. A case in point is the Museum of Modern Art.

MUSEUM WORKERS, UNITE!

There are two givens about the museum profession: that its rewards are modest and that even the best-trained workers must patiently accede to the claims of nonprofessionals both at the top and at the bottom—that is, trustees and docents.

Benjamin Ives Gilman, secretary of the Boston Museum of Fine Arts from 1894 to 1925, popularized the "forgotten English adjective *docent*," [11] now used to describe volunteers trained by museums as guides and teachers to initiate the lay public in the complexities of art. With the years, the docent, usually a gracious lady speaking in cultivated accents, has become a ubiquitous museum figure, leading schoolchildren or conducting adult tours through galleries. The benefit to museums has been enormous; the Boston Museum of Fine Arts has estimated that volunteers save its education department at least $100,000 a year in salaries alone. According to *Museums USA,* of 110,000 persons working in museums in 1971–72, 64,200 were volunteers.

Not only is it the unpaid volunteer who has subsidized the art museum, but it is also the professional through accepting wages that have been for the most part substandard. In 1971 the American Association of Museums reported that the median annual salary of an art museum director was $15,912; that of a curator, $9,271; and that of an assistant curator, $8,669. In 1971–72, *Museums USA* calculated the average annual salary of full-time art museum professionals, 45 percent of whom possessed advanced degrees, at $11,900. Women, not surprisingly, were paid substantially less than men; where a male curator received an average annual salary of $12,500, his female counterpart received $7,100.

In a 1971–72 salary survey undertaken by the New York State

Association of Museums, it was shown that in a state known for its high levels of compensation, curators were on the average paid less than elementary school teachers or sanitation workers. The six biggest museums in New York City paid full-time curators a median annual salary of $20,000, but curatorial assistants were started at less than $7,400, at the time a typist's pay.

There are few professions in the United States that offer more modest economic rewards to those holding graduate degrees than does the museum calling. Because museum work is thought to be pleasant, prestigious, and even glamorous, museum professionals are expected to settle for working for relatively low wages. Given these financial facts, it is the more remarkable that strikes at museums have been concerned less with compensation than with the seignorial role of trustees.

Until the 1970s the collective bargaining of art museums had been confined to trade unions representing guards, clerical workers, and maintenance personnel. A 1974 survey found that such negotiations had occurred in twenty-five institutions but that except in one case, contracts covered custodial and clerical workers, not professionals.

The exception was the Minneapolis Institute of Arts, a troubled museum that had been headed by no fewer than four directors within a decade. In an article on museum unionization in *Artforum*, Lawrence Alloway described the Minneapolis disturbances:

> At Minneapolis, the staff attached great importance to policy contributions, such as contesting an Institute decision to reduce community relations and concentrate on the newly erected central facility. They offered their expert knowledge and sense of the public to the boards, but this turned out to be the point of maximum resistance. . . . The staff's sense of obligation to culture, expressed by the desire for institutional participation, has been stonewalled. Trustees remain "those who rule," and workers are those with no control over policy. Decision-making remains closed to staff representation, though the boards have conceded higher salaries, improvements in job descriptions, and working conditions. Despite their intention, the associations have found themselves consigned to the economic concerns of a traditional union.[12]

The same note was sounded in 1971 at the Museum of Modern Art, where a new union also gave its highest priority to demands for a voice in policy—the focus, it turned out, of maximum board resistance. The MOMA unionization campaign took place during a four-year period in which there were three successive directors: Bates Lowry, John B. Hightower, and Richard Oldenburg. In 1970, as the museum was projecting a deficit for the next year of $1,000,000,

younger staff members organized what they called the Professional and Administrative Staff of the Museum of Modern Art, or, as it was quickly dubbed, PASTA/MOMA.

Within a short time PASTA/MOMA voted to affiliate with the Distributive Workers of America, an independent union with a predominantly black and Hispanic membership known for its militance. The museum's choice of union was symbolic. *The New York Times* labor writer A. H. Raskin quoted a union source as having said, "The PASTA members, mostly white, mostly women and mostly holders of college degrees, have a great need to feel proletarian in their affiliations and commitments. They shrivel up inside when you call them elitists." [13]

In August 1971, PASTA/MOMA staged a two-week walkout to protest staff layoffs (by this time it had won an election enabling it to speak both for clerical workers and for professional employees up to the rank of assistant and associate curator). John Hightower, young and green, sent an anguished letter remarking that the staff had grown from 295 in 1966 to 539 in 1970 and pleaded for recognition of the museum's financial plight.

Hightower's arguments had practically no impact because they centered on money when what the strikers were particularly concerned with was gaining a voice in museum policy. Their mood was conveyed in a *Village Voice* article by Robin Reisig:

> "It's like being the Lancashire cotton mill workers," said the young woman. "We work in nineteenth century situations and want to unionize for the same reasons they did—to end exploitation and a system where your job depends on grace and favor." I blinked. The woman was elegantly dressed, her accent aristocratic, her private office all glass and windows and paintings and charm. But her boss, the Museum of Modern Art, still operated in ways that sometimes seemed to belong to another era. Its curators described the museum's operations in terms of feudal fiefdoms and court intrigue, of *noblesse oblige* and benevolent patronage. Of grace and favor.[14]

Reisig discovered that the union was less interested in wages than in exhibition policy and the increase in admission charges—which happened to be the line of most resistance on the part of the trustees. There followed a second PASTA strike, in 1973, which lasted for seven weeks. Raskin wrote in *Art News*: "It may well be recorded in cultural history as the first serious reaching out by the junior staff of an art museum for a more assertive role in curatorial policy and in defining relations between the institution and the community." [15]

PASTA had demanded representation on the MOMA board, in-

A MOMA picket enlists Wyeth's *Christina's World*, one of the museum's famous works, in a 1971 strike for better wages and a policy voice

cluding its key committees, in exchange for which it was willing to make financial sacrifices. But the museum trustees preferred opening their purses to opening their doors. Rejecting out of hand anything that touched on their prerogatives, they agreed to an annual salary increase of 11 percent, half of it retroactive, and to a modest annual increase of $250 in the minimum starting hiring rates. Mrs. John D. Rockefeller III, MOMA president, stated the case for the board:

> A place on the board entails responsibility, liability. In some ways I can understand their view—they're young and they see the trustees as symbols of power; they're frustrated by the fancy names. But they don't have a concept of the problems involved in running a museum. They couldn't contribute the level of experience that a board would [require]. We want to be fair and forward-looking, but this is, after all, a privately-financed institution.[16]

But Mrs. Rockefeller was begging the question. How better to educate the members of PASTA in the difficulties of museum economics than by admitting a couple of them to the board? And how could the board pride itself on its "level of experience" when its record of managing finances was so dismal? Could MOMA accurately describe itself as a "privately-financed institution" when, without major public assistance, ranging from federal and state grants to tax write-offs

for private contributions, it would not be able to continue operating?

An opposite view to Mrs. Rockefeller's was expressed by Daniel Catton Rich in an essay contributed to *On Understanding Art Museums*:

> There seems no reason why a member of the museum staff (unionized or not) should not become a voting trustee. Experience with student trustees in universities has been far from revolutionary. . . . The staff member on the board would, one believes, add more weight, for he is constantly involved in carrying out decisions made by trustees.[17]

No museum in the United States has adopted Rich's suggestion. Another innovative idea, offered by the great art historian Meyer Schapiro, is that the membership of the Metropolitan Museum should be empowered to elect one or more representatives of its own to the board; this idea should carry special weight since it is members who provide a large percentage of museum revenues. The notion has not been acted on by the Metropolitan board.

A Metropolitan trustee, the lawyer and elder statesman Francis T. P. Plimpton, once tellingly remarked at a Bar Association forum, "In a way, it makes no sense for museums to be run by me and people like me. I'm no expert on art. . . ." [18]

MOMA: EXIT HIGHTOWER

The directors of the leading 100 or so American art museums meet often at professional conferences and are in constant touch with one another about loans, special exhibitions, and shifting personnel; their world is in effect a kind of freemasonry. Whenever a museum director is fired, other museum directors generally wind up having a fairly clear picture of what transpired.

When the director of a major museum resigns, retires, or is "decapitated," there is usually an already prepared short list of available qualified candidates. On occasion, however, boards of trustees select an unorthodox candidate. To a low-paid staff already resentful of trustee imperiousness, the imposition of an outsider can sometimes seem an unendurable final humiliation. The newcomer, whatever his abilities, is at a serious disadvantage, especially if he seeks to institute policies that impinge on curatorial privileges. Department heads invariably have patrons and allies on the board, which is usually committed more to the appearance than to the substance of change—a truth that will become all too apparent to the new director once he has been "decapitated."

In 1970 the Museum of Modern Art, influenced by the activism of the 1960s, named as director someone young, unconventional, and seemingly in tune with the times: John Hightower, the thirty-seven-year-old executive director of the New York State Council on the Arts and a protégé of Governor Nelson A. Rockefeller, who had proposed his candidacy to William S. Paley, then MOMA's president.

In an as yet unpublished memoir, Hightower describes his first encounter with Paley, in a thirty-fifth-floor executive suite of the CBS Building overlooking the museum:

> He apologized for the time it took to reach a decision. Part of the delay, he told me, was due to [his] having asked someone else to take the job. . . . In Paley's forthright fashion, he felt obliged to tell me the museum's first choice: Sherman Lee, the museum professional's professional—eminent Far Eastern scholar and director of the prestigious wealthy Cleveland Museum of Art. . . . I could not imagine two people in the United States with more diametrically opposed views on museums than Sherman Lee and me. "Sherman Lee's view of a museum is totally different from mine," I said. Paley responded with noticeable astonishment. "It is?" he asked. He was no more astonished at my comment than I was at his response.[19]

Questioned by the author, Paley rejoined:

> Four or five people thought highly of Hightower. But we're in a family situation: We have traditions, policies, and standards that we've lived by. Hightower was not prepared to live by them. But at none of the search committee meetings did he express his differences with us. He was amenable, he knew he had to learn, and would take it easy at the beginning. We thought he was a great administrator, which was what we needed. The place needed tidying up. He didn't have an art background and, as it turned out, he didn't have an administrative background either.[20]

Ambitious for the highly desirable appointment, Hightower may have been overanxious to please the search committee; in any case, he was not in a situation where it would have been either comfortable or wise to make provocative statements. But the search committee could not have probed into Hightower's views very deeply if it assumed that his outlook was essentially conventional. Hightower's position was a matter of record. In 1969 he had published an article in *Curator*, "Are Art Galleries Obsolete?," based on his speech to an arts conference the year before. *Inter alia*, he had boldly declared:

> The courtship of collectors is often the principal role of a museum director. To think of the unsettling, painful rides to the hounds in pursuit of a painting makes one instinctively clutch for a pillow. The

pursuit persists. . . . The view that art galleries are only for the elite or a limited segment of society is changing as both public and financial demands force museums toward sources of public money. Nothing could be better than the innocent conspiracy of the arts and the public in shaping the direction of art museums. . . . The multimedia Harlem exhibition at the Metropolitan Museum of Art is a case in point of a museum functioning as more than a place where hordes of people parade dutifully past objects usually unrelated to anything outside the museum.[21]

But William S. Paley, in an interview with the author, could not recall ever having read this article, in which Hightower had expressed a distaste for the traditions, policies, and standards of such institutions as MOMA.

Once in office, Hightower quickly learned why MOMA department heads were referred to as Chinese warlords. "They run the musuem," he observed in his memoir. "Their weekly meetings with the director and a few other senior members of the staff, where exhibition plans are presented and problems aired, are charged with competitive combat."[22] The newcomer was at a marked disadvantage in these encounters; not only was he not an art historian, but he also did not believe in the all-importance of connoisseurship. His experiments in "outreach" and relevance misfired with critics and the public alike. One such exhibition, called "Information," featured a "Dial-a-Poem" device that unloosed tape-recorded incantations by 1960s rebels on museum visitors.

Hightower soon discovered that the board was far less concerned with policy innovation than with an ambitious building program involving the selling of its air rights and the construction of a commercial office building (a project that, as we have seen, was to surface in a different form a few years later). Adding to his general burden were an angry unionization campaign conducted by junior staff members resentful of both the board and the senior curators and an annual operating deficit that had reached $1,000,000, forcing cutbacks in staff and service. Even a seasoned museum professional might have been overwhelmed.

In January 1972 came the inevitable decapitation. As described by Russell Lynes in *Good Old Modern,* his history of MOMA, the termination was brutal and abrupt. Hightower was handed a letter of resignation by Paley and ordered to sign it; stunned, he asked to be allowed to write his own letter and was given until three o'clock that afternoon to do so. On its receipt, Paley and David Rockefeller, a key museum trustee, circulated the following memorandum to the

trustees: "We regret to inform you that Mr. John Hightower has resigned as director of the Museum of Modern Art." Copies were distributed to the press, along with Hightower's own "Dear David and Bill" letter, which made no reference to the manner in which he had been dismissed or to the basic differences between "Dear David and Bill" and him.[23]

Richard Oldenburg, head of the museum's publications department and brother of the artist Claes Oldenburg, was immediately named acting director. Under his leadership, the museum has resumed its stately course, affording the trustees a hiatus of peace and quiet in which plans for the new building were drawn up as a fitting golden anniversary goal.

BOSTON: EXIT RUEPPEL

In 1970 the Boston Museum of Fine Arts, even more tradition-ridden than MOMA, adopted an ad hoc report written by Erwin D. Canham, then editor-in-chief of the *Christian Science Monitor*, that expressed concern over the museum's failure to make its treasures more accessible to a wider segment of the community. Two years later a totally unforeseen circumstance served further to underline the museum's need for a self-examination—the forced resignation of Perry T. Rathbone in the wake of a public scandal resulting from the illegal importing of a painting attributed to Raphael. The search for a new director was led by the museum president, George C. Seybolt, the chief executive officer of the William Underwood Company, a major food-processing firm with headquarters in Westwood, Massachusetts. Large, hearty, and self-made, Seybolt had a serious interest in museums and their problems (in 1977 President Carter was to appoint him board chairman of the newly created Institute of Museum Services).

One day Merrill Rueppel, the prepossessing director of the Dallas Museum of Fine Arts, happened to come to Seybolt's office to discuss museum problems in general. "I'd never heard of him before he walked into my office," Seybolt told the Boston *Globe* several years later. "I spent two hours with him because he seemed to have some understanding of what we were trying to do with the '*ad hoc.*' I found that he was one of the few professionals I'd talked to who had any ability [and who had done] any thinking in this regard." [24]

Rueppel, then forty-nine years old, had earned his doctorate in nineteenth-century American art at the University of Wisconsin. At

Director Merrill C. Rueppel, new on the job, inspects a Renoir at the Boston Museum of Fine Arts, alongside his patron (right), President George Seybolt

the Minneapolis Institute of Arts he was resident assistant in 1956–57, and then assistant to the director from 1959 to 1961. He served as an assistant director at the City Art Museum in St. Louis from 1961 to 1964, and in 1964 he was named Dallas director.

Shortly after their talk, Seybolt, backed by a powerful trustee, John Coolidge, former director of Harvard's Fogg Museum, who in 1973 succeeded him as museum president, enthusiastically recommended Rueppel for the Boston post. How thoroughly Seybolt or Coolidge investigated Rueppel's background and credentials is open to question. According to Mrs. Edward S. Marcus, then president of the Dallas board, nobody ever asked her for information about Rueppel; she stated to the author that had she been asked, she would have informed the search committee that Rueppel had been told to look for another job. He had qualities, Mrs. Marcus added, but sensitivity to staff wishes and community problems was not among them.

At Boston, Rueppel proved to be a left-footed administrator. In a museum riven by departmental schisms, he was at a fatal disadvantage in dealing with the curators, some of whom made no secret of their disdain of his scholarly attainments. He quarreled with staff over his plan to limit further their teaching activities, over educational programs, and over exhibition policies. Whenever Rueppel prevailed,

the staff could be counted on to protest to individual board members.

Finally, the staff took their complaints to the press, and in 1975 an investigative series appeared in the Boston *Globe*, prompting denials, countercharges, columns of letters to the editor, and the following editorial:

> At the core of the dilemma is a conflict between the museum's scholarly curators on the one hand and its administrators and some trustees on the other. . . . Rueppel's qualifications as an administrator, scholar, and fund-raiser were acceptable, hardly but outstanding. But infinitely more surprising than his selection was the manner in which he was selected. George Seybolt, a wealthy processor who was then president of the museum, took it upon himself to offer the job to Rueppel without bothering to consult search committees who had been seeking suitable candidates for the job.[25]

Within a few months after publication of the articles, Rueppel was asked to resign, and Jan Fontein, curator of the Asiatic art department, was named acting director. A new and chastened search committee eventually appointed him director.

BROOKLYN: EXIT CAMERON

A third victim of the penchant of trustees for choosing the wrong person for a difficult job is Duncan Cameron, appointed director of the Brooklyn Museum in 1971. At the time it no doubt seemed refreshing, even daring, that a museum would look for innovative leadership in Toronto, where the trimly good-looking Cameron, then forty-one years old, was public relations director of the Royal Ontario Museum. Known as an articulate reformer and an advocate of multimedia technology, he had designed some of the electronic software that made Expo '67, the Montreal world's fair, a milestone of McLuhanism. Thomas S. Buechner, who was resigning after eleven years as Brooklyn director to become head of the Corning Museum of Glass in upstate New York, mentioned Cameron's name to William Covington Hardee, head of the museum's governing committee and board chairman of the Lincoln Savings Bank.

Hardee was so impressed with Cameron that he urged the museum's governing board to look no further. Unfortunately, as he admitted to the author in 1975, he was at the time only vaguely aware of a speech that his candidate had made to a UNESCO conference in Paris in 1969:

> In summary, then, the traditional museum has been administered by a curatorial élite whose members are trained as scholars in disciplines

relevant to the museum collections . . . structured according to specific models of knowledge. These models are generally incomprehensible to other than those trained in a specific discipline and may be said to be encoded in the private languages of scholarship. . . . This situation has persisted through the reluctance of the public to protest it and the willingness of governing bodies to support it. Both have been in awe of the mystique of curatorship, both have been unprepared to admit that the content of the museum is meaningless and lacks personal relevance.

Thus, for many, the museum is a fantasy playground, an unreal world offering escapist adventure. For even more it becomes, after minimal experience, a threatening environment in which the frustration of attempting to understand or to find meaning in the incomprehensible leads to anxiety. For a few, the upper-middle class with higher education and therefore some key to the secret codes, it becomes a domain with class and status connotations.[26]

Not long after Cameron was named the Brooklyn director, copies of this speech were being anxiously perused by the museum's senior curators, who took to calling it Cameron's *Mein Kampf.*

One of the long-established encyclopedic galleries in the United States, the Brooklyn Museum bears witness to the grandiloquent aspirations of Brooklyn when it was a city in its own right. The cornerstone of the McKim, Mead & White Beaux-Arts structure was laid in 1895 by Franklin Hooper, president of the Brooklyn Institute of Arts, who ambitiously announced: "If the museum is wisely planned, it will take into account all human history, the infinite capacity of man to act, to think, and to love." [27] But like Brooklyn itself, the museum has had to resign itself to more modest goals. Less than half the original building plan was completed; in 1901 Brooklyn became a borough of New York City and with the years proceeded to lose its baseball team, its daily newspaper, and its middle-class character. At the same time black and Hispanic newcomers were changing its demography so that by 1971 a full third of the museum's 950,000 annual visitors was nonwhite.

That year about half the museum's budget of $2,200,000 was met by direct city appropriations; the remaining support—since the museum exacts no admission fee—derived from private contributions and endowment income. The Brooklyn Museum knew that the only way it could justify these large city appropriations was by reaching out to all the borough's inhabitants. Most of the curators felt that the institution was already sufficiently responsive to community needs and resented any suggestion to the contrary from a director who understood very little about New York—and perhaps even less about his new position. When Cameron invited the staff to

a series of informal get-togethers in his office, rumors spread that he was cultivating favorites in an attempt to divide-and-rule. The gossip reached a pitch when Cameron made an unqualified junior staffer, the twenty-eight-year-old Damian de Aragon, a senior planning officer.

A few months later, in April 1973, De Aragon was arrested for stealing eight silver candlesticks, said to be worth $50,000. De Aragon subsequently confessed to the theft and was released for psychiatric treatment. Cameron blamed J. Stewart Johnson, the museum's curator of decorative arts, for security negligence, and gave him the choice of resigning or being fired. Johnson chose not to resign; instead, twenty-one of his colleagues chose to sign the following letter of protest, which was sent to every member of the governing board: "During the last two years, morale within the museum has deteriorated as the gulf has widened between the administration and the professional staff. This arbitrary action against a curator, highly respected by his colleagues, has forced upon us the realization that any one of us may be subjected to similar treatment. This is an intolerable situation in which to work." [28]

Accounts of the turmoil presently appeared in the *Village Voice, The New York Times*, and the New York *Post*. On December 18, Cameron, though defending his record, submitted his resignation to a divided board. His successor, appointed some months later, was the thirty-year-old Michael Botwinick, an assistant director at the Philadelphia Museum of Art and former associate curator of medieval art at The Cloisters.

Cameron, like Hightower and Rueppel, is less to be blamed for the dissension caused by his appointment than are the trustees who appointed him. In all three cases, the appointments were made on adventurous impulse—ultimately, at some cost to the directors' careers (it is, after all, not museum presidents who resign). In instances such as these, one can reasonably speak of trustees exercising power without responsibility.

PROFESSIONALIZING THE BOARD

There are remedies for the casual proprietorship that boards of trustees may evince from time to time, without even thinking about it. The broadening of representation has already been discussed, but consideration also should be given to changes in board procedure, some of which were outlined by Richard Brown in a speech to a trustees' committee of the American Association of Museums: Every

board, he urged, should adopt a formal policy statement, written in plain language, that would define the goals and priorities of the institution. The statement should be widely disseminated to obviate the most fundamental misunderstandings. All board votes should be noted, thereby requiring each member to think through a choice and put himself on record. Recorded votes would help a director judge the temper and evolution of board thinking and would be available for public scrutiny when necessary. Directors should have the security of a written contract, defining their responsibilities and specifying their tenure.

A further spur to accountability would be the opening of all board meetings to the press, a reform so drastic that it would cause end-of-the-world mutterings among some trustees. In any case, it can be maintained that the least that boards owe the public is a full and clear accounting of museum finances, certified by independent auditors.

In the first thorough study of American museums, published in 1939, Laurence Vail Coleman characterized museum financial reports as "motley," "crude," and "fragmentary":

> Nearly a score of very important museums—more than half of them art museums—do not publish financial reports at all, apparently on the principle that what they do not care to make known is nobody else's business. Some carry this to the point of being unwilling to give out any financial information under any circumstances. This is surely short-sighted, and also wrong.[29]

Four decades later *Museums USA* expressed a similar exasperation about museum bookkeeping. Describing it on the whole as "almost totally inadequate," the report went on to elaborate that the majority of museums "had great difficulty reporting their budgets, not because their system was different but because their records were deficient. . . . It would seem fair to say at this time that the museum field collectively—even though there are outstanding exceptions—is not prepared to make a proper financial accounting of itself." [30]

Mindful of this reproach, the American Association of Museums, in consultation with leading accountants, prepared two booklets of suggested guidelines, one for large museums and the other for small and medium-sized ones. There is evidence that most major museums have come to accept the necessity of greater financial accountability.

Procedures and specific practices to the side, boards should be prevailed upon to act as a unit, and power plays between individual

trustees and favored curators should be discouraged, if not pro-
scribed. The new code of museum ethics adopted by the American
Association of Museums in 1978 flatly states:

> Trustees have an obligation to define the rights, powers and duties
> of the director. They should work with the director, who is their chief
> executive officer, in all administrative matters, and deal with him
> openly and with candor. They should avoid giving directions to, acting
> on behalf of, communicating directly with, or soliciting administrative
> information from staff personnel, unless such actions are in accord
> with established procedure or the director is apprised. Staff members
> should communicate with trustees *through* [author's emphasis] the di-
> rector or with his knowledge, but a procedure should be provided to
> allow staff personnel to bring grievances directly to the trustees.
>
> The trustees must act as a full board in appointing or dismissing
> a director, and the relationship between director and board must reflect
> the primacy of institutional goals over all personal or interpersonal
> considerations. The director should attend all board meetings and im-
> portant committee meetings except executive sessions concerning him.[31]

This long-overdue statement from the AAM distills what Vergil
called the tears of things for a generation of museum directors.

PAYING THE PRESIDENT

By the 1970s, in quest of a cure to its management ills, both the
Minneapolis and Chicago Art Institutes had appointed a paid presi-
dent to serve as full-time administrator, with a director in a sub-
ordinate role. (It should be pointed out that both institutes operate
art schools and theaters as well as museums and so constitute a kind
of cultural complex.) But when this measure was formally approved
by the Metropolitan Museum in 1977, it initiated a wide-ranging
debate on the multifarious issues involved.

For most of this century the director has been the chief executive
officer in a museum. The AAM code of ethics specifies that it is
the director who must "carry out the policies established by the
trustees, and adhere to the budget approved by the board. Whenever
it is necessary to deviate from established policies or to alter or
exceed budget guidelines, the director should notify the board in
advance and request appropriate approval." The director has been
responsible for the day-to-day decisions, the most important of which
have usually been made in consultation with the museum president.

Major museum programs have thus been carried out under a pro-
fessional in the museum's particular cultural domain, the fine arts.
Since World War I almost all the directors of leading galleries have
risen from the curatorial ranks. According to *Museums USA*, in

1971–72, 66 percent of art museum directors had graduate degrees (compared to 64 percent in science museums and 38 percent in history museums), most were male and white (an unremarkable fact, given the biases of our culture), and the average tenure of each was 6.3 years, lower by a third than that of science museum directors.

Promoting from curatorial positions has its obvious benefits in that the director will speak the same language as the staff and share its commitment to excellence. Considering the predominance of non-professionals on museum boards, there is another important benefit in having a museum professional serve as director: He will be guided by a professional conscience.

Tampering with this chain of command is no simple matter of administrative convenience, but raises instead the most fundamental issues of museum purposes. These have tended to be overlooked partly because of the piecemeal fashion in which the change in command has taken place.

In 1963 the Minneapolis board elected a bank president, Charles Robinson, its chief executive officer. After fifteen successful years as the museum's paid president, Robinson looked back on his first days there: "Our biggest problems were with the trustees, not the staff, although some of them wouldn't even speak to me when I first came on board." [32]

In 1972 the Art Institute of Chicago named as its director E. Laurence Chalmers, a former chancellor of the University of Kansas and a Ph.D. in psychology. Shortly thereafter the institute's bylaws were changed, so that Chalmers could become paid president, a post he still occupies.

The Metropolitan's decision to follow suit was a matter of a different color; it could be seen as the awarding of a seal of endorsement to what had been an experiment at museums with variant structures. Under the Metropolitan plan, C. Douglas Dillon, the museum's unpaid president, would become chairman of the board and yield his powers to a full-time, paid administrator. Dillon rejected the criticism that the change would compromise the country's greatest museum: "Since the beginning of time, the trustees have set the priorities. Now the trustees will be advised by an administrator and an art historian as director." The board had always been in charge, he maintained, and would remain in charge: "We are looking for someone as president who will be sympathetic to the concerns of an art historian, the kind of person who heads a university. If the two

of them keep arguing all the time, then of course one of them will have to leave." [33]

Dillon's defense of the plan serves only to underscore the point that arouses the greatest apprehension—that in institutions struggling to maintain professional standards, nonprofessional boards would hire chief executive officers lacking the firsthand knowledge essential for informed advocacy.

Dillon's own analogy of the university can be used against him, in that institutions of higher learning have found that by and large a faculty background is the best preparation for a college presidency. Faced with mounting fiscal and bureaucratic problems, universities have indeed had to employ full-time administrators but, in most cases, as provosts or vice-presidents whose duties are almost solely nonacademic. There would have been no cause for alarm if the Metropolitan had decided to appoint a seasoned administrator to serve under the director, with the board retaining the power of final decision. But according to the new plan, the administrator would supervise programs as well as budgets and at the same time be responsible for defending the integrity of the museum's professional standards. (The fears expressed by the opponents of the plan were not allayed in April 1978, when the Metropolitan Museum announced the appointment as paid president of William Butts Macomber, Jr., a former State Department official and onetime ambassador to Turkey, who openly acknowledged his lack of arts credentials. Macomber described his election to the Metropolitan presidency to *The New York Times* as "the darndest thing to luck into." Succeeding Hoving in the diminished post of director was Philippe de Montebello, vice-director for curatorial and educational affairs.)

In 1977 Alan Shestack, thirty-nine-year-old director of the Yale Art Gallery, was invited to serve as director of the Art Institute of Chicago—and accepted. As head of the Association of Art Museum Directors' policy committee, he had opposed dual leadership of museums, and had misgivings about having consented to serve under a paid president. After looking further into the particular division of authority and its implications, he withdrew his acceptance, deciding to remain at Yale. Personal considerations may have played a part, but the rejection of the prestigious directorship by an able and energetic young scholar can be taken as an augury of what the dual arrangement could mean: that museums will have to settle for second-rate directors—and second-rate professional standards.

CHAPTER

VIII

SUMMING UP: SIX PROBLEMS
IN SEARCH OF A SOLOMON

God help the Minister that meddles with Art!

—LORD MELBOURNE, in conversation with artist and diarist Benjamin Robert Haydon (1836)

THE FOREGOING PAGES HAVE SHOWN IN SOME DETAIL WHY GOVERN-ment assistance to art museums is now a topic worthy of general concern. American art museums, partly for reasons beyond their control, such as inflation and declining private support, and partly through circumstances very much of their own making, such as imprudent capital expansion, are for the most part in serious financial difficulties. In a number of cities, the result can be as plainly read as the unpleasant sign on a gallery's main entrance: "Museum Closed Today."

In their search for new sources of money, art museums have found themselves in the tar pit of our complicated system of public patronage—local, state, and federal. In the hope of being able to budget predictably at least part of their maintenance expenses, they have looked to Washington. Their plea has been heard, thanks both to

their own lobbying and to the abiding interest of Senator Claiborne Pell and Congressman John Brademas. An Institute of Museum Services was established in 1977 within the Department of Health, Education, and Welfare for the express purpose of seeking out and assisting museums of all kinds.

What makes the new institute significant is not so much its size—its initial budget was a modest $4,011,000—as its nature. For the first time a federal agency was authorized to subsidize a share of basic museum maintenance costs (this form of aid had hitherto come only from municipal, county, and state governments). To be sure, for more than a decade museums have been receiving financial assistance from the two national endowments and from other federal departments, but nearly all this money has been earmarked for special projects; grants made by the Institute of Museum Services, in contrast, are in most cases unrestricted.

Does this innovation imply a basic change in national arts patronage policy? More fundamentally, does a policy even exist? If not, should one be devised (and who should devise it and administer it)? Should the federal government concern itself with the internal operations of what historically have been local institutions managed by private boards? Should the Institute of Museum Services be given a wider mandate? Do the tax incentives intended to encourage private contributions to museums need modification? Whose interests do global loan shows serve? Just what should we expect from art museums—in other words, what are they for? The author has tried to encompass these varied and daunting problems under six headings.

IS A NATIONAL ARTS POLICY NEEDED?

No such policy now exists, and we badly need one for the mutual benefit and protection of government and of the arts. Certainly, a clearer definition is needed of the federal government's role as an arts patron—a definition based on a more accurate picture of what is actually being done. There is not only a lamentable lack of systematic information about existing federal programs and tax incentives but also a Balkan profusion of power centers. The danger for the arts is that in this profusion other considerations may dictate what passes for policy—bureaucratic self-interest, diplomatic necessity, congressional logrolling, White House power plays, and in-group factionalism within the arts constituency itself. To suggest that all these considerations can be eliminated would be naive, but it is

A mall of museums. Seen from atop the Capitol are (1) the Air and Space Museum, (2) the Hirshhorn, (3) Natural History Museum, (4) National Gallery and its East Building. Three other museums are beyond camera range.

reasonable to hope that a body of standards can be formulated that will at least define impermissible procedures.

The basic principles of federal arts policy must be set forth by a varied and distinguished group of citizens serving on a commission independent of the government. In Great Britain the traditional device for dealing with such broad and sensitive questions is the Royal Commission. Although we have no equivalent mechanism, we can look with a measure of confidence to private philanthropy for a substitute. A precedent exists in broadcasting policy.

In 1967 the fifteen-member Carnegie Commission issued its landmark report *Public Television: A Program for Action*, which provided the groundwork for the Public Broadcasting Act of 1967. Funded by the Carnegie Corporation of New York and headed by Dr. James R. Killian, Jr., then chairman of the corporation of the Massachusetts Institute of Technology, the commission gathered the information and formulated the recommendations that enabled Congress to provide a national charter for public television. The deficiencies in the system are now being examined, with the benefit of hindsight, by a second Carnegie Commission, under the chairmanship of Dr. William McGill, president of Columbia University. The commission report, due in January 1979, is likely to serve as the

touchstone for further reforms and in any event will provide a body of judgments and data less self-serving than any document shaped under political auspices.

That a commission with a similar mandate could perform a clarifying function in arts policy is suggested by the history of national cultural patronage.

Government policy in relation to the arts is colored at every point by the profound American ambivalence concerning official patronage. To the philistine, the state has no business spending money on frills, but wariness about mixing government and the arts derives from much more than an atavistic anti-intellectualism. Emerson, in an essay on art written more than a century ago, was probably speaking for the majority of educated Americans when he insisted: "Beauty will not come at the call of a legislature, nor will it repeat in England or America its history in Greece. It will come, as always, unannounced, and spring up between the feet of brave and earnest men." [1]

In both England and America, however, leading artists maintained that the state had a positive duty to encourage native talent and thereby to elevate public taste. This belief was vigorously championed by James Jackson Jarves in *The Art-Idea*, and with the years, the adherents of cultural activism were successful in persuading city governments to allocate funds to art museums. But other early experiments in state patronage seemed to bear out Emerson. The interminable quarrels over the design and decoration of the new Houses of Parliament in London had their counterpart in arguments over our new Capitol in Washington. Over a fifty-year period no fewer than five architects were driven to despair in their dealings with Congress over questions of taste (indeed, the conflict persists into the present day: Despite the horrified protests of architects, Congress extended the east front of the Capitol in 1959, and a similar "improvement" is promised for the west front).

During this century, artists have continued to be in the forefront of the campaign for national arts patronage. When newly elected President Warren G. Harding asked the prominent New York sculptor J. Massey Rhind in 1921 what he thought government could do to further the cause of art, Rhind responded, "Establish a cabinet post for a Secretary of the Fine Arts." [2] The nonplussed Harding said he found the idea interesting and promised to think about it. But despite an energetic campaign led by Rhind, the idea expired in fallow soil.

In 1933 painter George Biddle wrote to another newly elected President, his Harvard classmate Franklin Delano Roosevelt, and pressed the argument for a federal arts program. Biddle's letter bore fruit in the launching of four WPA projects, intended as emergency measures to assist the jobless and to bring the benison of art to as many Americans as possible. But the WPA programs became the object of wrathful dissent in Congress, and the White House allowed them to die during World War II.

In the postwar period the old arguments for national arts patronage took on a different guise. The increase in leisure time and the expansion of educational opportunity had combined to build a new, large, and enthusiastic audience for all the arts—which in turn led to chronic deficits at arts institutions and to subsequent appeals to Washington for help. In the 1960 presidential campaign both John F. Kennedy and Richard M. Nixon saw fit to endorse the principle of federal aid to the arts.

By 1965 national arts patronage was an idea whose time had clearly come, and when President Johnson proposed establishing the two national endowments as part of his Great Society program, he encountered no formidable opposition. Johnson's initiative had its genesis in plans nurtured during the Kennedy administration and was inspired in part by the example of New York State, which had formed the first statewide council on the arts six years earlier. Under Nixon, appropriations for both the National Endowment for the Arts and the National Endowment for the Humanities increased fifteen-fold, and this expansion proved to be one of the least controversial of his innovations.

Whatever else divided Jimmy Carter and Gerald Ford in the 1976 election, it was not the subject of federal aid to the arts. National patronage was by then very nearly a democratic piety, on a par with iterations about the need to improve the quality of life. But pieties do not produce policies, and once in office, President Carter found himself mired in the Byzantine complexities of the national arts patronage issue.

First the new President had to decide whom to appoint as the heads of the two national endowments. Nancy Hanks had announced that she wished to step down as NEA chairman when her term expired in 1977, although her partisans continued to insist in private that she would stay on if asked. Dr. Ronald S. Berman, the NEH chairman and a Shakespeare scholar, had pressed for a second four-year term, but his reappointment was blocked by Senator Pell, the chairman of

the Senate subcommittee with jurisdiction over the endowments, who took exception to what he regarded as an elitist cast in the NEH's heavy appropriations for specialized academic research. The senator further faulted the chairman for failing to spur the formation of broadly based, independent state humanities councils on the model of the state arts councils. In the view of Berman and his defenders, Pell's criticisms were unwarranted; nevertheless, they carried the *ex cathedra* weight of a subcommittee chairmanship. By the time Carter took office Berman had already resigned.

Informal White House task forces began to canvass candidates for the two endowment posts. During the months-long search for the next NEH chairman the President ruefully remarked that he was spending more time on the Humanities Endowment appointment than he was on the SALT talks. The task forces dutifully consulted the fissiparous interest groups concerned with cultural patronage: arts organizations, trade unions, ethnic and minority lobbies, interested legislators, and the academic establishment. Whenever a likely candidate emerged, the search committees sent up trial balloons—which were invariably punctured by a shower of darts, if not arrows.

In the end, in the absence of a consensus, President Carter relied on his political instincts. He named Joseph D. Duffey, one of his early supporters, chairman of the National Endowment for the Humanities. An activist Connecticut liberal and onetime Congregationalist minister, Duffey had once served as general secretary of the American Association of University Professors and was a former national chairman of Americans for Democratic Action. At the time of his appointment to the NEH post, he was serving as assistant secretary of state for cultural affairs, a position that was about to be eliminated in a departmental reorganization. To all appearances, Duffey's credentials were essentially political.

Carter's choice for the NEA chairmanship was Livingston Biddle, Jr., staff director of the arts subcommittee headed by Senator Pell. Bespectacled, soft-spoken, and aristocratic, Biddle had all the formal qualifications for the chairmanship: He had served as NEA deputy chairman in 1965–67, as head of the arts division at Fordham University, and as board chairman of the Pennsylvania Ballet, and he was also the author of four popular novels. In an earlier tour of duty in Senator Pell's office, he had helped draft the legislation bringing the endowments into existence. But what attracted more attention than his qualifications was his friendship with Pell, which dated back to their days at St. George's School in Newport and at Princeton.

The birth of an institute: Lee Kimche, director of the just-formed Institute of Museum Services, chats with Senator Claiborne Pell. To her right is George Seybolt, head of the institute's board. The swearing-in ceremonies were at the Brooklyn Children's Museum.

Symbolically, if not in fact, President Carter demonstrated through these two appointments the dangers of confusing the meanings of the word "patronage." Every chief executive has political debts to repay, and by the same token every department of the federal government must defer to some extent to its suzerain in Congress. Without the practice of judiciously rewarding loyal supporters, political parties could not flourish. Moreover, legislators are bound by their oaths of office to see to it that unelected officials faithfully discharge their duties. In expressing his dissatisfaction with Berman's stewardship at NEH, Senator Pell was well within his rights. However, one can scarcely imagine that, in a virtual no-man's-land of public policy, either the President or the Democratic senator from Rhode Island will be able to appraise with detachment the performances of Duffey and Biddle.

The terrain is all the more uncertain because the United States has no real tradition of national arts patronage and is only now in the process of shaping one. Lacking the restraints of tradition, arts patronage is particularly vulnerable to expedience. So immense is the prestige of art and so widespread the public's awe of the mysteries of creative genius that the pragmatic, both inside government and out, are tempted to turn art to their advantage. Then the intrinsic

magic of art almost certainly will be trivialized and commercialized, and certainly, it will be politicized. Some of the risks are apparent in the exploitation of the international loan show.

ART FOR DIPLOMACY'S SAKE

Technology has made possible the postwar flowering of cultural exchange programs, but the concept of people-to-people diplomacy long predates the invention of the airplane. As a representative of the American colonies in London and later at the court of Versailles, Benjamin Franklin sought to reach beyond the chancellory to a wide public and did so with considerable success. Revolutionary France appealed over the heads of kings to the people, and Napoleon was among the first to use both art and the museum as implements of propaganda. By 1826 the British foreign secretary, Lord Canning, was calling respectful attention to what he termed "the fatal artillery of popular excitation." [3]

In our own century the French have led the way in confirming the usefulness of art in diplomacy. In 1932 the officials of Les Musées de France lent one of the most celebrated pictures of all time, Whistler's *Mother*, to an exhibition at the Museum of Modern Art. The risks entailed in transporting the painting were undertaken by both sides in the cause of goodwill and artistic solidarity. "Suddenly," writes Russell Lynes in his history of MOMA, "attendance at the museum leaped to a figure that nearly doubled the number who had come to any exhibition it had held thus far. More than 102,000 people pressed into the newly opened galleries, three times as many as had come to the International Style show, more than six times as many as saw the [Mexican] murals that caused such consternation." [4]

The Whistler then went on national tour, traveling in an armored car with a motorcycle escort—a ritual that received page-one publicity. It made a prolonged stop at the Century of Progress World's Fair in Chicago, went on to Cleveland, Boston, and other cities, and returned to the Museum of Modern Art for four days. During the Whistler's stay in America an estimated 2,000,000 people had paid homage to it; obviously, a single picture could be worth more than 1,000 diplomatic orations.

It was significant that the tour coincided with the organization of MOMA's first publicity department, headed by the resourceful Sarah Newmeyer. She had been quick to see—and seize upon—the pub-

licity value of emphasizing that the French had asked MOMA to insure the painting for $1,000,000 (in the end the Louvre finally settled for half that amount). She persuaded President Roosevelt's venerable mother to "unveil" the painting but was disappointed when she declined to pose alone for a photograph with the Whistler. "It was too bad," said Miss Newmeyer. "The Number One Mother of the United States with the Number One Mother of the world of art. What a natural that would have been!" [5]

Miss Newmeyer was equally adept at promoting the next MOMA international loan, the great van Gogh show of 1935, which included forty-three paintings from the Kröller-Müller Foundation in The Hague and from the collection of the painter's nephew. Lynes writes of the show: "The response was, quite literally, overwhelming, and for this Sarah Newmeyer is due a share of the credit." [6] Museum attendance broke all records, netting more than $20,000 in admission fees alone, and the show proved as great a draw in Boston, Cleveland, and San Francisco, where visitors came from as far as 900 miles away aboard trains known as the "van Gogh Specials." Years later, in an interview with Roger Butterfield in the *Saturday Evening Post*, Miss Newmeyer irrepressibly recalled: "We played the van Gogh show like a polo game—dribbled the ball down the field first, and then, bang, right between the goal posts! It was a honey, if I do say so myself." [7] Despite MOMA director Alfred H. Barr's discomfort at some of her publicity techniques, Miss Newmeyer held her post for fifteen years, in the course of which she pioneered the pattern of lavish promotion for loan shows.

The Museum of Modern Art established another innovation by becoming an active partner with the State Department in organizing shows abroad. During World War II Nelson Rockefeller, a president of the museum, was also serving as coordinator of the Office of Inter-American Affairs, and as part of his campaign to win friends for the United States elsewhere in the hemisphere, he arranged nineteen Latin American exhibitions of MOMA treasures. The response was so favorable that after the war the museum set up an International Council for the purpose of arranging, in collaboration with the State Department, loan exhibitions throughout the world. But the traffic was to become increasingly two-way; at the Metropolitan Museum of Art, director Francis Henry Taylor initiated a spectacular series of loan shows that included treasures from Great Britain, France, Germany, Austria, the Netherlands, and China. Two million visits

From the Louvre to Camelot: André Malraux, his wife Made-
leine, and *Mona Lisa* are welcomed to the National Gallery of
Art by the Kennedys and Vice President Johnson

were clocked at the museum in 1950, double the number in 1940,
and most of the increase could be attributed to Taylor's foreign loan
program.

The spectacular impact that a work of art could have was demon-
strated anew in 1962. When André Malraux, France's Minister of
Culture, was asked at a Washington press luncheon if he would lend
the *Mona Lisa* for exhibition in the United States, he unhesitatingly
said yes. Within months the Leonardo was aboard the *France* bound
for an extended visit to the National Gallery of Art and the Metro-
politan Museum. The *Mona Lisa*'s debut in Washington was the
occasion for a full-dress opening so symbolically important that Mal-
raux reported at length to President de Gaulle on the nuances of the
occasion. At each institution on any given day of the exhibit, the
queues stretched nearly half a mile.

What became known as the détente show, in which art is served
up as a kind of offering, was to an extent an outgrowth of the
Leonardo loan. During the 1970s it became a practice at summit
meetings to include an agreement to exhibit art in the final com-
munique; this innovation owed a great deal to the vigorous lobbying
of such museum directors as the Metropolitan's Thomas Hoving and
the National Gallery's J. Carter Brown (who had the advantage of
having the secretary of state as one of his ex officio trustees).

But the détente show tends to be as much a political as an aesthetic
event and may well entail self-censorship by the host museum. The

extreme instance of this was "The Exhibition of Archaeological Finds of the People's Republic of China," which in 1975 traveled from the National Gallery to museums in Kansas City and San Francisco. Installations were made taking account of Peking's sensibilities, without so much as a hint of the fearful destruction of the art and architecture of the past that had taken place during the Cultural Revolution. The circumstances surrounding the exhibition were no doubt special; nevertheless, the museums involved could fairly be accused of enhancing the prestige of a regime the tenets of which were inimical to the fundamental concept of artistic freedom. Revealingly, the Chinese did not suggest that American museums reciprocate by sponsoring an exhibition of Western art in Peking.

This delicate problem has clouded loan shows from the Soviet Union as well. In order to obtain the prized Scythian gold, the Metropolitan Museum had to agree to sponsor an exhibition in 1977 that included roomfuls of hackwork in the style of socialist realism. Outstanding early modernist works by Picasso, Matisse, and Chagall also were on view, but how many visitors to the museum would know that these pictures had been kept from the Soviet public for thirty years or more and the artists denounced as incorrigible decadents? A similar inhibition on the part of the museum prevailed when it came to making references to the Russians' savage persecution of avant-garde Soviet artists from the 1930s to the present day.

For its part, the National Gallery of Art, in a determined effort to outdo the Metropolitan, has availed itself of the services of an interested go-between: Dr. Armand Hammer, owner of two leading New York art galleries; head of one of the largest American oil companies, the Occidental Petroleum Corporation; and a prominent collector. Hammer personifies the confusion of interests in the manipulation of art for diplomacy's sake, and it is worth a digression to describe him more fully.

In a career as colorful as it has been long, Hammer has enjoyed a reputation both for making money out of communism and for turning art to profitable account. As a recent graduate of Columbia University's College of Physicians and Surgeons, he surfaced in the Soviet Union in 1921 to help a struggling Bolshevik government turn back an epidemic of typhus and cholera. In the course of his medical work he met key leaders of the Soviet regime, including Lenin. Before long he had abandoned medicine and was negotiating barter exchanges of American wheat for Russian furs and caviar as well as setting up a pencil factory under a special concession from the

Dr. Armand Hammer, a new proud possessor, beams at *Juno* after he paid a record $3,250,000 for the Rembrandt in 1976

government. Part of his profits he invested in art. In gratitude for his services as *entrepreneur extraordinaire*, Soviet authorities in 1930 allowed him to return to the United States with a shipload of czarist-era art treasures.

In partnership with his brother, Victor, Hammer had founded the Hammer Galleries, subsequently located in New York. During the early 1930s he toured major American cities with exhibitions of Russian art which were for sale. In the 1940s William Randolph Hearst made Armand and Victor the principal agents for the sale of the Hearst art collection, whose value was estimated at $50,000,000. The sale of Hearst's holdings continued well into the wartime years, when Hammer, in another improbable coup, was increasing his considerable fortune by distilling whiskey from Maine potatoes.

In 1957 Hammer purchased the near-bankrupt Occidental Petroleum Corporation. The firm's California leases turned out to be unexpectedly lucrative, and in 1966, when it obtained drilling rights in Libya, "Oxy" became an international force. Even following the overthrow of the Libyan monarchy in 1969, Occidental held onto its concession by agreeing to a new profit split that was so generous to the junta headed by Colonel Muammar el-Qaddafi it caused consternation among the world's major oil producers. Once again, Hammer's business instincts were borne out: By 1972 Occidental ranked thirty-sixth in *Fortune*'s roll of the 500 largest American corporations. The same year Hammer negotiated a multibillion-dollar deal

with the Soviet Union involving natural gas, fertilizers, and the construction of a trade center in Moscow.

As Occidental grew, so did Hammer's private art collection. In 1970 there was an exhibition in Washington of his Old Masters and School of Paris works, and when their quality was questioned by art critics, Hammer invited John Walker, the just-retired director of the National Gallery, to advise him on upgrading his collection. At Walker's urging, he eliminated inferior works and, as for new ones, bid only for the best. He also took care to associate himself not only with the National Gallery but also with the Los Angeles County Museum of Art, on the board of which both he and Walker now serve as trustees.

Hammer's involvement in the art market intensified with his purchase in 1971 of the controlling interest in the Knoedler Gallery, in New York City, which gave him an insider's edge in the Old Masters field. It was through Knoedler that he purchased Rembrandt's *Juno* in 1976 for $3,250,000, the record for a Rembrandt. Most Hammer purchases became the property of a family-controlled foundation, which kept the collection in continuous circulation through loan shows in Europe, Russia, Japan, and the United States. Tax advantages aside, the Hammer foundation loan program yielded public relations benefits for an entrepreneur in serious legal trouble. In 1975 Hammer pleaded guilty in federal court to three charges of illegally making contributions in the name of other persons to the 1972 Nixon reelection campaign; he was fined $3,000, placed on a year's probation, and spared a jail sentence only on the grounds that he was old and ailing.

Hammer clearly had his reasons for playing a *pro bono publico* role in arranging East-West art exchanges: He had extensive business dealings with the Kremlin, a sideline interest in two New York galleries, and an obvious need for sympathetic media attention. Under the umbrella of his museum interests, he was able to turn these disparate needs to his advantage.

In 1973 Hammer arranged for forty-one Impressionist and Postimpressionist works from the Hermitage in Leningrad and the Pushkin Museum in Moscow to tour America. Following a festive opening at the National Gallery, the show traveled to Knoedler in New York, the Los Angeles County Museum, the Art Institute of Chicago, the Kimbell Art Museum in Fort Worth, and the Detroit Institute of Arts.

There was an even grander sequel in 1975–76, when a selection

of forty-three masterpieces on loan from the Hermitage—including works by Rubens, Velazquez, Rembrandt, Hals, Poussin, and Picasso —traveled to the National Gallery, the Detroit Institute, the Los Angeles County Museum, the Houston Museum of Fine Arts, and, of course, Knoedler. In reciprocation, each of the American museums agreed to lend prize works from its collection to the Soviet Union, with Hammer and Knoedler serving as the intermediaries.

In 1974 the State Department formally recognized the diplomatic utility of museum exchanges by establishing, under a senior foreign service officer, Peter Solmssen, an Office of International Arts Affairs, to participate in negotiations concerning major loans from China, the Soviet Union, Egypt, and other countries. The office was instrumental in formulating the Arts and Artifacts Indemnity Act approved by Congress in 1975; modeled on legislation enacted by Great Britain and Australia, the act serves to reduce the financial burdens on American art museums by providing federal indemnification of insurance risks on major loan shows.

In the absence of federal underwriting, major loan shows would be substantially—and in some cases prohibitively—more expensive. It is, however, arguable whether the decision to extend federal guarantees should lean on advice by the State Department, which is likely to give the greatest weight to diplomatic considerations. The task of administering the act could be transferred to the Institute of Museum Services, where more consideration might be given to aesthetic merit and to the conservation hazards involved.

If a commission on arts policy is established, an important item on the agenda will be defining the principles that would control future international loans and the preferred method of furnishing federal indemnification for major exhibitions. Another important item, it goes without saying, would be a review of federal tax laws.

THE ARTS OF TAXING

The explosive growth of art museums in the United States could never have taken place without the silent, generous, and usually unacknowledged partnership of the American taxpayer. Since the Federal Revenue Act of 1917, which first sanctioned income tax deductions for charitable contributions, the Internal Revenue Service (IRS) has been integrally involved in the growth of art museum holdings.

Two questions deserve consideration. Are existing tax laws ade-

quately enforced? And should the incentives provided for contribution of works of art to museums be modified? The first question can be readily answered: Enforcement procedures are flagrantly inadequate and cry out for reform.

In 1968 the IRS established an Art Advisory Panel to monitor appraisals on art for estate purposes and charitable deductions. The panel, comprising museum representatives, art dealers, and academics, meets three times a year in Washington, and its members receive only per diem expenses. All sessions are closed to the public since disclosure could clearly violate the confidentiality of taxpayer returns. Nevertheless, in 1975 the Freedom of Information Clearing House, a Ralph Nader group, took formal steps under the Freedom of Information Act against the IRS in an attempt to have the panel's deliberations opened to the public. In the process of defending its right to confidentiality, the IRS for the first time released minutes of the panel's meetings, including one in March 1974 during which eight panelists and eight IRS officials previewed ninety-two items with an aggregate claimed valuation of $5,875,500. Appraisal adjustments of approximately $2,696,600 were recommended by the panel; this represented a 28 percent net reduction in charitable contributions claimed and a 110 percent increase in estate and gift appraisals claimed. Only 34 percent of the items considered by the panel were accepted at the values claimed. The same pattern could be seen to have prevailed at the other meetings for which minutes had been disclosed, suggesting that roughly two-thirds of all art appraisals offered for tax purposes are subject to challenge. The high proportion of rejected appraisals is astonishing, considering that about a third of the panelists are art dealers reviewing prices set by their colleagues.

IRS Senior Appraiser Thomas Patrick Hartnett and his staff of five professionals and a secretary, working with the unpaid members of the panel, have been able to verify only a comparative handful of deductions claimed and appraisals offered. (Hartnett's office also has responsibility for reviewing tax claims on rare books, vintage automobiles, and musical scores.) William Lieberman, curator of prints and drawings at the Museum of Modern Art and a panel member for three years, described the panel's methods to the author as "very haphazard. . . . We never saw anything in context, only photographs, and they were often lousy. You never knew what you were looking at." [8]

Since Hartnett's office already recoups more in unpaid taxes than it costs to operate, a larger, better-staffed bureau seems to be called

The Washington Presence. Architect I. M. Pei (left) converses with National Gallery of Art director J. Carter Brown and benefactor Paul Mellon in the museum's resplendent East Building prior to its public opening in June, 1978.

for. In cases involving large sums of money, panelists should have an opportunity to study the objects. The question of dealer representation on the panel also needs to be openly discussed. On the theory that a poacher turned gamekeeper knows the tricks of the trade, dealer participation makes sense, and in any case, an art advisory panel would have to consult extensively with dealers in judging fair market values. But it is also a fact that dealers have a common stake in defending the rising price levels for art and that they also can be influenced by their relations with the colleagues who have made the appraisals the panel is reviewing.

Possibly the best solution would be to have the Institute of Museum Services nominate panel members; in this way the agency would enjoy greater responsibility for monitoring gifts of art to public institutions. Whichever way members are selected, the panel should be required to issue an annual report providing summary figures on total adjustments in appraised values as well as on the total worth of all art contributed annually to charitable institutions. This information is not now obtainable, and without it, changes in the charitable deduction provisions of the law cannot be properly weighed.

Nearly everyone would agree that certain provisions—such as those pertaining to estates—should remain unchanged. By giving heirs the option of thereby reducing their tax liability, the IRS helps ensure that the public inherits private art treasures. Were there no such realistic provision for the settlement of estates, art collections would inevitably be privately dispersed, many of them abroad.

There are other issues involved in providing tax incentives for donors. Until 1969 artists contributing their work to museums or other charitable trusts could claim, as do all other donors, a tax deduction

up to the level of 30 percent of their annual income, with the gifts appraised at current market value. But evidence of abuse abounded. In 1963 the Tax Court ruled that Baroness Hilla Rebay von Ehrenweisen, the first director of the Guggenheim Museum and an amateur artist, had placed excessive valuations on gifts of her own work. In 1955, for example, she took a deduction of $60,000 for two paintings she contributed to Arizona State College, although she had never sold any of her nonobjective works. In 1956 she claimed $35,000 in deductions; in 1957, $24,000; in 1958, $26,000; and in 1959, $24,000, for contributions of her work to Arizona State, Milwaukee-Downer College, and Emma Willard, a preparatory school in Troy, New York.

Baroness Rebay's only major sale was to a Mr. Crane, who in 1962 paid her $15,000 for a painting. However, the Tax Court noted, among other things, that the buyer was not an art collector but an engineer who was associated with the baroness in business ventures and that the most expensive painting he had hitherto purchased cost $50; accordingly, it reduced the allowed deductions for the artist's gifts from $169,000 for the years 1955–59 to $9,300.

In order to eliminate, insofar as possible, collusive appraisals, the Tax Reform Act of 1969 provided that henceforth artists would be able to claim as deductions only the literal cost of materials in any gifts of their work they might make to charitable institutions. But in eliminating one inequity, Congress created another: The reform meant that private collectors and even speculators in art now enjoyed a tax advantage denied to living creators. In 1975 Edward Koch, then a New York congressman, and Senator Jacob K. Javits both attempted to have tax privileges restored to living artists, but their ministrations did not persuade. It is surely not beyond human ingenuity to find a way to give a fairer break to the artist, yet still exercise adequate safeguards against collusion.

Further modifications in the charitable deduction provisions must take into account the interests of the public, the museum, the artist, the collector, and the dealer. The complete elimination of the provision for deductible gifts by living donors would drastically curtail the flow of both giving and buying—with dire consequences for artists. Tax calculations are today so intimately connected with buying decisions that any radical revisions in the IRS code would plunge the art market into disarray without compensatory benefits to museums or artists.

This is not to suggest that IRS provisions should be regarded as immutable. Manifestly, when an art museum accepts gifts that it knows

will be either consigned indefinitely to storerooms for lack of space or returned surreptitiously to the art market, the basic spirit of the charitable deduction is negated. One possible reform, proposed by J. Michael Montias of Yale—a public auction of gifts, at which the benefiting institution could buy back art at auction prices or settle for the cash proceeds—has been described in Chapter VI. Another suggestion was made to the author by Stanley Marcus, board chairman of Neiman-Marcus, a Dallas museum trustee and a prominent collector. "Perhaps the right way to attack the problem would be to require that museums circulate, distribute, or loan any material that they cannot place on exhibition," Marcus offered. "Why shouldn't regional museums obtain art on extended loan from major institutions, as is the case in France?" [9] Still another possibility, in Marcus's view, would be to distinguish between the have and the have-not museums and to give a preferred position in the tax treatment of gifts to the latter. The practical difficulties in carrying out either reform would be considerable, not to mention the risks of unwittingly creating new problems and imbalances.

For example, the Tax Reform Act of 1969 imposed a 4 percent excise tax on the investment income of foundations that did not receive at least 10 percent of their revenues from public sources; the purpose was to generate new taxes from closely held, family-controlled private foundations. Yet one unforeseen result of the act was to impel some museums to impose admission charges. Since 1970 the Frick Collection in New York has had to pay between $55,000 and $75,000 in annual taxes because more than 90 percent of its income derives from private endowments. In 1975 the Frick director, Everett Fahy, wrote to the White House to urge support for a bill introduced by Congressman Edward Koch that would have exempted museums and libraries from the foundation excise tax. Only when Congress failed to act did the Frick Collection reluctantly introduce a $1 admission fee.

In the absence of a coherent national arts patronage policy, tax laws can have a shotgun impact. An arts policy commission would necessarily review inadequate enforcement of charitable donations, lack of authoritative data, the inequities and anomalies in existing tax laws, and the grant-making guidelines of federal arts agencies.

PROJECTITIS

A recurring motif in this book has been the grudging reluctance on the part of patrons, public and private alike, to keep the boiler warm.

Arts organizations everywhere are wrestling with the tedious problem of having to pay higher wages and pension costs, inflated energy bills, and all the other unglamorous maintenance expenses that nobody is anxious to pay. For art museums, the traditional life-support system has been the municipal appropriation for operating costs; these days, though, most American cities have all they can do to keep essential services running.

As private funding also has fallen off, museums have turned for emergency relief to new government patronage agencies, both state and federal. But public councils and endowments have for the most part been modeled on philanthropic foundations, with their emphasis on seed money and matching grants and their zeal for innovative projects. For reasons that certainly are partly political, the new arts agencies have sought to justify their existence by scattering grants, building a constituency, and making taxpayers aware of benefits received.

There are advantages to this system. The public, in giving grant-making power to autonomous councils, can rest assured that merit will be taken into account. The councils and reviewing panels in most cases are composed of unsalaried private citizens who make a conscientious effort to appraise proposals fairly. To date, there have been hardly any financial scandals of consequence arising from the giving of public money for arts programs.

Few would argue that individual arts allocations should be voted by a legislature, but there is an urgent case to be made for requiring arts agencies to allocate more money toward basic operating expenses. Decisions on specific grants could remain with the autonomous councils, with the stipulation that a fixed proportion of funds be earmarked for unrestricted grants. This is the procedure now followed in New York State, and more recently the State of Illinois has also made direct line-item appropriations to troubled museums.

A similar approach was taken by President Carter in 1977, when he recommended that the Corporation for Public Broadcasting limit itself to the broad allocation of federal funds and leave the decisions on specific programs to public broadcasters. Because CPB has been involved in funding specific programs since its creation in 1966, there have been interminable delays as reviewing panels ponder the merits of various proposed programs. One of the benefits of the reform, Carter pointedly noted, would be the likely reduction of the CPB payroll, an argument that could as readily be applied to the ever-growing national endowments.

The main objection to allocating funds for operating expenses is that the large flagship institutions would enjoy unfair advantages. A museum such as the Metropolitan as a matter of course exerts far more influence than a small gallery in some remote city. Established institutions have an edge in so rudimentary a matter as filling out applications for grants since most of them employ full-time specialists for just that purpose. At the same time the trustees and staffs of the large museums have privileged access to patronage officials and key legislators. Harry Parker III, director of the Dallas Museum of Art, was speaking for many of his fellows when he remarked to the author, "There is a big difference in sending an application to the NEA with a Dallas postmark instead of New York. When I was at the Metropolitan and requested funds for a project, I was aware, and so was the endowment, that any museum program would attract national attention. Here we have to struggle to catch anything like that attention." [10]

Yet it must be stated that the overall quality of our cultural life is determined by our flagship institutions far more than by smaller craft. When the American Shakespeare Theater in Stratford, Connecticut, went under in 1977 because it was unable to raise its share of a $1,500,000 matching grant from the Ford Foundation, the loss was far greater than it would have been in the case of some community playhouse of more limited aims. The Shakespeare Theater, whatever its imperfections, was an important focus for a repertory tradition in classical drama sorely needed in the United States. One cannot imagine the British government permitting the Royal Shakespeare Theatre to perish for lack of operating funds.

The way to offset the advantage that large institutions have in obtaining public funds is to develop better methods of identifying real needs and of judging the quality of performances. No patronage system could be defended that put a small museum at a permanent disadvantage in competition with one that, although its deficits are the result of its own profligacy, is able by virtue of its size and influence to obtain federal funds.

In the difficult task of evaluating both need and performance, the Institute of Museum Services could play an important role.

SEARCHING FOR A YARDSTICK

American museums undercut their own best efforts by failing to establish a uniform and readily intelligible system of bookkeeping. It is difficult to arrive at rudimentary statistics on museum deficits

when major museums have used different methods of treating such basic items as endowment income. Widely published figures, including some that the author has of necessity quoted here, tend to be "ball-park estimates."

The issue was nicely summed up by Goldwin A. McLellan, president of the Business Committee for the Arts, in a paper he delivered at a 1975 panel discussion in Washington:

> We are all agreed, I believe, that an income gap is inherent in the economics of all nonprofit organizations, and, for them, patronage is the condition for survival. But this is only the beginning of wisdom about our arts world. We've made little progress in collecting useful statistics and what we have learned in the past ten years is fragmentary and confusing. The absence of precise information has made it possible for both ardent supporters of the arts and those who are indifferent to their fate to make any statement, without fear of accurate refutation, about the kind of support the arts need. Where all are ignorant, everyone is an expert.
>
> The field of arts funding has suffered from studies that have involved duplication of effort, categories of information in some reports that are not congruent with those of others in the same field, lack of agreement on terminology and, worse, lack of agreement on the questions that ought to be asked. There is no adequate topography of the nation's arts world available and there is no machinery for obtaining comprehensive nationwide information at regular intervals on the programs, finances and income sources of every arts organization. Central organizations in the major art fields—dance, symphony, opera, theater and museums—produce information about their constituents but it is seldom sufficiently revealing to enable potential grantors to develop a coherent and effective arts-support strategy.[11]

As McLellan has stated, we need to know which major arts organizations are in the most serious financial trouble—and then we need to know why. When this is determined, it will be possible to decide, on the basis of something more than intuition, how much support should be given to the smaller arts organizations.

Since the Institute of Museum Services is the first cultural agency empowered to provide funds for institutions rather than for projects, it is in the perfect position to develop a uniform standard for measuring the financial need of museums.

One way for the institute to realize this objective would be for it to take over the task of administration of the National Museum Act from the Smithsonian Institution. Authorized by Congress in 1966 and supported with annual appropriations of almost $1,000,000, the National Museum Act is intended to improve professional standards at museums throughout the country. Under the NMA aegis, the

Smithsonian has sponsored seminars, conferences, publications, and travel grants. And it was partly through funds available from the act that the American Institute of Accounting was able to prepare two reports recommending accounting guidelines for large and small museums.

The absorption of NMA administrative responsibilities from the Smithsonian would help strengthen the new institute in its roles as a clearinghouse for information and as a definer of professional standards. Over a period of years, by working closely with museums and with the Washington-based American Association of Museums (AAM), the institute should be able to assemble an indispensable body of information on museum needs.

Frustrated by nonprofessional management, museum workers have been campaigning for a clearer definition of both museum purposes and codes of professional behavior. Today the AAM, which began as a letterhead in 1906, speaks for the entire profession. It publishes an official annual directory, a nine-issues-a-year magazine and a monthly newsletter, and a series of specialized monographs; it also runs six regional conferences, each of which sponsors annual meetings; and since 1974 it has operated an accreditation program.

In the long run AAM accreditation ought to be a prerequisite for federal grants. If small museums cannot afford to underwrite visiting committees for accrediting appraisals, then the institute should help provide the money. In the very process of opening up its operations to a visiting committee, a museum engages in self-examination. And the accreditation committee's reports can only stimulate overdue improvements in professional standards.

No museum board would question the desirability of professionalism and of financial accountability where public funding is involved, or the obligation to make museum services as widely available as possible, or the need for some measure of public disclosure—in the abstract. But in reality lethargy combined with tradition, particularly at art museums, has inhibited change. Through a Fabian strategy of determined gradualism, the new Museum Services Institute can become the ally and partner of those within the museum community who also want better, not just bigger, museums.

What makes a better museum? Subjective imponderables obviously enter in, but there are criteria that can be precisely defined. Clearly, the museum that is open without charge, or that provides for free admission days and for reduced fees for those least able to pay, is doing more for the public than the institution with a fixed entry fee.

The museum that takes adequate care of its collection and that maintains accurate and accessible records of its works of art is discharging a primary obligation. The museum that attempts to use its collection not only in imaginative educational programs but also in an extended loan program is to be highly valued. The museum that follows orderly procedures in staff management and that clearly defines its ethical standards concerning its relations with the art market is surely more deserving of public confidence than the museum that is run like a corner candy store with a sideline traffic in betting.

PYROTECHNICS OR LIGHTHOUSE?

In the absence of a defined policy of national arts patronage, catchwords have had to suffice. During 1977 and 1978, responding to considerable controversy engendered by the manner in which they had been appointed chairmen of the endowments, Livingston Biddle, Jr., and Joseph Duffey sought to reconcile the claims of populism and elitism in a formula intended to make everyone happy. Each chairman explained that the policy of the endowments would be to make the best available to the most.

The first problem in cultural patronage is that there is no metric standard for determining "the best," particularly in the visual arts. For example, in 1976 the NEA awarded $43,750—on a matching basis with the Hartford Foundation for Public Giving—to Minimalist sculptor Carl Andre to create what he called "Stone Field Sculpture," an assemblage of Connecticut rocks on the Hartford public green. Whether the mayor of Hartford was justified in subsequently dismissing Andre's work as "just a bunch of rocks" [12] is not at issue here; Livingston Biddle would probably be the first to concede that even respected art critics would find themselves in spirited disagreement over Andre's work. The point is that there must be a willingness to take chances—with at least some public funds—on adventurous art and to admit that there are risks.

Still more problematic is the question of "access." Television programs on art provide access; so do great loan exhibitions and the production of quantities of replicas of the treasures on display. But as long ago as 1857 John Ruskin in a public lecture considered the merits of mass-produced replicas. He asked rhetorically whether "good art, as well as other good things, ought to be made as cheap as possible, and put as far as we can within the reach of everybody?" He then offered this answer:

Livingston Biddle, Jr., chairman of the National Endowment for the Arts, a weigher of imponderables

Pardon me, I am not prepared to admit that. I rather side with the selfish objectors, and believe that art ought not to be made cheap, beyond a certain point; for the amount of pleasure that you can receive from any great work depends wholly on the quantity of attention and energy of mind you can bring to bear upon it. Now, that attention and energy depend much more on the freshness of the thing than you would at all suppose. . . . If you see things of the same kind and of equal value very frequently, your reverence for them is infallibly diminished, your powers of attention get gradually wearied, and your interest and enthusiasm worn out. . . . [A] work of art of any kind is always in some degree fenced and closed about with difficulty. . . . Do not force the multiplication of art, and you will not have it too cheap.[13]

A variation of this argument was developed by Walter Benjamin, a distinguished German aesthetician who wrote from an individualistic Marxist viewpoint. In a celebrated essay, "The Work of Art in the Age of Mechanical Reproduction," written in the 1930s, Benjamin dealt thoughtfully with the impact of photography on the perception of a work of art. There was in reproduction, he felt, an inescapable depreciation:

This holds not only for the art work but also, for instance, for a landscape which passes in review before the spectator in a movie. In the case of the art object, a most sensitive nucleus—namely, its authenticity—is interfered with whereas no natural object is vulnerable on that score. The authenticity of a thing is the essence of all that is transmissible from its beginning, ranging from its substantive duration to its testimony to the history which it has experienced. . . . And what is really jeopardized when the historical testimony is affected is the authority of the object.[14]

The unique work, Benjamin maintained, possesses an "aura" deriving from its existence in a specific place at a specific time. It is

this aura that impelled hundreds of thousands of visitors to line up for hours outside museums to catch a fleeting glimpse of the *Mona Lisa,* on loan to the United States.

If museums have a hallowed function, it is to preserve and celebrate the magic of a work of art—a magic all the more important in a country where the inhabitants live in a house of mirrors with a thousand spectral images. It is therefore strange and disturbing that art museums, in their zeal to increase attendance and revenues, have —in Benjamin's memorable phrase—pried the "object from its shell to destroy its aura."

The most depressing example is the commercial exploitation of the "Treasures of Tutankhamun," a show that began its three-year American tour at the National Gallery of Art in November 1976. Crowds pitched in pup tents on the eve of the opening, and the general pandemonium did not abate as the pharaoh's funerary offerings moved on to Chicago, New Orleans, Los Angeles, and Seattle, winding up at the Metropolitan Museum, whose former director, Thomas Hoving, had organized the show. It was very much a Hoving production. It was Hoving who had served as spokesman for a six-museum consortium in all negotiations with the Egyptian government. Agreeing to a $2,600,000 cash guarantee (with revenues deriving from the sale of replicas going to the hard-pressed Cairo Museum), he told Grace Glueck of *The New York Times* on the eve of the announcement of the tour:

> Actually, we are developing the concept of traveling shows into a fine art, working with the Egyptians on a ten-year program of such shows that will generate revenues. What we're doing, in a sense, is acting as management, architectural and marketing consultants to help them generate revenues for reconstruction.[15]

Hoving successfully solicited grants for the Tutankhamun show from the National Endowment for the Humanities, the Exxon Corporation, and the Robert Wood Johnson, Jr., Charitable Trust. An anonymous well-wisher, said to be Mrs. Lila Acheson Wallace of the Reader's Digest Corporation, offered a gift of $1,000,000, to be used for assisting Egyptian museums. Federal indemnification of insurance risks was furnished courtesy of the Arts and Artifacts Indemnity Act.

To meet the cash guarantee, museums encouraged what *Newsweek* described as "Tut-o-mania." Wherever the pharaoh's treasures went, there were local commercial tie-ins: Stores featured hieroglyphic watches, Egyptiac datebooks, and napery with a Nile theme. "Offi-

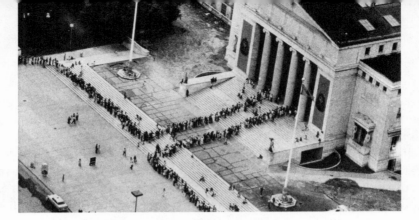

"Tut-o-mania" in Chicago. A double queue stretches for blocks around the Field Museum of Natural History for a moment's glimpse of an endlessly reproduced treasure.

cial" replicas were sold under museum auspices; in Washington and Chicago alone, according to *Newsweek*, gross museum sales exceeded $2,000,000, and the Metropolitan—which had scheduled the show's arrival to coincide with the opening of its Temple of Dendur wing—issued a lavish fifty-six-page catalogue of replicas and gimcracks.

The late Harvard economist Joseph Schumpeter invented the pregnant phrase "creative self-destruction" to describe an unavoidable tendency in capitalist economics, and there was certainly more than a measure of this in the willingness of museums to convert Tutankhamun's noble legacy into *kitsch*. But to the extent that "access" is a measure of museum performance, the loan show has proven a resounding triumph.

The risks intrinsic in such ventures are memorably illustrated in a *New Yorker* cartoon by Tobey, showing a family visiting the Metropolitan Museum and coming upon Rembrandt's *Aristotle Contemplating the Bust of Homer*. "Hey, look!" the precocious son exclaims. "That jigsaw puzzle you gave me last Christmas!"

The arguments against this kind of commercialism may seem, to many Americans, an expression of unreconstructed "elitism." But elitism is a meaningless word as far as art is concerned. We live in a society in which money is regarded as the final measure of all things, and the art museum—paradoxically, since it has grown up under the auspices of big business—serves as a symbolic reminder that in fact, there are things that even money cannot buy. No dollar sign can be posted on our experience in encountering, often by chance, an object of enthralling beauty. When all is said and resaid, museums exist not only to make that experience possible but also to confirm the reality of it.

"Hey, look! That jigsaw puzzle you gave me last Christmas!"

From the beginning, political populists have fretted about what they regarded as the elitist implications of museums. In 1833, during a House of Commons debate on the British Museum, William Cobbett, a champion of the masses, was moved to protest, "Why should a tradesman or a farmer be called upon to pay for the support of a place which was intended only for the amusement of the curious or the rich, and not for the benefit or instruction of the poor?" [16]

Cobbett's argument has been repeated ever since. Indeed, it is not an unfair objection. But by the same token, why should the childless have to contribute to the cost of public schools or the illiterate to the support of libraries, or the non-sports-minded to the underwriting of municipal bond issues for stadiums? Any public subsidy entails inequities.

The lighthouse is the classic example. Its beacon serves the interests of a limited constituency—the ships at sea, some of them commercial vessels, some of them pleasure craft. The lighthouse does not discriminate between them: Its beam is discernible by crews who have not contributed to its upkeep as well as by those who have. Anyone who buys anything carried on that ship also benefits. The question poses itself: Does the common and immeasurable benefit that the lighthouse provides outweigh the small outlay entailed in its operations?

The art museum is a cultural lighthouse, and its rays could be diminished, or turned to glaring neon, without fatal consequences. But is that what we want? Is that what we need?

❧ APPENDIX ❧
A

THE MODERNIST FLOWERING: ART MUSEUM AND VISUAL ARTS CENTER CONSTRUCTION, 1950–

Author's Note: The figures in this chart have been supplied in nearly every instance by the museums and visual arts centers listed. All data must be interpreted with caution. The criteria for construction costs and square footage vary markedly from institution to institution, and the per square foot calculation of costs is offered only as a crude yardstick. The expense of building depends on the year of construction and on labor costs in the given region. Although every effort has been made to list all museums and art centers, omissions are inevitable; some institutions, moreover, combine a variety of functions under a single roof. With these caveats in mind, it can be said that since 1950, a minimum grand total of $561,700,000 has been committed to the construction of at least 10.2 million square feet of total space at 123 American art museums and visual arts centers; more than a third of that (3.5 million square feet) comprises gallery space. Taking the figure of 750,000 square feet for the total size of the Louvre, one can calculate that the total square footage is the equivalent of 13.6 Louvres, or, to make a more parochial comparison, the equivalent of 1,643.7 football fields. In gathering this data, the author is indebted to Randy Gilbert of the Twentieth Century Fund and to Frank Kobe, an NBC statistician. The initials "n.a." indicate that information was not available.

NEW YORK CITY	DATE	ARCHITECT	COST	SIZE IN SQ. FT.	$ PER SQ. FOOT
MUSEUM OF MODERN ART	1939	Philip L. Goodwin Edward Durell Stone	$1 mil.	106,522 total 18,610 galleries	$9.39
East wing, garden wing, new lobby	1964	Philip Johnson	$5.5 mil.	73,000 total 18,000 galleries	$75.34
North wing	1967	Philip Johnson	n.a.	38,153 total	n.a.
Gallery additions, apartment tower	1979	Cesar Pelli	$40 mil. ($17 mil. for museum space)	50,00 for total museum uses	n.a.
SOLOMON R. GUGGENHEIM MUSEUM	1959	Frank Lloyd Wright	$3 mil.	52,204 total 35,125 galleries	$57.47
ASIA HOUSE GALLERY	1960	Philip Johnson	$1.2 mil.	19,000 total 2,500 galleries	$63.16

	DATE	ARCHITECT	COST	SIZE IN SQ. FT.	$ PER SQ. FOOT
NEW YORK CITY					
NEW YORK CULTURAL CENTER (formerly Gallery of Modern Art)	1964	Edward Durell Stone	$7.4 mil.	55,000 total	$134.55
WHITNEY MUSEUM OF AMERICAN ART	1970	Marcel Breuer Assoc.	$6.1 mil.	82,000 total 39,200 galleries	$74.39
METROPOLITAN MUSEUM OF ART, total of five wings	1975–	E. Kevin Roche John G. Dinkeloo	$75 mil.	500,000 total	$150
NORTHEASTERN STATES					
ALBRIGHT-KNOX ART GALLERY (Buffalo)	1962	Gordon Bunshaft, Skidmore, Owings & Merrill	$1.5 mil.	34,822 total 14,646 galleries	$43.08
EVERSON MUSEUM OF ART (Syracuse)	1968	I. M. Pei	$3.5 mil.	58,800 total 14,512 galleries	$59.52
MUNSON-WILLIAMS-PROCTOR INSTITUTE (Utica)	1960	Philip Johnson	$3.5 mil.	43,700 total 27,900 galleries	$80.09
HERBERT F. JOHNSON MU-SEUM, Cornell University (Ithaca)	1973	I. M. Pei	$4.8 mil.	55,000 total n.a.	$87.27
MEMORIAL ART GALLERY (Rochester)	1968	Waasdorp, Northrup & Kaelber	$1.4 mil.	33,000 total 16,000 galleries	$42.42
HUDSON RIVER MUSEUM (Yonkers)	1969	Sherman, Mills & Smith	$1.8 mil.	37,125 total 20,200 galleries	$48.48
ROY R. NEUBERGER MUSEUM OF ART, State University of New York (Purchase)	1974	Philip Johnson John Burgee	n.a.	n.a.	n.a.

Institution	Year	Architect	Cost	Square footage	$/sq ft
PICKER ART GALLERY, Colgate University (Hamilton)	1964	Paul Rudolph	$1.3 mil.	50,000 total n.a.	$26
YALE UNIVERSITY ART GALLERY (New Haven)	1953	Louis Kahn	$3 mil.	55,000 total 27,000 galleries	$54.55
YALE CENTER FOR BRITISH ART (New Haven)	1977	Louis Kahn	$10 mil.	95,311 total 29,218 galleries	$104.92
CENTER FOR THE ARTS, Wesleyan University (Middletown)	1973	E. Kevin Roche John G. Dinkeloo	$12 mil. (for complex)	19,800 total 4,500 galleries	n.a.
WADSWORTH ATHENEUM (Hartford)	1969	Huntington, Darbee & Dollard	$4.7 mil.	35,385 total 25,085 galleries	$70.80
WILLIAM BENTON MUSEUM OF ART, University of Connecticut (Storrs)	1968	Sternbach & Rheaume	$250,000	16,000 total 6,600 galleries	$15.62
NEW BRITAIN MUSEUM OF AMERICAN ART	1964	Moore and Salsbury	$80,000	3,400 total 1,700 galleries	$23.53
New wing	1977	Malmfeldt Assoc.	$300,000	5,800 total 2,000 galleries	$51.72
MUSEUM OF FINE ARTS (Boston), expansion	1967	Hugh Stubbins Assoc.	$1.5 mil.	24,500 total 12,600 galleries	$61.22
White wing	1968	Hugh Stubbins Assoc.	$2.5 mil.	45,000 total galleries	$55.55
West wing	1979	I. M. Pei	$5 mil.	70,000 total 25,000 galleries	$71.43
INSTITUTE OF CONTEMPORARY ART (Boston)	1975	Graham Gund	$1 mil.	16,400 total 4,000 galleries	$61.98

NORTHEASTERN STATES	DATE	ARCHITECT	COST	SIZE IN SQ. FT.	$ PER SQ. FOOT
CARPENTER CENTER FOR THE VISUAL ARTS, Harvard University (Cambridge)	1963	Le Corbusier	$2 mil.	57,000 total 2,975 galleries	$35.09
MOUNT HOLYOKE COLLEGE ART MUSEUM (South Hadley)	1971	Hugh Stubbins Assoc.	n.a.	n.a. 6,200 galleries	n.a.
FINE ARTS CENTER, University of Massachusetts (Amherst)	1974	E. Kevin Roche John G. Dinkeloo	$16.3 mil. (for complex)	206,600 total 2,500 galleries	n.a.
SMITH COLLEGE MUSEUM OF ART (Northampton)	1973	John Andrews	$7.6 mil. (for complex)	30,000 total 17,000 galleries	n.a.
ROSE ART MUSEUM, Brandeis University (Waltham)	1961 1973	Harrison & Abramovitz	$1.2 mil.	13,386 total 5,461 galleries	$89.65
STERLING AND FRANCINE CLARK ART INSTITUTE (Williamstown)	1973	Pietro Belluschi, The Architects Collaborative	n.a.	82,000 total 6,200 galleries	n.a.
WORCESTER ART MUSEUM, education wing	1971	The Architects Collaborative	$1.7 mil.	43,000 total n.a.	$39.53
MEAD ART GALLERY, Amherst College, new wings	1975	Drumney & Anderson Scholfield & Colgan	$185,000	10,000 galleries	$18.50
HOPKINS CENTER, DARTMOUTH COLLEGE MUSEUM (Hanover)	1962	Harrison & Abramovitz	$13 mil. (for complex)	250,000 total 9,793 galleries	n.a.
THE ART MUSEUM, Princeton University	1966	Walker O. Cain & Associates	$4.1 mil.	40,000 total 26,000 galleries	$102.50

NEW JERSEY STATE MUSEUM (Trenton)	1965	Frank Grad & Sons	$6 mil.	100,000 total 31,000 galleries	$60
ALLENTOWN (Pa.) ART MUSEUM	1975	Edgar Tafel	$2.5 mil.	27,500 total 14,300 galleries	$90.91
PHILADELPHIA MUSEUM OF ART, American wing	1977	John R. Caulk III	$1.4 mil.	14,000 total n.a.	$100
UNIVERSITY MUSEUM, University of Pennsylvania (Philadelphia), wing	1971	Mitchell & Giurgola	$5.4 mil.	110,000 total 10,000 galleries	$49.09
CENTER FOR THE ARTS, Muhlenberg College (Allentown)	1976	Philip Johnson John Burgee	$4.6 mil.	68,000 total 1,500 galleries	$67.65
WESTMORELAND COUNTY MUSEUM OF ART (Greensburg, Pa.) New wing	1959 1968	Sorber & Hoone Deeter, Ritchie & Sipple	$850,000 $375,000	27,048 total 13,944 galleries (for both)	$30.93
MUSEUM OF ART, Carnegie Institute (Pittsburgh) Sarah Scaife Galleries Heinz Galleries Bruce Galleries	1974 1975 1976	Edward Larrabee Barnes Edward Larrabee Barnes Edward Larrabee Barnes	$12.5 mil. 1.3 mil. $628,000	180,262 total 76,129 galleries	$79.88
WALTERS ART GALLERY (Baltimore), new wing	1974	Meyer, Ayers & Saint	$5.5 mil.	100,000 total 66,500 galleries	$55
PARKERSBURG (W. Va.) ART CENTER	1975	Ireland & Assoc.	$300,000	7,600 total 2,500 galleries	$39.47
HUNTINGTON (W. Va.) GALLERIES	1971	Walter Gropius, The Architects Collaborative	n.a.	n.a.	n.a.

DISTRICT OF COLUMBIA	DATE	ARCHITECT	COST	SIZE IN SQ. FT.	$ PER SQ. FOOT
DUMBARTON OAKS PRE-COLUMBIAN COLLECTION, Harvard University	1963	Philip Johnson	n.a.	13,068 total 3,041 galleries	n.a.
JOSEPH H. HIRSHHORN MUSEUM AND SCULPTURE GARDEN, Smithsonian Institution	1974	Gordon Bunshaft, Skidmore, Owings & Merrill	$16 mil.	176,476 total 61,500 galleries	$90.66
NATIONAL GALLERY OF ART, East Building	1978	I. M. Pei	$92 mil.	590,000 total 30,000 galleries	$155.93
NATIONAL PORTRAIT GALLERY NATIONAL COLLECTION OF FINE ARTS, Smithsonian Institution	1968	Faulkner, Kingsbury & Stenhouse	$7 mil.	374,000 total n.a.	$18
SOUTHERN STATES					
VIRGINIA MUSEUM OF FINE ARTS (Richmond), North wing	1955	Merrill C. Lee	$2.2 mil.	63,509 total 18,875 galleries	$34.65
South wing	1970	Baskerville & Assoc.	$3.1 mil.	91,199 total 16,871 galleries	$33.99
North wing	1976	Hardwicke Assoc.	$6.2 mil.	81,827 total 6,824 galleries	$75.79
CHRYSLER MUSEUM (Norfolk) wing	1968 1976	Williams & Tazewell	$1.3 mil. $2 mil.	25,000 total n.a.	n.a.
NORTH CAROLINA MUSEUM OF ART (Raleigh)	1979	Edward Durell Stone	$10.8 mil.	150,000 total 60,000 galleries	$72

Institution	Year	Architect	Cost	Square footage	Cost per sq ft
ACKLAND MEMORIAL ART CENTER, University of North Carolina (Chapel Hill)	1958	Eggers & Higgins	$988,000	38,650 total / 5,761 galleries	$26
SOUTHEASTERN CENTER FOR CONTEMPORARY ART (Winston-Salem)	1977	Newman, Van Etten & Winfree	$650,000	22,000 total / 14,000 galleries	$29.55
DUKE UNIVERSITY MUSEUM OF ART (Durham)	1968	n.a.	n.a.	n.a.	n.a.
ASHEVILLE (N.C.) ART MUSEUM	1976	Baber, Cort & Wood	$7 mil. (for complex)	7,000 total / 5,265 galleries	n.a.
CHARLESTON (S.C.) MUSEUM	1978	Crissman & Solomon	$6 mil.	85,000 total / 35,000 galleries	$70.59
GIBBES ART GALLERY (Charleston), wing	1977	Simons, Mitchell, Small & Donahue	$1.2 mil.	18,000 total / 16,000 galleries	$66.66
COLUMBIA (S.C.) MUSEUMS OF ART AND SCIENCE, new art wings	1962 1975 1976	Lyles, Bissett, Carlisle & Wolfe; Petroff & McClure; Lafaye Assoc.	$500,000	35,000 total / 10,652 galleries	$14.28
HIGH MUSEUM OF ART (Atlanta)	1968	Toombs, Amisano & Wells	$13 mil. (for complex)	50,000 total / 24,000 galleries	n.a.
UNIVERSITY OF GEORGIA ART CENTER (Athens)	1962	Toombs, Amisano & Wells	$60,000	990 total / n.a.	$60.60
HUNTER MUSEUM OF ART (Chattanooga)	1968	Derthick & Henley	$3 mil.	50,000 total / 10,500 galleries	$60

SOUTHERN STATES	DATE	ARCHITECT	COST	SIZE IN SQ. FT.	$ PER SQ. FOOT
BROOKS MEMORIAL ART GALLERY (Memphis), wing	1973	Jones & Mah	$841,211	22,026 total 22,026 galleries	$38.19
UNIVERSITY OF KENTUCKY ART MUSEUM (Lexington)	1979	Johnson & Romanowitz	$1.1 mil.	20,000 total 9,000 galleries	$55
GREENVILLE COUNTY MUSEUM OF ART (Greenville, S.C.)	1974	Craig & Gaulden	$2 mil.	56,000 total 20,000 galleries	$35.71
MUSEUM OF FINE ARTS (St. Petersburg, Fla.), main building, auditorium wing	1965 1973	John Volk	$1.3 mil.	32,658 total 9,032 galleries	$39.77
CUMMER GALLERY OF ART (Jacksonville)	1961	Saxelby & Powell	$1.2 mil.	225,000 total 32,000 galleries	$5.33
UNIVERSITY GALLERY, University of Florida (Gainesville)	1965	Kemp, Bunch & Jackson	n.a.	4,250 total 3,000 galleries	n.a.
JOHN AND MABEL RINGLING MUSEUM OF ART (Sarasota)	1967	Eliot Fletcher	$445,000	72,000 total 24,000 galleries	$6.18
BASS MUSEUM OF ART (Miami Beach)	1963	Robert Swartburg	$171,011	14,864 total n.a.	$12.21
NEW ORLEANS MUSEUM OF ART, wings	1971	August Perez, Arthur Feitel	$2.1 mil.	37,573 total 21,160 galleries	$55.89
LOUISIANA ARTS AND SCIENCE CENTER (Baton Rouge)	1976	Desmond-Miremont	$2.5 mil.	50,300 total	$50

MIDWESTERN STATES

MANSFIELD (Ohio) ART CENTER	1971	Don M. Hisaka	$213,000	10,000 total 3,500 galleries	$21.30
CLEVELAND MUSEUM OF ART, addition	1958	Hayes & Ruth	$9 mil.	100,000 total 100,000 galleries	$90
Education wing	1971	Marcel Breuer	$7.2 mil.	111,500 total 12,200 galleries	$64.57
ALLEN MEMORIAL ART MUSEUM, Oberlin College (Oberlin)	1976	Venturi & Rauch	$3.3 mil. (for complex)	33,000 total 3,000 galleries	n.a.
INDIANA UNIVERSITY ART MUSEUM (Bloomington)	1980	I. M. Pei	$10.5 mil.	105,000 total 34,000 galleries	$100
INDIANAPOLIS MUSEUM OF ART, Krannert Pavilion, Clowes Pavilion	1969 1972	Richardson, Severns, Scheeler & Assoc. Wright, Porteous & Lowe	$20 mil. (both facilities)	246,000 total 55,570 galleries	$81.30
KALAMAZOO INSTITUTE OF ARTS	1961	Skidmore, Owings & Merrill	$1.6 mil.	40,000 total 20,000 galleries	$40
FLINT (Mich.) INSTITUTE OF ARTS, new building, two wings	1958 1961 1966	Smith, Hinchman & Grylls	$2.4 mil.	72,083 total 32,399 galleries	$33.29
DETROIT INSTITUTE OF ARTS, south wing	1963	Harley, Ellington & Day; Gunnar Birkerts, design associate	$3.6 mil.	875,000 total 650,000 galleries	n.a.
North wing	1971	Harley, Ellington & Day; Gunnar Birkerts, design associate	$7.6 mil.		

MIDWESTERN STATES	DATE	ARCHITECT	COST	SIZE IN SQ. FT.	$ PER SQ. FOOT
BATTLE CREEK CIVIC ART CENTER, addition	1975	George Williams, Sarvis Assoc.	$270,000	3,987 total 1,160 galleries	$69.23
MIDLAND (Mich.) CENTER FOR THE ARTS	1971	Alden B. Dow Assoc.	$8.6 mil.	360,000 total 50,000 galleries	$23.89
KRESGE ART CENTER GALLERY (East Lansing)	1959 1966	Ralph Calder & Assoc.	n.a.	n.a. 5,200 galleries	n.a.
MILWAUKEE ART CENTER Bradley wing	1957 1975	Eero Saarinen Kahler, Slater & Fitzhugh Scott	$2.7 mil. $7.1 mil.	n.a. 125,000 total 90,000 galleries (combined)	n.a. $78.40
ELVEHJEM ART CENTER, University of Wisconsin (Madison)	1970	Harry Weisl	$3.5 mil.	97,300 total 20,000 galleries	$35.97
WALKER ART CENTER (Minneapolis)	1971	Edward Larrabee Barnes	$4.5 mil.	117,500 total 38,940 galleries	$115.56
MINNEAPOLIS INSTITUTE OF ARTS, additions	1974	Kenzo Tange	$10 mil. (for complex)	253,000 total 182,000 galleries	$39.53
DES MOINES ART CENTER Addition	1953 1968	Eero Saarinen I. M. Pei	n.a. $1.3 mil.	n.a. 24,971 total 19,452 galleries	n.a. $52.06
UNIVERSITY OF IOWA ART MUSEUM (Iowa City), Carver Wing	1969 1976	Harrison & Abramovitz	$3.3 mil. (combined)	25,500 total 17,400 galleries 10,500 total 5,571 galleries	n.a.
ST. LOUIS ART MUSEUM, addition	1960	Murphy & Mackie	$1 mil.	27,124 total 19,452 galleries	$36.87

	Year	Architect	Cost	Size	Cost/sq ft
WASHINGTON UNIVERSITY GALLERY OF ART (St. Louis), Steinberg Hall	1960	Russell Mullgardt with Schwarz Van Hoefen	$791,000	37,546 total 3,180 galleries	$21.07
ART INSTITUTE OF CHICAGO, additions to museum and School of Art	1976	Walter Netsch, Skidmore, Owings & Merrill	$18.5 mil. (for complex)	480,000 total 98,000 galleries	$38.54
DAVID AND ALFRED SMART GALLERY, University of Chicago	1974	Edward Larrabee Barnes	$2.75 mil.	20,000 total 7,500 galleries	$137.50
SPERTUS MUSEUM OF JUDAICA (Chicago)	1974	Dan Brenner	n.a.	14,000 total 10,000 galleries	n.a.
MUSEUM OF CONTEMPORARY ART (Chicago)	1978	Booth, Nagle & Hartray	$900,000	14,000 total 8,000 galleries	$64.28
GREAT PLAINS AND ROCKIES					
SHELDON MEMORIAL ART GALLERY (Lincoln, Neb.)	1963	Philip Johnson	$3.5 mil.	25,000 total 25,000 galleries	n.a.
WICHITA ART MUSEUM	1977	Edward Larrabee Barnes	$3.8 mil.	80,000 total 50,000 galleries	$47.50
ULRICH MUSEUM OF ART, Wichita State University	1974	Charles McAfee	$1.2 mil.	22,000 total 9,000 galleries	$54.55
DENVER ART MUSEUM	1971	James Sudler Assoc.	$6.6 mil.	239,211 total 190,000 galleries	$27.59
SOUTHWESTERN STATES					
PHOENIX ART MUSEUM, addition	1959 1965	Alden Dow Alden Dow	$1.4 mil.	75,000 total 55,000 galleries	$18.67

SOUTHWESTERN STATES	DATE	ARCHITECT	COST	SIZE IN SQ. FT.	$ PER SQ. FOOT
FINE ARTS MUSEUM, University of New Mexico (Albuquerque)	1964	Holien & Buckley	$7.8 mil. (for complex)	174,993 total 9,210 galleries	$44.57
GILCREASE INSTITUTE OF AMERICAN HISTORY AND ART (Tulsa)	1971	Olsen Coffey	$600,000	14,000 total 9,000 galleries	$42.85
OKLAHOMA ART CENTER (Oklahoma City)	1958	Parr & Aderhold	$250,000	23,277 total 11,200 galleries	$10.78
KIMBELL ART MUSEUM (Fort Worth)	1972	Louis Kahn	$7.5 mil.	125,000 total 30,000 galleries	$60
AMON CARTER MUSEUM OF WESTERN ART (Fort Worth), additions	1961 1964 1977	Philip Johnson	$6.4 mil. (total)	68,778 total 9,375 galleries	$93.05
ART CENTER (Waco, Texas)	1976	Ford, Powell & Carson	$417,000	9,351 total 3,300 galleries	$44.84
MEADOWS MUSEUM, Southern Methodist University (Dallas)	1965	George Dahl	$350,000	4,932 total 3,672 galleries	$71.43
AMARILLO ART CENTER	1972	Edward Durell Stone Cantrell & Co.	$780,000	21,000 total 7,000 galleries	$119.05
SAN ANTONIO MUSEUM OF ART	1979	Cambridge Seven Assoc.	$4 mil.	80,000 total 30,000 galleries	$50
ART MUSEUM OF SOUTH TEXAS (Corpus Christi)	1972	Philip Johnson	$1.3 mil.	30,000 total 11,500 galleries	$43.33
CONTEMPORARY ARTS MUSEUM (Houston)	1972	Gunnar Birkerts	$870,000	10,000 total 9,500 galleries	$87

Museum	Year	Architect	Cost	Size	Cost per sq. ft.
WICHITA FALLS (Texas) MUSEUM AND ART CENTER	1967	Pardue, Read & Dice	$293,000	16,000 total / 6,000 galleries	$18.31
MUSEUM OF FINE ARTS (Houston), Cullinan Hall, Brown Pavilion	1957	Miës van der Rohe	$550,000	72,000 total / 36,000 galleries (both wings)	$53.33
	1974	Miës van der Rohe	$4.5 mil.		
ABILENE FINE ARTS MUSEUM	1964	Woodlief Brown	$50,000	5,000 total / 3,000 galleries	$10
WEST COAST STATES					
UNIVERSITY ART MUSEUM, University of California (Berkeley)	1970	Mario Ciampi	$4.8 mil.	95,000 total / 31,050 galleries	$50.53
ASIAN ART MUSEUM OF SAN FRANCISCO, Avery Brundage Collection	1971	Gardner Dailey	$2.73 mil.	100,000 total / 75,000 galleries	$30
OAKLAND MUSEUM	1969	E. Kevin Roche / John G. Dinkeloo	$6.6 mil.	100,000 total / n.a.	$66
SANTA BARBARA MUSEUM OF ART, wings	1960 1961	Wallace Arendt	$382,000	2,930 total / n.a.	$131.72
NEWPORT HARBOR ART MUSEUM	1977	Langdon & Wilson	$1.5 mil.	20,000 total / 10,000 galleries	$75
LONG BEACH ART MUSEUM	1978	I. M. Pei	$7.3 mil.	30,000 total	$243.33 *
LOS ANGELES COUNTY MUSEUM OF ART	1965	William L. Pereira	$12 mil.	169,243 total / 54,906 galleries	$70.90

* This building project was indefinitely postponed.

WEST COAST STATES	DATE	ARCHITECT	COST	SIZE IN SQ. FT.	$ PER SQ. FOOT
NORTON SIMON MUSEUM OF ART (Pasadena)	1969	Ladd & Kelsey	$8.5 mil.	85,000 total 28,880 galleries	$100
J. PAUL GETTY MUSEUM (Malibu)	1974	Langdon & Wilson; Dr. Norman Neuerberg, Emmet Wemple, Stephen Garrett	$17 mil.	75,000 total 48,000 galleries	$226.17
TIMKEN ART GALLERY (San Diego)	1965	Frank Hope	$1 mil.	18,240 total 11,712 galleries	$54.82
LA JOLLA MUSEUM OF CON-TEMPORARY ART	1959 1979	Mosher, Drew, Watson & Assoc.	$1.5 mil.	22,000 total 5,000 galleries	$68.18
PUERTO RICO					
MUSEO DE ARTE DE PONCE	1965	Edward Durell Stone	$1.5 mil.	76,000 total 37,000 galleries	$19.74

APPENDIX
B

MUSEUM ETHICS
A REPORT TO THE
AMERICAN ASSOCIATION OF
MUSEUMS BY ITS
COMMITTEE ON ETHICS * (1978)

Preface Since the publication of the last Code of Ethics by the American Association of Museums in 1925, our museums have expanded their activities into disciplines and activities seldom a part of their institutional ancestors. Educational outreach, historical, environmental assessment and a host of other programs have become a normal and respected part of museum activity. Simultaneously, museum policy with respect to collecting has been influenced by expanded public awareness, a changing social conscience, and the decrease in intellectual isolationism and specialization among museum professionals. These expansive changes have caused the profession, one in which ethical requirements above and beyond the legal are everywhere apparent, to reexamine the ethical basis of its operational decisions. Some within the profession ask how their own views, or those of others, compare with the consensus or, for that matter, whether a consensus exists. Others question the ethical propriety of acts observed within their own institutions or others.

These thoughts were brought to the officers and council of the American Association of Museums during the mid-1970s. At the national meeting of the association in Fort Worth in 1974 President Joseph M. Chamberlain appointed a Committee on Ethics, which was continued in expanded form by his successor as AAM president, Joseph Veach Noble. This committee was to identify the ethical principles underlying museum operations in the broadest sense as viewed by the profession at this point in history.

The committee members were appointed by the president of the association in consultation with the committee chairman. Those sections of the document that discuss museum governance were prepared

in conjunction with the Trustee Ethics Subcommittee, appointed in part by the Trustees Committee of the association. The members of the Trustee Ethics Subcommittee were subsequently added to the Committee on Ethics.

Funds enabling the committee to meet were provided in part by the National Museum Act administered by the Smithsonian Institution, and by the Rockefeller Brothers Fund, support gratefully acknowledged here. The chairman also acknowledges with sincere appreciation the contributions made by each member of the committee, and the institution of each for its enabling indirect support of this effort.

The following serve as members of the Committee on Ethics:

William T. Alderson, *Director, American Association for State and Local History*, Nashville, Tennessee

Edward P. Alexander, *Director of Museum Studies, The University of Delaware*, Newark, Delaware

Robert G. Baker, *Chief Curator, Arizona State Museum*, Tucson, Arizona

Michael Botwinick, *Director, The Brooklyn Museum*, Brooklyn, New York

G. Ellis Burcaw, *Director, University of Idaho Museum*, Moscow, Idaho

Charles C. Cunningham, Jr., *Trustee, Museum of Fine Arts*, Boston, Massachusetts

William A. Fagaly, *Chief Curator, New Orleans Museum of Art*, New Orleans, Louisiana

Peggy Loar, *Program Director, Institute of Museum Services*, Washington, D.C.

Giles W. Mead, *Director, The Natural History Museum of Los Angeles County*, Los Angeles, California

Thomas Messer, *Director, The Solomon R. Guggenheim Museum*, New York, New York

Ellen M. Myette, *Assistant Curator, Renwick Gallery, National Collection of Fine Arts, Smithsonian Institution*, Washington, D.C.

Barbara Y. Newsom, *Staff Associate, The Rockefeller Brothers Fund*, New York, New York

Milton F. Perry, *Director of History, Historic Kansas City Foundation*, Kansas City, Missouri

Jerome G. Rozen, Jr., *Deputy Director for Research, The American Museum of Natural History*, New York, New York

Franklin G. Smith, *Superintendent, Chamizal National Memorial*, El Paso, Texas

Michael Spock, *Director, The Children's Museum*, Boston, Massachusetts

Susan Stitt, *Director, The Museums at Stony Brook*, Stony Brook, New York

William G. Swartchild, Jr., *Chairman of the Board of Trustees, Field Museum of Natural History*, Chicago, Illinois

H. J. Swinney, *Director, The Margaret Woodbury Strong Museum,* Rochester, New York

Alan D. Ullberg, *Associate General Counsel, Smithsonian Institution,* Washington, D.C.

Drafting Committee: Edward P. Alexander, Michael Botwinick, Giles W. Mead and Alan D. Ullberg

Technical Editor: Alan D. Ullberg

Chairman: Giles W. Mead

On matters of both substance and wording, the committee members were in total accord on few if any issues. Each, accepting compromise, has endorsed the final draft.

The committee has not been charged with the implementation of its report. It is presented here as a report to the association by its Committee on Ethics. The members of the committee hope that the association, its officers, council and membership will use this report toward the betterment of our museums and the furtherance of their purposes.

Giles W. Mead

March 1978

I / INTRODUCTION

Our museums include a broad array of diverse institutions that have come to be an important part of the intellectual and emotional life of man. Most of them have as their primary attribute a collection of tangible objects which they care for and hold in trust for the benefit and use of mankind, present and future. In all other respects, these institutions are as diverse as the intellects that conceived them and those that provide their current direction.

This report presents certain statements related to ethical conduct that, in the committee's opinion, represent the consensus of the profession. The committee has concluded that its primary role is to focus the attention of the profession on these ethical issues, but it recognizes the danger of oversimplified strictures. Whenever possible it has chosen to define its sense of the ethical issue and to provide statements of the consensus of the profession regarding beliefs and attitudes for the guidance of the conscientious individual faced with his * personal or institutional problems.

* In the text of this statement, "he" and related pronouns are used in the classical sense to denote the person, male or female.

This report does not pretend to completeness. The many disciplines and professions that cluster around the museum as an entity may find it not specific enough. Further statements of ethical or operational principles suited to specific needs are called for. Institutions distant from the classical concept, for example zoos and aquariums, may find major issues that are central to them omitted.

This report on ethical conduct presumes the acknowledged existence of a more fundamental code that is the foundation of civilized society. It is not intended to be a policy or procedural outline for museum administration or governance. To deal with the issues raised, each institution should develop its own document. Each individual can use the guidelines suggested in this report to focus his attention on these crucial issues. The choice of content reflects the committee's understanding of museum history and current practice. Therefore the statements are intended to be guidelines against which current museum policy and practice can be tested for ethical content. Little of the report is amenable to literal or absolute interpretation, and the force and intonation of much that is included will differ among museums and with the passage of time.

The separate sections of this report do not define the extent to which ethical standards apply to others beyond individual museum employees, volunteers and trustees. This statement must be understood to apply to the activities of third persons when they or their actions are relevant to the museum. Such persons may include members of the museum person's own household, his close relatives or friends, or other associates. It is not the precise degree of relationship that governs applicability of ethical standards, but rather the facts of the relationship. The museum person is ethically obligated to ensure that the principles of this code are not violated on his behalf by the acts of others, and to ensure, as far as possible, that the acts of others do not place the employee or his institution in a position of compromise or embarrassment.

II / THE COLLECTION

MANAGEMENT, MAINTENANCE AND CONSERVATION

Museums generally derive most of their prominence and importance from their collections, and these holdings constitute the primary difference between museums and other kinds of institutions. The collections, whether works of art, artifacts or specimens from the natural

world, are an essential part of the collective cultural fabric, and each museum's obligation to its collection is paramount.

Each object is an integral part of a cultural or scientific composite. That context also includes a body of information about the object which establishes its proper place and importance and without which the value of the object is diminished. The maintenance of this information in orderly and retrievable form is critical to the collection and is a central obligation of those charged with collection management.

An ethical duty of museums is to transfer to our successors, when possible in enhanced form, the material record of human culture and the natural world. They must be in control of their collections and know the location and the condition of the objects that they hold. Procedures must be established for the periodic evaluation of the condition of the collections and for their general and special maintenance.

The physical care of the collection and its accessibility must be in keeping with professionally accepted standards. Failing this, museum governance and management are ethically obliged either to effect correction of the deficiency or to dispose of the collection, preferably to another institution.

ACQUISITION AND DISPOSAL

No collection exists in isolation. Its course generally will be influenced by changes in cultural, scholarly or educational trends, strengths and specializations developing in other institutions, policy and law regarding the traffic in various kinds of objects, the status of plant and animal populations, and the desire to improve the collection.

In the delicate area of acquisition and disposal of museum objects, the museum must weigh carefully the interests of the public for which it holds the collection in trust, the donor's intent in the broadest sense, the interests of the scholarly and the cultural community, and the institution's own financial well-being.

Every institution should develop and make public a statement of its policy regarding the acquisition and disposal of objects. Objects collected by the museum should be relevant to its purposes and activities, be accompanied by a valid legal title, preferably be unrestricted but with any limitations clearly described in an instrument of conveyance, and be properly cataloged, conserved, stored or exhibited. Museums must remain free to improve their collections through selective disposal and acquisition and intentionally to sacri-

fice specimens for well-considered analytical, educational or other purposes. In general objects should be kept as long as they retain their physical integrity, authenticity and usefulness for the museum's purposes.

Illicit trade in objects encourages the destruction of sites, the violation of national exportation laws, and contravention of the spirit of national patrimony. Museums must acknowledge the relationship between the marketplace and the initial and often destructive taking of an object for the commercial market. They must not support that illicit market. Each museum must develop a method for considering objects of this status for acquisition that will allow it to acquire or accept an object only when it can determine with reasonable certainty that it has not been immediately derived from this illicit trade and that its acquisition does not contribute to the continuation of that trade.

Basic to the existence of institutions devoted to natural history is the obligation to acquire, preserve and use representative samples of the earth's biota, living and extinct. Museums should assume a position of leadership in the effort to halt the continuing degradation of our natural history resources. Each institution must develop policies that allow it to conduct its activities within the complexities of existing legislation and with the reasonable certainty that its approach is consistent with the spirit and intent of these programs.

Institutions and their staffs should be encouraged to anticipate the possible consequences of their own actions as they pertain to the acquisition of plants and animals. They must be aware of the potential damage that such acquisitions might have on the population of a species, a community of organisms or the environment in general. They must conduct their collecting activities within recognized standards that avoid insofar as possible the adverse effects of such activities. These principles apply to the acquisition of objects for all museum activities including educational, scholarly, commercial or display purposes.

When disposing of an object, the museum must determine that it has the legal right to do so. When mandatory restrictions accompany the acquisition they must be observed unless it can be clearly shown that adherence to such restrictions is impossible or substantially detrimental to the institution. A museum can only be relieved from such restrictions by an appropriate legal procedure. When precatory statements accompany the acquisition, they must be carefully considered, and consultation with the donor or his heirs should be attempted.

The museum must not allow objects from its collections to be acquired privately by any museum employee, officer, volunteer, member of its governing board or his representative, unless they are sold publicly and with the complete disclosure of their history. Objects, materials or supplies of trifling value which the museum cannot sell and that must be discarded may be given to anyone associated with the institution or to the public.

In disposing of an object, due consideration must be given the museum community in general as well as the wishes and financial needs of the institution. Sales to, or exchanges between, institutions should be considered as well as disposal through the trade. In addition to the financial return from disposals, the museum should consider the full range of factors affecting the public interest.

While the governing entity bears final responsibility for the collection including both the acquisition and disposal process, the curatorial and administrative staff together with their technical associates are best qualified to assess the pertinence of an object to the collection or the museum's programs. Only for clear and compelling reasons should an object be disposed of against the advice of the museum's professional staff.

APPRAISALS

Performing appraisals or authentications can be useful to a museum and the public it serves; however, there should be institutional policy covering the circumstances where appraisals are desirable or permissible as an official museum-related function. Any appraisal or authentication must represent an honest and objective judgment, and must include an indication of how the determination was made.

COMMERCIAL USE

In arranging for the manufacture and sale of replicas, reproductions or other commercial items adapted from an object in a museum's collection, all aspects of the commercial venture must be carried out in a manner that will not discredit either the integrity of the museum or the intrinsic value of the original object. Great care must be taken to identify permanently such objects for what they are, and to ensure the accuracy and high quality of their manufacture.

AVAILABILITY OF COLLECTIONS

Although the public must have reasonable access to the collections on a nondiscriminatory basis, museums assume as a primary responsibility the safeguarding of their materials and therefore may regulate

access to them. Some parts of the collections may be set aside for the active scholarly pursuits of staff members, but normally only for the duration of an active research effort.

When a staff member involved in scholarly research moves to another institution, the museum should give special consideration to the need he may have of objects or materials that remain in the collections. Such needs should be accommodated, where possible, by loans to the staff member's present institution.

The judgment and recommendation of professional staff members regarding the use of the collections must be given utmost consideration. In formulating his recommendation the staff member must let his judgment be guided by two primary objectives: the continued physical integrity and safety of the object or collection, and high scholarly or educational purposes.

TRUTH IN PRESENTATION

Within the museum's primary charge, the preservation of significant materials unimpaired for the future, is the responsibility of museum professionals to use museum collections for the creation and dissemination of new knowledge. Intellectual honesty and objectivity in the presentation of objects is the duty of every professional. The stated origin of the object or attribution of work must reflect the thorough and honest investigation of the curator and must yield promptly to change with the advent of new fact or analysis.

Museums may address a wide variety of social, political, artistic or scientific issues. Any can be appropriate, if approached objectively and without prejudice.

The museum professional must use his best effort to ensure that exhibits are honest and objective expressions and do not perpetuate myths or stereotypes. Exhibits must provide with candor and tact an honest and meaningful view of the subject. Sensitive areas such as ethnic and social history are of most critical concern.

The research and preparation of an exhibition will often lead the professional to develop a point of view or interpretive sense of the material. He must clearly understand the point where sound professional judgment ends and personal bias begins. He must be confident that the resultant presentation is the product of objective judgment.

HUMAN REMAINS AND SACRED OBJECTS

Research, which provides the very basic foundation for knowledge, is a dynamic and therefore continuing process. It is essential that col-

lections of human remains and sacred objects upon which research is based not be arbitrarily restricted, be securely housed and carefully maintained as archival collections in scholarly institutions, and always be available to qualified researchers and educators, but not to the morbidly curious.

We have learned much about human development and cultural history from human burials and sacred objects. There is merit in continuing such investigations. But if we are to maintain an honorable position as humanists concerned with the worth of the individual, the study of skeletal material and sacred objects must be achieved with dignity. Research on such objects and their housing and care must be accomplished in a manner acceptable not only to fellow professionals but to those of various beliefs.

Although it is occasionally necessary to use skeletal and other sensitive material in interpretive exhibits, this must be done with tact and with respect for the feelings for human dignity held by all peoples. Such an exhibit exists to convey to the visitor an understanding of the lives of those who lived or live under very different circumstances. These materials must not be used for other more base purposes.

III / THE STAFF

GENERAL DEPORTMENT

Employment by a museum, whether privately or governmentally supported, is a public trust involving great responsibility. In all activities museum employees must act with integrity and in accordance with the most stringent ethical principles as well as the highest standards of objectivity.

Every museum employee is entitled to a measure of personal independence equal to that granted comparable professionals in other disciplines, consistent with his professional and staff responsibilities. While loyalty to the museum must be paramount, the employee also has the right to a private life independent of the institution. But museums enjoy high public visibility and their employees a generous measure of public esteem. To the public the museum employee is never wholly separable from his institution. He can never consider himself or his activities totally independent of his museum despite disclaimers that he may offer. Any museum-related action by the individual may reflect on the institution or be attributed to it. He must be concerned not only with the true personal motivations and interests as he sees them but also the way in which such actions might be construed by the outside observer.

CONFLICT OF INTEREST

Museum employees should never abuse their official positions or their contacts within the museum community, impair in any way the performance of their official duties, compete with their institutions, or bring discredit or embarrassment to any museum or to the profession in any activity, museum-related or not. They should be prepared to accept as conditions of employment the restrictions that are necessary to maintain public confidence in museums and in the museum profession.

To protect the institution and provide guidance to its employees, each museum should issue a comprehensive and well-understood policy covering ethical questions related to personal activities and conflicts of interest. That statement must define the procedures essential to the implementation of and compliance with stated policy.

RESPONSIBILITIES TO THE COLLECTIONS
AND OTHER MUSEUM PROPERTY

Museum employees should not acquire objects from the collections owned or controlled by their museums unless such transactions have been subjected to a formal disclosure procedure by the individual and the institution, and were available through a disposal process totally public in nature.

No staff member should use in his home or for any other personal purpose any object or item that is a part of the museum's collections or under the guardianship of the museum, or use any other property, supplies or resources of the museum except for the official business of the institution. To the extent that factual circumstances or special policies warrant exceptions to this principle, the circumstances or policies should be a matter of written record.

The reputation and name of a museum are valuable assets and should not be exploited either for personal advantage or the advantage of any other person or entity.

Information about the administrative and nonscholarly activities of the institution that an employee may acquire in the course of his duties, and that is not generally known or available to the public, must be treated as information proprietary to the museum. Such information should not be used for personal advantage or other purposes detrimental to the institution.

Staff members should be circumspect in referring members of the public to outside suppliers of services such as appraisers or restorers.

Whenever possible, more than a single qualified source should be provided so that no appearance of personal favoritism in referrals is created.

PERSONAL COLLECTING

The acquiring, collecting and owning of objects is not in itself unethical, and can enhance professional knowledge and judgment. However, the acquisition, maintenance and management of a personal collection by a museum employee can create ethical questions. Extreme care is required whenever an employee collects objects similar to those collected by his museum, and some museums may choose to restrict or prohibit personal collecting. In any event, the policies covering personal collecting should be included in the policy statements of each museum and communicated to its staff.

No employee may compete with his institution in any personal collecting activity. The museum must have the right, for a specified and limited period, to acquire any object purchased or collected by any staff member at the price paid by the employee.

Museum employees must inform the appropriate officials about all personal acquisitions. They also must disclose all circumstances regarding personal collections and collecting activities, and furnish in a timely manner information on prospective sales or exchanges.

A museum's policy on personal collecting should specify what kind of objects staff members are permitted or not permitted to acquire, what manner of acquisition is permissible and whether different types of employees have different rights. Policy should specify the method of disclosure required for the staff member. It also should specify the manner and time period within which the museum can exercise the rights it has to purchase objects staff members have acquired for their personal collections. Such a policy can be most effective if explicitly a part of the conditions of employment clearly understood by all employees.

Except by special agreement with individual staff members, the right of a museum to acquire from employees objects collected personally should not extend to objects that were collected prior to the staff member's employment by that museum. Objects that are bequests or genuine personal gifts should be exempt from the museum's right to acquire.

No museum employee may use his museum affiliation to promote his or any associate's personal collecting activities. No employee may participate in any dealing (buying and selling for profit as distin-

guished from occasional sale or exchange from a personal collection) in objects similar or related to the objects collected by the museum. Dealing by employees in objects that are collected by any other museum can present serious problems. It should be permitted only after full disclosure, review and approval by the appropriate museum official.

OUTSIDE EMPLOYMENT AND CONSULTING

Certain types of outside employment, including self-employment and paid consulting activities, can be of benefit to both the institution and the employee by stimulating personal professional development. Remuneration may be monetary or nonmonetary, direct or indirect.

All employment activity must be undertaken within the fundamental premise that the employee's primary responsibility is to his institution; that the activity will not interfere with his ability to discharge this responsibility; and that it will not compromise the professional integrity of the employee or the reputation of the museum.

Museum employees often will be considered representatives of their institutions while they are engaged in activities or duties similar to those they perform for their museum, even though their work may be wholly independent of the institution. In other instances an employee's duties within or outside the institution may require little specialized knowledge of the functioning of a museum. In either case employees must disclose to the director or other appropriate superior the facts concerning any planned outside employment or consulting arrangements that are in any way related to the functions that such employees perform for their museums. Disclosure should not be required for small businesses or similar activities that are entirely unrelated to the work the individual carries out for his institution.

Appraisals, as an official museum activity and subject to well-defined policy, can be useful to a museum and its constituency. As an outside activity of an individual staff member it can present serious problems. No staff member should appraise without the express approval of the director. The related areas of identification, authentication and description, when pursued as an outside activity, should be subject to clearly defined museum policy.

The name of and the employee's connection with the museum should be sparingly and respectfully used in connection with outside activities.

In deference to the constitutional rights of museum employees to freedom of speech and association, disclosure should not be required

for their activities on behalf of voluntary community groups or other public service organizations, except for those organizations such as other museums where the staff member could appear to be acting in his official capacity. Museum professionals should conduct themselves so that their activities on behalf of community or public service organizations do not reflect adversely on the reputation or integrity of their museum.

GIFTS, FAVORS, DISCOUNTS AND DISPENSATIONS

Museum employees and others in a close relationship to them must not accept gifts, favors, loans or other dispensations or things of value that are available to them in connection with their duties for the institution. Gifts include discounts on personal purchases from suppliers who sell items or furnish services to the museum, except where such discounts regularly are offered to the general public. Gifts also can include offers of outside employment or other advantageous arrangements for the museum employee or another person or entity. Salaries together with related benefits should be considered complete remuneration for all museum-related activities.

Employees should be permitted to retain gifts of trifling value when acceptance would not appear to impair their judgment or otherwise influence decisions. Meals, accommodations and travel services while on official business may be accepted if clearly in the interest of the museum.

Museum employees have the right to accept and retain gifts that originate from purely personal or family relationships. It must be recognized that genuine personal gifts may originate from individuals who have a potentially beneficial relationship with the museum. In such cases the staff member is obliged to protect both himself and his institution by fully disclosing the circumstances to the appropriate museum official.

TEACHING, LECTURING, WRITING AND OTHER CREATIVE ACTIVITIES

Museum staff personnel should be encouraged to teach, lecture and write, as desirable activities that aid professional development. Museums should facilitate such activities so long as there is not undue interference with performance of regular duties, and employees do not take advantage of their museum positions for personal monetary gain or appear to compromise the integrity of their institution.

The employee must recognize that when an outside activity is directly related to his regular duties for the institution he is obliged to reach an agreement with the institution concerning all aspects of that activity.

Employees should obtain the approval of the institution of plans for any significant amount of outside teaching, lecturing, writing or editing. Any contemplated uses of the museum's research facilities, staff assistance and property such as copying machines, slides or objects from the collections should be described, and approvals should be obtained for uses of museum property in connection with such outside efforts.

The proprietary interest of both museum and individual in copyrights, royalties and similar properties should be a part of stated general institutional policy supplemented, through mutual agreement, to conform to the needs of the specific project.

Museum employees who are creative artists or pursue similar outside interests must perform these activities in such a way that their status with the institution is not compromised and the institution not embarrassed. It must be recognized that the exhibition of objects in a museum can enhance their value, and museums should display materials created by staff members only under circumstances in which objectivity in their selection can be clearly demonstrated.

FIELD STUDY AND COLLECTING

Field exploration, collecting and excavating by museum workers present ethical problems that are both complex and critical. Such efforts, especially in other countries, present situations that can result in difficult interpersonal and international problems. The statements that follow are offered with the knowledge that any action also must be guided by good judgment, tasteful deportment and current knowledge.

Any field program must be preceded by investigation, disclosure and communication sufficient to ascertain that the activity is legal; is pursued with the full knowledge, approval, and when applicable the collaboration of all individuals and entities to whom the activity is appropriately of concern; and is conducted for scholarly or educational purposes. A general if not specific statement of the nature of the objects to be collected, the purposes that they are intended to serve and their final disposition must be prepared and should be fully understood by all affected parties.

Any field program must be executed in such a way that all partici-

pants act legally and responsibly in acquiring specimens and data; that they discourage by all practical means unethical, illegal and destructive practices associated with acquiring, transporting and importing objects; and that they avoid, insofar as possible, even the appearance of engaging in clandestine activity, be it museum-related or not. Normally no material should be acquired that cannot be properly cared for and used.

In both act and appearance participants must honor the beliefs and customs of host individuals and societies. General deportment must be such that future field work at the site or in the area will not be jeopardized.

On completion of field work, full and prompt reporting of the activity should be made to all appropriate parties; all precatory and mandatory agreements must be fulfilled or the failure to do so fully explained; and all material and data collected must be made available to the scholarly community as soon as possible. Materials incorporated into permanent collections should be treated in a manner consistent with recommendations and restrictions developed for their care and use by zoologists, botanists, archeologists, paleontologists or other discipline-specific groups.

IV / MUSEUM MANAGEMENT POLICY

PROFESSIONALISM

Members of the museum's administration and governing entities must respect the professional expertise of the staff, each having been engaged because of his special knowledge or ability in some aspect of museum activity. Museum governance must be structured so that the resolution of issues involving professional matters incorporates opinions and professional judgments of relevant members of the museum staff. Responsibility for the final decisions will normally rest with the museum administration and all employees are expected to support these decisions; but no staff member can be required to reverse, alter or suppress his professional judgment in order to conform to a management decision.

Collectively, the staff professionals are most familiar with the museum, its assets and its constituency. As such they should be heard by museum management and governance on matters affecting the general long-term direction of the institution.

PERSONNEL PRACTICES AND EQUAL OPPORTUNITY

In all matters related to staffing practices, the standard should be ability in the relevant discipline. In these matters, as well as trustee selection, management practices, volunteer opportunity, collection usage and relationship with the public at large, decisions cannot be made on the basis of discriminatory factors such as race, creed, sex, age, handicap or personal orientation.

It must be remembered that the components of contemporary culture vary by reason of ancestry, experience, education and ability in the extent to which they can share in the museum experience, either as visitors or as a paid or volunteer participant. The museum must recognize that it is a significant force within its own social fabric and that these differences do exist. It should seize and indeed create opportunities whenever possible to encourage employment opportunity and the accessibility of the institution as a resource to all people.

VOLUNTEERS

Volunteer participation is a strong American tradition, and many museums could not exist without the contributions and personal involvement of devoted volunteers. Where volunteer programs exist, the paid staff should be supportive of volunteers, receive them as fellow workers, and willingly provide appropriate training and opportunity for their intellectual enrichment. While volunteers participate in most museum activities, those with access to the museum's collections, programs and associated privileged information work in areas that are particularly sensitive.

Access to the museum's inner activities is a privilege, and the lack of material compensation for effort expended in behalf of the museum in no way frees the volunteer from adherence to the standards that apply to paid staff. The volunteer must work toward the betterment of the institution and not for personal gain other than the natural gratification and enrichment inherent in museum participation.

Although the museum may accord special privileges, volunteers should not accept gifts, favors, discounts, loans, other dispensations or things of value that accrue to them from other parties in connection with carrying out duties for the institution. Conflict of interest restrictions placed upon the staff must be explained to volunteers and, where relevant, observed by them. Volunteers must hold confidential matters of program function and administration.

Volunteer organizations should understand clearly the policies and

programs adopted by museum trustees and not interfere with the administrative application of these policies and programs.

INTERPERSONAL RELATIONSHIPS

The professional museum worker always must be dedicated to the high standards and discipline of his profession, but he also must remain mindful that he is an employee as well as an independent expert. While he must strive for professional excellence in his own specialty, he must simultaneously relate productively to his colleagues, associates and fellow employees. The wisdom and experience of a professional can be lost to the institution if they are not made to act constructively within the total context of the institution.

INTERINSTITUTIONAL COOPERATION

If museums intend to contribute to the preservation of humanity's cultural and scientific heritage and the increase of knowledge, each should respond to any opportunity for cooperative action with a similar organization to further these goals. A museum should welcome such cooperative action even if the short-term advantages are few and it will not significantly increase the individual institution's own holdings or enhance its image.

OWNERSHIP OF SCHOLARLY MATERIAL

The object, its documentation and all additional documentation accrued or developed subsequent to its acquisition are the property of the institution.

The analysis of an object for scholarly purposes usually includes the production of interpretive notes, outlines and illustrative material. It can be held that such material is essentially an extension of the intellect and the memory of the scholar, and that as such it is the property of the individual. An equally persuasive case can be made for institutional ownership of all such interpretive material, especially if a staff member was paid to render scholarly analysis. Either is ethically acceptable if the institutional policy is made known beforehand to the staff member, and if the administrative determination of ownership and access is not the result of vindictive or punitive motivation. The guiding ethical principle must be the most effective and timely dissemination of analytical information derived from the collection.

V / MUSEUM GOVERNANCE

GENERAL RESPONSIBILITY

The governing body of a museum, usually a board of trustees, serves the public interest as it relates to the museum, and must consider itself

accountable to the public as well as to the institution. In most cases the board acts as the ultimate legal entity for the museum, and stands responsible for the formulation and maintenance of its general policies, standards, condition and operational continuity.

Trustees must be unequivocally loyal to the purposes of the museum. Each must understand and respect the basic documents that provide for its establishment, character and governance such as the charter, constitution, bylaws and adopted policies.

Each trustee must devote time and attention to the affairs of the institution and ensure that the museum and its governing board act in accordance with the basic documents and with applicable state and federal laws. In establishing policies or authorizing or permitting activities, trustees especially must ensure that no policies or activities jeopardize the basic nonprofit status of the museum or reflect unfavorably upon it as an institution devoted to public service.

Trustees should not attempt to act in their individual capacities. All actions should be taken as a board, committee or subcommittee, or otherwise in conformance with the bylaws or applicable resolutions. A trustee must work for the institution as a whole, and not act solely as an advocate for particular activities or subunits of the museum.

Trustees should maintain in confidence information learned during the course of their museum activities when that information concerns the administration or activities of the museum and is not generally available to the public. This principle does not preclude public disclosure of information that is properly in the public domain, or information that should be released in fulfilling the institution's accountability to the public.

The governing board holds the ultimate fiduciary responsibility for the museum and for the protection and nurturing of its various assets: the collections and related documentation, the plant, financial assets and the staff. It is obliged to develop and define the purposes and related policies of the institution, and to ensure that all of the museum's assets are properly and effectively used for public purposes. The board should provide adequate financial protection for all museum officials including themselves, staff and volunteers so that no one will incur inequitable financial sacrifice or legal liabilities arising from the performance of duties for the museum.

The board has especially strong obligations to provide the proper environment for the physical security and preservation of the collections, and to monitor and develop the financial structure of the mu-

seum so that it continues to exist as an institution of vitality and quality.

A critical responsibility of the governing board derives from its relationship to the director, the institution's chief executive. The selection of that executive and the continuing surveillance of his activities are primary board responsibilities which cannot be delegated and must be diligently and thoughtfully fulfilled.

In carrying out the duty to the collections, a policy must be developed and adopted by the board governing use of the collections, including acquisitions, loans and the disposal of objects. In formulating policies covering the acceptance of objects or other materials as gifts or loans, the governing board must ensure that the museum understands and respects the restrictions, conditions and all other circumstances associated with gifts and loans.

CONFLICT OF INTEREST

Individuals who are experienced and knowledgeable in various fields of endeavor related to museum activities can be of great assistance to museums, but conflicts of interest or the appearance of such conflicts may arise because of these interests or activities. Guidelines for the protection of both individual and institution should be established by the governing board of every museum.

The museum trustee must endeavor to conduct all of his activities, including those relating to persons closely associated with him and to business or other organizations, in such a way that no conflict will arise between the other interests and the policies, operations or interests of the museum. The appearance of such conflicts also should be avoided. The reputation of the museum can be damaged should a trustee continue an inappropriate activity concurrent with his service in a position of institutional and public trust.

A procedure minimizing the vulnerability to individual or institutional embarrassment should be formulated and stated by every museum board. Every museum trustee should file with the board a statement disclosing his personal, business or organizational interests and affiliations and those of persons close to him which could be construed as being museum related. Such a statement should include positions as an officer or director as well as relationships to other organizations, if the purposes or programs are in any manner related to or impinge upon the purposes, programs or activities of the museum. Such statements should be made available to the board prior to the trustee's election to that body. As an aid to preparing such statements

trustees should be provided relevant data on the museum's operations. Disclosure statements should be updated periodically or whenever significant changes occur.

A visible area for charges of self-interest at the expense of the institution, and of personal use of privileged information, arises whenever a trustee, a member of his family or a close associate personally collects objects of a type collected by the museum. Every museum governing board must clearly state its policy regarding such personal collections. The policy should contain statements to ensure that no trustee competes with the museum for objects; that no trustee takes personal advantage of information available to him because of his board membership; and that should conflict develop between the needs of the individual and the museum, those of the museum will prevail.

No trustee, person close to him, individual who might act for him may acquire objects from the collections of the museum, except when the object and its source have been advertised, its full history made available, and it is sold at public auction or otherwise clearly offered for sale in the public marketplace.

When museum trustees seek staff assistance for personal needs they should not expect that such help will be rendered to an extent greater than that available to a member of the general public in similar circumstances or with similar needs.

Whenever a matter arises for action by the board, or the museum engages in an activity where there is a possible conflict or the appearance of conflict between the interests of the museum and an outside or personal interest of a trustee or that of a person close to him, the outside interest of the trustee should be made a matter of record. In those cases where the trustee is present when a vote is taken in connection with such a question, he should abstain. In some circumstances he should avoid discussing any planned actions, formally or informally, from which he might appear to benefit. Sometimes neither disclosure nor abstention is sufficient, and the only appropriate solution is resignation.

A museum trustee should not take advantage of information he receives during his service to the institution if his personal use of such information could be financially detrimental to the museum. Any such actions that might impair the reputation of the museum also must be avoided. When a trustee obtains information that could benefit him personally, he should refrain from acting upon it until all issues have been reviewed by an appropriate representative of the museum.

Trustees serve the museum and its public. They should not attempt

to derive any personal material advantages from their connection with the institution. Trustees should use museum property only for official purposes, and make no personal use of the museum's collection, property or services in a manner not available to a comparable member of the general public. While loans of objects by trustees can be of great benefit to the museum, it should be recognized that exhibition can enhance the value of the exhibited object. Each museum should adopt a policy concerning the display of objects owned or created by the trustees or staff or in which the trustees or any person close to them have any interests.

THE TRUSTEE-DIRECTOR RELATIONSHIP

Trustees have an obligation to define the rights, powers and duties of the director. They should work with the director, who is their chief executive officer, in all administrative matters, and deal with him openly and with candor. They should avoid giving directions to, acting on behalf of, communicating directly with, or soliciting administrative information from staff personnel, unless such actions are in accord with established procedure or the director is apprised. Staff members should communicate with trustees through the director or with his knowledge, but a procedure should be provided to allow staff personnel to bring grievances directly to the trustees.

The trustees must act as a full board in appointing or dismissing a director, and the relationship between director and board must reflect the primacy of institutional goals over all personal or interpersonal considerations. The director should attend all board meetings and important committee meetings except executive sessions concerning him.

The director has an obligation to provide the trustees with current and complete financial information in comprehensible form; to bring before the board any matters involving policy questions not already determined; and to keep them informed on a timely basis about all other significant or substantial matters, or intended actions affecting the institution.

The director must carry out the policies established by the trustees, and adhere to the budget approved by the board. Whenever it is necessary to deviate from established policies or to alter or exceed budget guidelines, the director should notify the board in advance and request appropriate approval.

APPENDIX
C

The letters herein appear with
the permission of their authors

THE ART MUSEUM
AND TELEVISION:
AN EXCHANGE

THE FOLLOWING LETTERS WERE SENT TO DOUGLAS DILLON, PRESI-
dent of the Metropolitan Museum of Art, from Thomas Hoving,
director, and Roland L. Redmond, emeritus trustee and past presi-
dent of the Metropolitan. Though prompted by the proposed Annen-
berg School of Communication facility at the museum, the letters
touch in the broadest sense on the purposes of any public gallery of
art and constitute an insight into two wholly opposing attitudes toward
museums and art. Copies of the letters were provided all Metropolitan
board members and are among the papers deposited on an unre-
stricted basis by Paul O'Dwyer in the New York City Department
of Archives, 23 Park Row, New York, N.Y. 10038, where they may
be examined by bona fide researchers and reproduced. For reasons
of space, both letters have been condensed.

October 20, 1976

Dear Douglas:

You have asked me to describe the purposes and functions of the
proposed Fine Arts Center of the Annenberg School of Communica-
tions at the Metropolitan Museum and the benefit to the Metropolitan
of such a facility and its concomittant programs.

The Fine Arts Center is envisioned as an educational and communi-
cations entity that will by diverse means provide educational materials
relating to the holdings of the Metropolitan and to the fine arts of the

entire world to the broadest possible audience. It will provide educational programs to curators, conservators, professors and graduate students of art history, as well as museum educators of the Metropolitan and other institutions so that they will be able to utilize modern communications techniques more effectively and thus do a better job of disseminating knowledge about the fine arts. In doing this one of the fundamental goals of the Fine Arts Center will be to form a strong professional association between modern communications devices and the fine arts.

The Fine Arts Center will be a financially independent semi-autonomous entity housed in an appropriate portion of the new South-West Wing of the Metropolitan Museum utilizing all the most contemporary technetronic mechanisms to produce over an initial ten-year period, renewable upon mutual accord, a distinguished series of educational materials for all levels of interest ranging from the general public through graduate students in the fine arts. These materials will include films, television programs, tapes, publications of a wide variety, prints, slides, reproductions and other educational and communications devices to be developed. These materials will relate to the encyclopedic holdings of the Metropolitan Museum and to the broadest spectrum of what is defined as the fine arts of the entire world. The Center will undertake the dissemination of the fine arts as one of the most powerful ameliorative forces for the benefit of civilization and the expansion of man's learning.

From almost its very inception the Metropolitan Museum has been seeking to carry out what the Fine Arts Center embodies. In the attic of the Museum are stored literally tons of glass negatives of photographs taken in the earliest years of this century for the specific purpose of documenting exhibitions which could themselves make only limited stops. Nothing has ever been done with this invaluable archive. In 1932 the Museum promulgated an official set of guidelines for the use of the pictorial materials and objects for television. In 1937, NBC began to be a consumer of the Museum's expertise. By 1940 Gilbert Seldes of CBS began active work at the Metropolitan . . . By 1949 the Museum architects were working on a plan for a T.V. studio with the assistance of experts from CBS. That space, now a storage area in the Grace Rainey Rogers auditorium, was never developed.

In the early and mid-1950's other priorities arose. There began a decade and a half that must be characterized as an introspective point of view, a view that looked more sharply at the collection and the public in the Museum than at the interested public outside the institution. The earlier thirst for "expansion education" abated on all sides. Special exhibitions became less frequent. The public instruction publications program symbolized by the Metropolitan *Miniatures* and *Seminars* slowed down. A more restricted attitude arose concerning radio and television. With some notable exceptions, the Metropolitan experienced a hardening of arteries when it came to education and the broad dissemination of its treasures.

From the mid-1960's to today the picture has changed somewhat

for the better but still remains somewhat haphazard. Serious attempts, however sporadic, have been made to enter the area of television and film in order to utilize "television to exploit (in the best sense) to a larger constituency the fantastic treasures of the MMA" (Thomas Hoving to Bret Waller, July 1972) . . .

As an *anecdotal* indication of the power of T.V. at the Metropolitan let me inform you of what happened one Sunday in the Fall of 1968 when, by chance, one of our thirty-second spots on the *Great Age of Fresco* appeared during the Super Bowl Football game on NBC. The next day, Monday (we were open then), no less than 17,000 people caused a near riot to get into the show, the highest single day, single show attendance in our history . . .

One might raise the question, I suppose, of whether or not the Fine Arts Center needs to be actually housed at the Museum. Why couldn't it be physically placed elsewhere and supply the Metropolitan Museum and other institutions with the product? The answer to this hypothetical question is that at the Metropolitan all the collections reflecting the full span of man's visual creative history are in evidence; the broadest possible range of experts is firmly ensconced at the MMA; the world-wide contacts and entrees of the MMA to most of the countries of the world are unique (the Soviet Minister of Culture stated to me recently that if the Met or an organization linked to it were to make special films, doors closed tight to others would immediately be open); invaluable visual resources other than works of art such as incomparable collections of photographs, archival materials, hundreds of thousands of slides (for example, the Burton Tutankhamun photos, the matchless 10,000 color slides of the Keighly collection) exist here and only here; there is an excellent art library; there are also specialists in the field of publications and other related areas. Indeed it would not be an exaggeration to state that the *only* place where the proper professional and continuing production of broad educational materials on the fine arts should be is the Metropolitan Museum of Art . . .

What, in a *general* sense, would the Fine Arts Center do? One might visualize, just as one example, a multiple film series and its concomitant events as produced in and for the Center in something like the following way: after the subject matter has been decided by the Center's director and its board of trustees, a preliminary work schedule would be worked out and presented to the Board for final review and note. This would be done in concert with precise legal work relating to the specific contractual relationships with the proper authorities in the country in which the films were to be made and, obviously, with the special team hired to carry out the production . . .

The product expected to be delivered eventually would be, in general, the following:

1. A multiple film or television tape series on a major aspect of world art. The series would appear on PBS in prime season, prime time environment. The multiple series could be made so that it could easily by precondensed into a one-hour presentation, such that might appeal

at the right time to commercial television and for adult education distribution.

2. With the series it is critically important to issue a publication, possibly in series, more likely in a single, handsome, beautifully illustrated, excellently written book published in cooperation with the MMA publication material. It is to be observed that right now (and this will not hold forever) the major slice of revenues from film/television tape series will come from the accompanying book. Let me quote some gross revenue figures to indicate this pungently:

"Civilisation"—1970–1975
PBS run and CBS "Preview"	$ 650,000
Non-theatric Film Sales and Rentals	$2,750,000
Book, Hard-Cover, retail,	$6,300,000
360,000 @ $17.50	
Book, Soft-cover, retail,	$1,042,500
150,000 @ $6.95	

"Ascent of Man"—1974–1975
Commercial and Public Network runs	$2,100,000
Non-theatric Film Sales and Rentals	$2,886,733
Book, Hard-cover, retail,	$8,750,000
500,000 @ $17.50	
Book, Soft-cover (figures not currently available)	

3. The non-theatric products can also be of extreme importance. The theatrical multiple series must be handled in such a manner as to be expandable in depth and in detail so as to have with combination of film/tape and slides on television tape a fully accredited undergraduate course for Art History departments in whatever college or university that would want to purchase or rent them.

4. This expanded series would be accompanied by the appropriate textbooks and slide sets.

5. We might, in addition, do something never done in *Civilisation* or in any of the other television series produced so far—manufacture for sale through the proper outlets and mail-order catalogues a series of highly distinguished reproductions of certain key works of art discussed in the series . . . Naturally this would be done in close cooperation with MMA.

6. It might also be important in those film series, where applicable, to mount, in conjunction, an exhibition for presentation in key U.S. museums that specifically relates to whatever series is developed. . . .

In conclusion, after a careful analysis of the potential of the principles embodied in the proposed Fine Arts Center of the Annenberg School of Communications at the Metropolitan Museum, I would be inclined to state that this entity and this program would be the next logical step for the expansion of the Museum's influence around the world and for furtherance of its mission as expressed in its founding Charter, all

at no financial burden to the institution but at indeed at what all likelihood could substantially contribute to the strengthening of its financial position.

Sincerely yours,
THOMAS HOVING

Feb. 3, 1977

Dear Douglas,

At the November meeting of the Trustees of the Museum, a copy of Tom Hoving's letter to you, dated October 20, 1976, was distributed to those present. It and Tom Hoving's very brief review of the architectural sketches (which were projected so rapidly that they were hard to follow) were the first indication most of the Trustees had of the radical changes being proposed in the plans for the development of the South-West area.

As I wrote you early in December, Peter Frelinghuysen and I saw Mr. Rosenblatt on December 2nd and for the first time appreciated the very special needs of the Annenberg School of Communications. We did not see an elevation so there was no way of finding out the height of the various galleries. However, in answer to a question, Mr. Rosenblatt admitted that the galleries under the terrace in the southerly enclosed area, which are to be allocated to the Department of Western European Art, were about 9′ in the clear. That would be unusually low for an exhibition gallery in the Metropolitan.

A further study of the plans which were attached to the minutes of the November meeting of the Board (but which were not submitted to the meeting) shows that the areas for the Department of Twentieth Century Art are unusual since they lie beyond the Annenberg School of Communications portion of the building and are not directly connected with the rest of the Museum. This will present serious traffic and guardianship problems whenever the Annenberg School is closed and the rest of the Museum is open or when the opposite is true.

Aside from the architectural problems, there were several points about Tom Hoving's letter of October 20, 1976, that deserve comment. For convenience, I will discuss them in separately numbered sections.

I

First, I think the Board needs additional information in regard to the Annenberg School of Communications and the Annenberg Fund which are to be the source of such substantial sums. I assume that they are corporations but it does not appear where they are incorporated or who are their officers and directors. This information should be supplied. The Board should also be given current statements of their assets and liabilities and a resume of what the School has accomplished, in-

dependently and through its affiliation with the University of Pennsylvania and the University of Southern California.

It would also be helpful if the proposed program of the Fine Arts Center were described in more detail. The work "produce" is frequently used but it is still not clear whether this means that the Center will engage in the actual production of television programs and if so, how this will be accomplished. I cannot believe that the Center intends to own and operate studios and engage in the expensive and complicated procedures that are inherent in the creation of television programs. This leads to the further question of how the resulting "films, television programs, tapes, etc." will be distributed. While it is clear that they are to be made available for educational purposes, there is nothing in the papers that would prevent the Center from charging fees or even selling some of the films, tapes, etc. If revenues are to be derived from the sale or licensing of what the Center produces, there is a real danger that the project is essentially a commercial enterprise. For this reason I think a definite statement in regard to the ownership and control by the Museum of the copyrights of all material produced by the Center is essential.

II

There are two discrepancies in the statements already made about the proposed Center that should be clarified as promptly as possible. They are:

1) In the third paragraph of Hoving's letter, the following statement is made, "The Fine Arts Center will be a financially independent, semi-autonomous entity, housed in an appropriate portion of the proposed South-West Wing of the Metropolitan Museum." The Minutes of the June meeting of the Executive Committee (see page six) in discussing the control of the Center state, "The employees at the Center would be regular employees of the Museum." It is difficult to understand how an entity like the Center can control its employees if they are also employees of the Museum. The lines of authority between the Center and the Museum must be clearly drawn and the Chief Executive Officer of the Museum, whoever he may be, must have complete power to fix the duties and the compensation of all Museum employees.

2) The second discrepancy is between Mr. Annenberg's undated letter to you and the Minutes of the June meeting of the Executive Committee. The letter lists among the School's obligations (see Item 2 (b)), the following:

"To fund the net cost of the educational project to be conducted under the supervision of a joint committee of trustees of the Museum and of the School for at least ten (10) years."

The Minutes of the Executive Committee on the other hand state flatly,

"The School would also guarantee the first ten years of operating expenses of the Center in full."

There is a vast difference between these two corporations and yet there is no way of telling which will control.

III

Tom Hoving's letter, particularly in pages two to four, purports to summarize the Museum's efforts to make its collections available to the general public through illustrated publications, photographs, slides, films and television. As might be expected, a picture of relative inaction is painted until the middle 1960's when Hoving became Director and introduced new methods of publicity with great emphasis on television. Unfortunately, this picture is misleading. It is also unfair to both Francis Taylor and James Rorimer who were Tom Hoving's immediate predecessors as Directors of the Metropolitan. I will not include in the body of this letter the many accomplishments of both Taylor and Rorimer in the field of education but to rebut any misunderstanding, I will add an appendix listing the many important international exhibitions that they sponsored and the great development of the Museum's educational activities that occurred during their administrations.

However, it is worth noting that Taylor was responsible for the creation of the Junior Museum, which has become the model for similar activities in many other Museums. He was also responsible for the fact that the Grace Rainey Rogers Auditorium was equipped with the most modern means of projecting moving pictures as well as the slides then customarily used to illustrate lectures. It was also due to his insistence that the auditorium was equipped with the facilities needed by television mobile trucks, the method then used in televising programs originating outside T.V. studios. He encouraged and made possible the pioneer project of a television program broadcast from the Museum, which was sponsored by the Ford Foundation and on which Alistair Cooke was master of ceremonies.

Rorimer was not as active as Taylor in the use of moving pictures and television, possibly because he was more skeptical about the success of reproductions as a means of educating the public in art appreciation. Rorimer was a great believer in the importance of actually seeing and studying original works of art and he was never content to look at a photograph or a colored transparency, if the original object could be examined . . .

IV

This raises the basic question of whether any television program can effectually "teach" the appreciation of art. This is not a new topic, it has been debated for years in the field of general education, but there is still doubt as to whether television has the ability to teach as opposed

to its recognized ability to communicate information and entertainment and, unfortunately, advertising and propaganda, to huge audiences. This doubt may be especially true of art appreciation, which unlike historic facts or mathematical formulae, requires a sense of line, form, proportion and color which are unnecessary in the study of less complex subjects.

Whether we like it or not, television has certain limitations. This statement can best be explained by an example. A picture, no matter how accurate it may be, is only one aspect of a work of art. Any change in the angle from which an object is viewed, or in its lighting, will affect the impression which it makes on the beholder. Even when a number of pictures are linked together to suggest what an individual might see if he went to a Museum, the result will not be the same because a television program deprives the viewer of the ability to decide how he will proceed. In a museum each visitor can decide whether he wants to follow a chronological sequence or jump from one object to another. He can linger over a particular item or pass quickly to the next one. These possibilities are lost if one can see only an image on a screen on which the producer (or sometimes merely the technician in charge of the equipment) determines what will be shown and for how long.

Another serious question is whether the use of television will not change the character of all art museums as educational institutions. In the past, their primary function has been to provide each individual with an opportunity to educate himself or herself in regard to the cultural history of mankind. The emphasis, therefore, has always been on voluntary education, not on the acceptance of a particular point of view. The use of television to disseminate art programs will create a unique situation. While the viewer will remain in control by being able to switch at any time to another channel, the very nature of television requires that scripts be prepared in advance and be confined to a particular thesis. They must also be edited by public relations experts so as to avoid controversial topics or expressions that might give offense to special groups. The authors of these programs will not, therefore, have the freedom of expression which they enjoy in delivering lectures. They will be limited by the technical requirements of lighting and exact timing that are inherent in the use of television.

There are other more serious disadvantages. One is the fact that television programs can be studied at leisure by other art historians. This possibility will undoubtedly lead to qualified statements and insipid comments by every writer of a T.V. script. It is the same problem that faces every lecturer when asked to publish his lectures. There is a vast difference between the printed text and the "winged words" of speech . . .

Finally, there is the question of expense. Tom Hoving's letter, particularly in the last two pages, indicates that certain television series are already under discussion. The first would be a celebration of the Nineteen hundredth anniversary of the eruption of Vesuvius and the re-

sulting destruction of Pompeii, Herculaneum and the other towns and villas in the vicinity of the Bay of Naples. The expense of such a series would be monumental . . .

V

To indicate the economic possibilities of a successful television program involving the Fine Arts, Tom Hoving cites Lord Clark's *Civilisation* and gives what purports to be the gross revenues of the television series and the sales of the books that were subsequently published. These figures are surprisingly large but the profitability of any such activity depends not upon the gross revenues but upon the difference between that figure and the costs of production. Tom Hoving does not mention how much was spent to produce either the television series or the books. The actual costs of *Civilisation* must have been very large as the BBC Television crews had to travel to many different parts of Europe. Likewise, nothing is said of the cost of printing the two editions of the book which, with their many color plates, must have been very large. Finally, there is no indication of the cost of distributing these books, although it is conventional in this country for the retailer to retain 40% of the retail sales price.

The second instance cited to show the persuasive influence of T.V. is Bronowski's *Ascent of Man*. This was another BBC production and again estimates of gross revenues are mentioned and all costs of production are ignored . . . The accomplishments of Lord Clark and Bronowski cannot easily be repeated. They depend on the individual ability of the narrator, not on the electronic means of projection.

VI

In view of the possibility that television may be as disappointing as the moving pictures proved to be for educational purposes, I wonder whether the Trustees of the Museum should not insist upon a "pilot project" to test its real worth as an instrument of teaching. I realize that delay may not be acceptable to the Annenberg School, but I think it would be wise to make sure that television has the ability to teach before the plans for the South-West area are changed. As far as I am aware, no institution of higher learning in the United States has adopted television as a means of teaching any course leading to a recognized graduate degree. Unless a "pilot project" demonstrates television's capacity to teach or television has been generally accepted as a desirable method of teaching, I do not think that the Metropolitan Museum should accept Mr. Annenberg's offer which would dedicate a large and important area of the Museum's buildings to a highly specialized use. The proposed changes in the architectural plans will necessarily deprive the Department of Western European Art of the space that it needs for the exhibition of some of its great collections that have been in storage for many years. It will also make all collectors of this type of art realize that their collections are no longer considered important by the Metropolitan.

VII

Tom Hoving's letter quite naturally reflects his conviction that the Annenberg School's proposal offers the Metropolitan Museum a great opportunity to develop art appreciation through television. As pointed out above, he minimizes the accomplishments of his predecessors and gives a highly colored description of the changes that have been made during his own administration.

Some of these statements seem exaggerated but cannot be verified. An instance is the calculation at the top of page 4,

"ten to twenty times as many people see a T.V. program related to a special exhibition as ever see the show at the Museum itself" . . .

One statement is so clearly inaccurate that it cannot be allowed to stand unchallenged. It appears near the top of page 4. It states that during the *Great Age of Fresco* in 1968, one of the Museum's 30 second spots appeared "during the Super Bowl Football game on NBC." As a result, the next day, "no less than 17,000 people caused a near riot to get into the show, the highest single day, single show attendance in our history." This statement is wrong in two respects:

First, the *Great Age of Fresco* was exhibited between September 28 and November 15, 1968. The 1968 Super Bowl Football Game was played on January 12, 1969. Therefore, the exhibition had been closed for six weeks before the Super Bowl Game was played.

Second, the "highest single day, single show attendance in our history" was during the exhibition of the "Mona Lisa" in 1963, when the largest day's total was 102,000 people. It is surprising that Tom Hoving failed to remember the "Mona Lisa" Exhibition which lasted less than a month and attracted 1,077,00 visitors, as he was then an Associate Curator on the staff of the Museum.

It is, of course, possible that the Director confused this episode with another which showed even more clearly the connection between a news broadcast and an unexpected increase in Museum attendance. Some years ago, the Museum put on exhibition a newly unwrapped Egyptian "mummy," and an alert newsman included this fact in his radio broadcast. The next day, a large number of visitors appeared, asking where the "mummy" was being shown. Every Museum in New York has experienced the rapidity with which the public responds to an announcement on radio or T.V. of an unusual exhibit and these instances undoubtedly prove the power of the media to reach the populace. Unfortunately, there is no way of controlling the response; it may be a horde of curiosity seekers with a macabre interest in an ancient corpse or it may be, as the Director seems to imply, thousands of serious students intent on seeing an unusual form of art and the newly uncovered preliminary sketches that had been hidden for centuries under well-known frescoes.

VIII

The Annenberg offer will require the Trustees of the Metropolitan Museum to make their most momentous decision since 1904. In that year, General Cesnola, who had been the Director of the Museum for over thirty years, died. He had been brought up as a Cavalry Officer in his native Piedmont and joined the Union Army as a volunteer during the Civil War. As a reward for his service, he was appointed American General Consul to Cyprus. While he was stationed there, he began to collect archeological remains and, subsequently, sold the major part of his collection to the Metropolitan Museum shortly after it was organized. He was then hired to install this collection and he became the first Director of the Museum. He had no academic qualifications and had had no training as an art historian. He was a self-taught amateur.

His death raised the question as to the future course of the Museum. It was then decided that the Metropolitan should follow the practices of the great European Museums and devote itself to the collection, preservation and exhibition of works of art of all kinds. Quite naturally, emphasis was first placed on the cultures that had contributed to the major elements in the population of the city of New York. This was one of the reasons why the Metropolitan collections were particularly strong in Dutch and English paintings. The other fields of collecting that were emphasized were Greek and Roman and Egyptian Art which had been the basis of the classic revival of the 1820's and the Arms and Armour which reflected the popularity in the middle of the Nineteenth Century of Gothic Art.

At the same time, it was decided that the staff of the Museum should be highly trained art historians, preferably with some experience in the administration of Museums, and Sir Caspar Purdon Clarke, who had been Director of the Victoria and Albert Museum in London, was chosen as General Cesnola's successor. Ever since then, the Directors of the Museum have been trained art historians and the purpose of the Museum has been, as noted above, the collection, preservation and exhibition of objects of art.

The Annenberg offer proposes that the Museum should now devote a substantial part of its available space and a great part of its energies to experimentation in the field of television as a means of educating the public in the appreciation of the Fine Arts. The possible use of television as a means of education has not yet been proven, and I cannot help feeling that the Trustees of the Museum should "make haste slowly" before abandoning the traditional role that the Metropolitan has played in American affairs.

Sincerely yours,
ROLAND L. REDMOND

APPENDIX

D

MUSEUMS VISITED
AND OFFICERS INTERVIEWED

(ALL TITLES AS OF 1975–1977)

NEW YORK CITY

METROPOLITAN MUSEUM OF ART
Thomas P. F. Hoving, Director
C. Douglas Dillon, President
Roland L. Redmond, President Emeritus

MUSEUM OF MODERN ART
Richard Oldenburg, Director
Mrs. John D. Rockefeller III, President
William S. Paley, Chairman

MUSEUM OF THE CITY OF NEW YORK
Joseph V. Noble, Director
Louis S. Auchincloss, President

AMERICAN MUSEUM OF NATURAL HISTORY
Thomas D. Nicholson, Director

THE FRICK COLLECTION
Everett Fahy, Director

WHITNEY MUSEUM OF AMERICAN ART
Thomas Armstrong III, Director

SOLOMON R. GUGGENHEIM MUSEUM
Thomas M. Messer, Director

ASIA HOUSE GALLERY (of the Asia Society)
Allen S. Wardwell II, Director

COOPER-HEWITT MUSEUM OF DECORATIVE ARTS
Lisa M. Taylor, Director

THE JEWISH MUSEUM
Joy G. Ungerleider, Director

MUSEUM OF AMERICAN FOLK ART
Bruce Johnson (dec.), Director

NEW YORK CULTURAL CENTER
Mario Amaya, Director

PIERPONT MORGAN LIBRARY
Charles A. Ryskamp, Director

BROOKLYN MUSEUM
Duncan Cameron, Former Director
Michael Botwinick, Director
Covington Hardee, Chairman

NEW YORK STATE

ROY M. NEUBERGER MUSEUM, State University of New York
(Purchase)
Jeffrey Hoffeld, Director
Bryan Robertson, Director

HERBERT F. JOHNSON MUSEUM OF ART, Cornell University (Ithaca)
Thomas W. Leavitt, Director

NEW YORK STATE HISTORICAL ASSOCIATION (Cooperstown)
Lemuel Jones, Director Emeritus

NEW JERSEY

THE NEWARK MUSEUM
Samuel C. Miller, Director

THE ART MUSEUM, Princeton University
Peter C. Bunnell, Director

CONNECTICUT

YALE UNIVERSITY ART GALLERY (New Haven)
Alan Shestack, Director

THE YALE CENTER FOR BRITISH ART (New Haven)
Edmund P. Pillsbury, Director

MASSACHUSETTS

MUSEUM OF FINE ARTS (Boston)
Perry T. Rathbone, Former Director
George C. Seybolt, President

FOGG ART MUSEUM, Harvard University (Cambridge)
Daniel Robbins, Former Director
John Coolidge, Former Director

PEABODY MUSEUM OF ARCHAEOLOGY AND
ETHNOLOGY (Cambridge)
Stephen Williams, Director

PENNSYLVANIA

PHILADELPHIA MUSEUM OF ART
Evan H. Turner, Director

THE UNIVERSITY MUSEUM, University of Pennsylvania
(Philadelphia)
Froelich C. Rainey, Director

PENNSYLVANIA ACADEMY OF THE FINE ARTS (Philadelphia)
Richard J. Boyle, Director

DISTRICT OF COLUMBIA

NATIONAL GALLERY OF ART
J. Carter Brown, Director

THE SMITHSONIAN INSTITUTION
S. Dillon Ripley II, Secretary

JOSEPH H. HIRSHHORN MUSEUM
Abram Lerner, Director

MUSEUM OF AFRICAN ART
Warren M. Robbins, Director

FOLGER SHAKESPEARE LIBRARY
O. B. Hardison, Jr., Director

THE PHILLIPS COLLECTION
Laughlin Phillips, Director

CORCORAN GALLERY OF ART
Roy Slade, Director

THE TEXTILE MUSEUM
Andrew Oliver, Director

NORTH CAROLINA

NORTH CAROLINA MUSEUM OF ART (Raleigh)
Moussa M. Domit, Acting Director

OHIO

CLEVELAND MUSEUM OF ART
Sherman Lee, Director

ILLINOIS

THE ART INSTITUTE OF CHICAGO
E. Lawrence Chalmers, Jr., President
Daniel Catton Rich (dec.), Former Director

MICHIGAN

DETROIT INSTITUTE OF ARTS
Frederick J. Cummings, Director

NEW MEXICO

MUSEUM OF NEW MEXICO (Santa Fe)
George H. Ewing, Director

TEXAS

DALLAS MUSEUM OF FINE ARTS
Harry S. Parker III, Director
Mrs. Edward Marcus, President

KIMBELL ART MUSEUM (Fort Worth)
Richard F. Brown, Director

AMON CARTER MUSEUM OF WESTERN ART (Fort Worth)
Mitchell A. Wilder, Director

THE FORT WORTH ART MUSEUM
Richard Koshalek, Director

MUSEUM OF FINE ARTS (Houston)
William C. Agee, Director

CONTEMPORARY ARTS MUSEUM (Houston)
James Harithas, Director

CALIFORNIA

THE FINE ARTS MUSEUMS OF SAN FRANCISCO
Ian McKibbin White, Director

SAN FRANCISCO MUSEUM OF ART
Henry T. Hopkins, Director

ASIAN ART MUSEUM OF SAN FRANCISCO (the Avery Brundage Collection)
René-Yvon Lefebvre d'Argence, Director

THE OAKLAND MUSEUM
John E. Peetz, Director

UNIVERSITY ART MUSEUM, University of California (Berkeley)
Peter Selz, Director

LOS ANGELES COUNTY MUSEUM OF ART
Kenneth Donahue, Director
Richard E. Sherwood, President
Franklin D. Murphy, Former President

NORTON SIMON MUSEUM OF ART AT PASADENA
Robert S. McFarlane, President
Norton Simon, Director

J. PAUL GETTY MUSEUM (Malibu)
Stephen Garrett, Director

✦ NOTES ✦

INTRODUCTION

1. William Hazlitt, *Selected Essays*, ed. Geoffrey Keynes (New York: Random House, 1948), pp. 668–69.
2. Germain Bazin, *The Museum Age* (New York: Universe Books, 1967), p. 261.
3. Hilton Kramer, "The National Gallery Is Growing: Risks and Promises," *New York Times*, June 9, 1974.
4. Lynne Vincent Cheney, "1876, Its Artifacts and Attitudes, Returns to Life at Smithsonian," *Smithsonian* (May 1976), p. 48.
5. Smithsonian Institution, news release, May 31, 1976.

CHAPTER I

1. Henry T. Rowell, "A Home for the Muses," *Archaeology* (April 1966), pp. 76–83.
2. James Jackson Jarves, *The Art-Idea*, ed. Benjamin Rowland, Jr. (Cambridge, Mass.: Harvard University Press, 1973), pp. 266–67.
3. Francis Henry Taylor, *The Taste of Angels* (Boston: Little, Brown, 1948), p. 331.
4. Wilhelm Treue, *Art Plunder: The Fate of Works of Art in War, Revolution, and Peace*, trans. Basil Creighton (London: Methuen & Co., Ltd., 1960), p. 177.
5. Ibid., pp. 176, 175.
6. Bazin, *The Museum Age*, p. 190.
7. Taylor, *The Taste of Angels*, pp. 571–89.
8. William St. Clair, *Lord Elgin and the Marbles* (London: Oxford University Press, 1967), p. 272.
9. Jarves, *The Art-Idea*, p. 264–65.

10. P. T. Barnum, *Struggles and Triumphs*, ed. George S. Bryan (New York: Knopf, 1927), p. 229.
11. Mrs. Frances Trollope, *Domestic Manners of the Americans*, ed. Donald Smalley (New York: Knopf, 1949), p. 345.
12. Calvin Tomkins, *Merchants and Masterpieces* (New York: Dutton, 1970), p. 23.
13. Ibid., p. 100.
14. Henry James, *The American Scene* (New York: Horizon, 1967), pp. 191–92.
15. Thorstein Veblen, *The Portable Veblen*, ed. Max Lerner (New York: Viking, 1948), p. 75.
16. Thucydides, II, 41 (Oxford: Clarendon Press, 1881), translated by Benjamin Jowett, Vol. I, p. 120.
17. Karl E. Meyer, *The Plundered Past* (New York: Atheneum, 1973), p. 109.
18. Jarves, *The Art-Idea*, p. 151.
19. Henry James, *Hawthorne*, in *The Shock of Recognition*, ed. Edmund Wilson (New York: Doubleday, 1943), p. 460.
20. Nathaniel Wright Stephenson, *Nelson W. Aldrich* (New York: Scribner's, 1930), p. 337.
21. *Congressional Record*, June 12, 1909, Vol. 44, Pt. 2, 3169.
22. Jerome S. Rubin, "Art and Taxes," Horizon, 8 (Winter 1966), p. 12.
23. Geraldine Keen, *The Sale of Works of Art* (London: Thomas Nelson and Sons, Ltd., 1971), p. 27.
24. Gerald Reitlinger, *The Economics of Taste: The Rise and Fall of the Picture Market* (New York: Holt, Rinehart & Winston, 1961), p. 229.
25. Edward I. Koch, "Tax Equity for the Artist," *Congressional Record*, June 6, 1975. Extension of remarks, E 2912.
26. John J. Kominski, "Tax Reform a 'Half-Axe' Effect on Manuscript Contributions," *Manuscripts* (Fall 1970), pp. 242–46.
27. Frank Kingdon, *John Cotton Dana* (Newark, N.J.: The Public Library and Museum, 1940), p. 45.
28. Ibid., p. 52.
29. Ibid., p. 57.
30. Ibid., p. 99.
31. John Cotton Dana, *A Plan for a New Museum* (Woodstock, Vt., Elm Tree Press, 1920), p. 24.
32. John Cotton Dana, *Ibid*.
33. Dana, *A Plan for a New Museum*, pp. 9–10.
34. Newark Museum, *American Primitives* (Newark, N.J.: The Newark Museum, 1930), p. 5.
35. Undated interview with Paul J. Sachs, Columbia University Oral History Project.
36. Rorimer's notes are preserved in the library of the Metropolitan Museum of Art.
37. Sachs to Berenson, December 31, 1936; letter in Sachs Papers, Fogg Museum.
38. Roberta Faul, "Nothing Succeeds Like Success," *Museum News* (January-February 1975), p. 33.

39. Government Accounting Office, *Need to Strengthen Financial Accountability to the Congress* (1977), p. 75.
40. Ibid., p. 79.
41. Ibid., p. 84.
42. Geoffrey T. Hellman, *The Smithsonian: Octopus on the Mall* (Philadelphia: Lippincott, 1967), p. 211.
43. House of Representatives, General Hearings Before the Subcommittee on Libraries and Memorials of the Committee on House Administration, 91st Congress, 2d Session, July 1970, p. 424.
44. Ibid., pp. 523–527.
45. Ibid., p. 601.
46. Ibid., p. 787.
47. Government Accounting Office, p. 38.
48. Ibid., p. 106.
49. Philip M. Kadis, "Plucking Pelicans at the Smithsonian," *Washington Star*, June 26, 1977.
50. Dillon Ripley, *The Sacred Grove: Essays on Museums* (New York: Simon & Schuster, 1969), pp. 73–74.

CHAPTER II

1. National Endowment for the Arts, press release, May 3, 1975, announcing publication of *Museums USA*.
2. J. Michael Montias, "Are Museums Betraying the Public's Trust?" *Museum News* (May 1973), p. 31.
3. R. H. Tawney, *Religion and the Rise of Capitalism* (New York: Harcourt Brace, 1952), p. 118.
4. Gail Kennedy, ed., *Democracy and the Gospel of Wealth* (Boston: D. C. Heath, 1949), p. 8.
5. Ibid., pp. 7–8.
6. Peter Collier and David Horowitz, *The Rockefellers: An American Dynasty* (New York: Holt, Rinehart & Winston, 1976), p. 49.
7. Appeal to the State Legislature, brochure, June 1975, issued by the Detroit Institute of Arts.
8. Joanna Firestone, "Art Budget Slashed by $625,000," Ann Arbor *News*, May 22, 1975.
9. Letter from Cummings to Boris, September 7, 1976, in author's possession.
10. Undated flier, signed Harold O. Love, Founder's Benefit Chairman, in author's possession.
11. W. McNeil Lowry, *The Arts and Philanthropy*, speech at Brandeis University, December 10, 1962 (New York: Ford Foundation, 1962).
12. John Brooks, "Fueling the Arts, Or, Exxon as a Medici," *New York Times*, January 25, 1976.
13. Interview with John Hightower, November 4, 1975.
14. Interview with Lucia Salemme, January 12, 1976.
15. Annette Kuhn, "How to Give Away $33 Million and Still Not Get Any Respect," *Village Voice*, November 10, 1975, p. 85.
16. Ibid., p. 86.

17. Interview with Bryan Robertson, April 16, 1975.
18. Michael Straight, "The Arts Go Begging," *New Republic* (March 22, 1969), p. 14.
19. Interview with Leonard Garment, December 3, 1975.
20. Nancy Hanks, "The Arts in America," *Museum News* (November 1973), p. 45.
21. Ford Foundation, *The Finances of the Performing Arts* (New York: Ford Foundation, 1974), p. 82.
22. William J. Baumol and William G. Bowen, *The Performing Arts: The Economic Dilemma* (New York: The Twentieth Century Fund, 1966), p. 345.
23. Kennedy, *Democracy and the Gospel of Wealth*, pp. 112–13.
24. Joint Hearings Before Committee on Select Education, *Arts, Humanities and Cultural Affairs Act of 1975* (Washington, D.C.: Government Printing Office, 1975), pp. 22–23.
25. Ibid., pp. 403–04.

CHAPTER III

1. Richard Dougherty, "Nuhyawk, Nuhyawk," *Newsweek* (June 2, 1975), p. 11.
2. Robert Moses, *Public Works: A Dangerous Trade* (New York: McGraw-Hill, 1970), p. 43.
3. Ibid.
4. Tomkins, *Merchants and Masterpieces*, p. 302.
5. August Heckscher, *Alive in the City* (New York: Scribner's, 1974), p. 43.
6. Barbara Goldsmith, "The True Confessions of Thomas Hoving," *New York* (April 16, 1973), p. 73.
7. Moses, *Public Works*, p. 50.
8. Interview with Thomas Hoving, December 17, 1975.
9. Moses, *Public Works*, p. xi.
10. Germain Seligman, *Merchants of Art: 1880–1960* (New York: Appleton-Century, 1961), p. 30.
11. Russell Lynes, *Good Old Modern* (New York: Atheneum, 1973), p. 57.
12. Calvin Tomkins, *The Scene: Reports on Post-Modern Art* (New York: The Viking Press, 1976), pp. 4–6.
13. Francis Henry Taylor, *Babel's Tower: The Dilemma of the Modern Museum* (New York: Columbia University Press, 1945), p. 8.
14. Moses, *Public Works*, p. 49.
15. Francis Henry Taylor and Theodore Low, *The Museum as a Social Instrument* (New York: Metropolitan Museum of Art, 1942), pp. 10–11.
16. Ibid., p. 30.
17. Tomkins, *Merchants and Masterpieces*, p. 324.
18. Moses, *Public Works*, p. 49.
19. Interview with Stuart Silver, November 6, 1975.

20. Grace Glueck, "The Total Involvement of Thomas Hoving," *New York Times Magazine* (December 9, 1968), p. 45 et seq.
21. Milton Esterow, "Hoving's Metropolitan to Offer Multi-Media Look at Harlem History," *New York Times*, November 16, 1968.
22. Allon Schoener, ed., *Harlem on My Mind* (New York: Random House, 1968), p. 10.
23. Ibid., p. 14.
24. Metropolitan Museum of Art, *Annual Report 1974–1975*, p. 35.
25. Richard Dougherty, "A Store Manager Shouldn't Run the Met." Letter to the Editor, *New York Times*, August 7, 1977.
26. New York Supreme Court, Appellate Division—First Department. *Edward Hallam Tuck and Brendan Gill v. August Heckscher.* Record on Appeal, Index No. 01957/1971, p. 149.
27. Ibid., p. 150.
28. Murray Kempton, "The Agony in the Garden," *New York Review of Books* (September 24, 1970), p. 14.
29. Sophy Burnham, *The Art Crowd* (New York: McKay, 1973), p. 176.
30. Calvin Tomkins, "The Making of an Art Detente," *New York Times*, Arts and Leisure, April 13, 1975.
31. Interview with Thomas Hoving, December 17, 1975.
32. Kramer, "The Met Succumbs to a Box Office Mentality," *New York Times*, March 2, 1975.
33. Grace Glueck, "2nd Key Aide Quits Met in Dispute Over Hoving Method," *New York Times*, April 30, 1975.
34. Letter from Clark to Hoving, April 29, 1975, in author's possession.
35. Douglas Davis, "Hoving: Last of a Breed," *Newsweek* (March 12, 1973), p. 86.
36. Metropolitan Museum of Art, *Information for Trustees* (New York: Metropolitan Museum, 1978), pp. 49–50.
37. Letter from Hoving to Annenberg, March 16, 1976, in author's possession.
38. Letter from Hoving to Dillon, October 20, 1976, excerpted in Appendix C.
39. Letter from Redmond to Dillon, February 3, 1977, excerpted in Appendix C.
40. Barbara Goldsmith, "The Annenberg Affair," *New York*, March 7, 1977, p. 31.
41. Walter H. Annenberg, "Open Letter," advertisement, *New York Times,* March 15, 1977.

CHAPTER IV

1. René Gimpel, *Diary of an Art Dealer* (New York: Farrar, Straus & Giroux, 1966), p. 217.
2. Jean Lacouture, *Andre Malraux* (New York: Pantheon, 1975), p. 387.
3. Lynes, *Good Old Modern*, p. 189.

4. Paul Goldberger, "What Should a Museum Building Be?" *Art News* (October 1973), p. 33.
5. Ibid., p. 35.
6. Sherman E. Lee, ed., *On Understanding Art Museums* (Englewood Cliffs, N.J.: Prentice-Hall, 1975), p. 53.
7. Walter Gropius, *Apollo in the Democracy: The Cultural Obligations of the Architect* (New York: McGraw-Hill, 1968), pp. 143–44.
8. Charles Jencks, *Le Corbusier and the Tragic View of Architecture* (Cambridge, Mass.: Harvard University Press, 1973), p. 45.
9. Jane Jacobs, *The Death and Life of Great American Cities* (New York: Random House, 1961), p. 23.
10. Taylor, *Babel's Tower*, p. 6.
11. Lynes, *Good Old Modern*, p. 212.
12. Ibid., p. 408.
13. Ada Louise Huxtable, "A Dubious Plan for the Modern," Arts and Leisure, *New York Times*, August 7, 1977.
14. Lewis Mumford, "Sky Line," *New Yorker*, December 5, 1959, p. 105.
15. John Canady, "Wright vs. Painting," *New York Times*, October 21, 1959.
16. Thomas B. Hess, "First View of the Guggenheim," *Art News*, November 1959), pp. 46, 67.
17. "Last Monument," *Time*, November 2, 1959, p. 67.
18. Robert Alden, "Art Experts Laud Wright's Design," *New York Times*, October 22, 1959.
19. Moses, *Public Works*, p. 870.
20. Ibid.
21. H. L. Mencken, *A Mencken Chrestomathy* (New York: Knopf, 1949), pp. 184–86.
22. "A Strung-Out Museum from Stone," editorial, *Raleigh News and Observer*, September 23, 1973.
23. Letter from Wayne to Esberg, April 11, 1972, copy in author's possession.
24. Letter from Esberg to Wayne, April 27, 1972, copy in author's possession.
25. Interview with Franklin D. Murphy, October 23, 1975.
26. Steven Roberts, "Why a 63-year-old Tycoon Worth $100 Million Wants to Run for the Senate," *New York Times Magazine*, May 31, 1970, p. 26.
27. Ibid., p. 26.
28. Ibid., p. 26.
29. Pasadena Art Museum, press release, October 24, 1975.
30. Katharine Kuh, "Architecturally Successful But the Patient Died," *Saturday Review*, November 7, 1959, p. 36.

CHAPTER V

1. Seligman, *Merchants of Art*, pp. 218–19.
2. Keen, *The Sale of Works of Art*, p. 140.

3. Harold Rosenberg, *Art on the Edge* (New York: Macmillan, 1975), p. 276.
4. Eric Hodgins and Parker Lesley, "The Great International Art Market," *Fortune* (December 1955), pp. 118–32, 150–69, and (January 1956), pp. 122–25, 130–36.
5. Ibid., December 1955, p. 118.
6. Gimpel, *Diary of an Art Dealer*, p. 396.
7. Alfred Frankfurter, "How Great Is the Dale Collection?" *Art News* (May 1965), pp. 43–44, 90–95.
8. Harrison C. White and Cynthia A. White, *Canvases and Careers* (New York: Viking, 1965), p. 141.
9. James Brough, *Auction!* (New York: Bobbs-Merrill, 1963), p. 14.
10. Wesley Towner, *The Elegant Auctioneers* (New York: Hill and Wang, 1970), p. 602.
11. Bonnie Burnham, *The Art Crisis* (New York: St. Martin's Press, 1975), p. 194.
12. Ibid., p. 198.
13. Ibid., p. 199.
14. Ibid., p. 197.
15. Frank Arnau, *3,000 Years of Deception in Arts and Antiques* (London: Cape, 1961), epigraph.
16. Bernard Berenson, *Sketch for a Self-Portrait* (New York: Pantheon, 1949), p. 43.
17. S. N. Behrman, *People in a Diary* (Boston: Little, Brown, 1972), p. 261.
18. Kenneth Clark, *Another Part of the Wood* (London: Murray, 1974), p. 140.
19. John Walker, *Self-Portrait with Donors* (Boston: Atlantic–Little, Brown, 1974), p. 93.
20. Osbert Sitwell, *Left Hand, Right Hand!* (London: Macmillan, 1945), p. 221.
21. Patsy Orlofsky and Myron Orlofsky, *Quilts in America* (New York: McGraw-Hill, 1974), p. 68.
22. Interview with Thomas Armstrong, November 13, 1975.
23. Interview with B. H. Friedman, November 18, 1975.
24. Allen Funt, foreword to museum catalogue for Alma-Tadema show.
25. Michael Levey, "How Much?" *New York Review of Books* (February 25, 1965), p. 15.
26. Fred Ferretti, "The Anatomy of an Art Sale: Profiting on 'Worst' Painter," *New York Times*, November 16, 1973.
27. Rosenberg, "The Art World," p. 277.
28. For the complete AAM Committee on Ethics Report, see Appendix B.
29. Clark, *Another Part of the Wood*, pp. 264–65.
30. Walker, *Self-Portrait with Donors*, p. 255.
31. Franklin Feldman and Stephen E. Weil, *Art Works: Law, Policy, Practice* (New York: Practicing Law Institute, 1974), p. 913.

CHAPTER VI

1. Walker, *Self-Portrait with Donors*, p. 49.
2. Ibid., p. 57.
3. John McPhee, "A Room Full of Hovings," *The New Yorker* (May 20, 1967), p. 129.
4. Walker, *Self-Portrait with Donors*, p. xi.
5. Joseph V. Noble, "Museum Manifesto," *Museum News* (April 1970), p. 19.
6. Thomas Hoving, *The Chase, The Capture: Collecting at the Metropolitan* (New York: Metropolitan Museum of Art, 1975), pp. 88–89.
7. Museum of Fine Arts, *The Rathbone Years* (Boston: Museum of Fine Arts, 1972), p. 3.
8. Thomas B. Hess, "MOMA and Towering Limbo," *New York* (March 15, 1976), p. 78.
9. Interview with William Rubin, November 17, 1975.
10. Interview with Daniel Catton Rich, September 15, 1975.
11. Frankfurter, "How Great Is the Dale Collection?" p. 52.
12. Maurice Rheims, *The Strange Life of Objects* (New York: Atheneum, 1961), p. 32.
13. Kenneth Clark, "The Great Private Collections," *Sunday Times* (London), September 22, 1963, p. 14.
14. Interview with Daniel Catton Rich, September 15, 1975.
15. Interview with George Christopher, October 24, 1975.
16. Script for slide film and recorded narration, "A World Treasure for San Francisco," produced by Whitaker & Baxter, 1960.
17. Interview with Joseph L. Alioto, October 26, 1975.
18. David L. Goodrich, *Art Fakes in America* (New York: Viking, 1973), p. 101.
19. Paul Richard, "The Met Under Siege," *Washington Post*, February 18, 1973.
20. John L. Hess, "Bidder Is Back for Coups in Met Sale," *New York Times*, February 16, 1973.
21. Anthony M. Clark, *European Paintings from the Minneapolis Institute of Arts* (New York: Praeger, 1971), p. 6.
22. Feldman and Weil, *Art Works*, pp. 129–30.
23. John L. Hess, "Metropolitan Finds 'Odalisque' Not by Ingres," *New York Times*, January 17, 1973.
24. David Shirey, "A Trustee of Met Questions Sales," *New York Times*, April 12, 1973.
25. Kyran M. McGrath, "A Landmark Court Decision," *Museum News* (November 1974), p. 40.
26. Leah Gordon, "Trading a Museum's Treasure—A Very Hazardous Business," *New York Times*, March 31, 1974.
27. Editorial, "The Harding Museum in Court," *Chicago Tribune*, December 24, 1976.
28. Attorney General's Conference of Museum Representatives, Transcript, October 19, 1973, p. 4.

29. Ibid., pp. 58–59.
30. Montias, "Are Museums Betraying the Public's Trust?" p. 31.

CHAPTER VII

1. Alexis de Tocqueville, *Democracy in America*, ed. Phillips Bradley (New York: Knopf, 1948), II, p. 4.
2. Tomkins, *Merchants and Masterpieces*, p. 106.
3. Ibid., p. 105.
4. Clark, *Another Part of the Wood*, p. 264.
5. Richard F. Brown, "Can Policy and Management Be Happily Married in a Museum?" Text of speech to Trustees Committee, American Association of Museums, New Orleans, October 27, 1975.
6. Laurence Vail Coleman, *The Museum in America* (Washington, D.C.: American Association of Museums, 1939), p. 390.
7. Brian O'Doherty, ed., *Museums in Crisis* (New York: Braziller, 1972), p. 117.
8. Walter Muir Whitehill, *Museum of Fine Arts Boston: A Centennial History* (Cambridge, Mass.: Harvard University Press, 1970), pp. 839–40.
9. Louis Auchincloss, "Money, Vanity and Museum Boards," *New York* (August 9, 1971), p. 6.
10. Brown, "Can Policy and Management Be Happily Married in a Museum?" p. 14.
11. Barbara Newson and Adele Z. Silver, "Examining a Delicate Balance," *Museum News* (September-October 1977), p. 16.
12. Lawrence Alloway, "Museums and Unionization," *Artforum* (February 1975), p. 48.
13. A. H. Raskin, "Behind the MOMA Strike," *Art News* (January 1974), p. 37.
14. Robin Reisig, "Can You Be Both Modern and a Museum?" *Village Voice* (August 26, 1971), p. 25.
15. Raskin, "Behind the MOMA Strike," p. 36.
16. Grace Glueck, "Strike Hardens Attitudes at Modern," *New York Times*, February 5, 1974.
17. Lee, *On Understanding Art Museums*, p. 157.
18. David Shirey, "A Trustee of Met Questions Sales," *New York Times*, April 12, 1973.
19. John Hightower, "The Museums of Modern Art That Never Were," copy furnished to author, p. 9.
20. Interview with William S. Paley, December 3, 1975.
21. John Hightower, "Are Art Galleries Obsolete?" *Curator* (Vol. XII, No. 1, 1969), p. 11.
22. Hightower, "The Museums of Modern Art That Never Were," p. 1.
23. Lynes, *Good Old Modern*, pp. 429–30.
24. Otile McManus, Robert Taylor, and Patrick McGulligan, "Museum Controversy Rooted in Style, Identity, Accountability," *Boston Globe*, March 9, 1975.

25. Editorial, "A Museum in Trouble," *Boston Globe*, March 12, 1975.
26. Duncan F. Cameron, "The Administrative Structure of the Museum and Its Management." Speech, Symposium on Museums in Contemporary World, UNESCO House, Paris, November 24-28, 1969.
27. Thomas S. Buechner, *The Brooklyn Museum* (Brooklyn, N.Y.: The Brooklyn Museum, 1967), p. 1.
28. Letter to chairman and members of the Governing Committee of the Brooklyn Museum, May 4, 1973, copy in author's possession.
29. Coleman, *The Museum in America*, p. 196.
30. National Endowment for the Arts, *Museums USA: A Survey Report* (Washington, D.C.: Government Printing Office, 1975), p. 491.
31. For the complete AAM Committee on Ethics text, see Appendix B.
32. Philip M. Kadis, "Who Should Manage Museums?" *Art News* (October 1977), p. 51.
33. Ibid., p. 50.

CHAPTER VIII

1. Ralph Waldo Emerson, *Essays: First Series* (Boston: Houghton Mifflin, 1903), p. 368.
2. *Art News* report, "Cabinet Post for Art Seems Near," April 9, 1921, reprinted in *Art News*, 75th Anniversary Issue, November 1977, p. 146.
3. Harold Nicolson, *Diplomacy* (Oxford: Oxford University Press, 1939), p. 168.
4. Lynes, *Good Old Modern*, p. 130.
5. Ibid., pp. 131–32.
6. Ibid., p. 133.
7. Ibid., p. 134.
8. Interview with William Lieberman, July 18, 1975.
9. Interview with Stanley Marcus, November 3, 1975.
10. Interview with Harry Parker III, November 4, 1975.
11. Goldwin A. McLellan, speech, panel discussion, "Can the Needs of the Arts Be Assessed on a National Basis?" October 27, 1975, Washington, D.C.
12. "Indentations in Space." *New Yorker*, May 21, 1977, p. 51.
13. John Ruskin, lecture delivered July 13, 1857, "The Accumulation and Distribution of Art," reprinted in *The Laws of Fesole and Modern Painters* (Boston: Aldine, n.d.), p. 177.
14. Maynard Solomon, ed., *Marxism and Art* (New York: Knopf, 1973), p. 553.
15. Grace Glueck, "Met Guarantees Egypt $2.6 Million in 3-Year-Tutankhamun Tour," *New York Times*, September 28, 1976.
16. Quoted, César Graña, "The Private Lives of Public Museums," *Transaction* (April 1967), p. 20.

❧ BIBLIOGRAPHY ❧

Author's Note: It had been my original intention to list all books, official documents, and articles consulted; all archival materials examined; and all persons interviewed. But since the listing would have filled more than a hundred pages, I was forced to limit the bibliography to cited materials and a scattering of important other sources.

Alden, Robert. "Art Experts Laud Wright's Design." *New York Times*, October 22, 1959.

Alloway, Lawrence. "Museums and Unionization." *Artforum* (February 1975), 46–48.

Association of Art Museum Directors. *Professional Practices in Art Museums*. New York: Association of Art Museum Directors, 1971.

Attorney General of New York State. *Conference of Museum Representatives*, October 19, 1973, typed transcript.

Auchincloss, Louis. "Money, Vanity and Museum Boards." *New York* (August 9, 1971), 9.

Barnum, P. T. *Struggles and Triumphs*, ed. George S. Bryan. New York: Knopf, 1927.

Baumol, William J., and William G. Bowen. *The Performing Arts: The Economic Dilemma*. New York: The Twentieth Century Fund, 1966.

Bazin, Germain. *The Museum Age.* New York: Universe Books, 1967.

Behrman, S. N. *Duveen.* New York: Random House, 1952.

———. *People in a Diary.* Boston: Little, Brown, 1972.

Bender, Marilyn. "The Boom in Art for Corporate Use." *New York Times,* January 28, 1973.

Berenson, Bernard. *Sketch for a Self-Portrait.* New York: Pantheon, 1949.

Brooks, John. "Fueling the Arts, Or, Exxon as a Medici." *New York Times,* January 25, 1976.

Brough, James. *Auction!* New York: Bobbs-Merrill, 1963.

Brown, Milton W. *The Story of the Armory Show.* New York: Joseph H. Hirshhorn Foundation, 1963.

Brown, Richard F. "Can Policy and Management Be Happily Married in a Museum?" Text of speech to Trustees Committee, American Association of Museums, New Orleans, October 27, 1975.

Buechner, Thomas S. *The Brooklyn Museum.* Brooklyn, N.Y.: The Brooklyn Museum, 1967.

Burnham, Bonnie. *The Art Crisis.* New York: St. Martin's Press, 1975.

Burnham, Sophy, *The Art Crowd.* New York: McKay, 1973.

Burt, Nathaniel. *Palaces for the People.* Boston: Little, Brown, 1977.

Cameron, Duncan F. "The Administrative Structure of the Museum and Its Management." Speech, Symposium on Museums in Contemporary World, UNESCO House, Paris, November 24–28, 1969.

Canaday, John. "Wright vs. Painting." *New York Times,* October 21, 1959.

Caplin, Lee Evan. "Art, Taxes and the Law." *Art Journal,* XXXII (Fall 1972), 12–20.

Cheney, Lynne Vincent. "1876, Its Artifacts and Attitudes, Returns to Life at Smithsonian." *Smithsonian* (May 1976), 37–48.

Clark, Anthony M. *European Paintings from the Minneapolis Institute of Arts.* New York: Praeger, 1971.

Clark, Kenneth. *Another Part of the Wood.* London: Murray, 1974.

————. "The Great Private Collections." *Sunday Times* (London), September 22, 1963.

"Cleveland, Dali, and Reynolds Morse." *Harvard Business School Bulletin* (March/April 1972),17–19.

Coleman, Laurence Vail. *The Museum in America*. Washington, D.C.: American Association of Museums, 1939. 3 volumes.

Collier, Peter, and David Horowitz. *The Rockefellers: An American Dynasty*. New York: Holt, Rinehart & Winston, 1976.

Connolly, William G. "Strains at Westbeth Threaten a Noble Vision." *New York Times*, September 24, 1972.

Dana, John Cotton. *The Gloom of the Museum*. Woodstock, Vt., 1917.

————. *The New Museum*. Woodstock, Vt., 1917.

————. *A Plan for a New Museum*. Woodstock, Vt.: Elm Tree Press, 1920.

Davidson, Joan K. "Westbeth: The First Five Years." *New York Times*, February 13, 1973.

Davis, Douglas. "Hoving: Last of a Breed." *Newsweek* (March 12, 1973).

Dorian, Frederick. *Commitment to Culture*. Pittsburgh: University Press, 1964.

Dougherty, Richard. "Nuhyawk, Nuhyawk." *Newsweek* (June 2, 1975), 11.

————. "A Store Manager Shouldn't Run the Met." Letter to the Editor, *New York Times*, August 7, 1977.

Emerson, Ralph Waldo. *Essays: First Series*. Boston: Houghton Mifflin, 1903.

Esterow, Milton. "Hoving's Metropolitan to Offer Multi-Media Look at Harlem History." *New York Times*, November 16, 1968.

Faul, Roberta. "Nothing Succeeds Like Success." *Museum News* (January–February 1975), 33–35.

Feldman, Franklin, and Stephen E. Weil. *Art Works: Law, Policy, Practice*. New York: Practicing Law Institute, 1974.

Ferretti, Fred. "The Anatomy of an Art Sale: Profiting on 'Worst' Painter." *New York Times*, November 16, 1973.

Ford Foundation. *The Finances of the Performing Arts*. New York: Ford Foundation, 1974.

Frankfurter, Alfred. "How Great Is the Dale Collection?" *Art News* (May 1965), 43–44, 51–53.

————. "Picasso and His Public." *Horizon*, IV (December 1961), 4–13.

Gelatt, Roland. "Picasso's Legacy." *Saturday Review* (November 12, 1977), 8–16.

Geldzahler, Henry. *New York Painting and Sculpture: 1940–1970*. New York: Dutton, 1969.

General Accounting Office. *Need to Strengthen Financial Accountability to the Congress: Smithsonian Institution*. Washington, D.C.: General Accounting Office, 1977.

Gimpel, René. *Diary of an Art Dealer*. New York: Farrar, Straus & Giroux, 1966.

Glueck, Grace. "Met Guarantees Egypt $2.6 Million in 3-Year Tutankhamun Tour." *New York Times*, September 28, 1976.

————. "Museums Headed by Arts Council." *New York Times*, July 24, 1975.

————. "2nd Key Met Museum Aide Quits in Dispute over Hoving Method." *New York Times*, April 30, 1975.

————. "Strike Hardens Attitudes at Modern." *New York Times*, February 5, 1974.

————. "The Total Involvement of Thomas Hoving." *New York Times Magazine* (December 9, 1968), 45 et. seq.

Goldberger, Paul. "What Should a Museum Building Be?" *Art News* (October 1973), 33–36.

Goldsmith, Barbara. "The True Confessions of Thomas Hoving." *New York* (April 16, 1973), 68–73.

————. "The Annenberg Affair." *New York*, March 7, 1977, pp. 31–37.

Goodrich, David L. *Art Fakes in America*. New York: Viking, 1973.

Gordon, Leah. "Trading a Museum's Treasure—a Very Hazardous Business." *New York Times*, March 31, 1974.

Graña, César, "The Private Lives of Public Museums," *Trans-action* (April 1967), pp. 20–25.

Gropius, Walter. *Apollo in the Democracy: The Cultural Obligations of the Architect.* New York: McGraw-Hill, 1968.

Hanks, Nancy. "The Arts in America." *Museum News* (November 1973), 42–47.

Hazlitt, William. *Selected Essays,* ed. Geoffrey Keynes. New York: Random House, 1948.

Heckscher, August. *Alive in the City.* New York: Scribner's, 1974.

Hellman, Geoffrey T. *The Smithsonian: Octopus on the Mall.* Philadelphia: Lippincott, 1967.

Hersh, Burton. *The Mellon Family.* New York: Morrow, 1978.

Hess, John L. "Bidder Is Back for Coups in Met Sale." *New York Times,* February 16, 1973.

―――. "Metropolitan Finds 'Odalisque' Not by Ingres." *New York Times,* January 17, 1973.

Hess, Thomas B. "First View of the Guggenheim." *Art News* (November 1959), 46, 67.

―――. "MOMA and Towering Limbo." *New York* (March 15, 1976), 78–80.

Hightower, John. "Are Art Galleries Obsolete?" *Curator* (Vol. XII, No. 1, 1969), pp. 9–13.

―――. "The Museums of Modern Art That Never Were" (unpublished memoir, n.d.).

Hodgins, Eric, and Parker Lesley. "The Great International Art Market." *Fortune* (December 1955), 118–32, 150–69; and (January 1956), 122–25, 130–36.

House of Representatives. General Hearings Before the Subcommittee on Libraries and Memorials of the Committee on House Administration, 91st Congress, 2d Session, July 1970.

Hoving, Thomas. *The Chase, the Capture: Collecting at the Metropolitan.* New York: Metropolitan Museum of Art, 1975.

―――. "Very Inaccurate and Very Dangerous." *New York Times,* March 5, 1972.

Huxtable, Ada Louise. "A Dubious Plan for the Modern." Arts and Leisure, *New York Times,* August 7, 1977.

"Indentations in Space," in "Talk of the Town." *The New Yorker* (May 21, 1977), 51–52.

Jacobs, Jane. *The Death and Life of Great American Cities.* New York: Random House, 1961.

James, Henry, *The American Scene.* New York: Horizon, 1967.

————. *Hawthorne*, in *The Shock of Recognition*, ed. Edmund Wilson. New York: Doubleday, 1943.

Jarves, James Jackson. *The Art-Idea*, ed. Benjamin Rowland, Jr. Cambridge, Mass.: Harvard University Press, 1960.

Jencks, Charles. *Le Corbusier and the Tragic View of Architecture.* Cambridge, Mass.: Harvard University Press, 1973.

Joint Hearings Before Committee on Select Education. *Arts, Humanities and Cultural Affairs Act of 1975.* Washington, D.C.: Government Printing Office, 1975.

Kadis, Philip M. "Plucking Pelicans at the Smithsonian." *Washington Star*, June 26, 1977.

————. "Who Should Manage Museums?" *Art News* (October 1977), 46–51.

Keen, Geraldine. *The Sale of Works of Art.* London: Thomas Nelson and Sons, Ltd., 1971.

Kempton, Murray. "The Agony in the Garden." *New York Review of Books* (September 24, 1970), 12–16.

Kennedy, Gail, ed. *Democracy and the Gospel of Wealth.* Boston: D. C. Heath, 1949.

Kingdon, Frank. *John Cotton Dana.* Newark, N.J.: The Public Library and Museum, 1940.

Koch, Edward I. "Tax Equity for the Artist." *Congressional Record*, June 6, 1975. Extension of remarks, E 2912.

Kominski, John J. "Tax Reform a 'Half-Axe' Effect on Manuscript Contributions." *Manuscripts* (Fall 1970), 242–46.

Kramer, Hilton. "The National Gallery Is Growing: Risks and Promises." *New York Times*, June 9, 1974.

————. "The Met Succumbs to a Box-Office Mentality." *New York Times*, March 2, 1975.

Kuh, Katharine. "Architecturally Successful But the Patient Died." *Saturday Review*, November 7, 1959, pp. 36–38.

Kuhn, Annette. "How to Give Away $33 Million and Still Not Get Any Respect." *Village Voice* (November 30, 1975), 85–87.

Lacouture, Jean. *André Malraux*. New York: Pantheon, 1975.

"Last Monument." *Time*, November 2, 1959, p. 67.

Lee, Sherman E., ed. *On Understanding Art Museums*. Englewood, N.J.: Prentice-Hall, 1975.

Levey, Michael. "How Much?" *New York Review of Books* (February 25, 1965), 15–16.

Lowry, W. McNeil. *The Arts and Philanthropy*. Speech at Brandeis University, December 10, 1962. New York: Ford Foundation, 1962.

Lucie-Smith, Edward. "Bidding Big at Christie's and Sotheby's." *World* (January 16, 1973), 16–19.

Lynes, Russell. *The Art-Makers of Nineteenth-Century America*. New York: Atheneum, 1970.

———. *Good Old Modern*. New York: Atheneum, 1973.

McFadden, Elizabeth. *The Glitter and the Gold*. New York: Dial Press, 1971.

McGrath, Kyran M. "A Landmark Court Decision." *Museum News* (November 1974), 40–41.

McManus, Otile; Robert Taylor, and Patrick McGulligan. "Museum Controversy Rooted in Style, Identity, Accountability." Boston *Globe*, March 9, 1975.

McPhee, John. "A Room Full of Hovings." *The New Yorker* (May 20, 1967), 49–137.

Mencken, H. L. *A Mencken Chrestomathy*. New York: Knopf, 1949.

Metropolitan Museum of Art. *Information for Trustees*. New York: Metropolitan Museum, 1978.

Meyer, Karl E. *The Plundered Past*. New York: Atheneum, 1973.

Miller, Ronald L. *Survey of Collective Bargaining in 96 Museums*, Project Report No. 2 for National Museum Act, 1974.

Montias, J. Michael. "Are Museums Betraying the Public Trust?" *Museum News* (May 1973), 25–31.

Moses, Robert. *Public Works: A Dangerous Trade.* New York: Mc-Graw-Hill, 1970.

Mumford, Lewis. "Sky Line." *New Yorker,* December 5, 1959, pp. 105–11.

Museum of Fine Arts. *The Rathbone Years.* Boston: Museum of Fine Arts, 1972.

National Endowment for the Arts. *Museums USA: A Survey Report.* Washington, D.C.: Government Printing Office, 1975.

———. *Museums USA.* Washington, D.C.: Government Printing Office, 1975. A short version.

Neuberger Museum. *The Making of a Museum: 1.* Purchase, N.Y.: College at Purchase, 1974.

Newark Museum. *American Primitives.* Newark, N.J.: The Newark Museum, 1930.

Newson, Barbara, and Adele Z. Silver. "Examining a Delicate Balance." *Museum News* (September–October 1977), 15–20.

New York Supreme Court, Appellate Division—First Department. Edward Hallam Tuck and Brendan Gill v. August Heckscher. Record on Appeal, Index No. 01957/1971.

Nicolson, Harold. *Diplomacy.* Oxford: Oxford University Press, 1939.

Nielsen, Waldemar A. *The Big Foundations.* New York: Columbia University Press, 1972.

Noble, Joseph V. "Museum Manifesto." *Museum News* (April 1970), 17–20.

O'Connor, Francis, ed. *Art for the Millions.* Boston: New York Graphic Society, 1973.

O'Doherty, Brian, ed. *Museums in Crisis.* New York: Braziller, 1972.

Oehser, Paul H. *The Smithsonian.* New York: Praeger, 1970.

Orlofsky, Patsy, and Myron Orlofsky. *Quilts in America.* New York: McGraw-Hill, 1974.

Pach, Walter. *The Art Museum in America.* New York: Pantheon, 1948.

Pfeffer, Irving. "The Insurance Experience of Fine Arts Museums." Unpublished paper, 1973.

Raskin, A. H. "Behind the MOMA Strike." *Art News* (January 1974), 36–41.

Redmond, Roland L. "A Store Manager Shouldn't Run the Met." Letter to the Editor, *New York Times*, August 7, 1977.

Reid, B. L. *The Man from New York: John Quinn and His Friends.* New York: Oxford University Press, 1968.

Reisig, Robin. "Can You Be Both Modern and a Museum?" *Village Voice* (August 26, 1971), 24–27.

Reitlinger, Gerald. *The Economics of Taste: The Rise and Fall of the Picture Market.* New York: Holt, Rinehart & Winston, 1961.

————. *The Economics of Taste: The Rise and Fall of the Objets d'Art Market.* New York: Holt, Rinehart & Winston, 1963.

Rewald, John. "Should Hoving Be De-accessioned?" *Art in America* (January–February 1973), 25–30.

Rheims, Maurice. *The Strange Life of Objects.* New York: Atheneum, 1961.

Richard, Paul. "The Met Under Siege." Washington *Post*, February 18, 1973.

Ripley, Dillon. *The Sacred Grove: Essays on Museums.* New York: Simon & Schuster, 1969.

Roberts, Steven. "Why a 63-Year-Old Tycoon Worth $100 Million Wants to Run for the Senate." *New York Times Magazine,* May 31, 1970.

Rosenbaum, Lee. "MOMA's Construction Project: Reflections on a Glass Tower," Art in America, Nov.–Dec., 1977, 10–25.

Rosenberg, Harold. "The Art World: Old Age of Modernism." *The New Yorker* (August 5, 1974), 66–71.

————. *Art on the Edge.* New York: Macmillan, 1975.

Rowell, Henry T. "A Home for the Muses." *Archaeology* (April 1966), 76–83.

Rubin, Jerome S. "Art and Taxes." *Horizon*, VIII, 1 (Winter 1966), 4–15.

Rush, Richard H. *Art as an Investment.* New York: Bonanza Books, 1961.

St. Clair, William. *Lord Elgin and the Marbles.* London: Oxford University Press, 1967.

Schoener, Allon, ed. *Harlem on My Mind.* New York: Random House, 1968.

Seldes, Lee. *The Legacy of Mark Rothko.* New York: Holt, Rinehart & Winston, 1978.

Seligman, Germain. *Merchants of Art: 1880–1960.* New York: Appleton-Century, 1961.

Shirey, David. "A Trustee of Met Questions Sales." *New York Times,* April 12, 1973.

Sitwell, Osbert. *Left Hand, Right Hand!* London: Macmillan, 1945.

Solomon, Maynard, ed. *Marxism and Art.* New York: Knopf, 1973.

Spaeth, Eloise. *American Art Museums.* New York: McGraw-Hill, 1969.

Stephenson, Nathaniel Wright. *Nelson W. Aldrich.* New York: Scribner's, 1930.

Straight, Michael. "The Arts Go Begging." *New Republic* (March 22, 1969), 14–16.

Subcommittee on Select Education, House of Representatives. *Joint Hearings with Senate Special Subcommittee on the Arts and Humanities, 94th Congress, on Arts, Humanities and Cultural Affairs Act of 1975.* Washington, D.C.: Government Printing Office, 1975.

————. *Hearings, National Foundation on the Arts and Humanities.* Washington, D.C.: Government Printing Office, 1975.

Tawney, R. H. *Religion and the Rise of Capitalism.* New York: Harcourt Brace, 1952.

Taylor, Francis Henry. *Babel's Tower: The Dilemma of the Modern Museum.* New York: Columbia University Press, 1945.

————. *The Taste of Angels.* Boston: Little, Brown, 1948.

————, and Theodore Low. *The Museum as a Social Instrument.* New York: Metropolitan Museum of Art, 1942.

Taylor, John Russell, and Brian Brooke. *The Art Dealers.* New York: Scribner's, 1969.

Tocqueville, Alexis de. *Democracy in America,* ed. Phillips Bradley. New York: Knopf, 1948.

Tomkins, Calvin. *Merchants and Masterpieces*. New York: Dutton, 1970.

————. "Moving with the Flow." *The New Yorker* (November 6, 1971), 58–113.

————. "The Making of an Art Detente," *New York Times*, Arts and Leisure, April 13, 1975.

————. *The Scene: Reports on Post-Modern Art*. New York: Viking, 1976.

Towner, Wesley. *The Elegant Auctioneers*. New York: Hill and Wang, 1970.

Treue, Wilhelm. *Art Plunder: The Fate of Works of Art in War, Revolution, and Peace*, trans. from German by Basil Creighton. London: Methuen & Co., Ltd., 1960.

Trevor-Roper, Hugh. *The Plunder of the Arts in the Seventeenth Century*. London: Thames & Hudson, 1970.

Trollope, Mrs. Frances. *Domestic Manners of the Americans*, ed. Donald Smalley. New York: Knopf, 1949.

Vail, R. W. G. *Knickerbocker's Birthday*. New York: New-York Historical Society, 1954.

Veblen, Thorstein. *The Portable Veblen*, ed. Max Lerner. New York: Viking, 1948.

Walker, John. *Self-Portrait with Donors*. Boston: Atlantic–Little, Brown, 1974.

White, Harrison C. and Cynthia A. *Canvases and Careers*. New York: Viking, 1965.

Whitehill, Walter Muir. *Museum of Fine Arts Boston: A Centennial History*. Cambridge, Mass.: Harvard University Press, 1970.

Wittke, Carl. *The First Fifty Years: The Cleveland Museum of Art 1916–1966*. Cleveland: John Huntington Art and Polytechnic Trust and Cleveland Museum of Art, 1966.

Wittlin, Alma. *Museums: In Search of a Usable Future*. Cambridge, Mass.: MIT Press, 1970.

Woodford, Don. "Parnassus on the Hudson." *Bell Telephone Magazine* (July–August 1970), 2–9.

❧ INDEX ❧

Adams, John Quincy, 44, 46–47
Advisory Council on Historic Preservation, 161
African Art, Museum of, 55, 63
Afro-American Cultural Center, 78
Aldrich, Nelson, 31
Ali, Salim, 56
Alioto, Joseph L., 205–6
Alliance for Latin Arts, 78
American Academy of Arts and Letters, 213
American Academy of Fine Arts (National Academy of Design), 24
American Geographical Society, 213
American Indian, Museum of the, 63, 187, 213–17
American Museum, 23–24, 88, 92
American Museum of Natural History, 26, 47, 114, 220
American Numismatic Society, 118, 213
Amon Carter Museum of Western Art, 128, 282
Anderson, Jack, 50
Annan, Lord, 226
Annenberg, Lenore, 121
Annenberg, Walter H., 121–23, 125
Architecture, see Construction
Archives of American Art, 45, 57
Arensburg, Walter, 166
Armstrong, Thomas, 181–82
Art Advisory Panel (IRS), 257
Art Institute of Chicago, 41, 199, 281
 annual deficits of, 59–60

Brundage collection and, 202–3
international loan shows at, 255–56
paid president at, 240–42
sales by, 208
Art market, 16, 163–92
 auctions and, 171–76; see also Auctions
 Berenson in, 177–80
 characterized, 165–66
 confusion of values on, 185–92
 dealers, collectors and, 166
 dealers as collectors and, 180–85
 development of, 29–30, 169–71
 effects of museum acquisitions on, 164–65
 effects of museum displays on prices, 102
 and Picasso's fortune, 168–69
Art Museum Building Commission (North Carolina), 146–48
Art Museum of South Texas, 128, 282
Asia House Gallery, 80, 128, 270–71
Astor, Mrs. Vincent, 225
Astrophysical Observatory, 45, 47
Auctions, 22, 171–75, 182–84
 art market and, 171–76
 coinciding with museum shows, 182
 effects of museum acquisitions on, 164–65
 in New York City, 99
 1960s, 166–67
 See also specific auction houses

Bache, Jules, 166

Baker, George F., 27
Baldwin, Stanley, 223
Baltimore Museum of Art, 60
Barnes, Edward Larrabee, 128, 161
Barnes Collection, 64, 121
Barnum, P. T., 23, 24, 91–92
Barr, Alfred H., Jr., 43, 129, 135, 136, 251
Bass, Johanna, 206
Bass, John, 206–7
Bass Museum of Art, 206–7, 278
Baumol, William J., 84
Bazin, Germain, 12, 20
Beame, Abraham, 88, 138
Behrman, S. N., 179
Benjamin, Walter, 266–67
Benton, Thomas Hart, 35
Berenson, Bernard, 177–80
Berman, Ronald S., 247–49
Biddle, George, 67, 247
Biddle, Livingston, Jr., 67, 86, 248, 249, 265
Bier, Justus, 146
Blitzer, Charles, 51–52
Blodgett, William T., 26
Blue Four Collection, 150
Blumenthal, George, 224
Bonsignore, Joseph, 44
Boris, Walter R., 72
Boston Athenaeum, 27, 224
Boston Museum of Fine Arts, 26–27, 41, 60, 90, 187, 273
 acquisitions by, 196
 professionalization of trustees of, 220
 Rueppel fired from, 234–36
 sales by, 208
 tenure of directors at, 222
 volunteer work at, 227
Botwinick, Michael, 187, 238
Bowen, William G., 84
Brademas, John, 51, 86–90, 244
Breuer, Marcel, 101, 161
British Museum, 13, 20, 44, 181, 211
Brooke, Brina, 98
Brooklyn Institute of Arts, 237
Brooklyn Museum, 186, 187, 236–38
Brooks, John, 76
Brown, J. Carter, 252
Brown, Ralph Manning, Jr., 225
Brown, Richard, 159, 222, 226–27, 238
Brundage, Avery, 201–6
Bryant, William Cullen, 26, 225
Buechner, Thomas S., 236
Bullock, Sir Allan, 226
Bundy, Mary L., 225
Bunshaft, Gordon, 128, 162
Burgee, John, 80
Burnham, Bonnie, 176
Burns, Dorothy, 178
Business Committee for the Arts (BCA), 85
Businessmen
 architects and, 133–34
 See also Wealth
Butterfield, Roger, 251
Byrd, Robert C., 53

Cahill, Roger, 40
Caldwell, Catherine, 203–4
Cameron, Duncan, 236–38
Canaday, John, 118, 123, 141
Canham, Erwin D., 234
Canning, Lord, 250
Carey, Hugh, 77, 79–80
Carnegie, Andrew, 67, 85–86
Carnegie Institute, 174
Carpenter, Edmund S., 214–15
Carr, Ezra S., 149
Carr, Jeanne, 149

Carstairs Gallery, 200
Carter, Jimmy, 90, 234, 247–49, 261
Cavett, Dick, 214
Center for the Study of Man, 45
Centre Beaubourg, 129
Chalmers, E. Laurence, Jr., 59, 241
Chamberlain, Sir Neville, 189
Charles Town Library Society, 24
Chesapeake Bay Center for Environmental Studies, 45, 55
Chicago Historical Society, 60
Choate, Joseph H., 26–27
Christie, James, 171
Christie's (auction house), 155, 172, 173, 175, 185
Christopher, George, 204–6
City of New York, Museum of the, 79, 195
Clark, Anthony M., 115, 116, 209
Clark, Kenneth (Lord Clark of Saltwood), 42, 121, 179, 188–89, 201, 221, 226
Clark, Stanley, 175
Clark, William A., 31
Clarke, Sir Caspar Purdon, 220–21
Cleveland Museum of Art, 50, 161, 174, 207, 210, 279
Clinton, De Witt, 25
Cloisters, The, 94, 95, 106, 153, 196, 238
Cobbett, William, 269
Cohn, Harry, 121
Coleman, Laurence Vail, 127, 223, 239
Collections
 Jarvis on collecting as obsession, 31
 royal, 193–94
 See also Museum collections; and specific collectors
Collectors
 art market and, 166; see also Art market
 behavioral patterns of, 201–2
 curators and trustees as, 186–90
 dealers as, 180–85
 See also specific collectors
Colnaghi (dealer), 98
College galleries, 24
Conflict of interest
 curators and trustees as collectors and, 186–90
 in Modern Art Museum tower plan, 139–40
Construction (and architecture), 127–59
 alternatives to excesses in, 159–62
 as destiny, 148–59
 expenditures on, 127, 270–84
 as form of social autobiography, 126
 of Guggenheim Museum, 133, 140–44, 159, 270–71
 of Museum of Modern Art, 126, 127, 134–40, 270–71
 museum-building in the South, 145–47
 1950–1977, 13, 270–84
 psychological and ideological overtones to debates over, 131–33
Coolidge, John, 235
Cooper, Joel, 187, 215
Cooper, Peter, 53
Cooper-Hewitt Museum of Decorative Arts and Design, 46, 48, 53–55
Corcoran Gallery of Art, 13
Corning Museum of Glass, 236
Cowles, Gardner, 225
Crane, Mr., 259
Cultural bureaucracy, 73–75
 See also specific agencies
Cummings, Frederick J., 71, 72
Cunningham, Charles C., 187
Curators, as collectors, 186–88

Dale, Chester, 199–201

Dale, Maud, 199, 200
Daley, Richard, 204
Dali Museum, 208
Dallas Museum of Fine Arts, 109, 234, 262
Dana, John Cotton, 36–39, 41, 43, 44, 57, 107
Davidson, Joan Kaplan, 77–80
Davies, Arthur B., 100
Davis, Richard, 209
Davison, Daniel Pomeroy, 225
Dealers
 art market and dealers as collectors, 180–85
 confused values in relation with, 190–92
 effects of museum purchases on, 164
 French, 170–71
 New York City, 98
 role of, in art market, 166
 tax laws and, 35
De Aragon, Damian, 238
De Groot, Adelaide Milton, 118
De Montebello, Philippe, 109, 242
Detroit Institute of Art, 69–73, 115, 116, 187, 255, 279
Devree, Charlotte, 123, 124
Devree, Howard, 123
De Young Museum, 80
D'Harnoncourt, René, 136
Dies, Martin, 66
Dillon, C. Douglas, 225, 241–42
 Annenberg Center and, 120, 122, 123, 308–18
 Lehman Pavilion gift and, 113
 Metropolitan sales and, 118
 National Endowment for the Arts and, 88
 National Museum Services Board and, 90
Dime museums, 22–24
Dinkeloo, John, 111, 128, 161
Diplomacy, role of art in, 250–56
Dilworth, J. Richardson, 224, 225
Directors
 firing of, 221–23, 231–38
 See also specific museum directors
Dockstader, Frederick J., 214–15, 217
Donor memorials, defined, 63
Dougherty, Richard, 83, 110
Dreier, Katherine Sophie, 166
Dresden museum, 20
Duffey, Joseph D., 248, 249, 265
Dulwich Gallery, 12
Dumbarton Oaks Pre-Columbian Collection, 128, 161, 276
Dunne, Finley Peter, 85–86
Durand-Ruel, Jean-Marie, 98, 170–71, 191
Durand-Ruel, Paul, 98, 170, 171, 191
Duveen, Joseph (Lord Duveen of Millbank), 33, 98, 127, 173, 177–81, 188, 191
Duveen Brothers Art Gallery, 155

Eames, Charles, 121
Economos, James, 186–87
Ehrenweisen, Baroness Hilla Rebay von, 142, 259
Eisenhower, Dwight D., 81, 88, 120
Elitism, populism vs., 36–44, 57, 265–69
Elliott, Donald, 137, 140
Emerson, Ralph Waldo, 22, 38, 41, 246
Encyclopedic museums, defined, 63
Engelhard, Mrs. Charles, 225
Erickson, Alfred, 173
Erickson, Mrs. Alfred, 173
Esberg, Alfred M., 152
Ethics
 report on, 286–306
 See also Conflict of interest
Ettinghausen, Richard, 116
Ewing, Douglas, 186

Fagaly, William A., 187

Fahy, Everett, 118, 185, 260
Financial condition, 59–61
 of Detroit Institute of Arts (1970s), 69–73
 of Metropolitan Museum (1965; 1975), 109, 110
 of Museum of Modern Art, 59–60, 137–40
 of Pasadena Museum of Modern Art, 152–53
 public patronage and need to develop standard for determining financial needs, 262–65
Fischer, Harry, 191
Fish, Hamilton, 25
Fogg Museum, 41, 235
Follis, Gwin, 204
Fontein, Jan, 236
Forbes, Edward, 41
Ford, Gerald, 89, 247
Ford, Henry, 202
Ford, Mrs. Edsel, 70
Founders Society, Detroit Institute of Arts, 69–71
Fowles, Edward, 178
Frankfurter, Alfred, 168, 200
Franklin, Benjamin, 250
Franz Joseph II (prince of Lichtenstein), 194
Freer Gallery of Art, 47
Frelinghuysen, Peter H. B., 122
French, Daniel Chester, 226
French Art, Institute of (French Institute), 199
Frick, Henry Clay, 27, 31
Frick Collection, 63, 158, 185, 260
Friedman, B. H., 182
Fry, Roger, 220–21
Funding, *see* Patronage
Funt, Allen, 184–85

Galerie Georges Petit, 199
Gallatin, Albert, 25
Galleries
 defined, 17–18
 number of, in New York City, 98–99
 See also Public galleries; *and specific galleries and museums*
Gardner, Isabella Stewart, 166, 177, 180
Gardner Museum, 63, 161
Garment, Leonard, 81–82
Gates, John W., 31
Geldzahler, Henry, 101–2, 183, 198
General museums, defined, 63
George F. Harding Museum, 215
Gesell, Gerhard, 212
Getty, J. Paul, 59, 169, 175
Gilman, Benjamin Ives, 227
Gilpatrick, Roswell L., 225
Gimpel, René, 127, 168
Glazer, Nathan, 108
Glueck, Grace, 107, 267
Goldsmith, Barbara, 92, 96, 124
Gombrich, Sir Ernest, 226
Goodrich, Lloyd, 100
Goodwin, Philip L., 135, 139
Government support, *see* Public patronage
Greenberg, Clement, 102
Gropius, Walter, 128, 131–34, 159
Guggenheim, Harry, 142
Guggenheim, Solomon R., 133, 142
Guggenheim Museum, 94, 98, 187, 208, 259
 architecture of, 133, 140–44, 159, 270–71

Hamill, Pete, 125
Hammer, Armand, 150, 253–55
Hammer, Victor, 254
Hammer Galleries, 254
Hanks, Nancy, 72–74, 80–82, 87, 247
Hardee, William Covington, 236
Harding, Warren G., 246

Harkness, Edward S., 27
Hart, Kitty Carlisle, 80
Hart, Moss, 80
Hartford, Huntington, 208
Hartnett, Thomas Patrick, 257
Hazlitt, William, 11
Hearst, William Randolph, 254
Heckscher, August, 96, 113–14
Hellman, Geoffrey T., 48
Henry, Joseph, 47
Herbert F. Johnson Museum, 161
Hermitage Museum, 255, 256
Hess, John, 92, 211
Hess, Thomas B., 141, 198
Heye, George Gustav, 213–14
Hightower, John B., 76, 89, 228–29, 231–34, 238
Hirshhorn Museum and Sculpture Garden
 (Joseph H. Hirshhorn Museum), 14-15,
 45, 48–53, 162, 276
Hispanic Society of America, 213
History museums, private contributions to
 ˋ(1971–1972), 61
Hitchcock, Henry-Russell, 129
Hodges, Luther, 146
Hodgins, Eric, 167
Holstein, Jonathan, 181
Honolulu Academy of Art, 210
Hooper, Franklin, 237
Houghton, Arthur A., Jr., 96, 120
Houston Museum of Contemporary Art, 131,
 140, 282
Houston Museum of Fine Arts, 59, 131, 159,
 256, 283
Hoving, Thomas P. F., 110, 139, 193
 Annenberg Center and, 119–25, 308–12
 approach of, to museum operations, 90–93
 art dealers and, 181
 art as diplomacy and, 252
 ascendancy of, 95–96
 collecting and, 195–97
 duration of directorship of, 103
 exhibition policy of, 106–9
 gifts to Metropolitan Museum under, 65
 loan shows under, 115–17
 and Metropolitan expansion plan, 111–13
 Moses' influence on, 93–98
 motivating impulse of, 117–18
 New York State Council on the Arts alloca-
 tion and, 79
 Ripley compared with, 45, 92
 sales under, 208, 210, 211
 N. Simon and, 156
 successor to, 109, 242
 "Treasures of Tutankhamun" show and, 267
Hoving, Walter, 95
Howells, William Dean, 13
Hughes, Howard, 169
Hughes, Robert, 131
Humber, Robert Lee, 145–47
Huntington, Mrs. Collis P., 173
Hyam, Leslie A., 173–74

Institute of Museum Services, 61, 87–90, 234,
 244, 258, 262–64
Institutes of Contemporary Art (ICAs), 63–64

J. Paul Getty Museum, 59, 63, 284
Jacobs, Jane, 132
James, Henry, 28, 30
Japan Society, 80
Jarves, Deming, 22
Jarves, James Jackson, 18, 23, 36, 176, 202
 on absence of past, 30
 biographical sketch of, 22
 on collecting becoming an obsession, 31

lofty art-idea of, 18–19
moral dimension of art and, 28
need for courses in art history and, 40
public patronage and, 246
relation between bourgeois nationalism and
 art and, 21
Javits, Jacob K., 259
Jay, John, 25
Jewish Museum, 63, 108
John F. Kennedy Center for the Performing
 Arts, 55, 136
Johnson, Arnold P., 114, 225
Johnson, J. Stewart, 238
Johnson, John G., 27
Johnson, Lady Bird, 49
Johnson, Lyndon B., 49, 52, 66–67, 82, 247
Johnson, Philip, 80, 128–30, 136, 141, 161
Johnston, John Taylor, 26
Jones, Jennifer, 158
Jowett, Benjamin, 97

Kahn, Louis, 159, 160
Kahnweiler, Daniel-Henry, 168, 171
Kan, Michael, 186–87
Kaplan, Alice, 77
Kaplan, J. M., 77
Keeley, Charles, 203
Keen, Geraldine, 35, 165
Kelsey, John, 151
Kempton, Murray, 95
Kennedy, John F., 88, 96, 120, 247
Kent, Henry Watson, 41
Kenyon, Kathleen, 226
Killiam, James R., Jr., 245
Kimbell Museum of Art, 159, 160, 222, 255, 282
Kimche, Lee, 90
King, Rufus, 25
Kissinger, Henry, 81, 115, 224
Knoedler, Michael, 98
Knoedler Gallery, 255, 256
Koch, Edward, 259, 260
Kominski, John J., 36
Korda, Alexander, 141
Kramer, Hilton, 13
Kress, Rush, 146
Kress, Samuel H., 145–46, 179
Kuh, Katherine, 159
Kuhn, Walter, 100
Kuralt, Charles, 83

Ladd, Thornton, 151
La Guardia, Fiorello, 94
Laramore, Don N., 189–90
Le Corbusier (Charles-Edouard Jeanneret), 128,
 129, 132, 135
Lee, Sherman, 50, 200
Lefkowitz, Louis J., 213, 216–17
Lefebvre d'Argencé, René-Yvon, 205
Lehman collection, 65, 92
Lerner, Abraham, 51
Lesley, Parker, 167
Levey, Michael, 185
Lewis, McDaniel, 147
Libbey, Edward Drummond, 127
Lieberman, William, 257
Lind, Jenny, 92
Lindsay, John V., 77, 95, 113–14, 137–38
Lloyd, Frank, 190–92
Loflin, John J., 113
Los Angeles County Museum of Art (LACMA),
 153, 156, 160, 255, 256, 283
Louvre, 12, 19–22, 43, 44, 70, 114–16
Lowry, W. McNeil, 75, 76, 84
Luce, Henry R., 164, 225
Lynes, Russell, 136, 233, 250, 251
McFarlane, Robert S., Jr., 158

McGill, William, 245
McGrath, Kyran M., 212
Mackay, Clarence, 189
McLellan, Goldwin A., 85, 263
Macomber, William Butts, Jr., 242
McPhee, John, 195
Madame Tussaud's Waxworks, 23–24
Mallowan, Sir Max, 226
Malraux, André, 12, 127–28, 130, 169, 252
Marcus, Mrs. Edward S., 235
Marcus, Stanley, 260
Marlborough Galleries, 102, 118, 190–92
Massachusetts Historical Society, 24
Mead, Giles W., 187
Medici collections, 20
Meiss, Millard, 226
Meissner, Edward, 20
Mellon, Andrew W., 33–34, 160, 179, 202
Mellon, Paul, 160, 166, 175
Mencken, H. L., 144–45
Messer, Thomas M., 143, 187
Metropolitan Museum of Art, 31, 41, 88, 220, 231, 262, 272
 acquisitions by, 92, 93, 100, 102, 117–18, 155, 164–65, 174, 195
 Alma-Tadena exhibit at, 185
 Bacon show at, 192
 charter of, 26–27
 The Cloisters as medieval extension of, 94, 95, 106, 153, 196, 238
 Dale and, 199, 200
 educational function of, 57
 foreign loan shows at, 251–53
 Hoving as director of, *see* Hoving, Thomas P. F.
 international renown of, 98
 loan shows at, 115–17
 "New York Painting and Sculpture" show at, 101–2
 1970 expansion plan of, 110–15
 operating expenses of, 111–12, 137
 paid president at, 240–42
 private contributions to, 65, 112, 113
 Rorimer as director of, 42, 95, 96, 103, 106–7, 123
 sales by, 208, 210, 211, 213, 216
 Scull art holdings borrowed by, 182–84
 shows organized with Smithsonian by, 70
 state funds for (1975), 79
 F. H. Taylor as director of, 19, 103–7, 115, 117, 123, 133, 251–52
 tenure of directors at, 222
 "Treasures of Tutankhamun" show at, 267
 trustees of, 25–28, 224–25
 Wrightsman collection and, 189
Meyer, André, 224
M. H. de Young Memorial Museum, 204, 205
Michigan Council of the Arts, 69, 71, 72, 83
Midonick, Millard Lesser, 190
Miës van der Rohe, Ludwig, 128, 131, 159
Millennium Film Workshop, 78
Milliken, William, 71, 72
Minneapolis Institute of Arts, 209, 228, 235, 240, 241, 280
Modern Art, Museum of (MOMA), 40, 41, 49, 80, 101, 143, 152–53, 257
 architecture of, 126, 127, 134–40, 270–71
 Barr as first director of, 43, 129, 135, 136, 251
 collection of, and storage facilities of, 197–98
 Dale and, 199
 financial condition of, 59–60, 137–40
 firing of Hightower at, 231–34
 International loan shows at, 250–51
 international renown of, 98
 P. Johnson and, 129–30, 136

private contributions to, 35, 137
shows organized abroad by, 251
as specialized gallery, 63
Three Museums Agreement and, 105
tower plan of, 137–40
unionization at, 228–31, 233
Mondale, Joan, 90
Montias, J. Michael, 65, 217–18, 260
Morgan, Henry Sturgis, 224
Morgan, J. Pierpont, 27, 32, 33, 166, 220–21, 224
Morgan, J. Pierpont, Jr., 224
Morgan, Mary Rockefeller Strawbridge, 224
Morgenthau, Robert M., 192
Morris, Gouverneur, 25
Morse, A. Reynolds, 207–8
Moses, Robert, 92–98, 104, 106, 141
Moulin, Raymonde, 169
Moynihan, Daniel P., 108
Muhlenberg Center for the Arts, 128
Muir, John, 149
Mumford, Lewis, 97, 141
Municipal Art Society of New York, 113
Munson-Williams-Proctor Institute, 128, 272
Murdoch, Rupert, 124
Murphy, Franklin D., 153
Musées de France, Les, 250
Museum collections, 193, 218
 behavioral patterns of collectors, 201–2
 collecting characterized as hunt, 193–98
 guidelines needed for sales of, 216–18
 ownership of, 211–16
 private collections and, 199–208
 selling, 208–11, 213, 216
 sources of European, 19–21
Museum workers, 227–31, 233
Museums
 defined, 17, 18
 as defined by National Museum Services Board, 90
 general characteristics of, 17
 Hellenic idea of, 18
 historical background to birth of, 19–22
 number of (1972), 59
 standards defining, 62–64

Naifeh, Steven W., 98–99
National Academy of Design, 26
National Air and Space Museum, 53, 162
National arts policy, need for, 244–50
National Collection of Fine Arts, 35, 46, 48–50, 131, 161, 276
National Council for the Arts, 77
National Endowment for the Arts (NEA), 58, 62, 67, 72–74, 85, 248
 expansion of, 89
 under Hanks, 82–84, 247
 Institute of Museum Services and, 87–88
 Pell and creation of, 86–87
National Endowment for the Humanities (NEH), 247–49, 267
National Gallery, 21, 42, 181
National Gallery of Art, 13, 41, 49, 115, 160, 276
 acquisitions by, 168, 174, 179, 194–95
 in budget of Smithsonian, 44, 47
 conflict of interest involving Duveen at, 188–89
 Dale and, 199–201
 East Building of, 161
 Hammer and, 255
 international loan shows at, 252–53, 255–56
 opening of, 33, 34
 sales by, 208
 size of, 147
 "Treasures of Tutankhamun" show at, 267
National Museum of History and Technology, 47

National Museum Services Board, 90
National Portrait Gallery (British), 181
National Portrait Gallery (U.S.), 46, 47, 161, 276
National Research Center for the Arts, Inc., 62
National Science Foundation (NSF), 90
National Zoological Park, 47, 55
Natural History Museum of Los Angeles County, 187
New Orleans Museum of Art, 187, 278
New York City
 as art capital, 98–102
 See also specific New York City museums
New York Cultural Center, 60, 272
New York Museum of Contemporary Crafts, 139
New-York Historical Society, 25, 63
New York State Council on the Arts, 68, 74, 76–80, 108, 246, 260
Newark Museum, 38–40
Newmeyer, Sarah, 250–51
Nixon, Richard M., 74, 82, 246, 255
Noble, Joseph Veach, 79, 195
Nonprofessionals
 professionals vs., 219–21
 See also Museum workers; Presidents; Trustees
North Carolina Art Society, 145
North Carolina Museum of Art, 145–47, 276

Oakland Museum, 161, 283
O'Connor, Frank D., 114
O'Dwyer, Paul, 123–25
Offner, Richard, 42
Onassis, Aristotle, 137
Oldenburg, Claes, 234
Oldenburg, Richard, 228, 234
Operating (and maintenance) expenses, 15
 closings due to inability to meet, 59, 60
 of Detroit Institute of Arts, 70
 federal support for, 87–88
 of Guggenheim Museum, 143
 of Metropolitan Museum of Art, 111–12, 137
 of Museum of Modern Art, 136, 137, 233
 need for reform in allocation of public funds for, 261–62
 of Pasadena Museum of Modern Art, 152
Orlofsky, Myron, 181
Orlofsky, Patsy, 181

Packard collection, 117
Paget, Richard M., 225
Paley, William S., 136, 138, 140, 232–33
Parke-Bernet (auction house), 99, 174, 182, 206, 215–16
 Sotheby Parke Bernet, 99, 172–76, 182–85
Parker, Henry, III, 109, 262
Parkins, Richard Sturges, 225
Pasadena Art Institute, 150
Pasadena Museum of Modern Art (PMMA; Norton Simon Museum of Art), 60, 148–59, 284
Patronage, 15
 as contraption, 64–69
 cultural bureaucracy and, 73–74; see also specific agencies
 for Detroit Institute of Arts, 69–73
 federal, 86–90
 financial condition of museums and, 59–61
 Medici mentality of patrons, 75–86
 need for national policy on, 244–50
 types of museums and, 62–64
 See also Private patronage; Public patronage
Peabody Museum, 56
Pei, I. M., 128, 161
Pell, Claiborne, 67, 86–90, 244, 247–49
Pelli, Cesar, 138, 140

Pennoyer, Robert Morgan, 224, 225
Pennsylvania Academy of Fine Arts, 24
Phifer, Robert F., 145
Philadelphia Museum of Art, 199, 238, 275
Philadelphia Royal Academy, 24
Philanthropic tradition, 67–68
 See also Private patronage; and specific philanthropists
Phillips, Duncan, 166
Phillips Collection, 63, 161, 208
Photo-Secession Gallery, 99
Picasso, Pablo, fortune amassed by, 167–68
Pierpont Morgan Library, 161
Piper, John, 226
Plimpton, Francis T. P., 211, 231
Populism, elitism vs., 36–44, 57, 265–69
Portmanteau museums, defined, 63
Post, Marjorie Merriweather, 55
Presidents
 paid, 240–42
 See also specific presidents
Prices, see Art market
Primitive Art, Museum of, 80
Princeton University Art Museum, 156, 274
Private collections, 31, 199–208
 See also Collectors; and specific collectors
Private patronage, 58
 for Brooklyn Museum, 237
 for Cooper-Hewitt Museum, 54
 for Detroit Institute of Arts, 70–71
 by Ford Foundation (1957–1973), 76
 by foundations (1971–1972), 84
 for Guggenheim Museum, 143
 for Metropolitan Museum, 65, 112, 113
 for Museum of Modern Art, 35, 137
 1971–1973, 61, 65
 1965–1975, 84–85
 for North Carolina Art Society, 145
 for North Carolina Museum of Art, 145–46
 for Pasadena Museum of Modern Art, 151, 157
 for Smithsonian, 46, 48
 for "Treasures of Tutankhamun" show, 267
 for Yale Center for British Art, 160
Professionals
 nonprofessionals vs., 219–21; see also Presidents; Trustees
 salaries of, 227–38
 See also Curators; Directors
Public patronage, 21, 58, 243–44
 for Art Institute of Chicago, 60
 for arts councils, 68
 for Brooklyn Museum, 237
 to build museum housing Brundage collection, 204–6
 for Detroit Institute of Arts, 69–73
 in Europe and U.S. compared, 54–67
 expansion of museums and, 57
 for Guggenheim Museum, 143
 and investigation of Smithsonian financial practices, 53–56
 justifying, with populist arguments, 43–44
 for Metropolitan Museum, 26–27, 111–12, 114
 for Museum of Modern Art, 136
 need for reform in allocation methods, 261–62
 and need to develop standard for measuring financial needs, 262–65
 in New York State (1975), 78–79
 1971–1972, 61
 in North Carolina, 145–48
 number of aid programs, 74–75
 for operating expenses, 87–88
 for Pasadena Museum of Modern Art, 152
 for Smithsonian, 45–46, 48–52, 54, 55
 Works Progress Administration projects as examples of, 40, 66

Public galleries, 23–25
 early, 24–25
 See also Museums

Quinn, John, 32, 166

Radiation Biology Laboratory, 45
Raskin, A. H., 229
Rathbone, Perry T., 197, 234
Redmond, Roland L., 110, 123–25, 308, 312–18
Reisig, Robin, 229
Reitlinger, Gerald, 35
Rewald, John, 171, 210
Renwick Gallery, 46, 162
Rheims, Maurice, 168
Rhind, J. Massey, 246
Rhode Island School of Design, 59–60, 210
Rich, Daniel Catton, 199, 203, 231
Ripley, S. Dillon, 14, 45, 48–49, 52, 55–57, 92
Robbins, Lord, 226
Roberts, Steven V., 153–54, 157
Robertson, Bryan, 81
Robertson, Jaquelin, 138
Robinson, Charles, 241
Roche, Kevin, 111, 114, 128, 161
Rockefeller, Abby Aldrich, 80
Rockefeller, Blanchette Ferry Hooker, 80, 137
Rockefeller, David, 85, 137, 233
Rockefeller, John D., Jr., 80, 106
Rockefeller, John D., Sr., 68, 80
Rockefeller, John D., III, 80
Rockefeller, Mrs. John D., III, 230–31
Rockefeller, Nelson A., 49, 136, 202, 224, 232, 251
 Museum of Modern Art tower and, 135, 137–38
 New York State Council on the Arts and, 68
 as philanthropist, 65, 80–81, 111
Rockefeller Museum, 80
Rogers, Francis D., 225
Roosevelt, Franklin D., 33, 34, 66, 67, 202, 247, 251
Roosevelt, Theodore, 220
Rorimer, James J., 42, 95, 96, 103, 106–7, 123
Rosenbaum, Lee, 140
Rosenberg, Harold, 85, 167, 185–86
Rosenblum, Robert, 116
Rosenstiel, Lewis S., 121
Rothko, Kate, 190
Rothko, Mark, 66, 190–92, 213
Rousseau, Jean-Jacques, 132
Roy R. Neuberger Museum of Art, 80–81, 128, 272
Royal Ontario Museum, 236
Rubin, Jerome S., 35
Rubin, William S., 198
Rueppel, Merrill, 234–36, 238
Ruskin, John, 22, 172, 184, 265

Saarinen, Eero, 49
Sabin, Hib, 131
Sachs, Paul J., 36, 40–43, 106, 129, 179, 203
St. Louis Art Museum, 235, 280
Salemme, Lucia, 77
Sales
 of museum collections, 208–11, 213, 216
 of museum collections, need for guidelines, 216–18
 New York City annual, 99
Saltzman, Henry, 114
San Francisco Art Museum, 161
Schapiro, Meyer, 231
Scheyer, Galka, 150
Schiller, Friedrich von, 20
Schoener, Allon, 107–8

Schumpeter, Joseph, 268
Science museums, private contributions to (1971–1972), 60
Scott, Ray, 72
Scott, William J., 216
Scudder, John, 23
Scull, Ethel, 182, 183
Scull, Robert C., 182–85
Seldes, Lee, 190
Seligman, Germain, 98, 164
Seligman, Jacques, 98, 164
Sellers, Boris G., 73
Selznick, David O., 158
Seybolt, George C., 90, 234–36
Shaviro, Sol, 114
Sheldon Memorial Art Gallery, 128, 281
Shelley, John F., 205
Shestack, Alan, 242
Silberstein, Muriel Rosoff, 114
Silver, Stuart, 106–7
Simon, Lucille, 154
Simon, Norton, 150, 153–58
Simonson, Lee, 103
Sitwell, Osbert, 181
Smith, Hamilton, 101
Smithson, James, 44, 46
Smithsonian Astrophysical Laboratory, 45
Smithsonian Institution, 44–57, 90, 92, 161, 187
 bicentennial exhibitions at, 13–14
 financial practices of, investigated, 53–56
 and founding of Hirshhorn Museum, 14–15, 48–52
 growth of, 45, 47–48, 56–57
 National Museum Act administered by, 263–64
Smithsonian Tropical Research Institute, 45, 55
Solinger, David M., 101
Solmssen, Peter, 256
Somerset, Lord David, 191
Sotheby's (and Sotheby Parke Bernet), 99, 172–76, 182–85
South Kensington Museum, 220
Specialized galleries, defined, 63
Sprigge, Sylvia, 178
Staats, Elmer B., 53
State, *see* Public patronage
Stella, Frank, 102
Stevens, George, 127
Stevens, Mrs. George, 127
Stevens, Roger L., 82
Stevens, Ted, 53
Stieglitz, Alfred, 99
Stillman, James, 31
Stone, Edward Durrell, 128, 129, 135–36, 139, 141, 147
Straight, Dorothy Whitney, 82
Straight, Michael, 81–82
Straight, Willard Whitney, 82
Stratton, Charles S. (Tom Thumb), 23
Streit, Saul S., 113
Stuyvesant, Peter G., 25
Sutton, Percy, 124
Swarzenski, Hanns, 197
Sweeney, James Johnson, 143

Taft, William Howard, 46
Tange, Kenzo, 128
Tate Gallery, 49, 121, 181
Tax laws (and incentives), 58, 64–65, 68, 156, 167, 189, 244, 256–60
Taylor, Francis Henry, 19, 103–7, 115, 117, 123, 133, 251–52
Taylor, John Russell, 98
Taylor, Joshua, 131
Taylor, Robert, 186
Textile Museum, 63
Thayer, Walter, 225

Thompson, Frank, Jr., 50–52
Thompson, Helen, 74
Thyssen, Baron von, 174
Tillman, Benjamin R. (Pitchfork Ben), 31
Tobey, 268
Toffel, Alvin, 158
Toledo Museum of Art, 127
Tomkins, Calvin, 101
Trollope, Francis, 24
Trumbull Gallery, 24
Trust for Cultural Resources, 138–40, 139
Trustees
 as dealers and collectors, 186–89
 early, 25–28
 and firing of directors, 231–38
 function of, 223
 professionalizing, 238–40
 socioeconomic characteristics of, 224–27
Tweed, William Marcy (Boss), 26

Uffizi, 13
Ullberg, Alan D., 187
Union League Club, 25
Unionization, 228–31, 233
University collections, defined, 63
University of St. Thomas Art Gallery, 128

Valentiner, W. R., 146
Vanderbilt, Cornelius, 31
Van der Hoof, Gail, 181
Van Ellison, Candice, 108
Vatican museums, 20
Veblen, Thorsten, 28
Vivant-Denon, Baron Dominique, 20
Vollard, Ambroise, 171
Volunteer work, 227

Walker, John, 179–80, 189, 194–95, 200–1, 255
Walker Art Center, 161, 280
Wallace, Henry, 82
Wallace, Lila Acheson, 267
Walsh, John, 115, 116
Walter H. Annenberg Visual Arts Communication
 Center, 119–25, 308–18
Walters, Henry, 27
Wayne, Luce, 152

Wealth
 art as talisman of, 28
 art gilding, with antiquity, 30
 See also Collections; Collectors; Elitism;
 Presidents; Trustees
Wedgwood, C. V., 226
Weinstein, Richard, 137–38, 140
Weitzner, Julius H., 209
West, Rebecca, 127
Western Museum, 24
Wharton, Edith, 123
White, Cynthia, 169–70
White, Harrison C., 169–70
White, Thomas J., 147–48
Whitehill, Walter Muir, 224
Whitney, Gertrude Vanderbilt, 101, 166
Whitney, John Hay (Jock), 225
Whitney, William C., 82
Whitney Museum of American Art, 80, 181–82,
 272
 growth of, 101
 international renown of, 98
 sales by, 208
 Three Museums Agreement and, 105
 trustees at, 225
Wildenstein & Company, 98, 155
Williams, G. Mennen, 69
Wilson, Peter, 99, 175
Winlock, Herbert E., 103
Worcester Art Museum, 103, 104, 274
Works Progress Administration art projects, 66,
 67, 145, 247
Workers, museum, 227–31, 233
World Museum, 133
Wright, Frank Lloyd, 94, 128, 130, 132–36, 140–
 42, 159
Wrightsman Charles B., 189–90
Wrightsman, Jayne, 189–90, 225

Yale Center for British Art, 160, 273
Yale University Art Gallery, 22, 159, 160, 242,
 273
Yates, Sidney R., 55
Young, Richard, 71

Zuccotti, John, 137